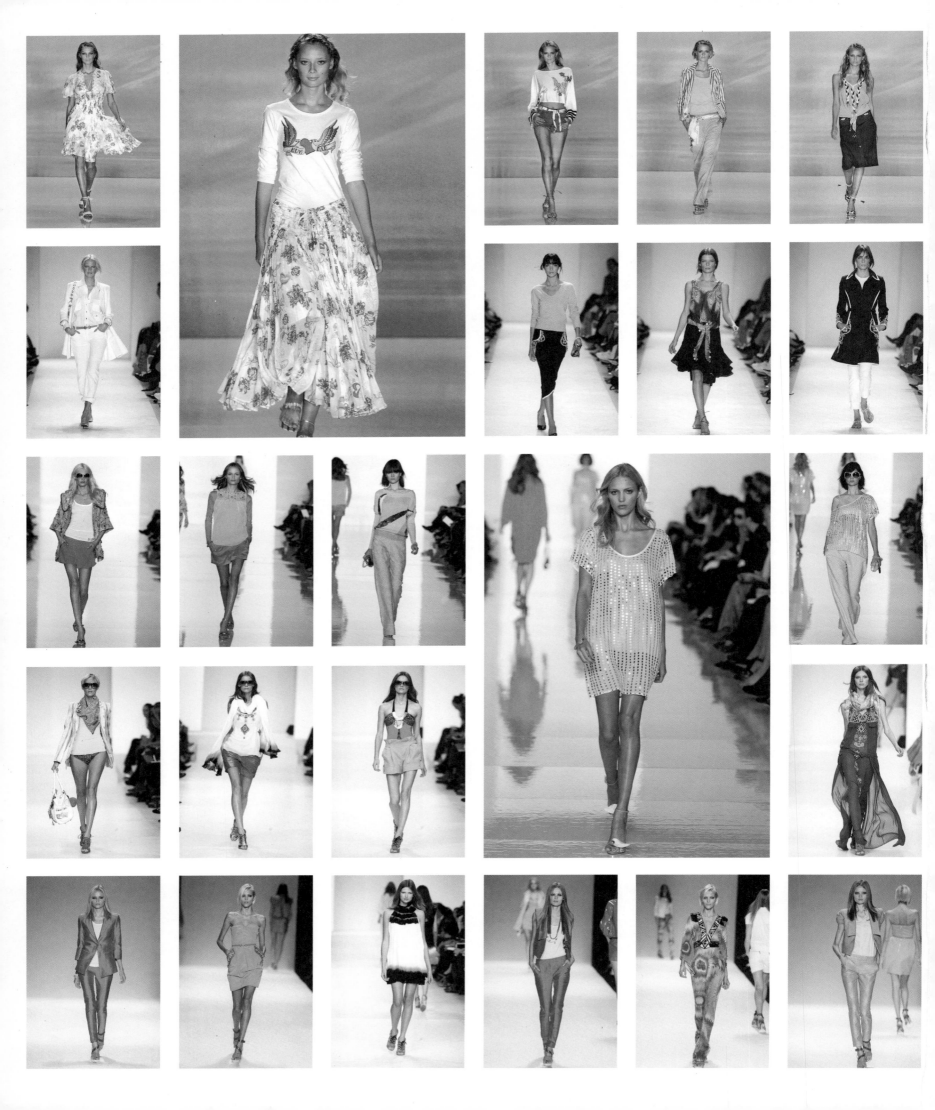

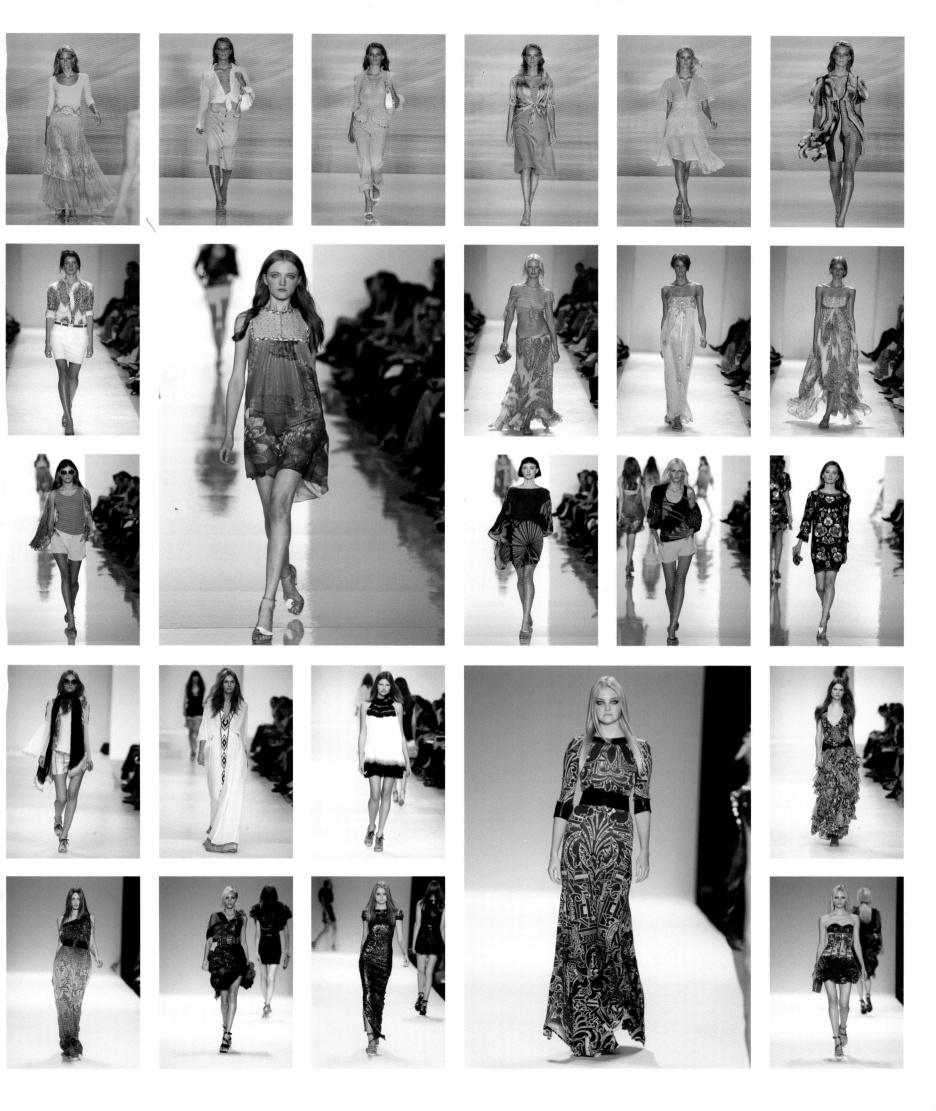

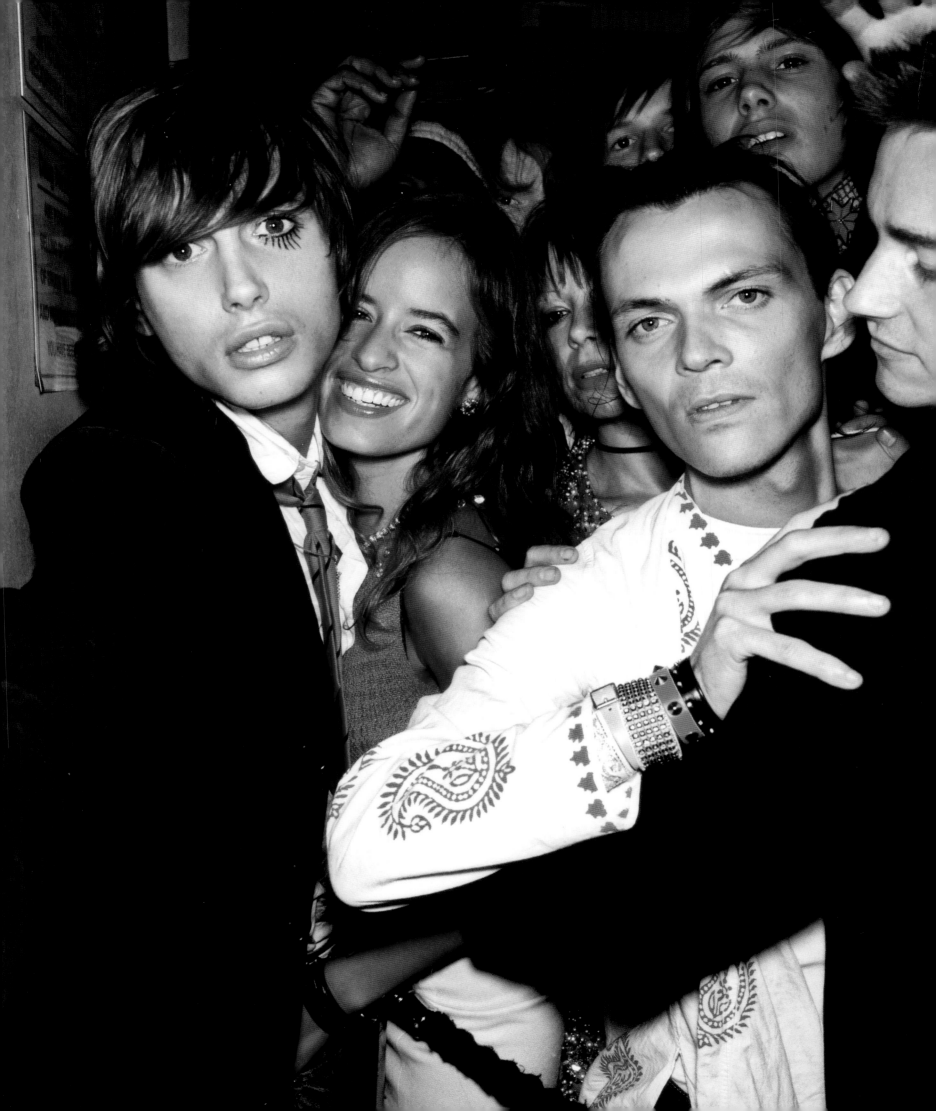

MATTHEW WILLIAMSON

COLIN McDOWELL

New York Paris London Milan

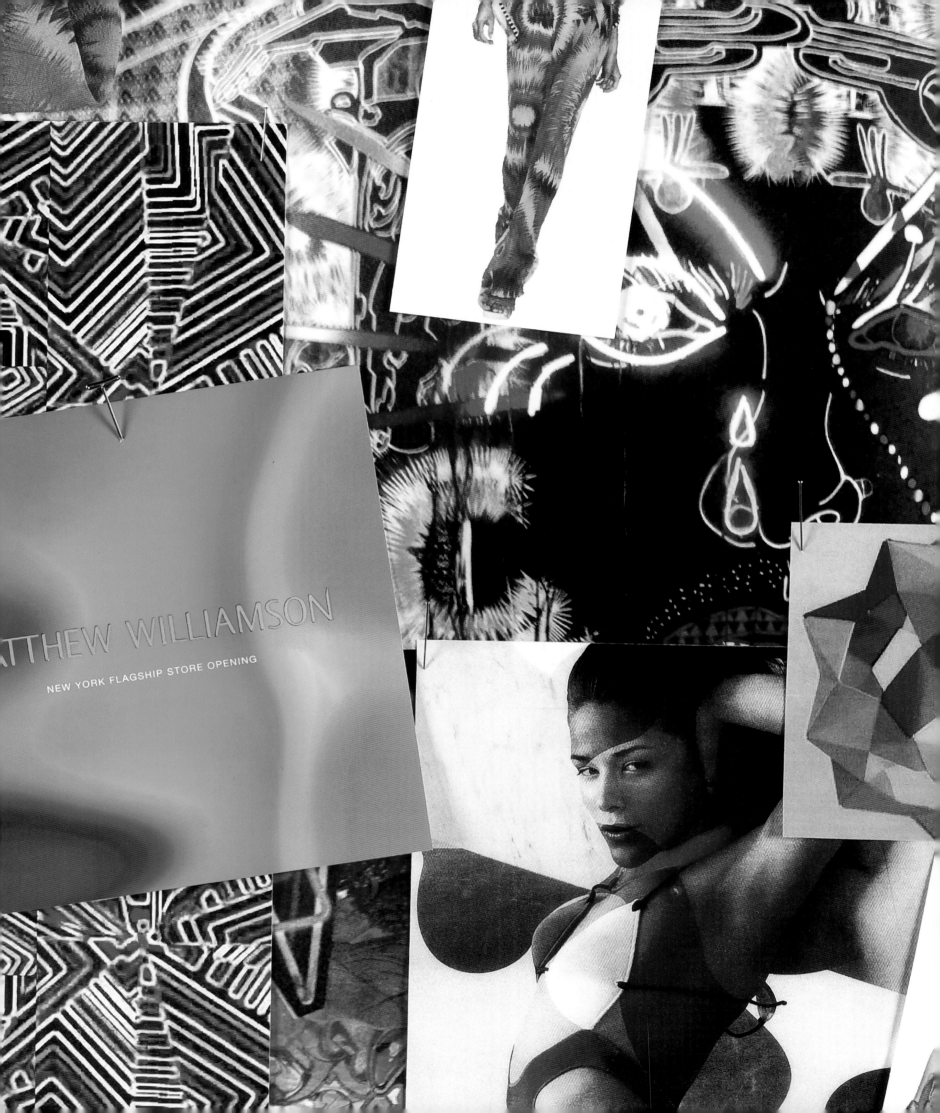

ATTHEW WILLIAMSON

NEW YORK FLAGSHIP STORE OPENING

CONTENTS

previous spread
|
Matthew Williamson,
Jade Jagger and
Dan Macmillan
photographed by Mario
Testino for *Vogue* 1999

left
|
Mood board for
SS09 collection

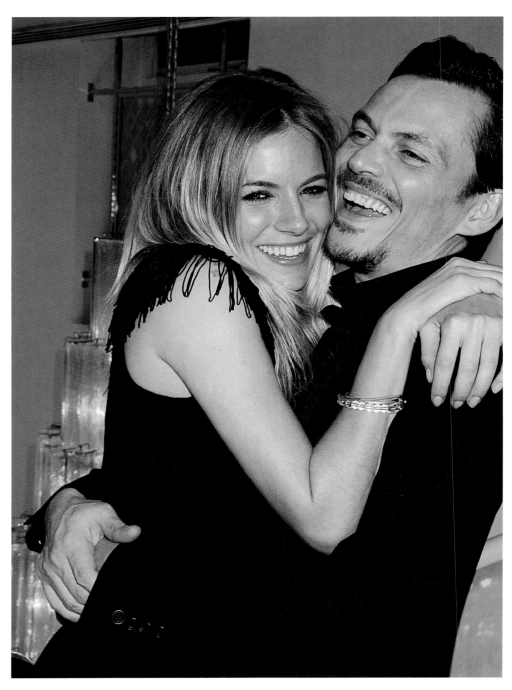

Matthew and Sienna Miller photographed at the Ivy Club,
February 2010

FOREWORD
SIENNA MILLER

I FIRST

fell in love with Matthew Williamson in my mother's kitchen in 2001. She had a magazine on the table with Jade Jagger on the cover wearing the most beautiful bright pink dress I had ever seen. I remember thinking it was my dream dress. I now feel that way about almost every dress I have worn of Matthew's. It was very serendipitous, our meeting. He had seen some photo of me at a party in a magazine and tracked me down to come and have tea with him. I don't think he realised how in awe I was of him, but it was love at first sight and we've never looked back.

Women love wearing Matthew's clothes, ultimately because Matthew loves women. There is nothing contrived or pretentious about what he creates. When I step into one of Matthew's dresses, I feel like I am stepping into his world, which is colourful, ethereal and dreamlike. His clothes are more than garments. They are magical mood enhancing creations and that is an absolute testament to the man designing them.

It's a funny thing to try to write the preface of your best friend's book. I keep desperately trying to not smother these words in sentiment, but it is impossible not to, because I feel such pride and love for him and his work. Matthew is an artist and an inspiration.

In the transient world of fashion, he has stayed true to his ultimate aesthetic: to make women look and feel beautiful. He has never compromised his values as a person, regardless of the success which he has enjoyed. He remains the same hilariously witty intelligent and loyal person I know, and it is an honour to call him my friend.

Love
Sienne
x x

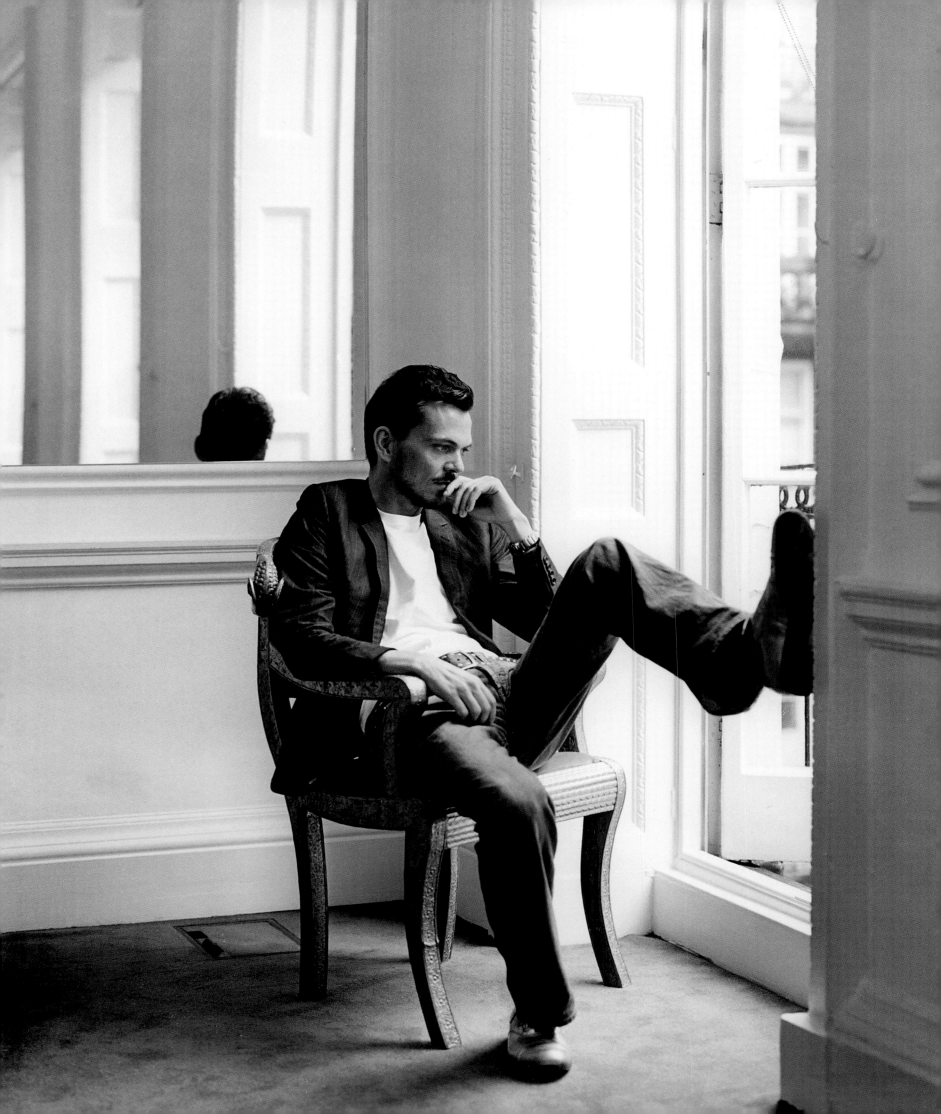

INTRODUCTION
MATTHEW WILLIAMSON

BEING a part of creating a book is very interesting, especially if that book is about your own company. The process allows you to gather your thoughts and take stock of what you have achieved over the years and pause for reflection; a luxury that's all too rare and often overlooked in the day-to-day running of a company. For me, this book has come at the right time and has been a valuable tool for understanding what has been achieved so far and therefore enabled me to consider my plans and ambitions for the future.

My first collection in 1997 was built with no real agenda or laboured structure, but was more a reflection of where I was at the time. The clothes I made were simply intended to make women stop and take a look, and to feel feminine and unique wearing them. I saw little point then, and still do today, in following fashion's ever-changing trends just to fit in. My main objective was to create clothes I had a passion for and I hoped that other people would feel that passion and enjoy wearing them as much as I had enjoyed creating them. When asked to name my favourite part of my job, I always reply that apart from the creative process of building a collection, it is seeing someone wear one of my pieces and knowing that the garment plays a positive role in their lives, no matter how small.

Over a decade on now, and there is, of course, a structure and an agenda for running our business, and I like that. As the business grows, new challenges emerge and I enjoy meeting those challenges, but all the while return to the fact that creating clothing is my passion. I consider it a great privilege to still be doing what I love most. I remember many years ago my business partner Joseph, saying, "In this business you are nothing if you don't first have a creative vision", and he saw and believed in my vision long before anyone else. Whilst I often struggle to define my vision in words, I hope this book will go some way to explaining it, and will chart our company's journey from humble beginnings as a two-man operation with no money to where we are in the present day.

I believe the greatest fashion designers are those who have established a strong signature, a recognisable identity and then built onto it slowly but surely over the years, creating new dimensions and depth to their founding design principles. This ideal remains my central design goal as we move forward with each and every collection.

As this book goes off to print, I feel lucky to have been able to express my vision and journey so far on paper. Much like a picture diary, it now holds special memories that I am proud of. As we continue on, I'm inspired and excited to see what unfolds and look forward to the twists and turns, highs and lows that lie ahead and ultimately form the future of Matthew Williamson.

I would like to dedicate this book to my parents, Maureen and David for their unfailing belief and support and of course Joseph, my business partner and best friend.

left
|
Matthew photographed for
Elle Decoration, 2009

Dragonfly print
Winter 2004

MATTHEW'S ARTISTIC TALENTS
WERE OBVIOUS FROM AN EARLY
AGE, HE WOULD SIT AT THE
KITCHEN TABLE DRAWING AND
COULD EASILY RESIST AN
INVITATION TO GO OUT AND PLAY

Maureen Williamson
Matthew's mother

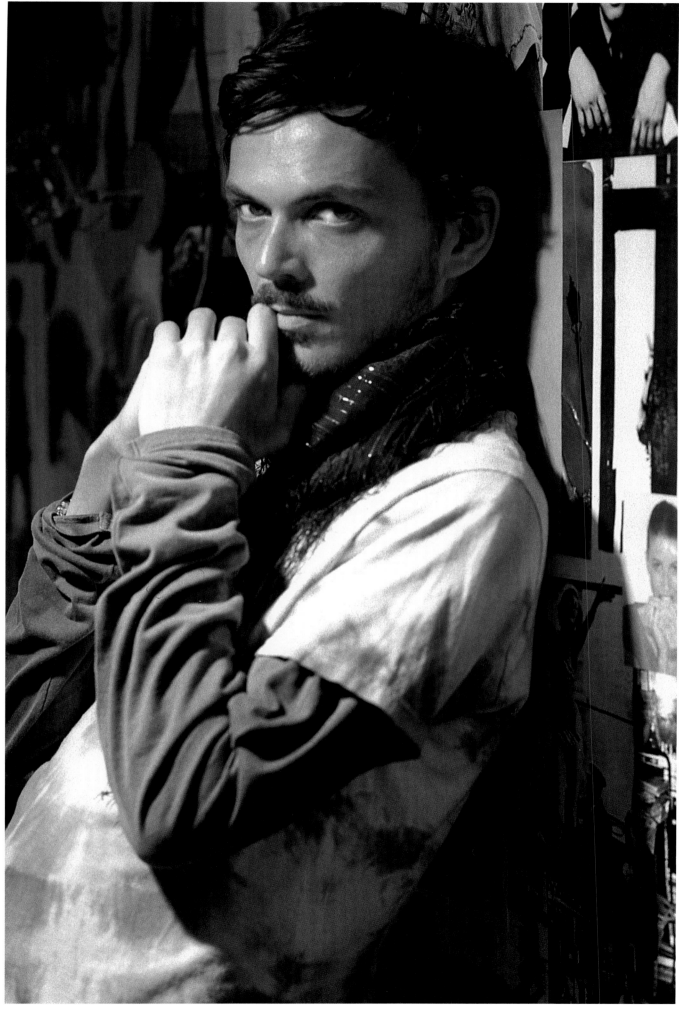

BEGINNINGS

MATTHEW

Williamson was born in Manchester, in the northwest of England, in 1971. He still retains the accent of his youth with its flat, short vowels, especially when he becomes animated, and the attitudes of the North are still very much part of him. The city has had a lasting impact on Williamson's sensibility because of his need to react and rebel against its severe and overcast atmosphere.

Manchester's grit made it one of the United Kingdom's great industrial cities in the nineteenth century, a city which was built on the cotton industry that clothed an empire. Mancunians are noted for their strength of character, determination and intolerance of mindless show. They are also famous for their non-conformity. Methodism was strong in the nineteenth century, as was civic pride. The people of Manchester never tugged their forelocks to the South, and certainly don't do so now. They are perfectly aware of the strengths which have enabled them to overcome many problems—poverty, lack of jobs and all the social difficulties that most Western cities have to face. The people are known to be strongly independent, and yet very warm.

These traits seem to have been built into the Williamson DNA. Matthew's parents—Maureen and David—are a very Northern couple, you feel their strength within five minutes of talking to them. Catholics, who take their duty as parents as seriously as they do their religion, they have a yin-yang relationship which has developed over their 40 years of marriage. Maureen is the extrovert and emotional partner; David is quiet, but no less intense. Both are devoted to their children—Matthew has an older sister, Andrea, who is a district nurse—and the ties between them are very strong. Matthew's parents have always worked; his father as a television salesman, his mother as a receptionist. He enjoyed a stable family background, full of love and care. "Andrea gave him a lot of support when he was young", his mother recalls.

The first brick in the designer's foundation is a stable, loving family supporting him at every point and in every decision in his life. The second is his relationship with Joseph Velosa, his business partner from the start, and his personal partner until seven years ago. "Joseph is my closest friend," Matthew states, "he's as important as my parents."

At any moment, whatever the fashion zeitgeist, top designers have their own signature, a vision that is part of the general fashion mood but entirely belonging to them. How each one arrives at that vision is a journey through experiential influences from the cradle onwards.

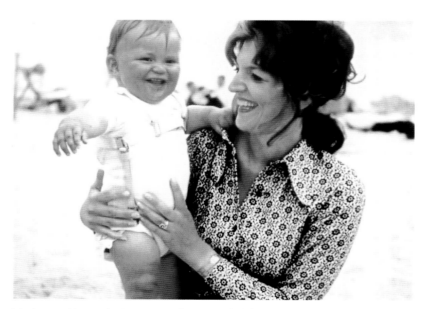

Matthew and his mother Maureen Williamson on holiday, 1972

Matthew Williamson has no doubt about what was the greatest influence on his design approach, with its floaty, light-as-air fabrics and colours exotically strong or brilliantly clear — Manchester. "Even when I was young, I was conscious of how grey it always was", he says. "A grey city in a grey country. As I grew up, I was struck with how sombre it always was, with none of the colours I craved." Luckily, his parents allowed him to bring colour into his private world, at least, by giving him carte blanche to decorate his bedroom in whatever way he fancied. "I knew my bedroom was mine. I owned it as a space. And I was always changing it", he recalls. "The very last time I painted it, in my mid-teens, I chose a ghastly lavender shade from Homebase for the walls, with silver paint for the woodwork. This was at the time I was wearing gold shoes! I was probably about 15 and obsessed with my appearance — which included my room, where I brought my girl friends to gossip, listen to music, talk clothes and make little bits of fashion. And I was very proud of my room. I made my own curtains! I've always loved interiors."

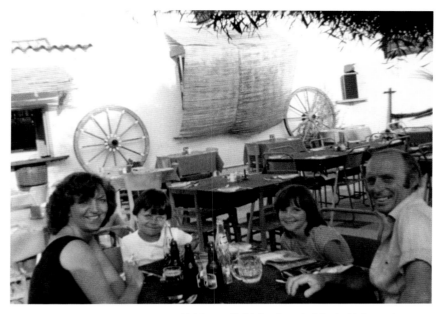

Matthew with his family on holiday in Malta, 1976

"The true source of my inspiration", Matthew explains, "could surprise you but every collection I have ever done has been initially inspired by nature in one form or another. The more exotic the inspiration the better: exotic countries and sun-drenched landscapes are really what capture my imagination and lead me to delve into different cultures from around the world. I would travel to India, Morocco, far flung exotic places and return to my studio, weaving the things I saw back into my own visual language of design."

With this principle at the core of his work, he taps into a sensibility that is linked to the idea of a free-spirited woman who is not afraid to be bohemian — but his inspiration is never a common idea of what a bohemian woman is. It's a million miles from the trite cliché of gypsy earrings and flounced skirts. Matthew has a very British idea of Bohemia: it is a loose, classless way of putting the elements together and is more refined than dramatic. His inspiration is all those beautiful English fireflies, going right back to Talitha Getty and, of course, his friend Sienna Miller. The kind of women who know about clothes and respond to them, but after that, just wear them. They

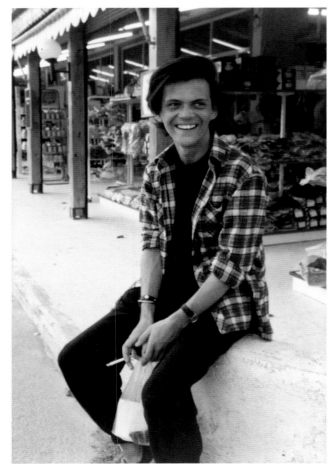

Matthew on holiday in Greece, 1988

would never think of letting their clothes make their statement; they know that they are the statement. That is the philosophical basis for the Williamson woman.

But perhaps that is a little disingenuous. The woman who has had the greatest influence on Matthew Williamson is his mother and there is nothing

casual or random in the way she dresses. Matthew remembers how, when he was a boy, his great pleasure each night was watching his mother sorting out her wardrobe for the following day for her job as a receptionist. "She used to lay everything out on the bed", he recalls. "The blouse, the skirt, the jewellery, the scarf. The shoes were cleaned, the nail varnish done." Nothing was left to chance and it is this sense of order that Matthew has inherited – and also what he values in Joseph Velosa, whose tidy mind allows nothing to slip or be forgotten.

Matthew Williamson has no illusions. Totally grounded, he knows who and what he is.

"I suppose I began clubbing back in Manchester. I was very confident within myself because I knew my parents totally embraced my difference. I suppose I must have been about 15 when I started to go clubbing. At The Hacienda I got in with all the drag queens. I was curious about these tall languid creatures, some of whom were really beautiful. I thought they were so courageous. They weren't afraid to be extreme. I admired that."

"There was a place in Deansgate in Manchester called Afflecks Palace, up a scruffy side-street. It was an emporium of tat and it attracted all the cool Manchester kids. On a Saturday it was heaving with Goths, Rockabillies and Teddy Boys. I loved it. And it was important for giving me the confidence to realise my own image. I knew that I absolutely had NOT to be the same as everybody else."

Matthew was keen on studying fashion at Central St Martins in London. He was advised at the timey to do a foundation course before he applied to do a BA.

He went to Manchester Polytechnic for the interview and at the end of it the interviewer said, "You'd be wasting your time here. You are so far ahead, work like this is what we hope will come at the end of the course, not the beginning." The upshot was that he was advised to apply directly to St Martins to do a BA. He was 17 years old.

Arriving at Central St Martins, in the heart of London's Soho district, was quite a scary experience for a lad from Manchester who had barely travelled at all, and never alone. The arrogance of

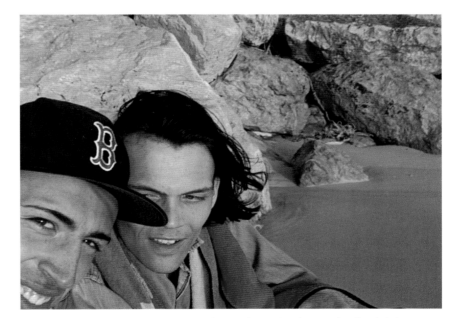

Matthew and Joseph Velosa on their first holiday together in Portugal, 1991

the school permeates the whole building and affects tutors as well as students. It is an unreserved and competitive place that sets out to force would-be designers to push the barriers and set themselves the highest personal standards. Matthew was terrified on the day of his interview. All the clever points he had thought to make when he was travelling down from Manchester and mentally

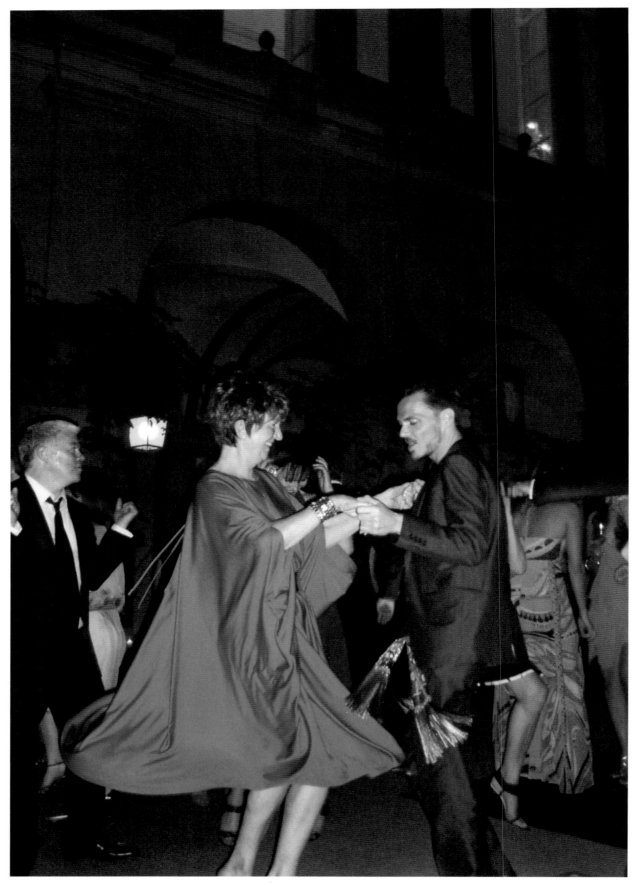

Matthew and Maureen at the Pucci 60th Anniversary
celebrations in Florence, 2007

rehearsing, disappeared very quickly. Matthew Williamson is a good speaker, able to marshal his arguments and order his thoughts, but at that moment he was barely able to speak. "I wanted it so much", he says now, "but I was told later by a tutor that my manner didn't come over as shy or scared but as very self-possessed and arrogant." Anyone who knows anything about St Martins knows that this is what they look for – the grit that might eventually make a valuable pearl.

"I was the youngest student on the BA course but I wasn't worried. I was breathing the same air as Alexander McQueen and John Galliano, both of whom are great designers." In fact, Matthew found the spirit of St Martins very difficult to cope with. "It was all about star-making and that meant being revolutionary. Something I had never wanted to be. I wasn't in the right box. In fact, there wasn't a right box for me." His mother recalls his sad voice on the other end of the phone, "Can I come home, mum?" Not that he wanted to give up, just to visit for a weekend in the environment he understood.

Looking back now, Matthew thinks he was simply too young and inexperienced for such an overwhelming place. "I soon realised that I was, by St Martins standards, pretty average. I was determined not to sink but I wasn't exactly walking on water. We were expected to compete so I put my head down worked hard and just got on with it, developing my ideas in the best way that I could."

Professor Louise Wilson, head of the Fashion MA at St Martins School of Art, London, remembers Matthew's early days as a BA fashion student, "he had a natural flair for colour, creativity and experimentation. He applied them to all his work and personal style – you always noticed him in the corridors. A memorable project I remember involved combining hundreds of postcards covered in coloured glitter and rolled to form 3D shapes and then applied as a trim to a dress. As I said, he always experimented."

Matthew Williamson received his BA in fashion in 1994. His final show at school reflected his work experience placement with Zandra Rhodes, whose great loves were colour, pattern and softly feminine dresses. A figure as colourful as her clothes, Zandra, with her pink hair and deep blue eye make-up, was (and still is) one of London fashion's originals. As Christian Lacroix has said, she stands out in London because she is a radical of the sort who "inno-

Matthew and Maureen on holiday in India, 2001

Matthew and fellow St Martins students attending Paris Fashion Week, 1991

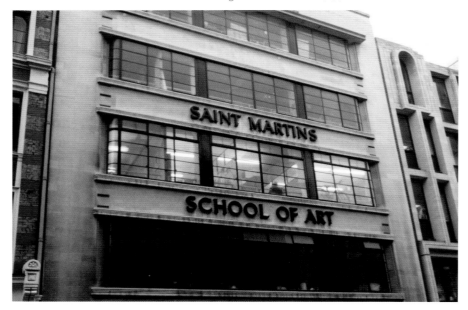
Central St Martins, Charing Cross Road, London

vate and bring the kind of oxygen we need." Silk, chiffon, dramatic colour and embroidery were the basis of her fashion vision, as they are with Williamson.

Zandra Rhodes recalls, "Matthew felt very much drawn towards my prints, beading, and use of colour to the extent that he took off-cuts of lace and printed fabric home to create his own garments." Matthew would collect discarded couture lace scraps from the studio floor, which he used to make the final dress for his graduation show. It seemed fitting to use something from the real world as the centrepiece of a show bidding farewell to a period of his life that Matthew didn't like.

Out in the world of commercial fashion, Matthew — who was at this point living with his partner, Joseph Velosa — had a lucky break. His final graduate show had been noted by the high-street chain Monsoon and very quickly he was offered a job as their accessories designer, where he stayed for two years. Joseph takes up the story, "He would arrive home complaining about the lack of time and how he ultimately wanted to work for himself creating his own ideas. He had his own vision which he was eager to pursue."

Joseph and Matthew met in Manchester, where Joseph was studying French and History. Joseph left Manchester University and transferred to London to read Philosophy and to be close to Matthew, his new partner. "I had been taking lessons for a pilot's licence and had a part-time job with Air France, to make a little money and help with my French."

The label was born out of the relationship that developed between Velosa and Williamson, and was aided immensely by the ability to travel at little personal cost, thanks to Joseph's job. Velosa says, "We knew that to do what we wanted, we needed, more than anything else, to travel. Especially to India. Frequently. We could do it — without the thousands of pounds a travel budget would require. Everything pointed to India. We went out there with no real contacts — and not much of a clue, to be honest. But we both knew we had to find our own suppliers, meet them face to face, with no middle men. They were a luxury we simply couldn't have afforded."

From the very first trip in 1987, Matthew fell in love with India. He had already worked in Delhi and Mumbai on jewellery for Monsoon so he had learned

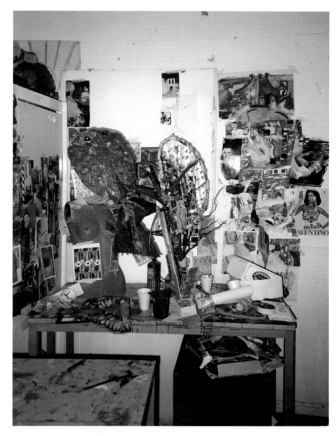

how to approach suppliers. Matthew and Joseph began to persuade vendors to give unheard of concessions, such as holding payments as much as 120 days after delivery. In that way, "little by little we built our business," Joseph says, "and eventually we were able to generate some cash-flow but it was very hand to mouth. Certainly, we were ambitious. We really felt we could do anything. When we first met, I had known nothing about fashion, but being with Matthew — and his enthusiasm — meant that, by a process of osmosis, I began to get the message."

Matthew, who has a good business head of his own, realised that their skills were so complementary that Joseph had to become a real part of Matthew Williamson the company. As Joseph explains, "Actually we were so far down the line that it didn't seem such a big deal at all. It was simply a logical progression to the next point. I was making the money to keep us going and getting us the cheap travel. We were there already, really." So, the pieces all began to come together. Matthew's clothes captured something new: an innocence, a playfulness and a sense of a woman's femininity, which were absolutely right for the moment. They both worked together to bring their vision to the public, to convert their dream into a wearable reality.

Matthew's studio space at Central St Martins

Matthew and fellow St Martins student and flatmate Debbie Douglas at the Notting Hill Carnival, 1992

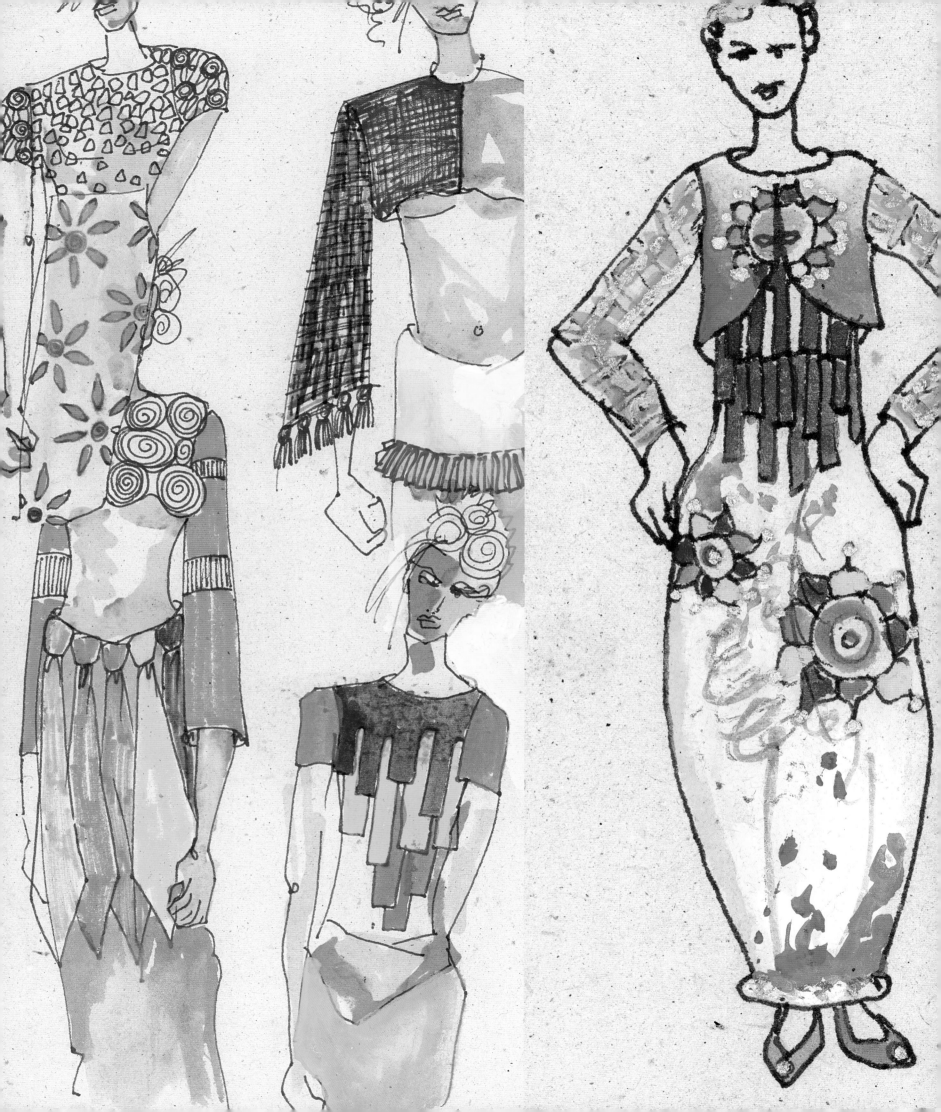

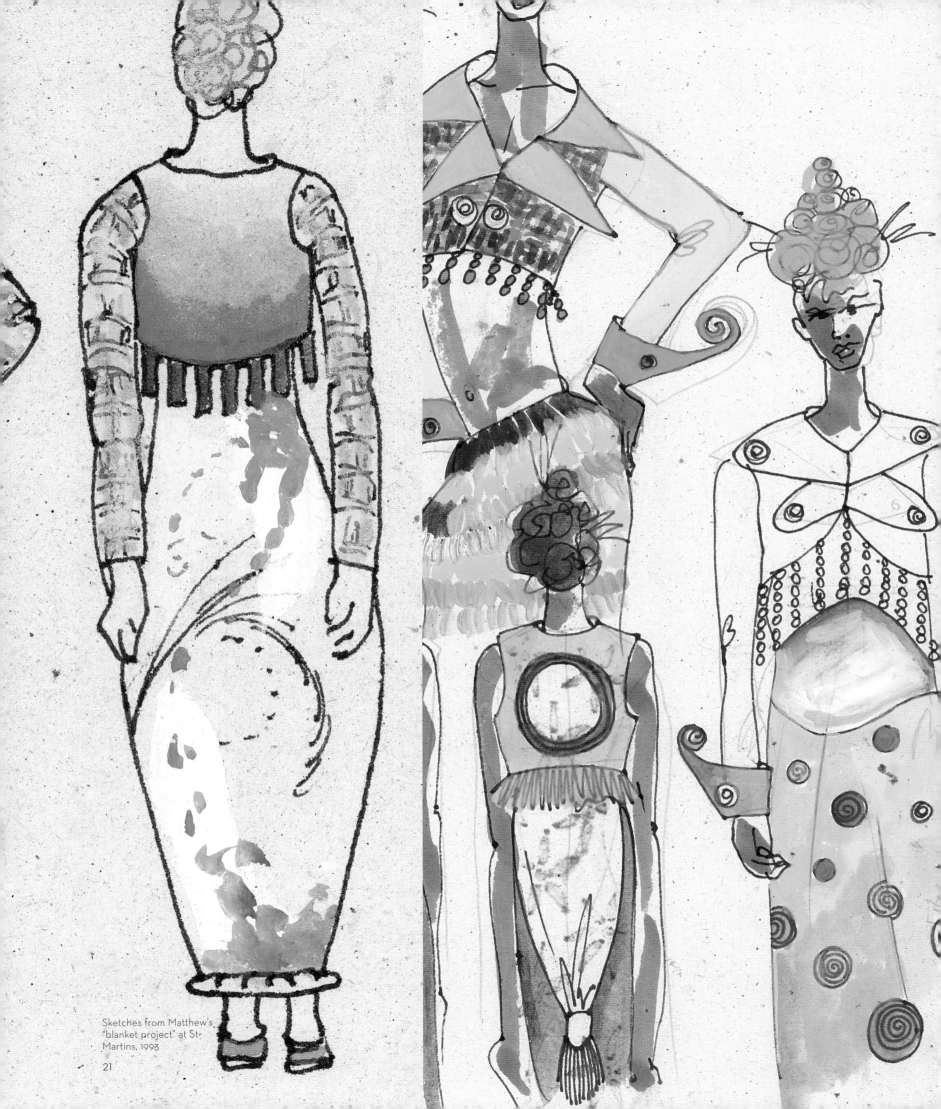

Sketches from Matthew's
"blanket project" at St-
Martins, 1993

21

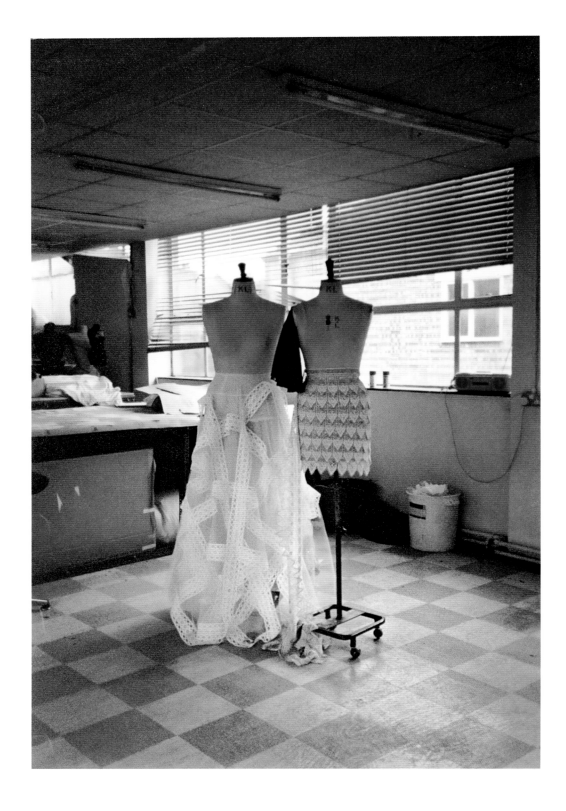

clockwise from left
|
Picture taken by Matthew of Zandra Rhodes' studio during his placement in 1992

Print artwork for one of Matthew's graduate collection dresses

Zandra Rhodes and Ben Scholten at their studio where Matthew had a placement in 1992

Picture taken by Matthew of Zandra Rhodes' studio during his placement in 1992

Matthew and his mother Maureen at home working on a hand painted and beaded top for his graduate collection 1994

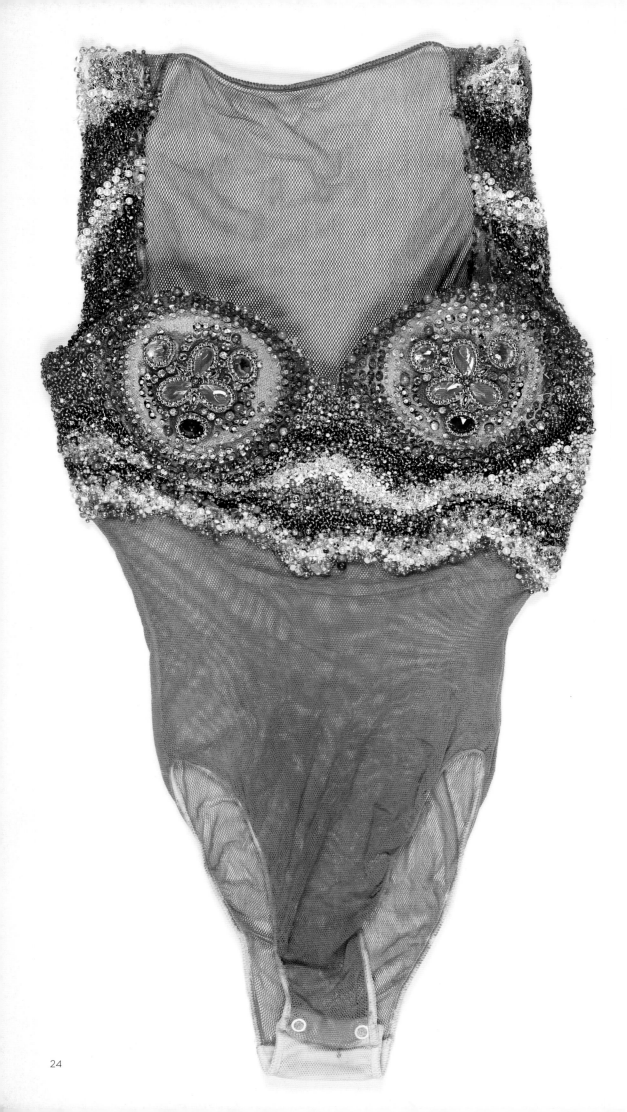

this page
|
Mesh bodice which
Matthew beaded by hand
over the 3 months leading
up to his graduate collec-
tion show

right
|
Model wearing bodice in
graduate collection show.
The outfit is completed with
a hand printed skirt trimmed
with hand rolled postcards
from Matthew's travels.

24

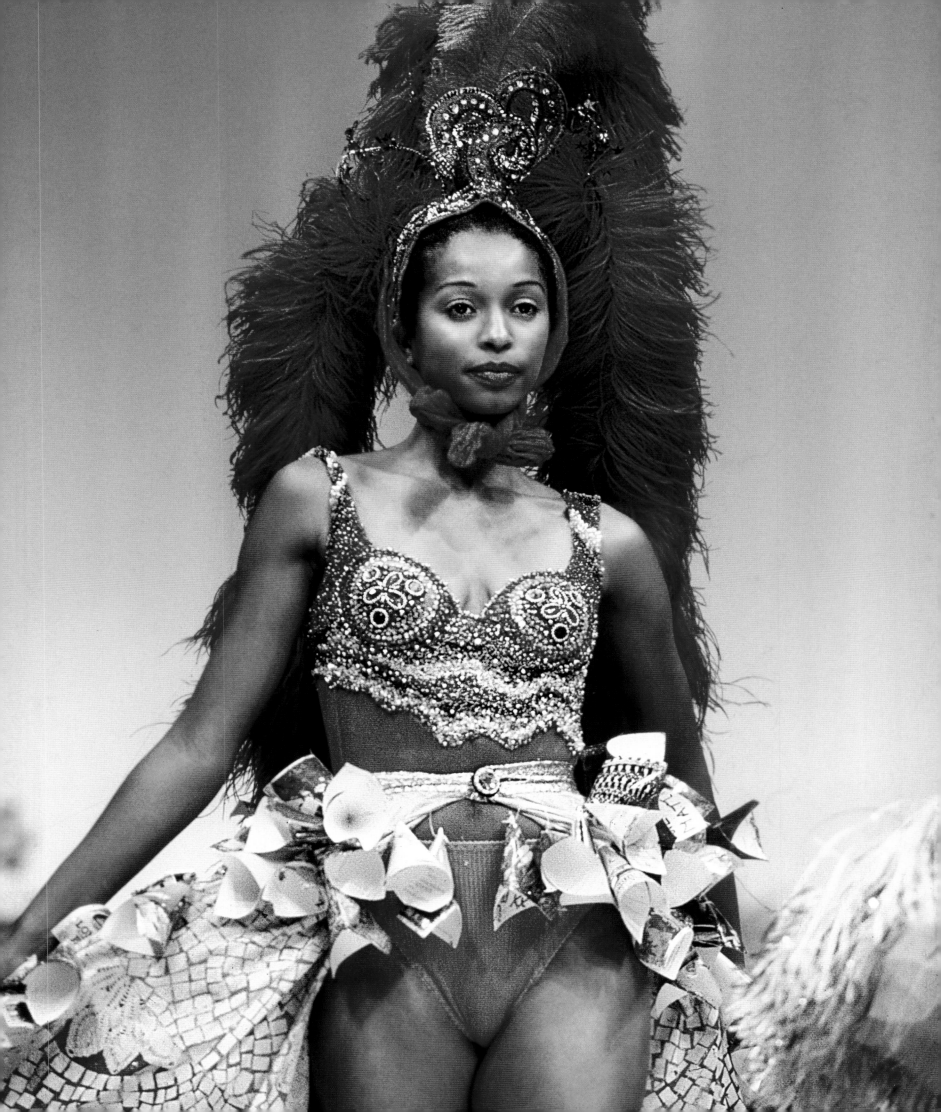

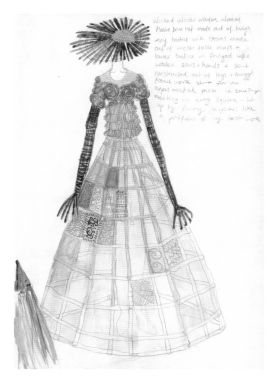

Sketch from Matthew's graduate collection, 1994.

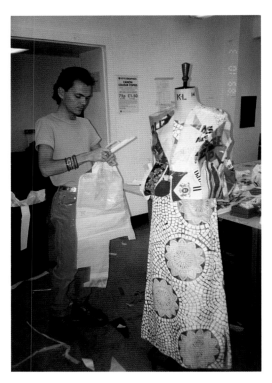

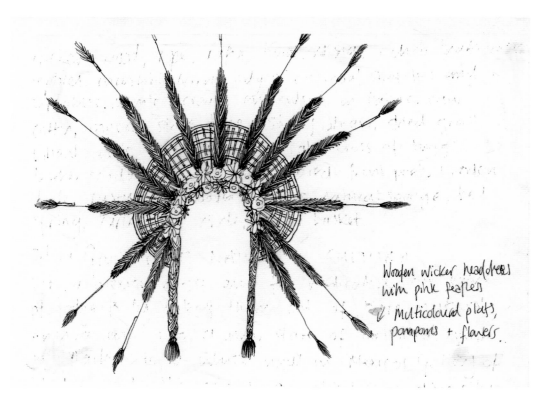

Wooden wicker headdress with pink feathers & multicoloured plaits, pompoms + flowers.

Sketch from Matthew's graduate collection, 1994.

above
|
Matthew working on his graduate collection at St Martins, weeks before the final graduate show. Here he is seen constructing a jacket panelled together from duty free plastic bags collected on his travels

right
|
Look 3 from Matthew's graduate collection shown on the runway, 1994.

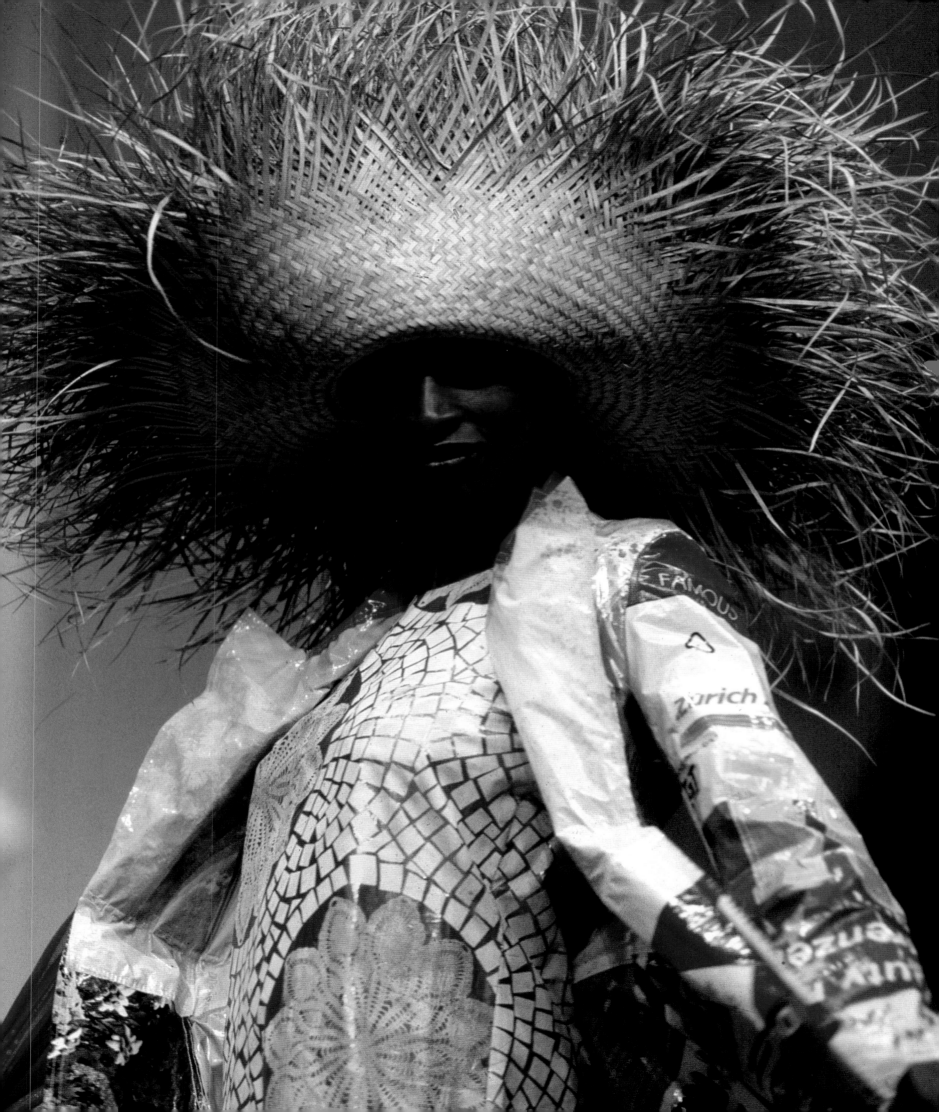

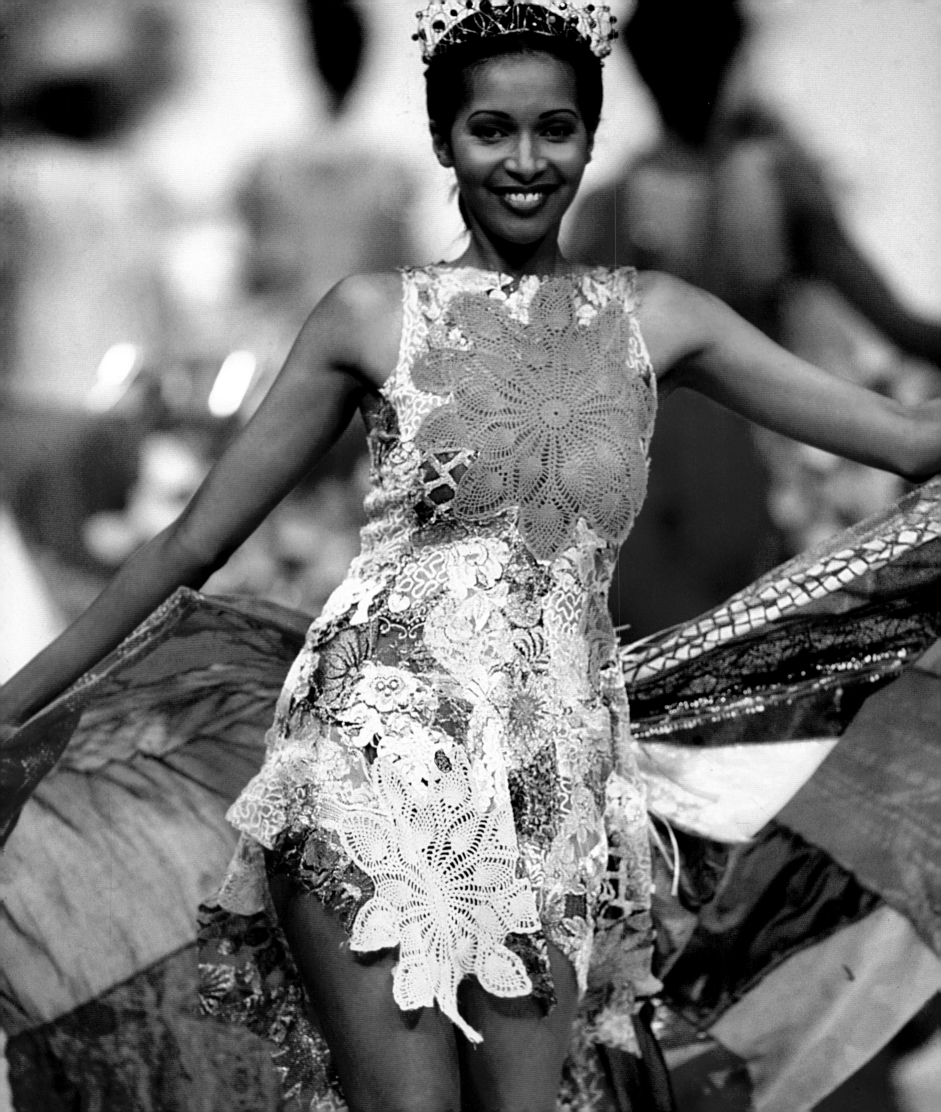

Hotshots

Unlike most of us, fashion college Central St Martins does not like to pick up talent that's young and innocent. Four years ago, however, it accepted Mancunian Matthew Williamson at the tender age of 18. He has now returned the compliment by producing a graduate collection that turned the catwalk into the Rio Carnival at the college's recent show. Showgirls' heads were weighed down with feathery crowns, and the dresses were big enough to house a shanty family. Williamson admits that the clothes are overblown in colour combinations and style – 'it could take you half an hour to look at each garment properly' – and says this is the consequence of taking a year out to travel in beige-free Mexico, Guatemala and India. His appreciation of the spectacular was not hindered by a spell working for Zandra Rhodes, who indeed resembles a mini-carnival float with her day-glo hair. Williamson says this was a 'good learning experience, although she often went crazy', and Williamson was even given advice for his final collection by her right-hand-man Ben Scholtzen.

tip for the top
Matthew Williamson

LORENZO AGIUS

The show has won him promises of coverage from most of the fashion glossies and several prestige job interviews but he now contemplates a return to college to get his MA.
Andrew Tuck

Matthew's first piece of press featured in *Time Out London* after his graduate collection in 1994

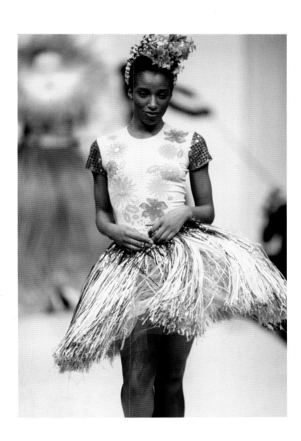

above
|
Hand painted t-shirt and grass skirt, look 4 in his 6 look graduate collection. Matthew graduated from St Martins with a 2:1 BA Honours

left
|
Final look from Matthew's graduate show, 1994

Labyrinth print
Summer 2009

IT IS INCREDIBLY HARD WORK
BUILDING AND MAINTAINING
A BRAND FROM SCRATCH
BUT IT'S MADE A WHOLE LOT
EASIER DOING IT WITH YOUR
BEST FRIEND

Joseph Velosa
CEO *Matthew Williamson*

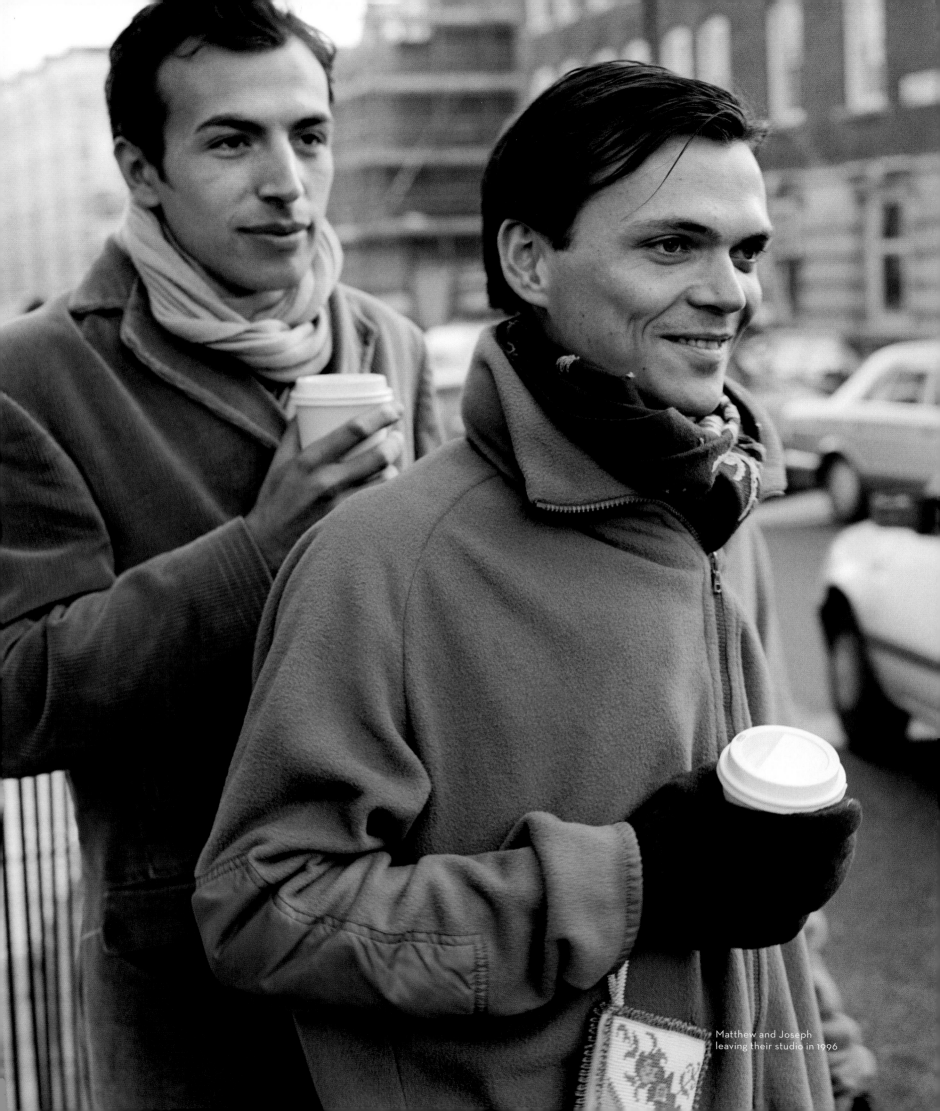

Matthew and Joseph
leaving their studio in 1996

AMBITION

Running a fashion company had never been my career goal. But then again I believe that sometimes we are given beginner's luck in life and we should embrace it when it comes along. Matthew and I were so fortunate in the early days in many respects and this created a real sense of motivation for creating our business together. From the onset we had a similar vision for our tiny company and it is still this vision that drives us today.

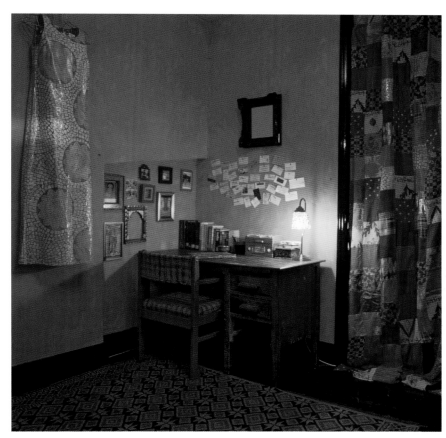

Joseph's working area in their studio/living space which was then a one bedroom flat on Gray's Inn Road, London

Twelve years on and I must say it's been quite a thrilling ride! No day is ever the same and the launch of a new collection is still as exciting and nerve-wracking as ever. It is incredibly hard work building and maintaining a brand from scratch but it's made a whole lot easier doing it with your best friend. We have shared some real highs (and lows, of course) and that makes the whole journey thus far seem more real and worthwhile. The people and the places we have encountered while running our business together have surpassed all expectations, but that all pales into insignificance when compared to that sense of saying to one another—"we did it!" For as long as there is that motivation in place, I expect us to be "partners in crime" for some time yet."

Joseph Velosa
CEO, Matthew Williamson

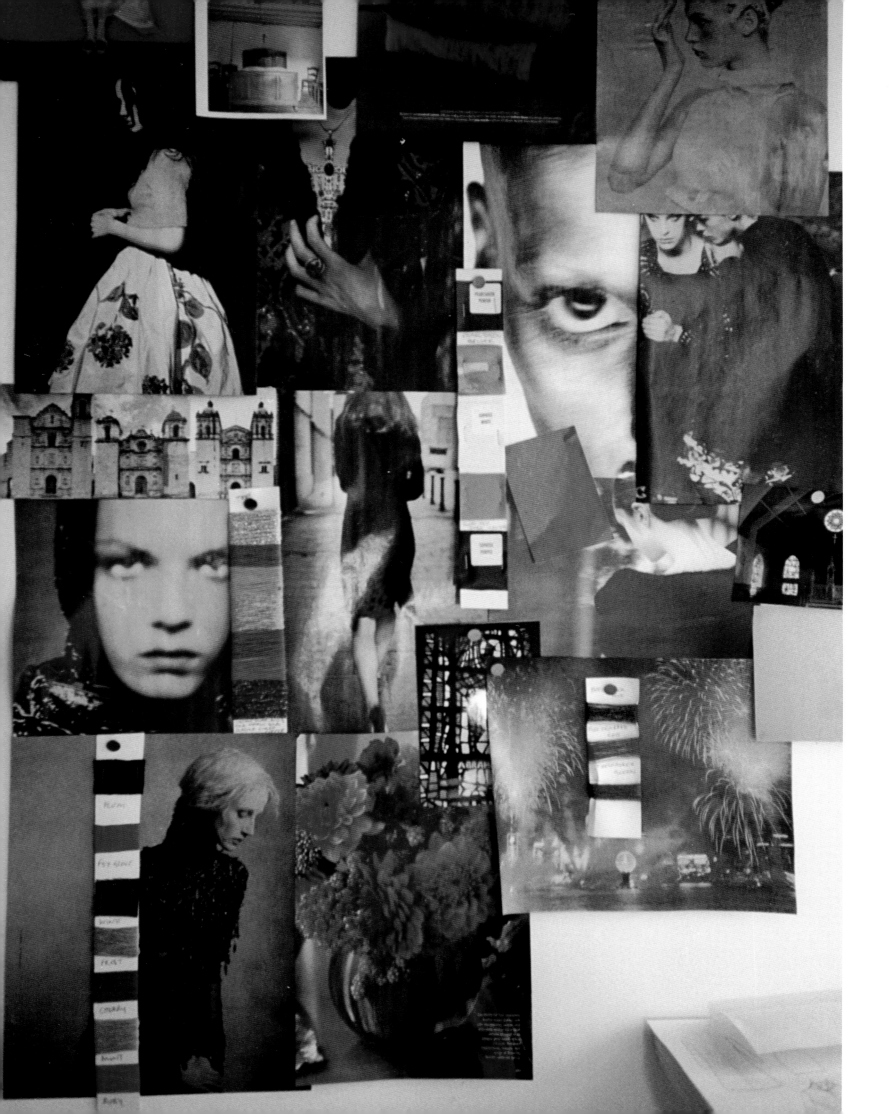

THE Matthew Williamson business is built on tenacity as much as talent. From the beginning Matthew and Joseph have both had the will to work. In both cases, it comes from their parents. At the time, Joseph concedes, "we had nothing except my salary, which was not big. We didn't want backers. We wanted to do it alone. Of course, I got free or discounted travel so we were able to go to all the places Matthew longed to see. They fed his aesthetic — and mine, too. It was a big learning curve for me after French and Philosophy at university. But it was India that did it for him and, after a while, me. Everything came from there because that is the place that confirmed everything he loved."

"We went to Mexico and Guatemala in summer 1992 for three weeks' holiday. We travelled for two weeks in Mexico, from Mexico City to the southern cities and then into Guatemala and travelled round there for a week. I think it was the first and last time Matthew ever went anywhere backpacking.

"I was always much happier to travel around with a backpack and just get on with things and enjoy living off £20 for that day and being a bit of a student, even hippie traveller whereas Matthew, I quickly realised, was not going to be happy roughing it.

"I knew that this wasn't someone who was just going to settle for the grey option. Even if we couldn't afford it he would go after experiences that pleased him aesthetically and I was drawn to that immediately. I thought, here is someone who excites me because this is going to be a journey, and I think we'll both come out of this better if we stick at it."

"So that was a very immediate moment at the beginning that I clocked, that boded well for the future, for having a good experience together. Then there were also those kind of silly moments — picture-postcard moments — you know, when you're watching a hummingbird and a rich sunset draws in. He drew my eye to things, colours for example, that I wouldn't normally have noticed."

Priya Tanna, Editor of *Vogue* India, explains how Williamson brings the exotic cultures he visits into his clothes, "I am in love with Mathew Williamson's India. It is an India so different from the one I know and live in. It is an India where fantastical motifs, rich embellishments and a crazy riot of colours work overtime to energise simple silhouettes, transforming clothes into a wearable wonderland. Mathew's shows are a journey I greatly enjoy undertaking season after season, as they bring me closer to home in ways I have never imagined, re-introducing me to sights and scenes that could have been in my backyard but are instead on my dress.

"It's no surprise that Matthew's grasp on colour appeals to the Indian in me, as do his billowy and flirty silhouettes to most women. I can understand why a growing tribe of Indian women are ascribing to his aesthetic. It takes a particular sort of spirit to carry his pieces— a fun, sexy and confident dresser who is both playful and purposeful with her fashion choices; someone who marries femininity and modernity in equal measure."

left
|
Mood board from
Matthew's first AW
collection, 1997

Joseph recalls the moment Matthew asked whether he would consider being his business partner. He said, "You know I've got these fabric swatches and I want to do something with them on my own, and if I do it on my own will you help me?" It seemed like a small enterprise. It was those swatches that he sent to *Vogue* May 1996, that started everything.

"At my suggestion," says Joseph, "Matthew decided to send one of his dresses to *Vogue*. Who should he address it to? We looked down the masthead of British *Vogue* and saw an intriguingly original name which just amused us." So Matthew sent it to her. The journalist's name was Plum Sykes and she showed the dress to the editor, Alexandra Shulman. Matthew was invited in. Plum Sykes recalls her first meeting with Matthew:

"I remember a heavenly package of exotic silk swatches landing on my desk at British *Vogue*. There was a note inside saying something like 'I thought you'd love these . . . please can we meet?' They were from a 22-year-old ex St. Martins student called Matthew Williamson. I must have cancelled our appointment six times, and Matthew did too (always off to India). Finally the day of the meeting came. I was not especially excited. I met so many disappointing young designers and so I was wary.

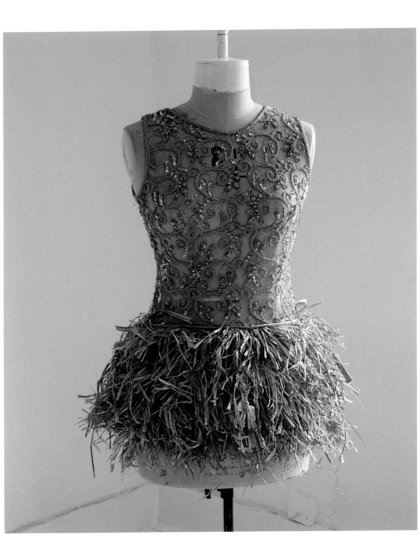

"I arrived at least ten minutes late back from lunch. But as I sauntered back into Vogue House I noticed a beautifully tanned, blue-eyed boy, wearing an emerald green silk scarf twisted round his neck. I'll admit I was mesmerized; Matthew had amazing personal style. He dressed like a glam rock n' roll gypsy. Not only did I want everything he was wearing, I wanted everything that he pulled out of his bag and scattered all over my desk upstairs, especially the beautiful dresses in turquoise chiffon with lilac butterflies embroidered on them.

"Like bees to a honey-pot, the other *Vogue* girls sidled over and went berserk over the clothes. That was the beginning of a very special relationship between Matthew, *Vogue* and myself."

Soon after their meeting Plum said, "You must come back—turn this into a dress and we'll have another visit." On the next visit, she said, " I need a stockist to feature you in *Vogue*. If I can get a stockist I will write about you." Alexandra Shulman, the editor of *Vogue*, then joined us and gave her approval. There was a ripple effect, it went from Plum Sykes right up through the *Vogue* hierarchy to the

A costume made by Matthew for the Wayne McGregor dance company, 1995

editor, and Lucinda Chambers, the stylist. Matthew had long admired her and they struck it off immediately. Velosa says, "Matthew created a painting for her—it was a painted illustration of an idea of one of his samples, about to be made in India—and Lucinda loved the work so much she commissioned him to do some beading artwork for Marni. So just before we launched our business, Lucinda had commissioned Matthew already for an artwork."

Original sketch for the costume seen on previous page

"This was in May 1996 and our first piece was in the *Vogue* issue January 1997 that came out just before Christmas", says Velosa. "At that point a snowball effect was about to begin. On a subsequent trip to Vogue House to show Plum more garments, we left a silver organza beaded skirt with her. Natalie Massenet, who used to be at *Tatler* at the time, borrowed it from Plum and it found its way onto a fashion shoot where Jade Jagger was being shot for a cover story. Before we knew it, Jade picked up the skirt and called us since she wanted to find out more about the designer. This was September 1996—and I was so wet behind the ears that when a call came through, I took it—and it wasn't Jade but her assistant who said, 'I'm calling on behalf of Jade Jagger. She's worn a skirt for the shoot which she loves. Is there any chance she could keep it?' I said, 'Well, I'll find out the price and get back to you,' and just put the phone down. I turned to Matthew and said, 'Jade Jagger's interested but we'll have to charge her the full price.' Matthew looked at me and said, 'Just give me the phone number.' At that point I had no idea how this all worked! They arranged a meeting shortly thereafter and got on and had a creative friendship from the get-go.

"We went to New York in autumn 1996 but, before we left, we showed Plum the pieces. That silver skirt was now a little mini collection of dresses, which we had created samples for in India. She said 'this is great, you should now show the dresses to A La Mode and Browns, and if you can get a stockist then it's a done deal and we'll definitely write about it.' We went to see both boutiques and they both placed an order. So we did a stock take. We've got *Vogue* with a page that they're definitely going to write, we've got Jade Jagger wearing the skirt, we've got London stockists, so let's get an appointment in New York. So I picked up the phone, to Julie Gillhart at Barneys, and it happened. I was very green and I thought, 'This is how it's going to all work—the doors are going to open forever and a day and what a lovely industry, we love these people and they love us! Mutual admiration!' We had orders from top stores without even having to prove that we could do it, without having to declare who was going to manufacture these things. It all seemed so easy then."

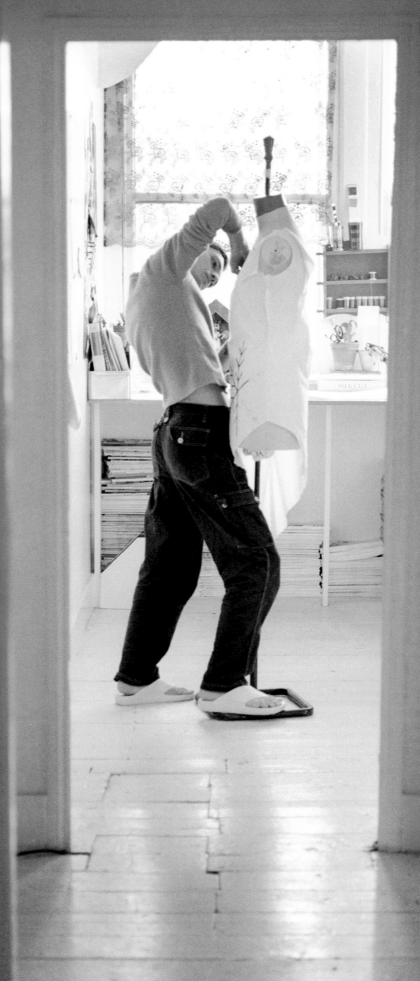

this page
|
Matthew at work at
Gray's Inn Road, 1996

right
|
Kitchen at Gray's Inn Road.
The floor seen here was
made up of hundreds of
playing cards Matthew
overlayed and then
varnished. The tea cups
were cut from wrapping
paper and applied by hand
to the units as decoration.

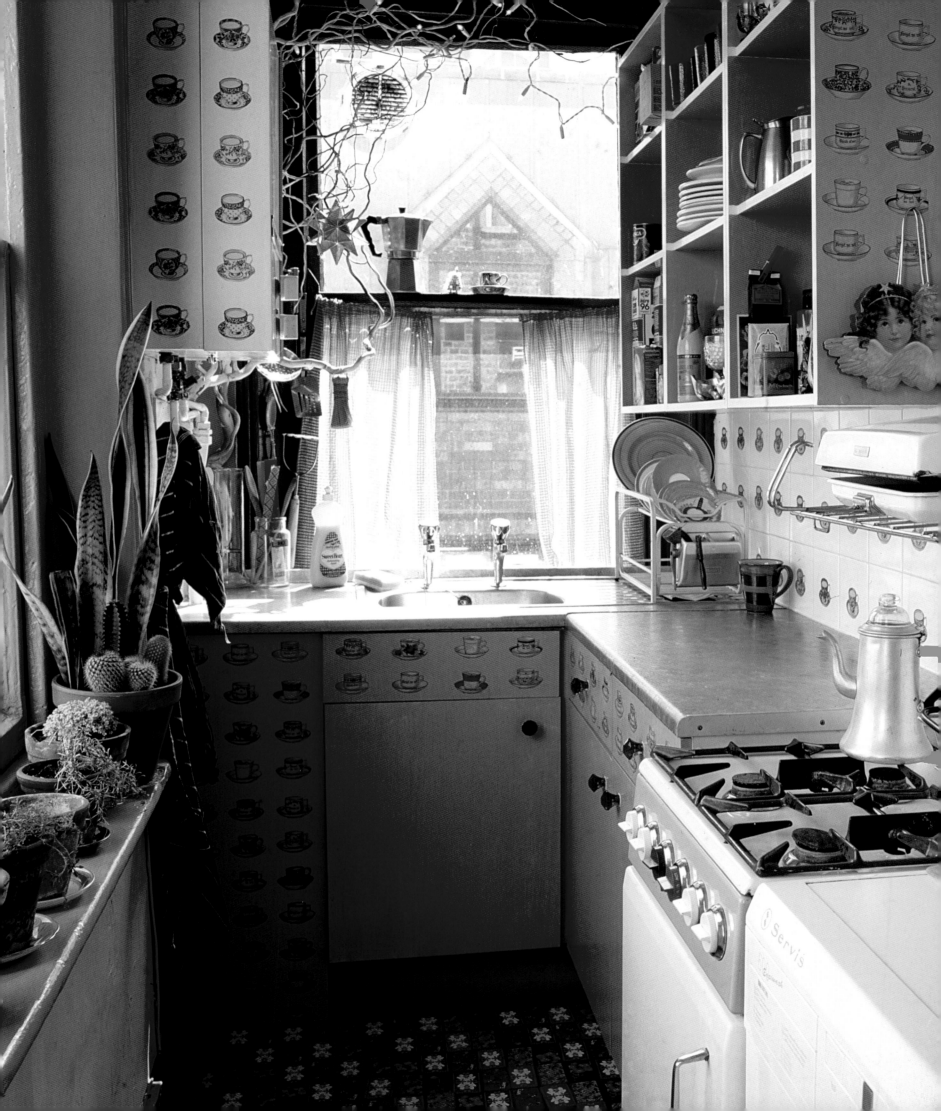

Mood board for SS 98 Electric Angels collection

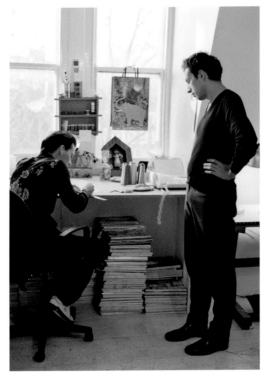
Matthew and Joseph at work in their flat, 1996

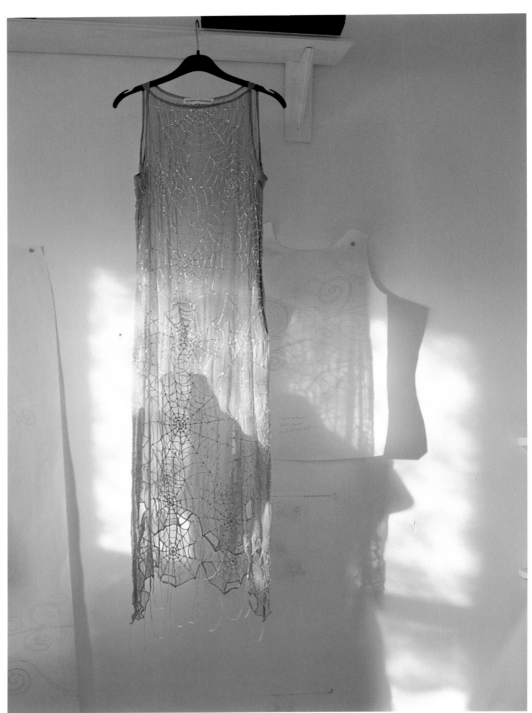

above
|
First sample received of the 'Cobweb Dress' hanging in Gray's Inn Road, 1996

right
|
Lounge of Gray's Inn Road flat which was converted into a make-shift studio for first sales appointments. Seen on the rail are the first cashmere samples received from Johnstons of Elgin, the company's first cashmere supplier.

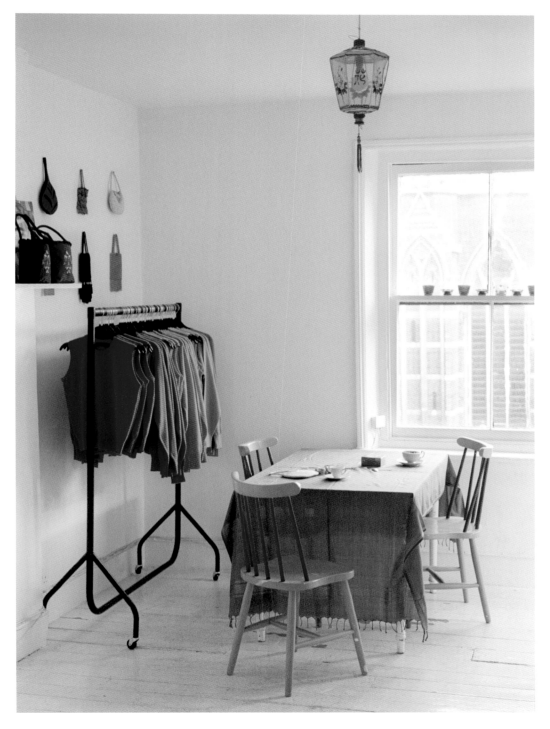

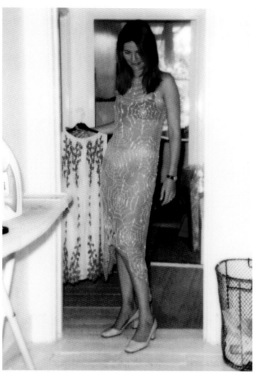

Plum Sykes on a visit to the flat trying on samples before the first show in 1997

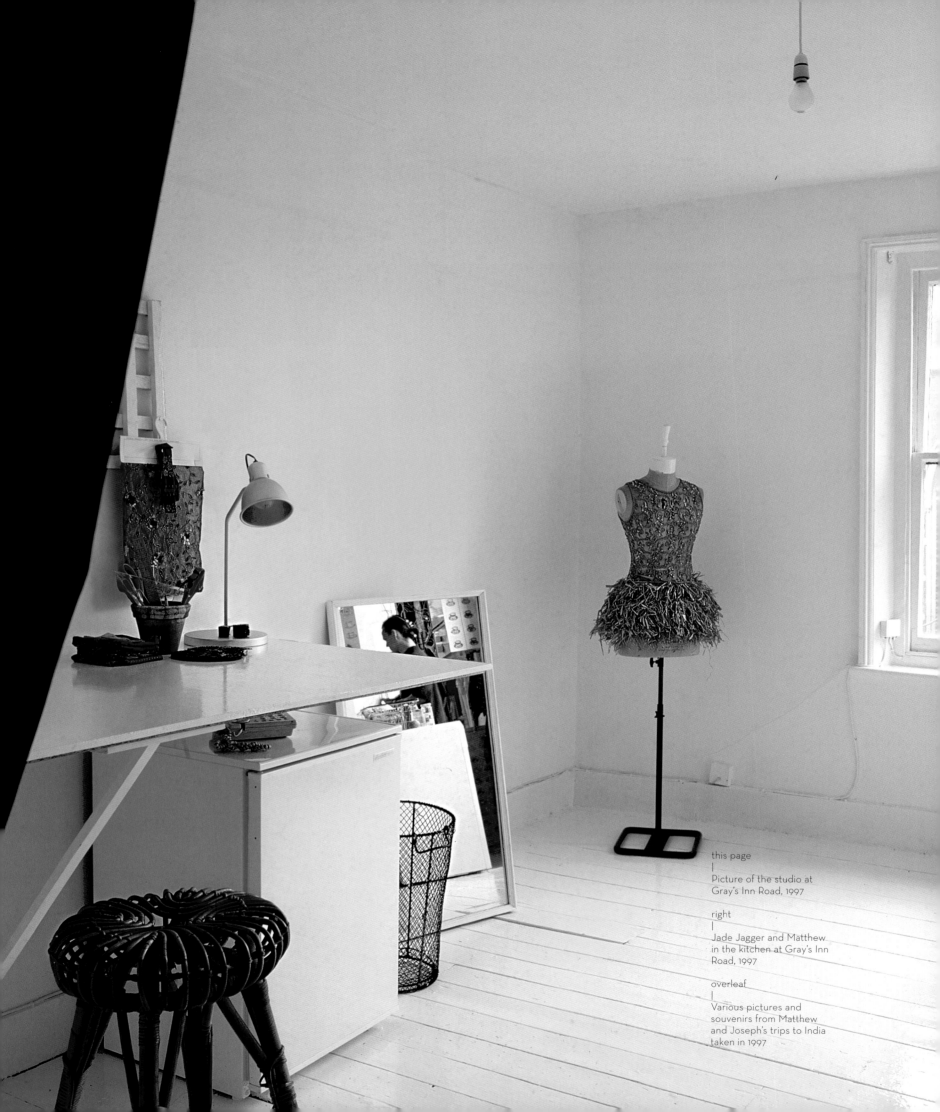

this page
|
Picture of the studio at
Gray's Inn Road, 1997

right
|
Jade Jagger and Matthew
in the kitchen at Gray's Inn
Road, 1997

overleaf
|
Various pictures and
souvenirs from Matthew
and Joseph's trips to India
taken in 1997

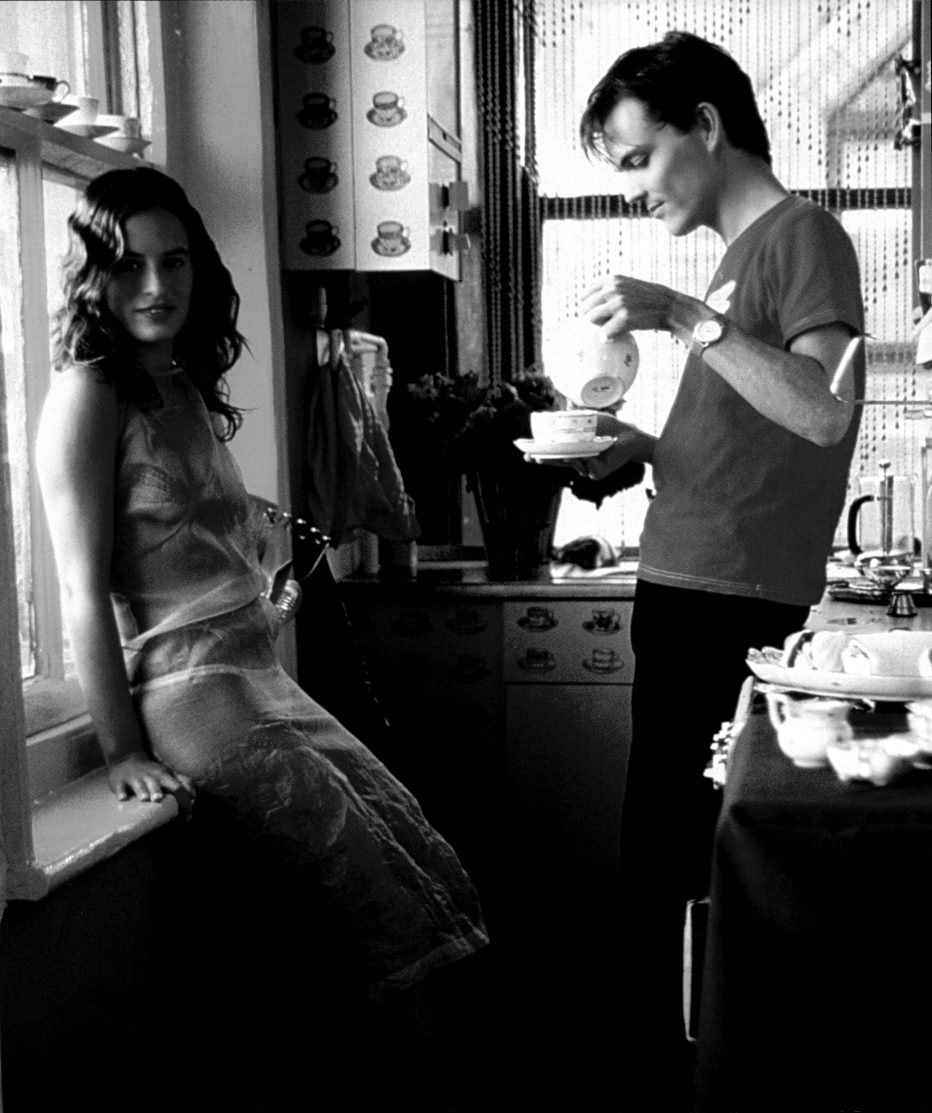

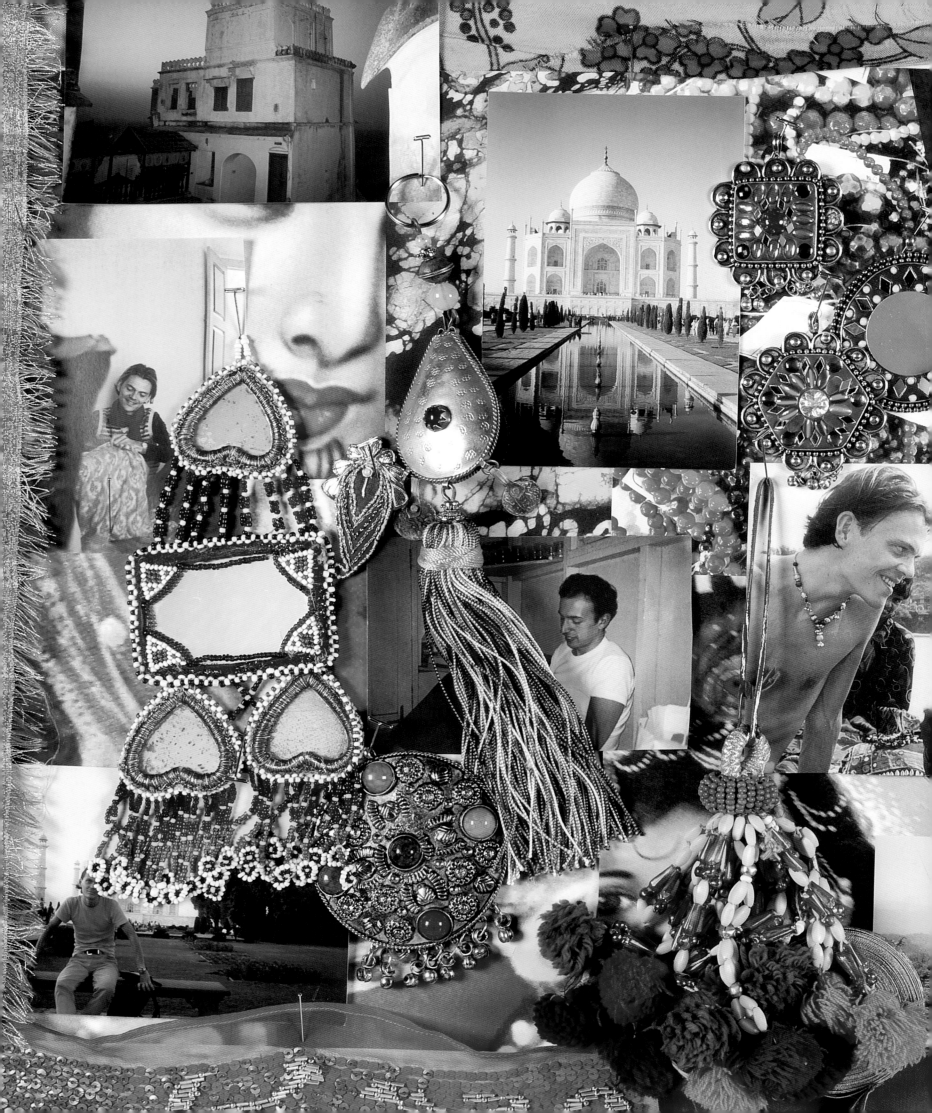

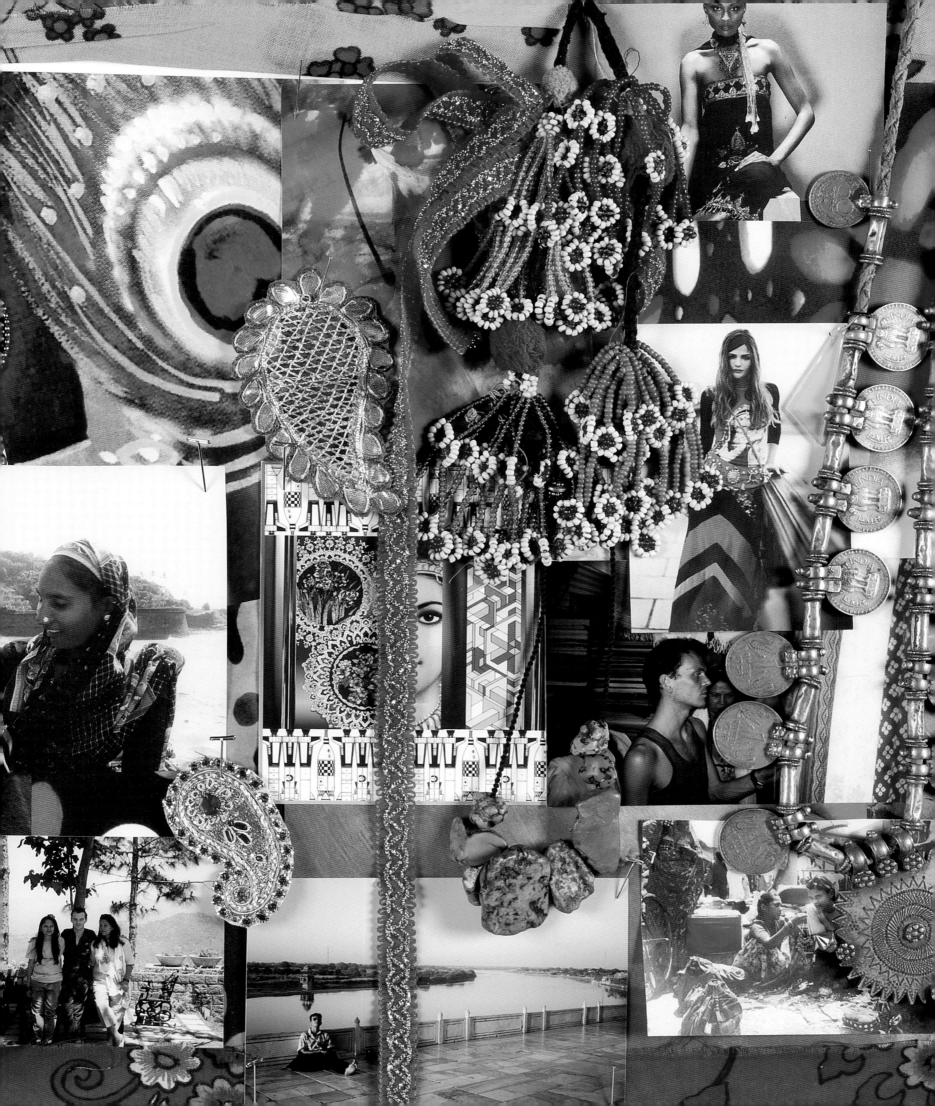

MATTHEW'S USE OF COLOR
AND TEXTURE HAS ALWAYS
BEEN THE FOCUS OF HIS
COLLECTIONS AND MAKES
THE WEARER FEEL UPLIFTED

Joan Burstein
*Director and Founder
of Browns, London*

*Amazon print
Summer 2008*

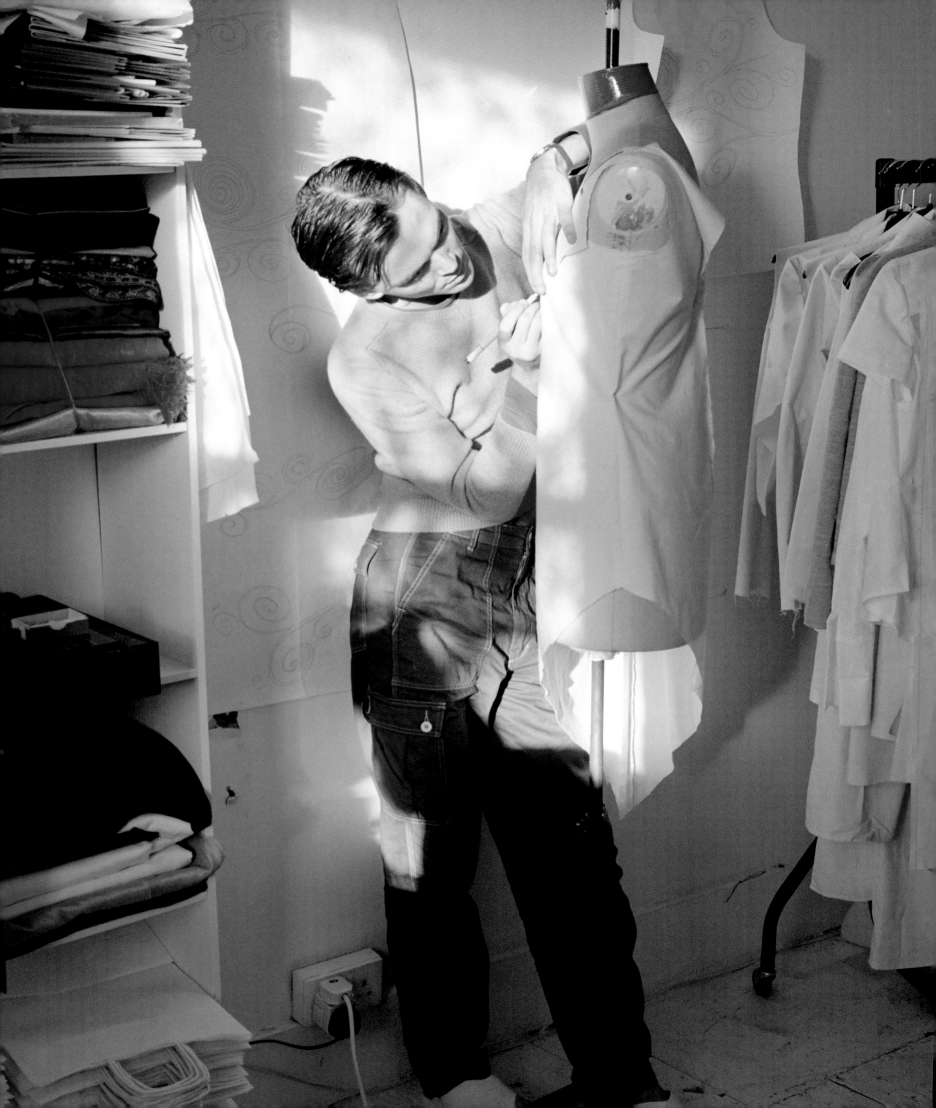

ELECTRIC ANGELS

left
|
Matthew at work in
his studio, seen here
drawing onto a toile in
preparation for his SS98
show Electric Angels

"Matthew Williamson's universe is a kaleidoscope of color. He creates a world where everyone is gorgeous, glamorous, and golden. There's a reason why It girls love him; without Matthew, they'd be just girls.

In 1997, at Matthew's debut show in London, everyone knew a major talent was born. His collection, Electric Angels, had only 14 dresses, but it made an impact far beyond that. Kate Moss and Helena Christensen swanned about in shocking shades of pink, orange, and turquoise. Matthew's exquisite pieces opened our eyes to color in a way that hadn't been seen in years. And every year since, he turns our senses on.

Not only does Matthew love his work, he lives it too. He'll be searching for fabrics on vacation in Goa, flitting around with his social butterflies, and, at dinner, delivering a toast with the most. Even in his studio in London, he'll somehow find the sun.

The world would be a duller place without Matthew and his gorgeous collections in it. When you can have a rainbow dress, who needs a pot of gold?"
Glenda Bailey
Editor-in-Chief, *Harpers Bazaar*

"I began working on this first collection just a couple of months before it was shown on the London Fashion Week schedule in September 1997" Matthew recalls. "It was inspired by my trip to India earlier that year, where I witnessed such electrifying colour combinations and the skills of the artisans I met there, working by hand to create amazing beading and embroidery. I wanted to bring this feeling back to London and show something different. I met Jade Jagger at this time in London, who was painting a series of butterflies. We became close friends and found a real connection in the work we were both doing at the time. In many ways Jade became my muse for this collection as it developed and I was flattered when she said she'd like to model in the show.

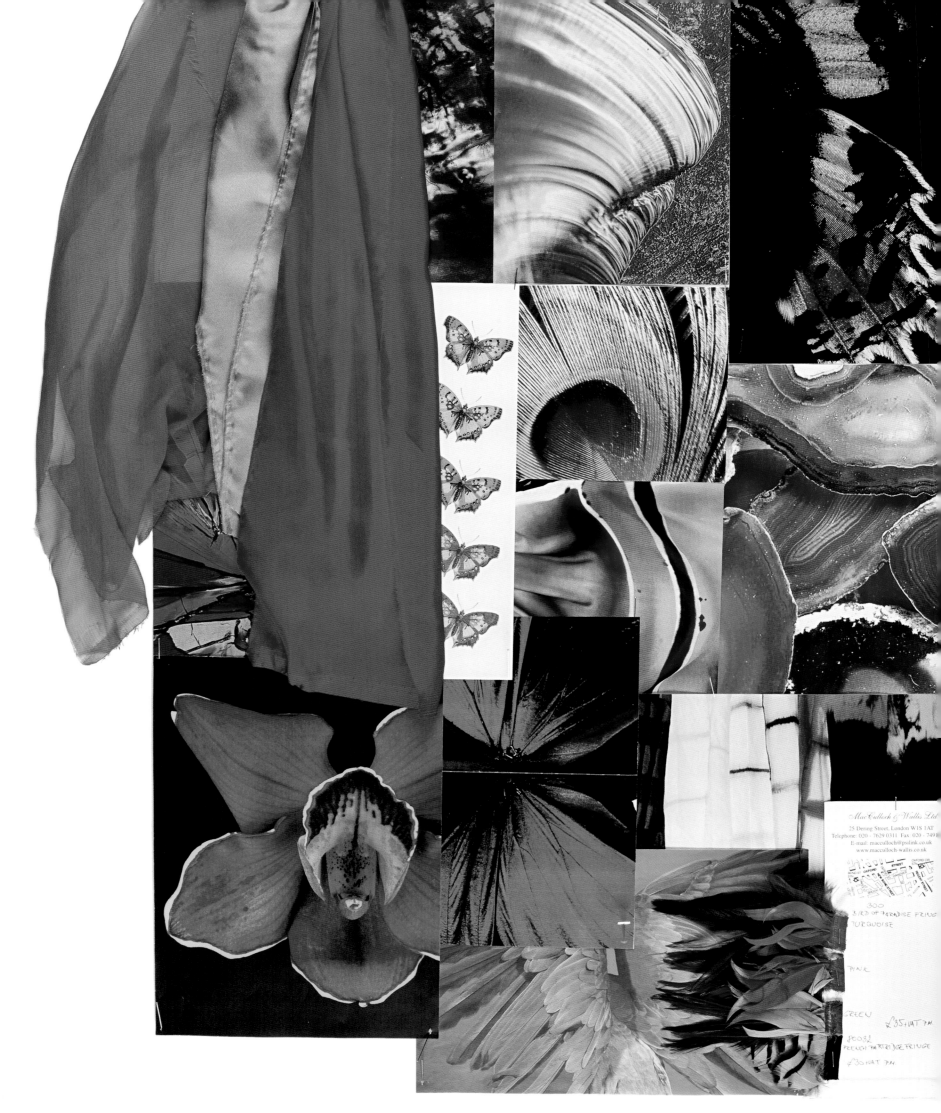

left
|
Mood board showing
fabrics and inspiration
images from the Electric
Angels collection

Word got out that I was going to have a show and Kate Moss and Helena Christensen also agreed to model. My designs were simple, colourful and unlike the prevailing fashion trends at the time. They stood out from the crowd. The girls wearing them in the show also went a long way to securing this collection as a front page story in The Times the next day.

"The fashion business is tough and fraught with challenges which seem to get bigger the longer you carry on, and so I look back at this time and this collection with such fond memories, as it seemed to come together with such ease. I often look back at these clothes and still try to rework some of these ideas into the work that I do today. Somehow the image of this collection has a timeless quality which is still synonymous with the Matthew Williamson brand."

Matthew Williamson's clothes are unlike any others coming out of a designer's atelier. There is a Williamson look and it really hasn't changed in essence over the creative development in the 12 years since Electric Angels, his very first collection, in which he laid down the elements of his style. The essence remains, as it does with all designers — which, after all, is what makes one line of clothes distinctive from another, even without looking at the label or logo — but the spirit responds to the mood of the time.

Delicate embroidery, colours both soft and sharp, kaleidoscopic pattern, arpeggios of colours racing across a skirt; all are trademarks of his rich aesthetic. All these ingredients were present at his first collection to be shown on a runway, Electric Angels.

When you say the name Matthew Williamson to a fashion follower, the immediate mental picture is of hot pinks, turquoise, lime with deep jewel hues, embroidery, crystal and lace; chiffon and cashmere, sequins and, above all, pattern in parabolic swirls of delicate and strong colour. We think of the colour of Africa, the patterns of Morocco and the richness of India and, holding them all together, the hedonism of Ibiza.

Electric Angels was like a perfect menu for what was to come in the years to follow; little beaded cardigans, camisoles, sexy short skirts, silk jersey, chiffon, and brilliant colour have prevailed. The future of Matthew Williamson's aesthetic was clear.

Hair stylist Sam McKnight remembers that first show well, "there was a real buzz about the show, I was creating big neon shapes in the hair and all these amazing creatures crammed into a tiny space, it was quite a spectacle".

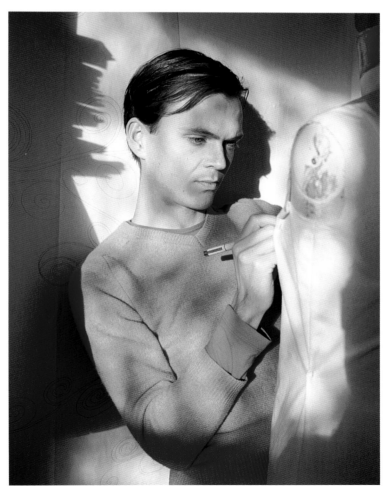

Matthew working on a toile for the Electric Angels collection

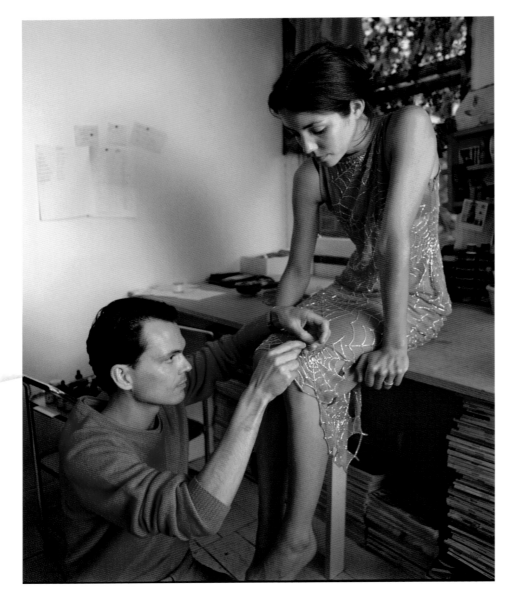

left
|
Matthew working on final
touches to his cobweb
dress; here seen attaching
strings of bugle beads to
the hem

below
|
Mary Greenwell, make-up
artist for Electric Angels
show with Kate Moss and
Helena Christensen

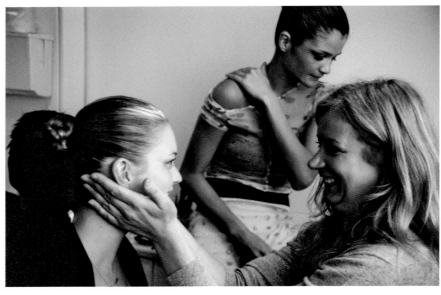

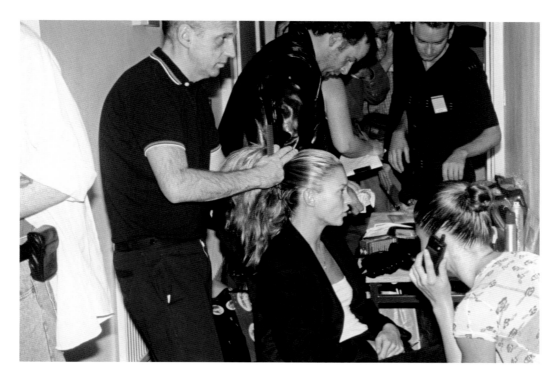

above
|
Sam McKnight, hairdresser for Electric Angels with Kate Moss, prior to adding the head pieces which formed an integral part of the look of the show.

right
|
With such a tight budget for the show, the models were asked to do their own nails backstage prior to the show

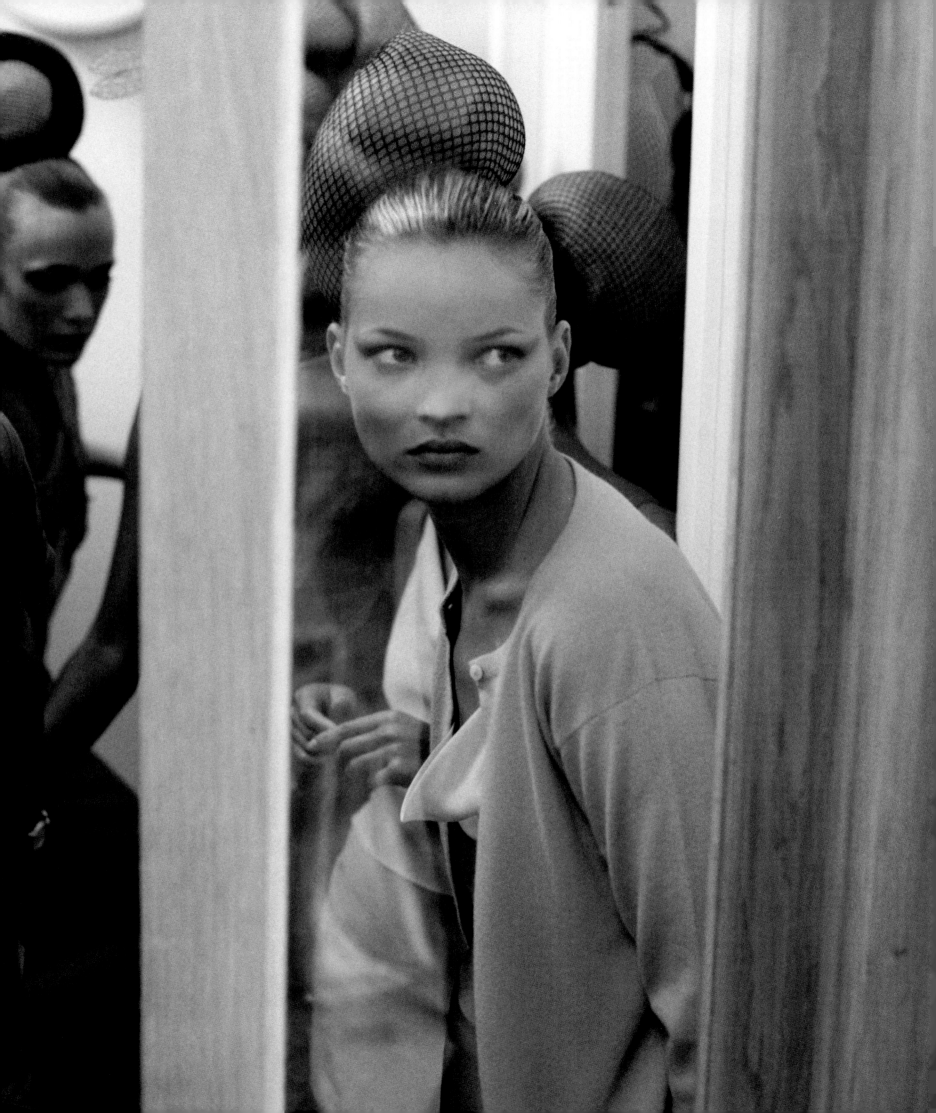

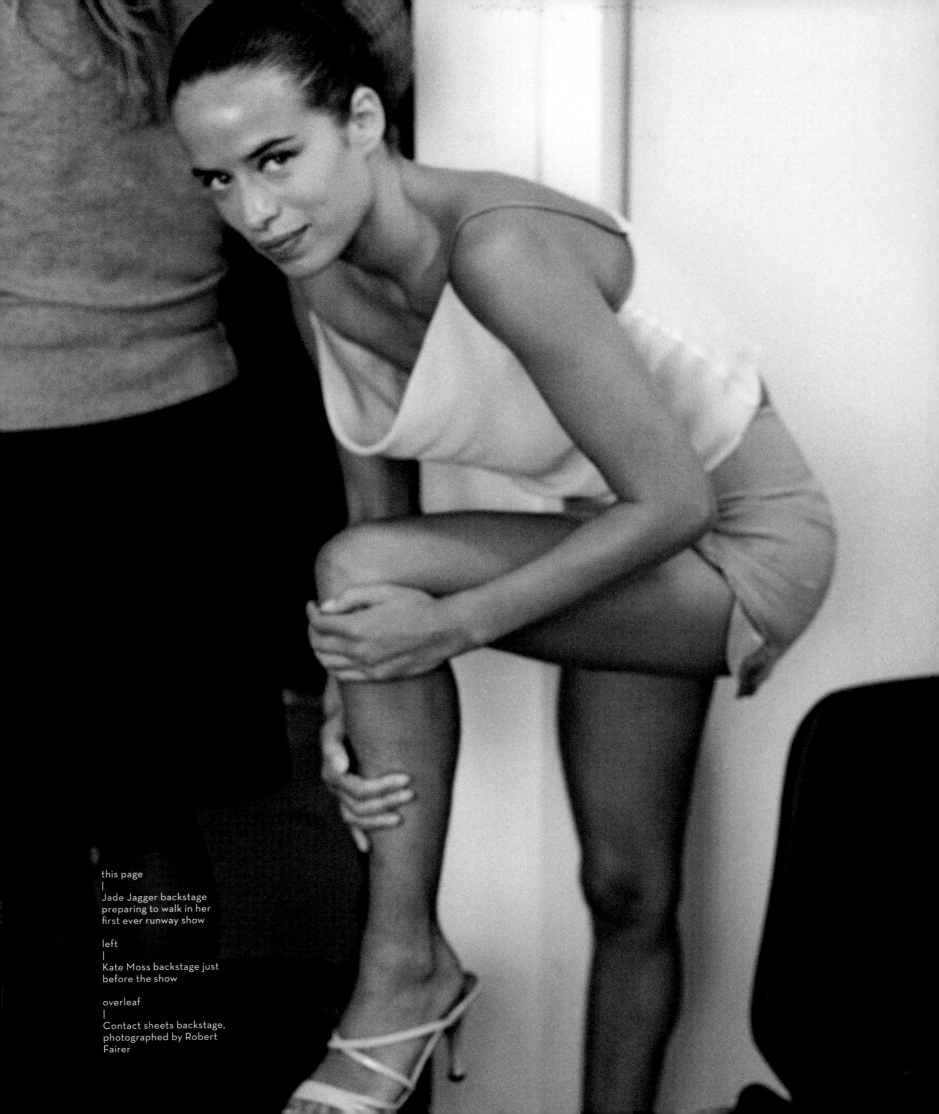

this page
|
Jade Jagger backstage
preparing to walk in her
first ever runway show

left
|
Kate Moss backstage just
before the show

overleaf
|
Contact sheets backstage,
photographed by Robert
Fairer

GPY ► 1 GPY ► 2 GPY ► 3

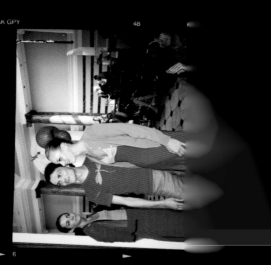

45 KOD"AK GPY 46 KOD"AK GPY 47 KOD"AK GPY 48

GPY ► 4 GPY ► 5 GPY ► 6

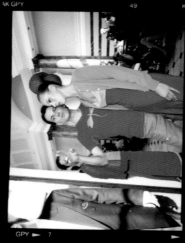

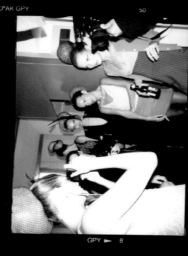

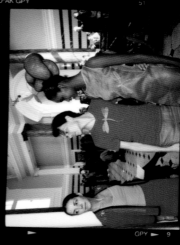

AK GPY 49 KOD"AK GPY 50 KOD"AK GPY 51 KOD"AK GPY 52

GPY ► 7 GPY ► 8 GPY ► 9 1 8 3 1 2 0

KOD"AK GPY 53 KOD"AK GPY 54 KOD"AK GPY 55 KOD"AK GPY 5

Matthews + Williamson

C073998

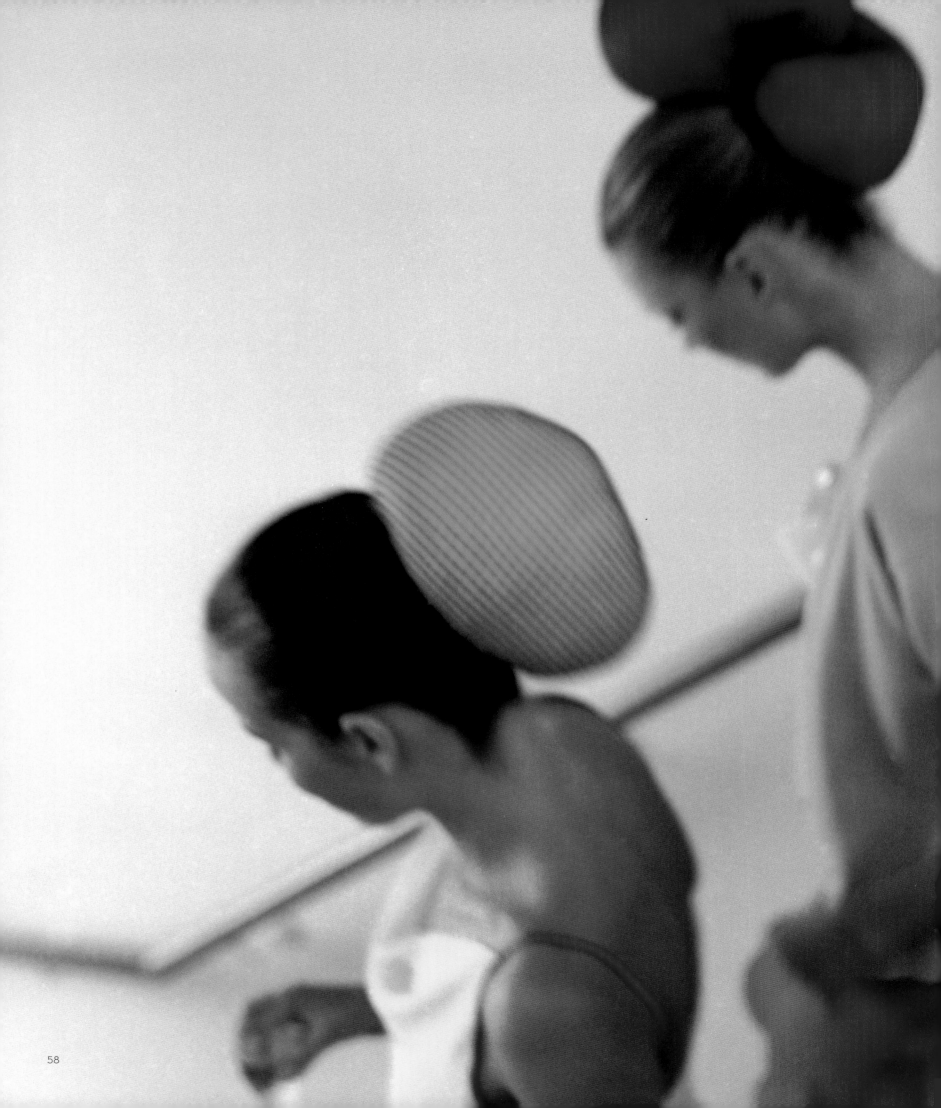

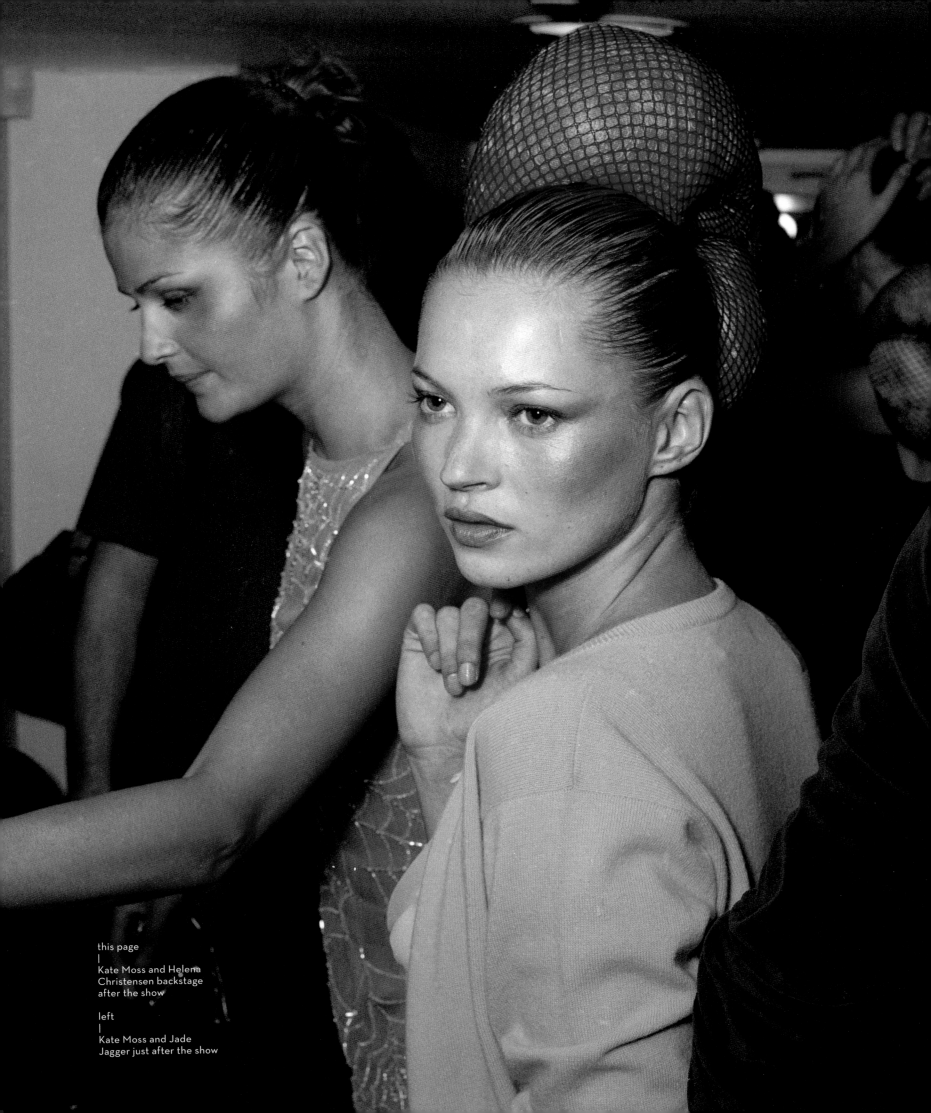

this page
|
Kate Moss and Helena
Christensen backstage
after the show

left
|
Kate Moss and Jade
Jagger just after the show

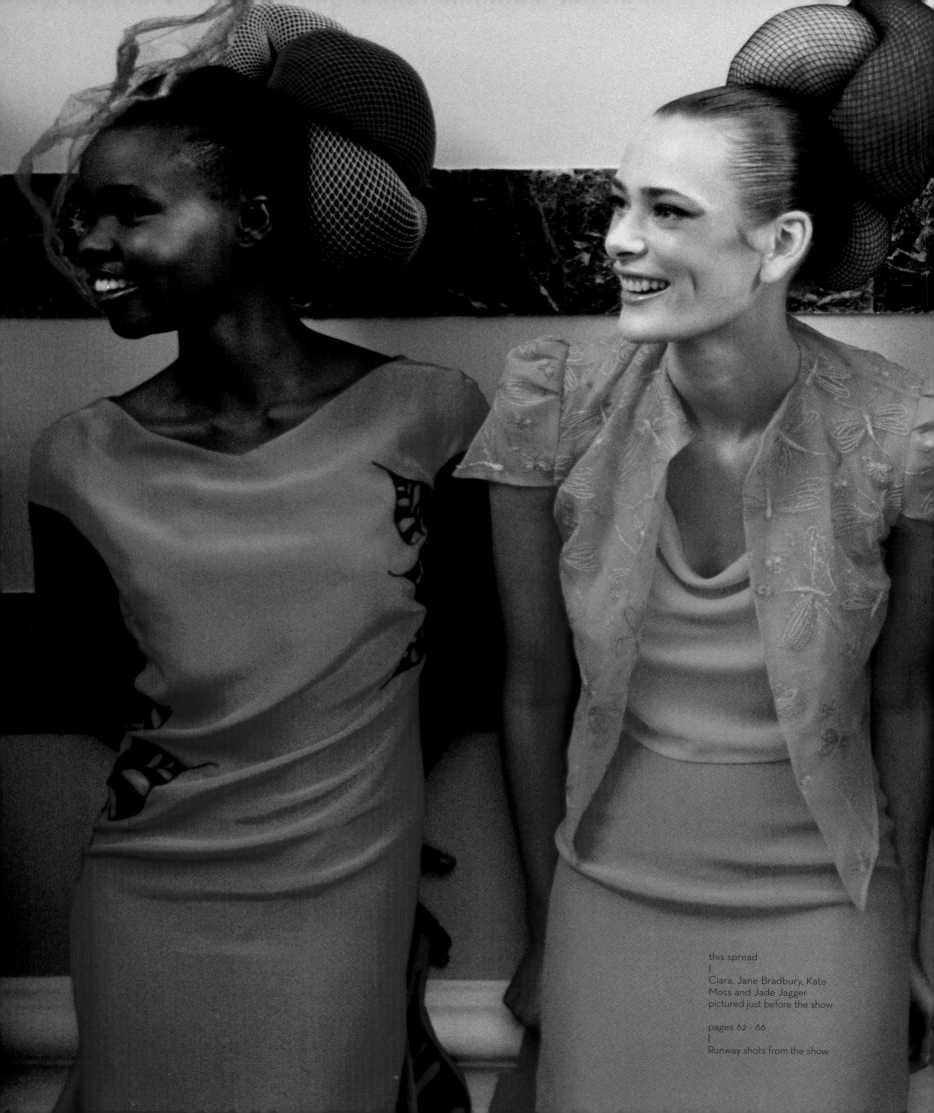

this spread
|
Ciara, Jane Bradbury, Kate
Moss and Jade Jagger
pictured just before the show

pages 62 - 66
|
Runway shots from the show

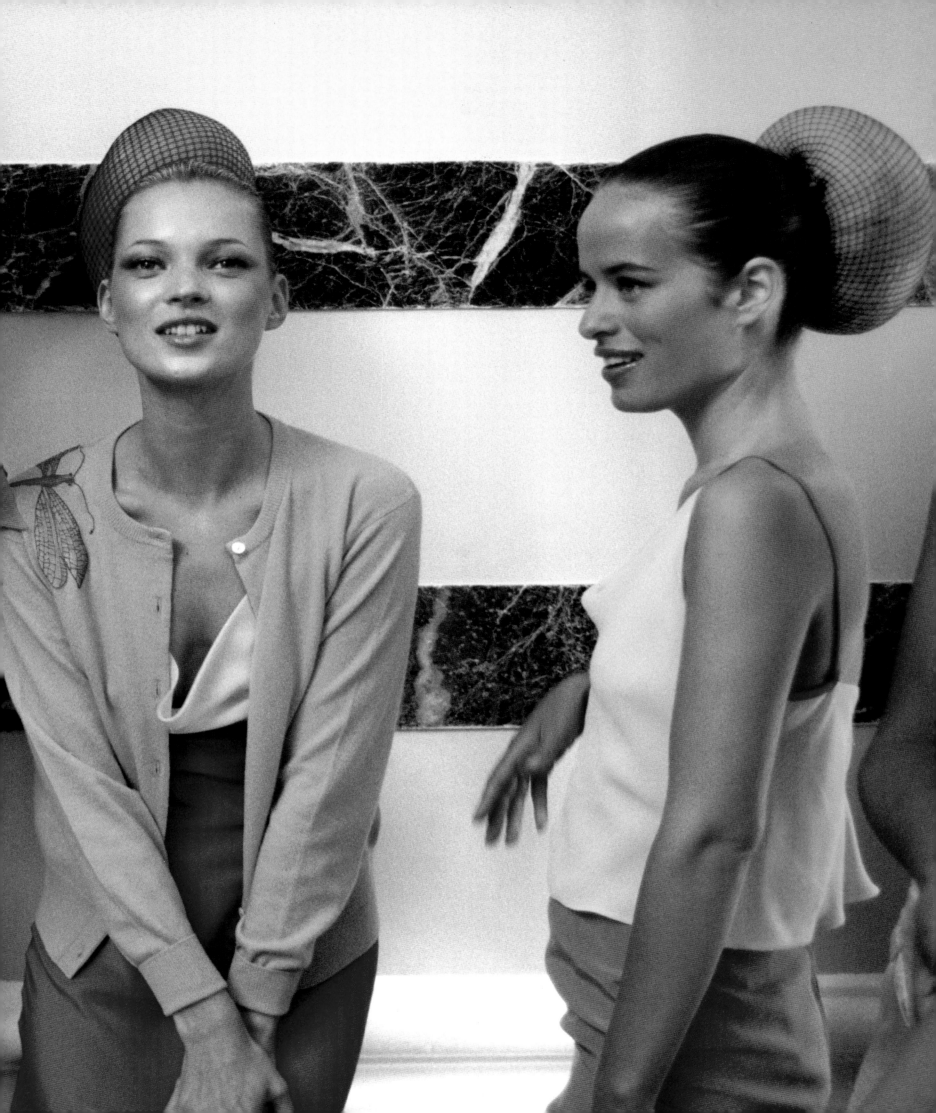

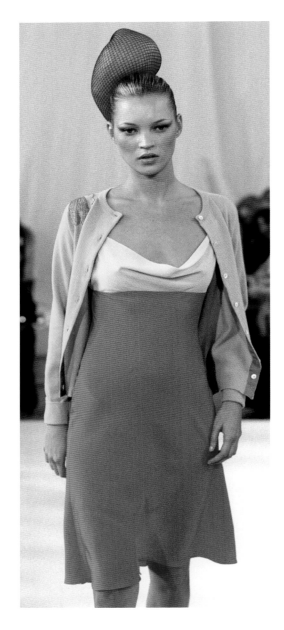
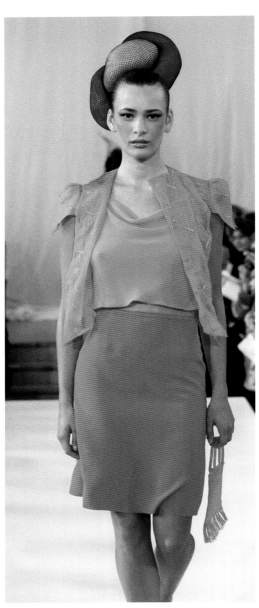

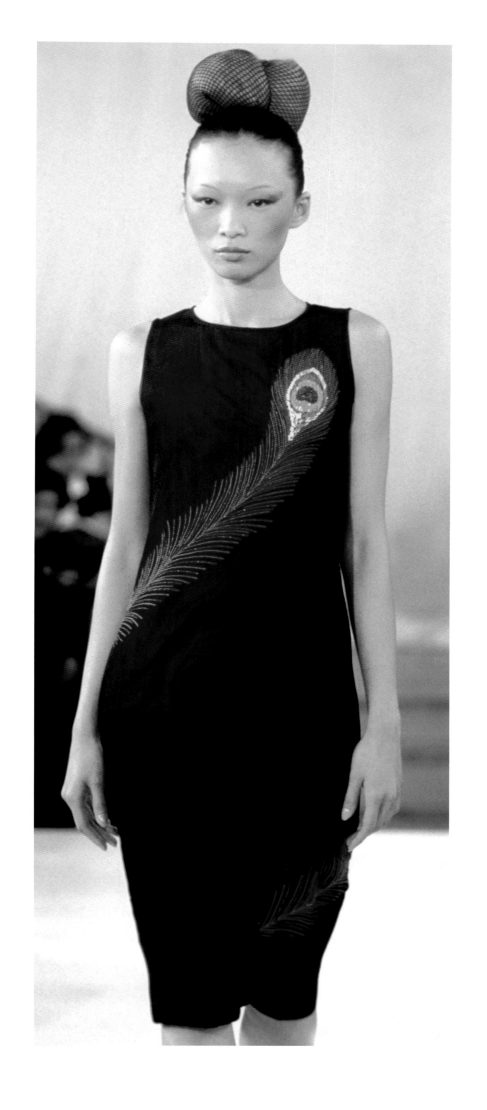
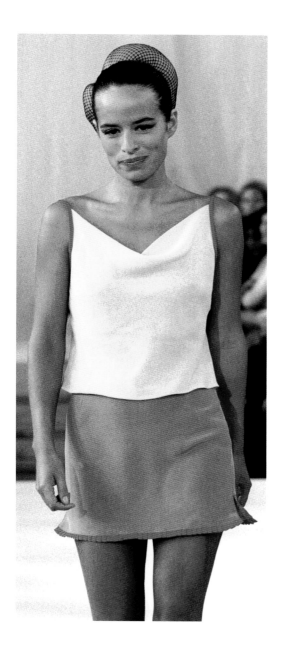

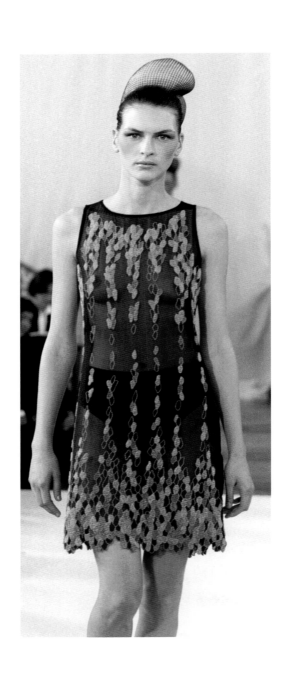
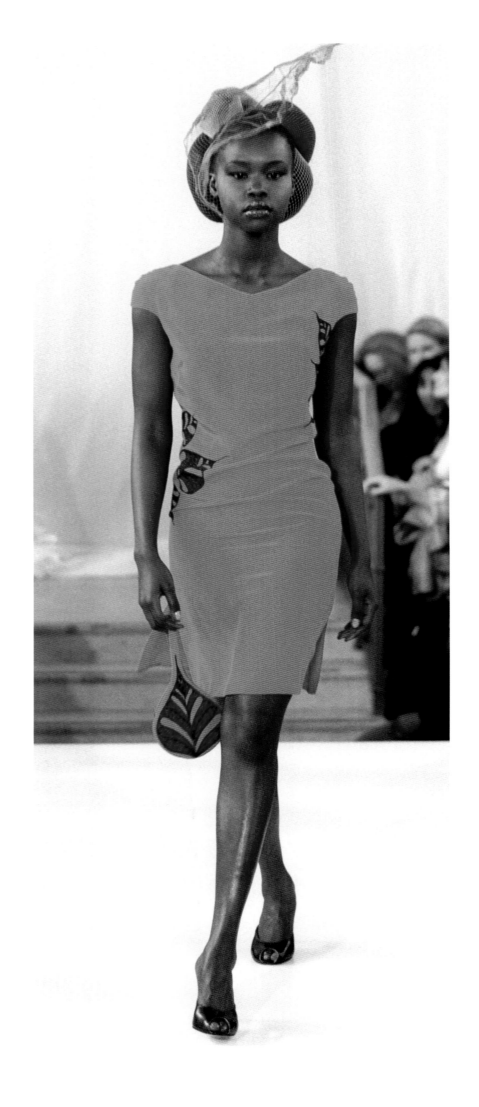

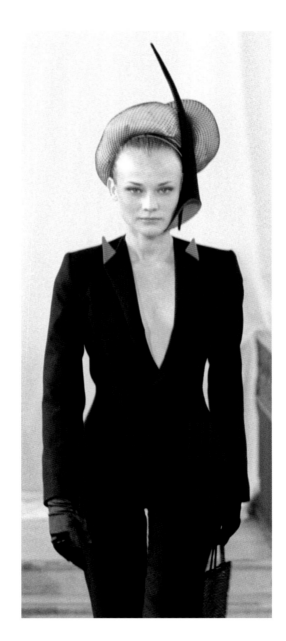

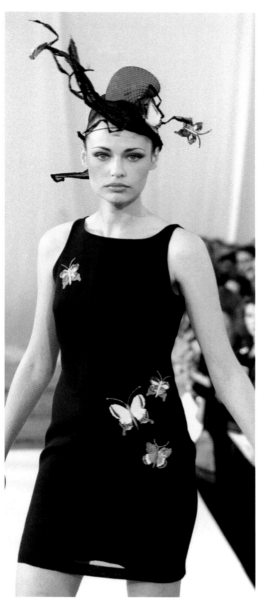

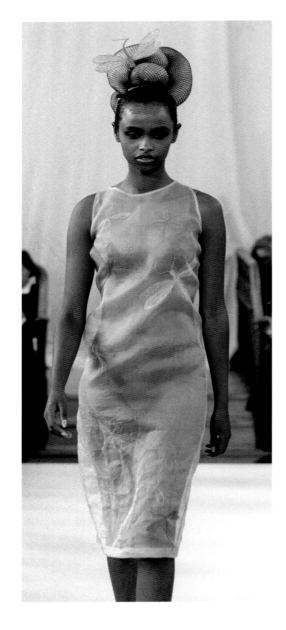

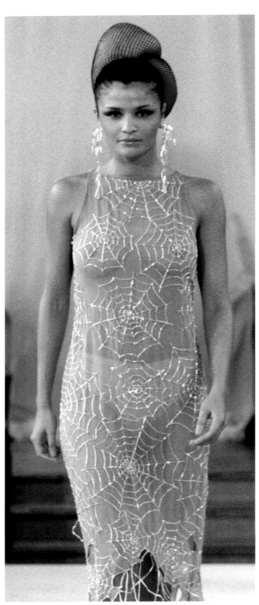

right
|
Helena Christensen
in the Cobweb Dress,
photographed by
Rankin, 2003

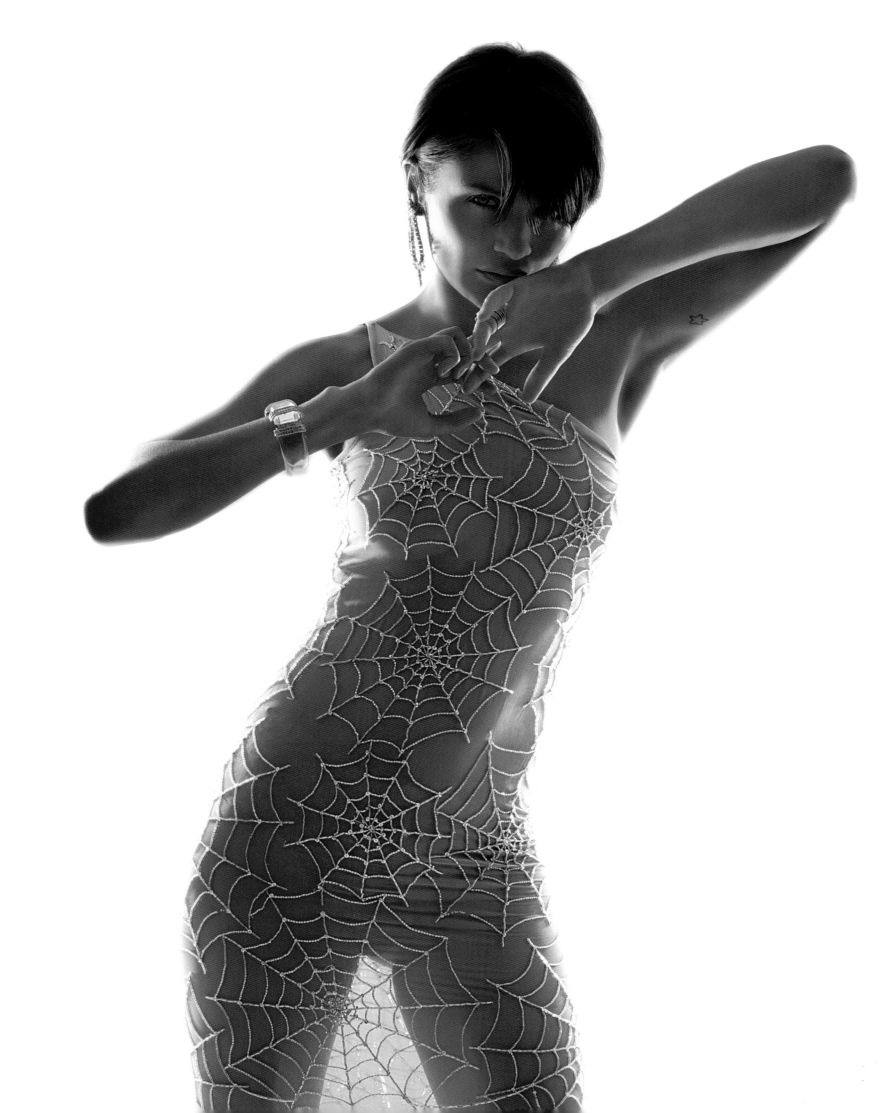

Hothouse Floral print
Summer 2010

MATTHEW'S EXCITEMENT FOR THE PROCESS IS INFECTIOUS; YOU CAN'T HELP BUT FEEL IT

Catherine Kendall
Technical Manager
Matthew Williamson

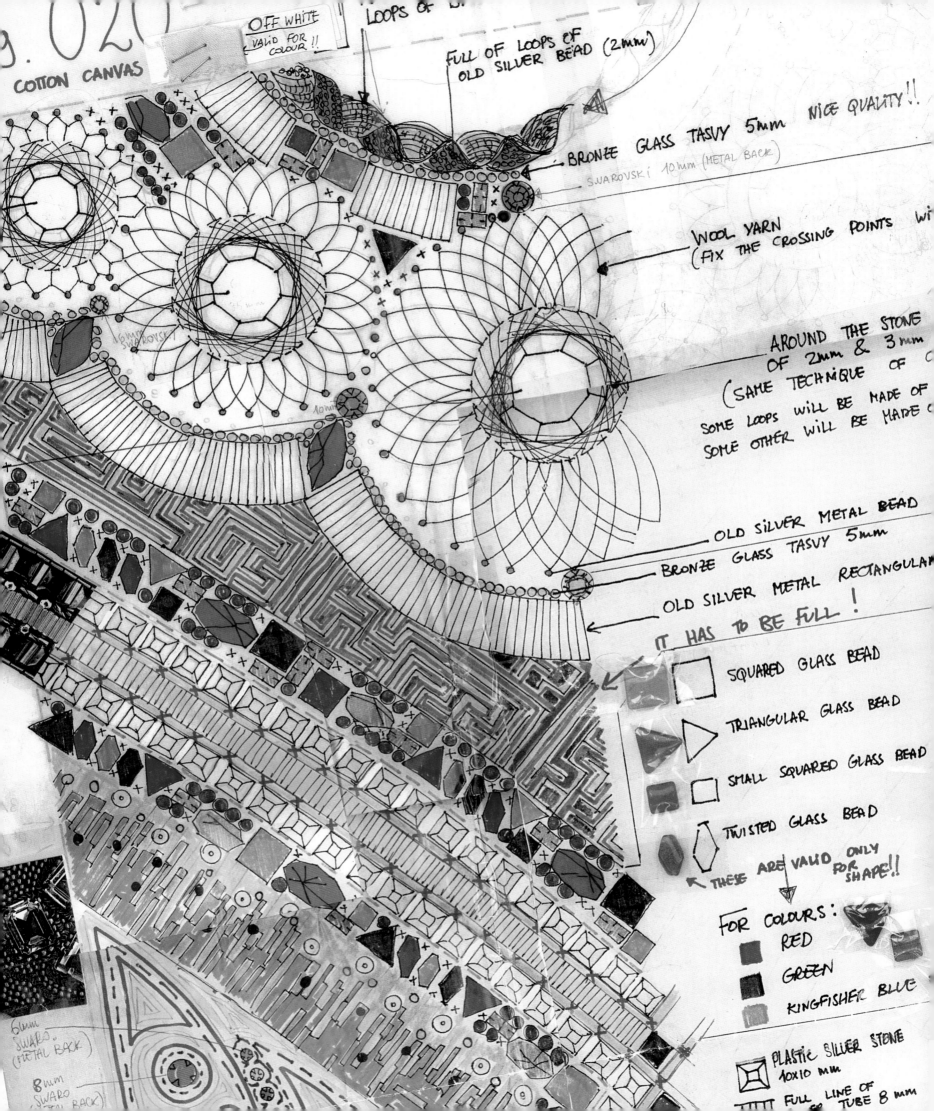

COTTON CANVAS

9.020

OFF WHITE
VALID FOR
COLOUR !!

LOOPS OF B...

FULL OF LOOPS OF
OLD SILVER BEAD (2mm)

BRONZE GLASS TASVY 5mm NICE QUALITY !!
SWAROVSKI 10mm (METAL BACK)

WOOL YARN
(FIX THE CROSSING POINTS WI...

6mm
SWAROVSKI

10mm

AROUND THE STONE
OF 2mm & 3mm
(SAME TECHNIQUE OF ...
SOME LOOPS WILL BE MADE OF ...
SOME OTHER WILL BE MADE ...

OLD SILVER METAL BEAD
BRONZE GLASS TASVY 5mm
OLD SILVER METAL RECTANGULAR

IT HAS TO BE FULL !

SQUARED GLASS BEAD

TRIANGULAR GLASS BEAD

SMALL SQUARED GLASS BEAD

TWISTED GLASS BEAD

THESE ARE VALID ONLY FOR SHAPE !!

FOR COLOURS:
RED
GREEN
KINGFISHER BLUE

6mm
SWARO.
(METAL BACK)

8mm
SWARO
(...TAL BACK)

PLASTIC SILVER STONE
10x10 mm

FULL LINE OF
TUBE 8 mm

left
|
Hand drawn artwork
detailing embroidery and
embellishment placement
from the AW09 collection.
All beading and threadwork
is drawn in minute detail by
the London studio.

overleaf
|
Realised beadwork from
the artwork

HOW

Matthew Williamson creates a collection has changed little since his first one, Electric Angels, although his aesthetic has developed, deepened and, to a degree, darkened with the sophistication and self-knowledge that grows within any creator, simply through the act of creation. He says, "We are currently turning a corner with our aesthetic and what we have to offer. We've been so heavily associated for so long with a certain way that it is quite difficult to do it successfully, by which I mean keeping what is core to Matthew Williamson and building new levels onto it. You build a brand, you build a style and you build a signature consistently to reach an understanding of who you want to dress and to make a real turn can't happen overnight. And it is quite scary, the more successful you have been. Let's be honest, it's easy on day one, even year one with a business because you've got nothing to prove and nothing to lose. It's a clean slate. You don't even have an agenda. You're just being creative — and what a wonderful position that is. But with success, everything changes. And it's no longer just you. You can't afford to be selfish when you have a business to run.

"I have staff to care for, and I oversee three stores — London, New York and Dubai. It could seem that as a designer all I do all day is sit in an ivory tower throwing pieces of chiffon around, designing with gay abandon and hoping it will work. It's a bit more complicated than that, I can tell you. There's a formula and it starts with the creative process, of course, and that's where I get my energy and excitement, but then it turns into a commodity and a product and then it becomes a business.

"I start a collection with fabric, which comes in from hundreds of agents and suppliers from around the world. Once I source all the fabrics and make my selection, edit them down and pinpoint the ones that I think work, at that moment starts the creative process. I would say this element becomes the first layout of my thoughts for the season.

"I then create a mood board — a collage of inspiring images that I source personally that will demonstrate to my team a flavour of where I think the collection should be heading. I spend time developing these inspirations and researching different elements of design. For example, the tailoring designer will start researching a brilliant idea for frock jackets and high-waisted pants, and then my print designer will go and research graffitti or underground artists in, for example, Spain. There are all these little pockets of intense activity which sprout up, teeming with ideas. My stylist — it's currently Vanessa Coyle, fashion director at *Harper's Bazaar* — will arrive and we bounce ideas off each other, retaining the essence of what I'm about creatively and, at the same time, adding a new dimension."

Matthew at his desk at his studio in Percy St, London, 2005

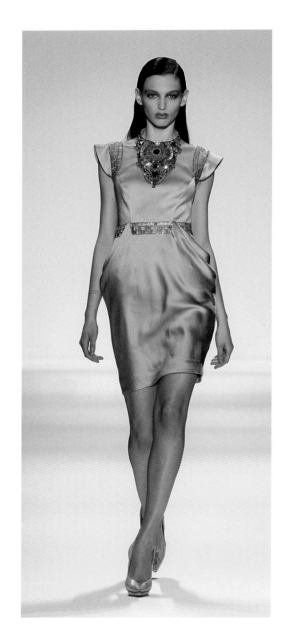
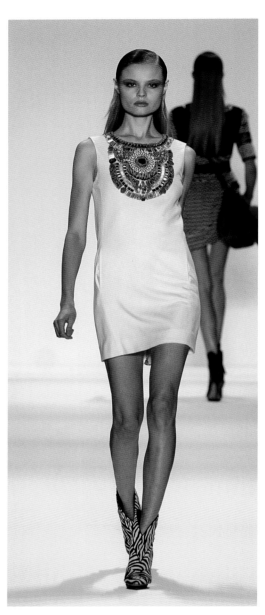

left to right
|
AW09 Runway shots showing
the beadwork technique
from previous page

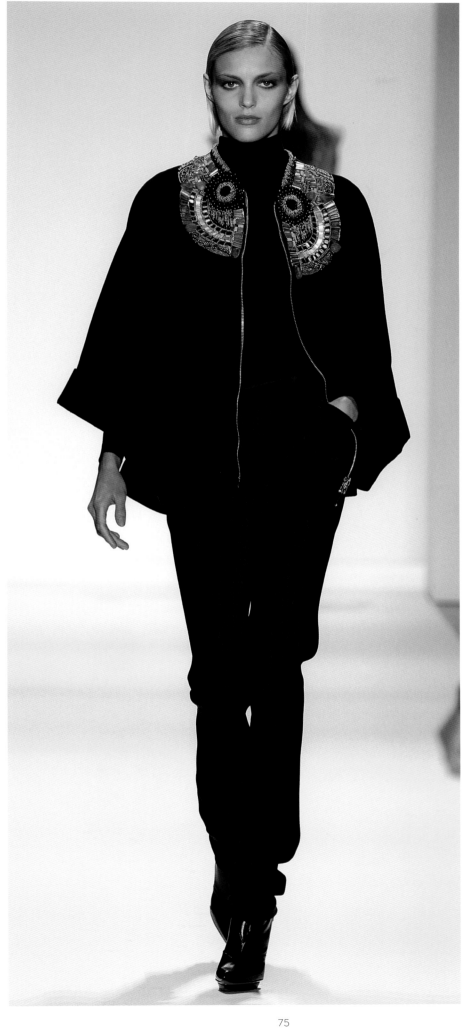

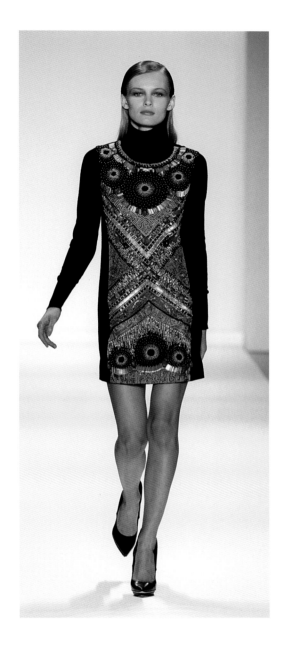

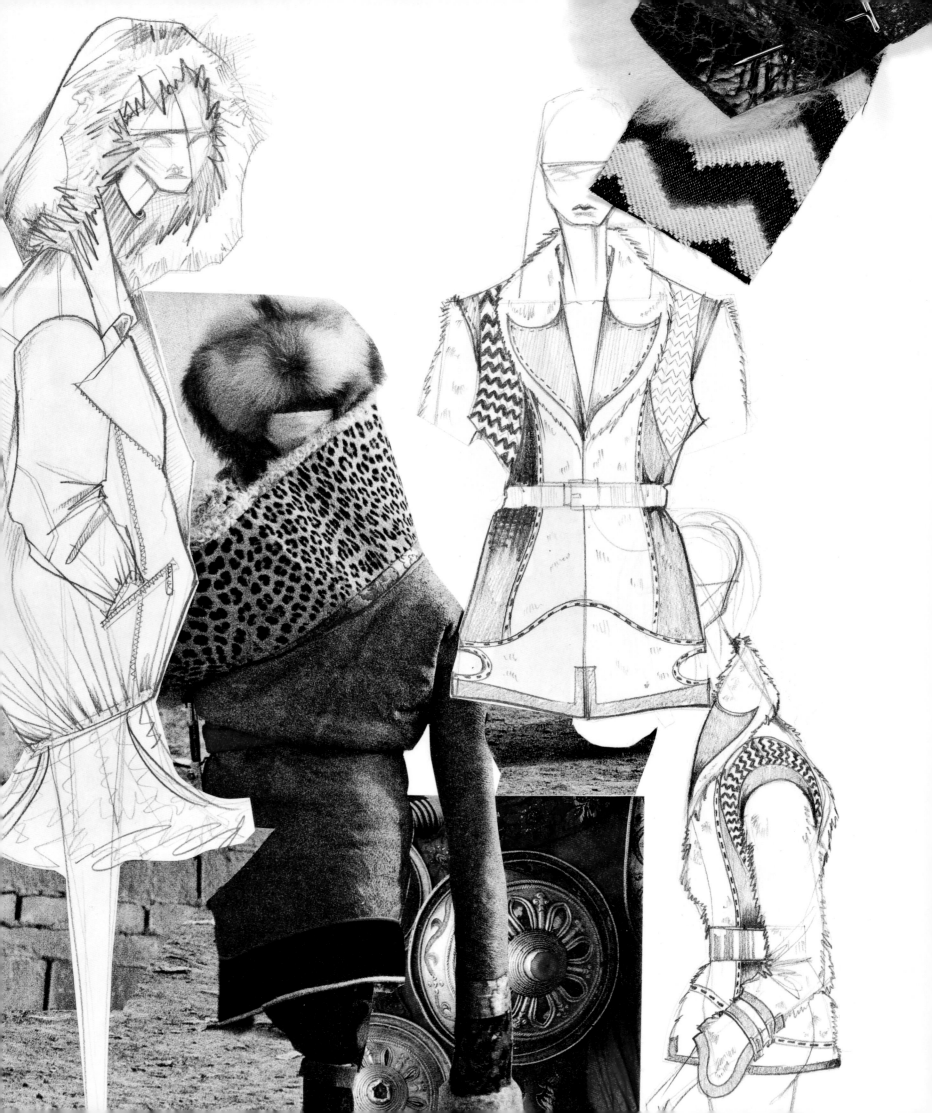

Matthew often sketches his ideas on the move, they might be on a cigarette packet on a flight, or whilst on a train, it might be anywhere — it's often when Matthew is abroad.

"I'll create a page and I'll literally sit there and scribble, sometimes I may jot notes down, ie, 'beaded that would be nice' or draw a creation in the middle of the night", says Matthew. This process goes on over weeks at which point Matthew starts to work with his right-hand girl, his designer, to interpret his sketches. Then, from there, Matthew will show the sketches to the team who then create toiles (muslin mock-ups) at the aetelier. So the process of creating the samples for the collection begins, as soon as the sketches are up, on the wall and they're all clear, with a style and a number. "I then get my pattern cutting team to come into the showroom", Matthew says, "I sit with my technical team and from this point on in the creation of a collection, begins a collaborative journey of up to about three months work.

"The colour and the fabric choice has to happen before the toile process even starts. So when you're creating your mood board and your fabric swatches are arriving that's when I create the palette — and I do that entirely myself — woe betide anyone else thinking they can trump my colour palette! I have an immediate sense of colour," continues Matthew, "wherever I am, it is the first thing I pick up on. And I just have the ability to work colour, in its combinations. It's about placement. Interactions. I like dual palettes. Although it surprises people, natural colours appeal a lot to me. I like injections of synthetic colours. Polar opposites. Beige and acid yellow, for instance, vintage green with fluorescent shocking pink.

"It's never laboured, it's something that I don't really torture myself over and I think that's when it works at its best. Often when I design like that it's at its best. Our bestsellers are often ones I've thrown out at the eleventh hour and said, 'Let's just do it'.

"While the growth of the company excites me, making money was never my motivation. I'm way more excited by someone in the street saying, 'I bought one of your dresses', or if I'm sitting in Claridges and I see someone in something of mine and she looks good — it's great.

"Throughout the work that I have done from my first collections, the stakes have become higher, the drops have become sharper and therefore one has to work harder, work smarter, and creatively one has to evolve and keep the momentum. I consider myself very fortunate to be able to continue to design, as this is my greatest passion in life. Joseph and I often look back and think, it has been fantastic and wonderful. We are doing what we love."

Matthew buying trims from a wholesale store in London, 2006

left
|
Working sketches and fabric swatches from AW09 outerwear ideas developed by Matthew and his team

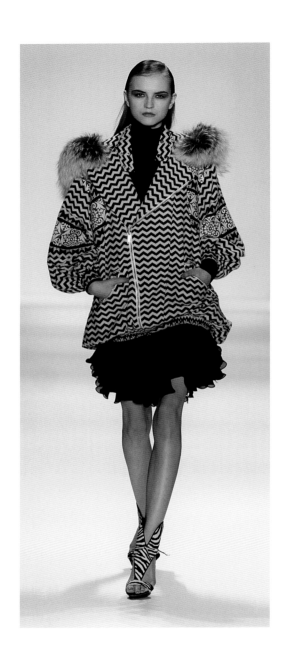
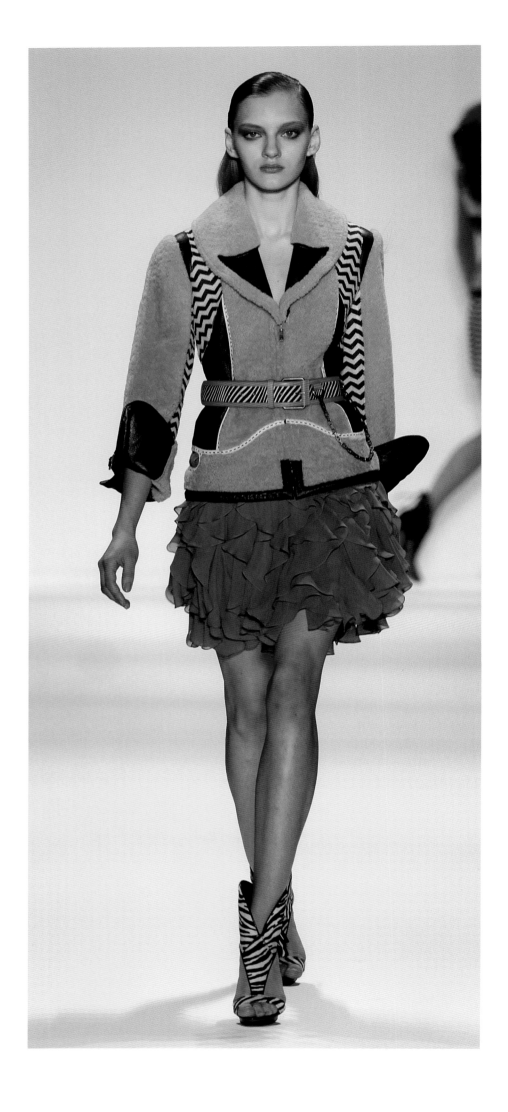

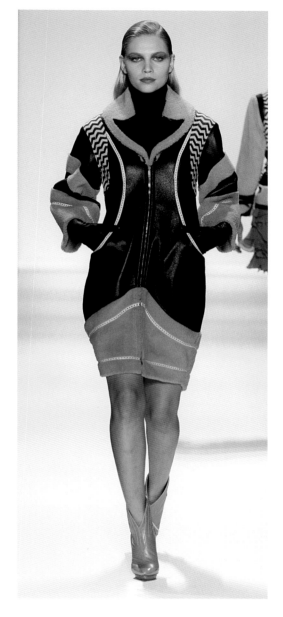

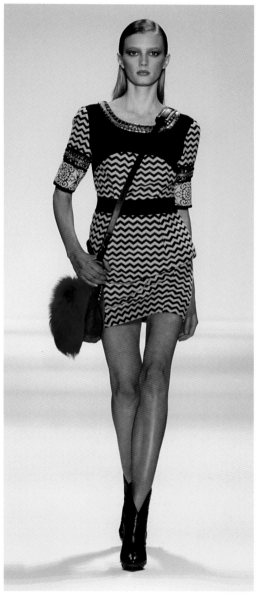

left to right
|
AW09 Runway shots show-
ing the realised outerwear
from sketches shown on
page 76

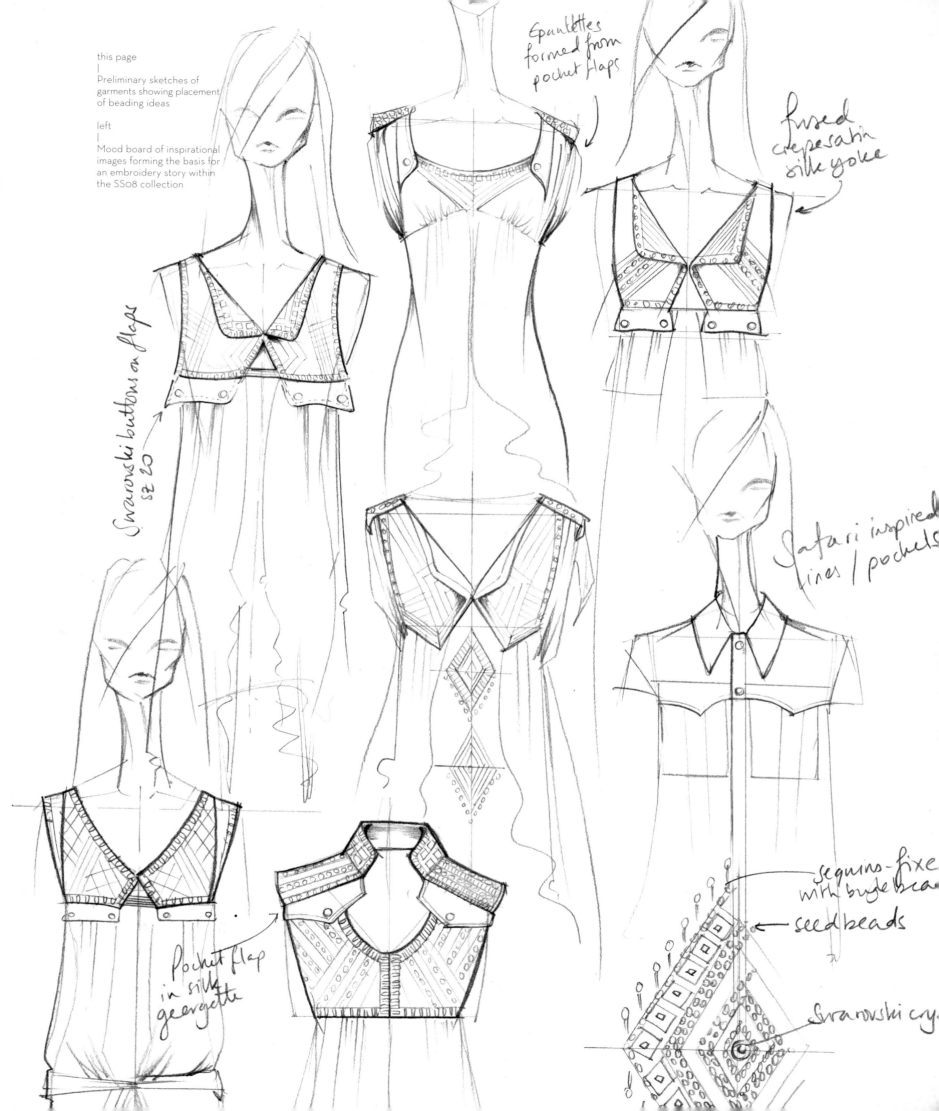

this page
|
Preliminary sketches of
garments showing placement
of beading ideas

left
|
Mood board of inspirational
images forming the basis for
an embroidery story within
the SS08 collection

Epaulettes
formed from
pocket flaps

fused
crepe satin
silk yoke

Swarovski buttons on flaps
sz 20

Safari inspired
lines / pockets

Pocket flap
in silk
georgette

sequins fixed
with bugle bead
seed beads

Swarovski cry

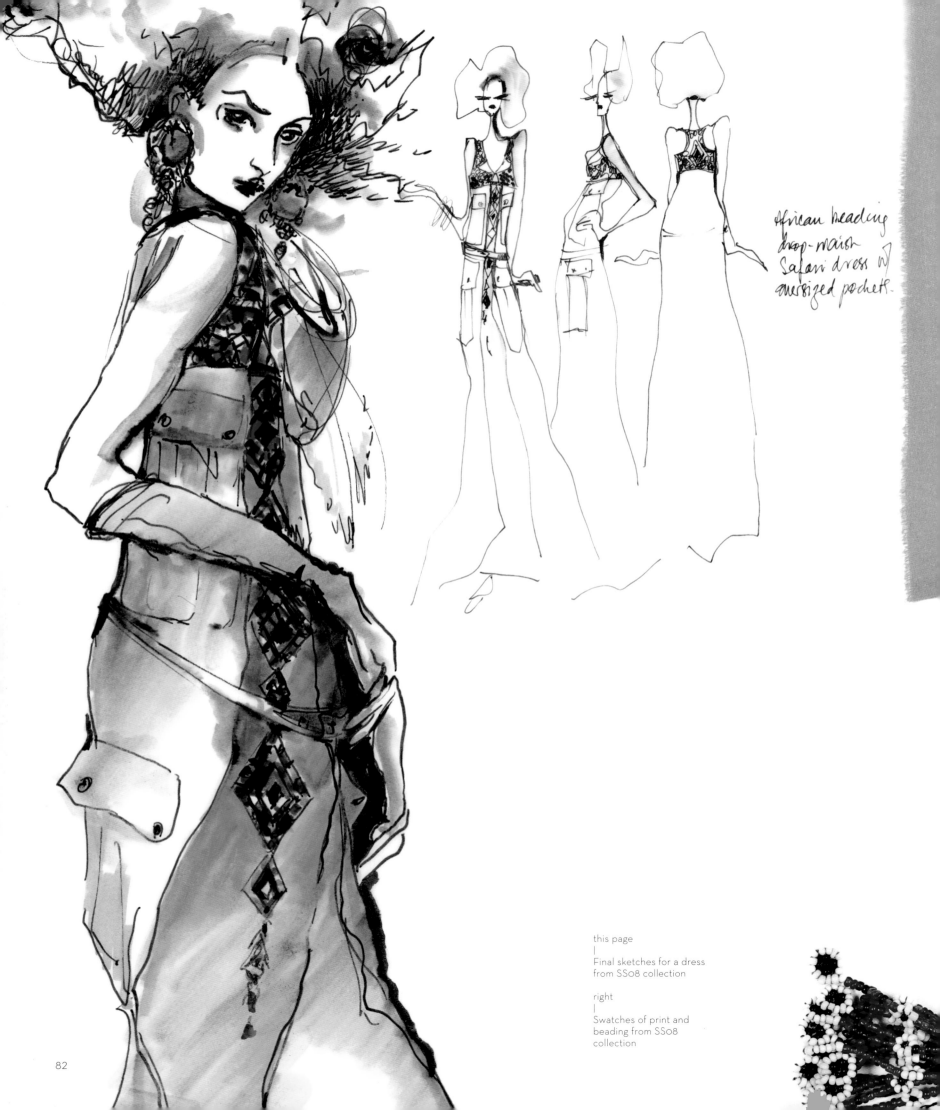

African beading
drop-waist
Safari dress w/
oversized pockets.

this page
|
Final sketches for a dress
from SS08 collection

right
|
Swatches of print and
beading from SS08
collection

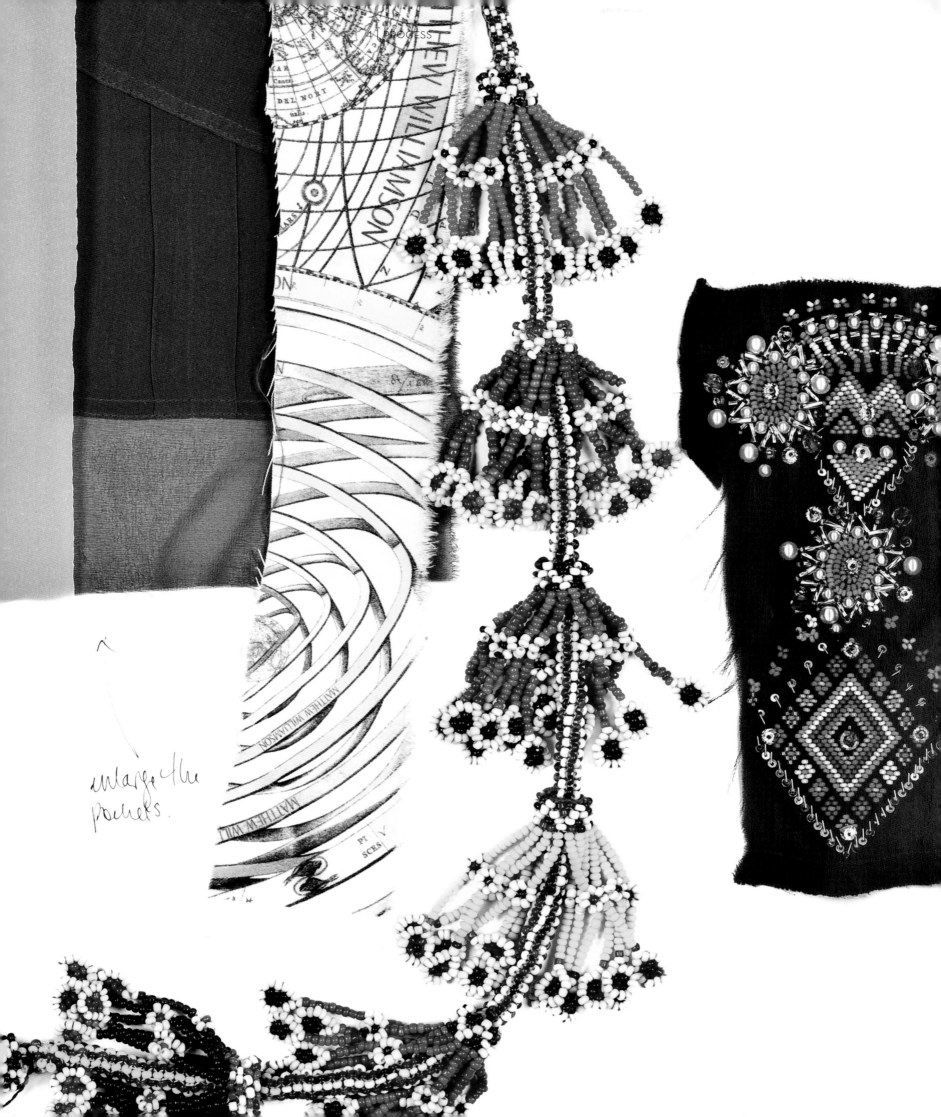

enlarge the
pockets.

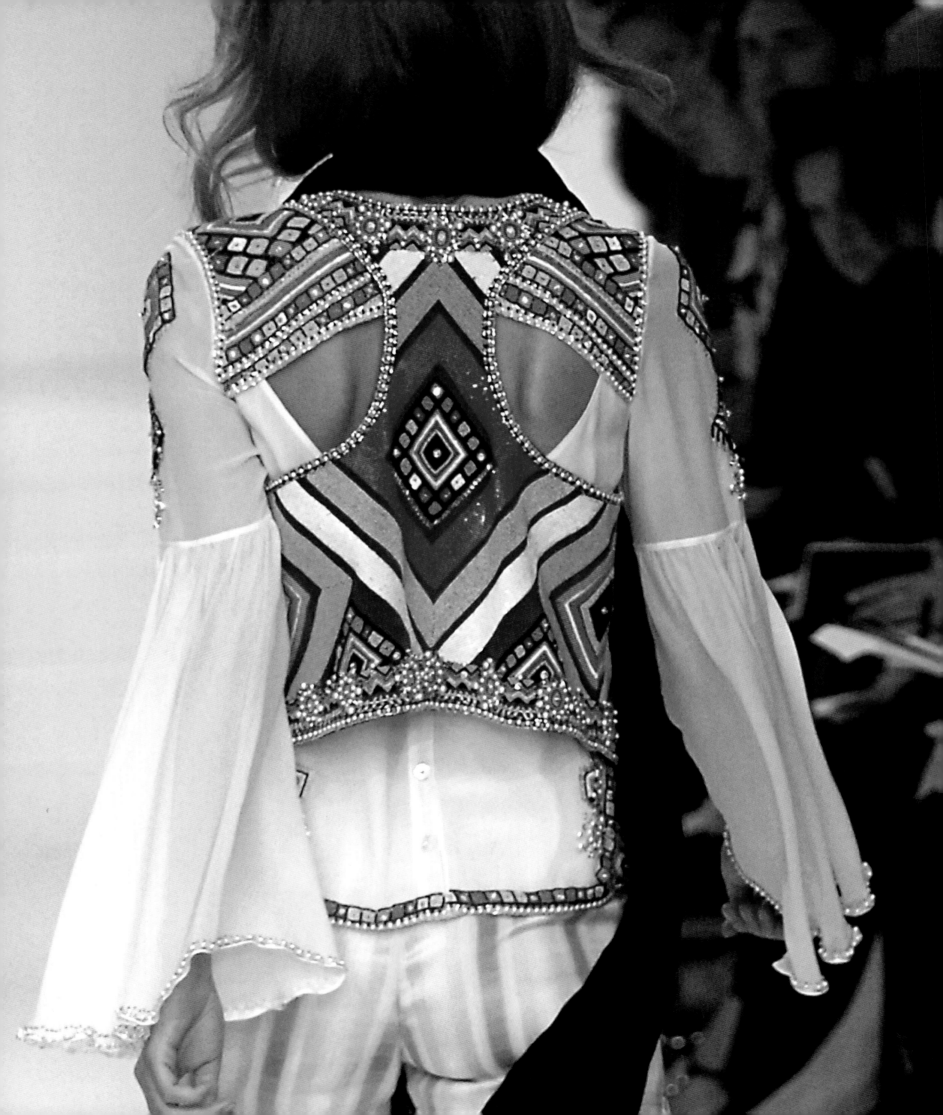

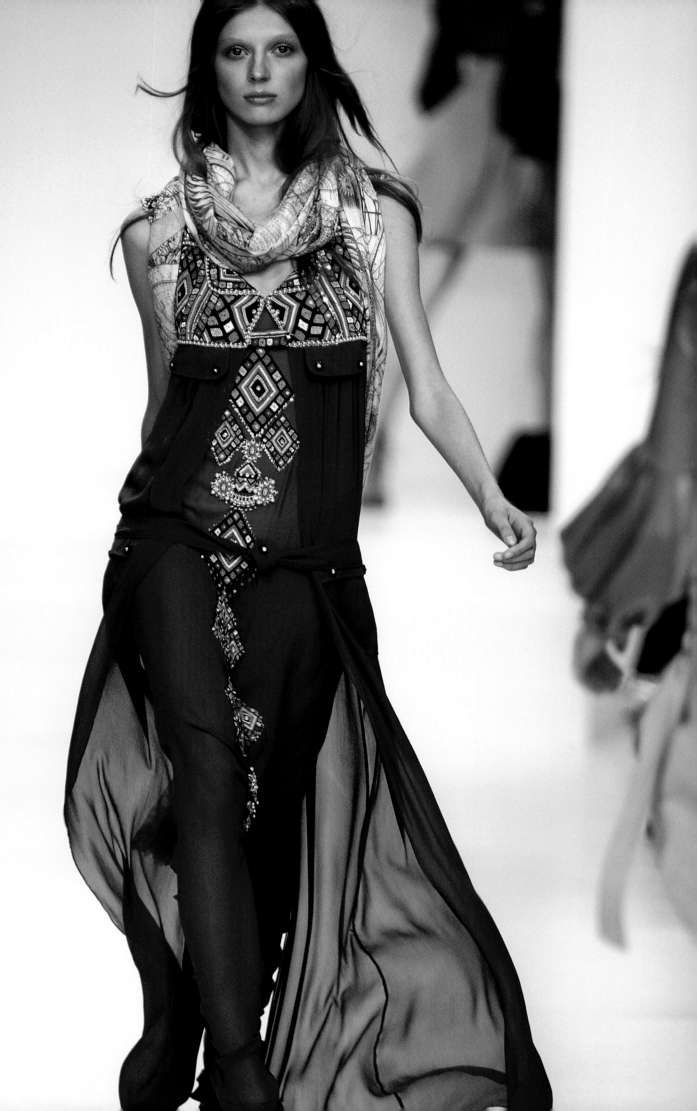

Runway shots from SS08
showing the realised
beading technique shown
on page 83

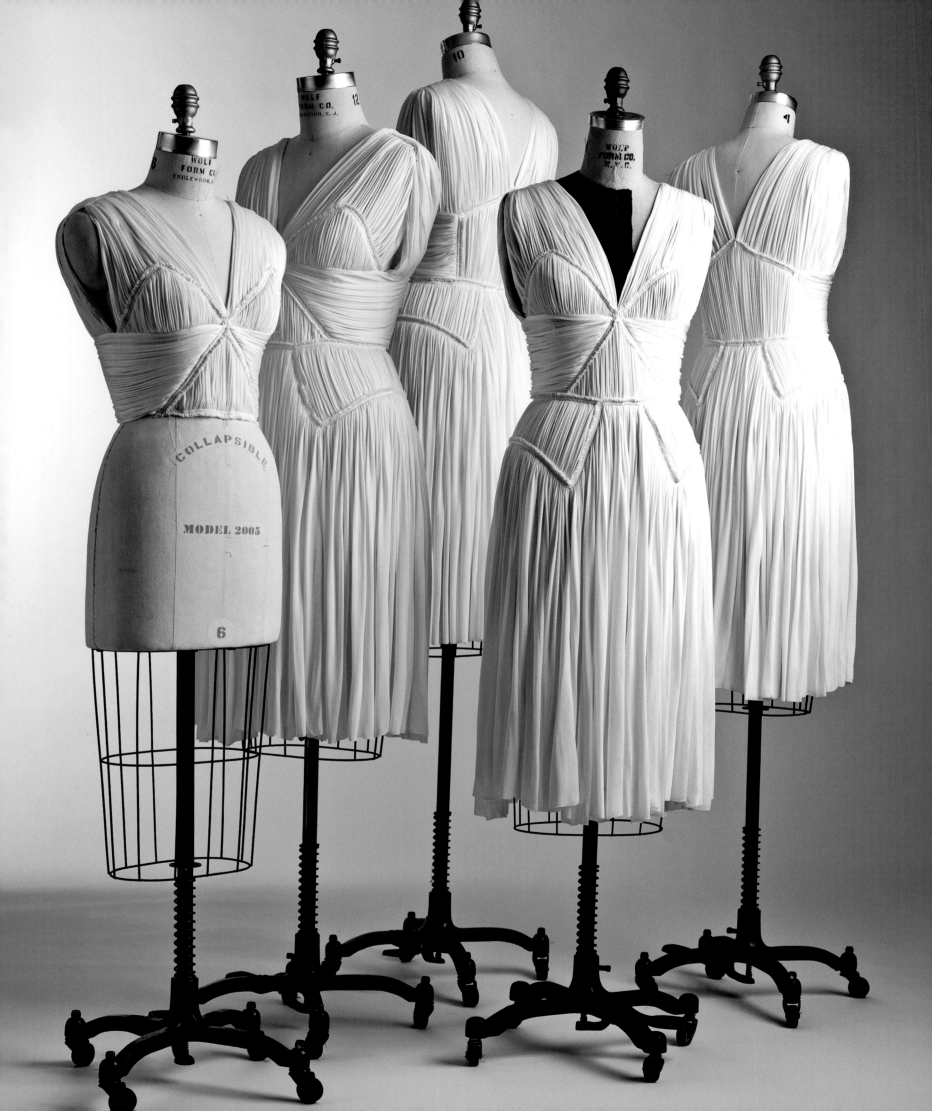

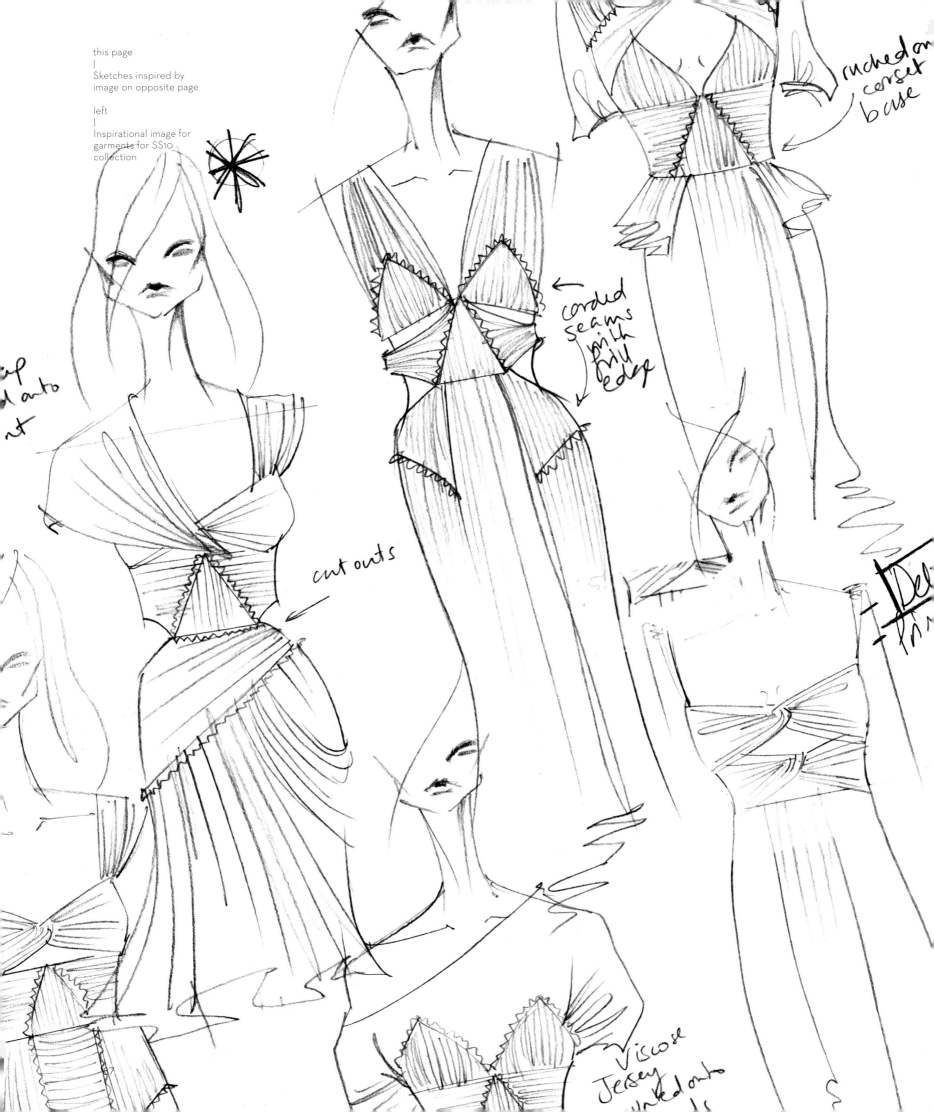

this page
|
Sketches inspired by
image on opposite page

left
|
Inspirational image for
garments for SS10
collection

ruched on
corset
base

corded
seams
with
frill
edge

cut outs

Viscose
Jersey

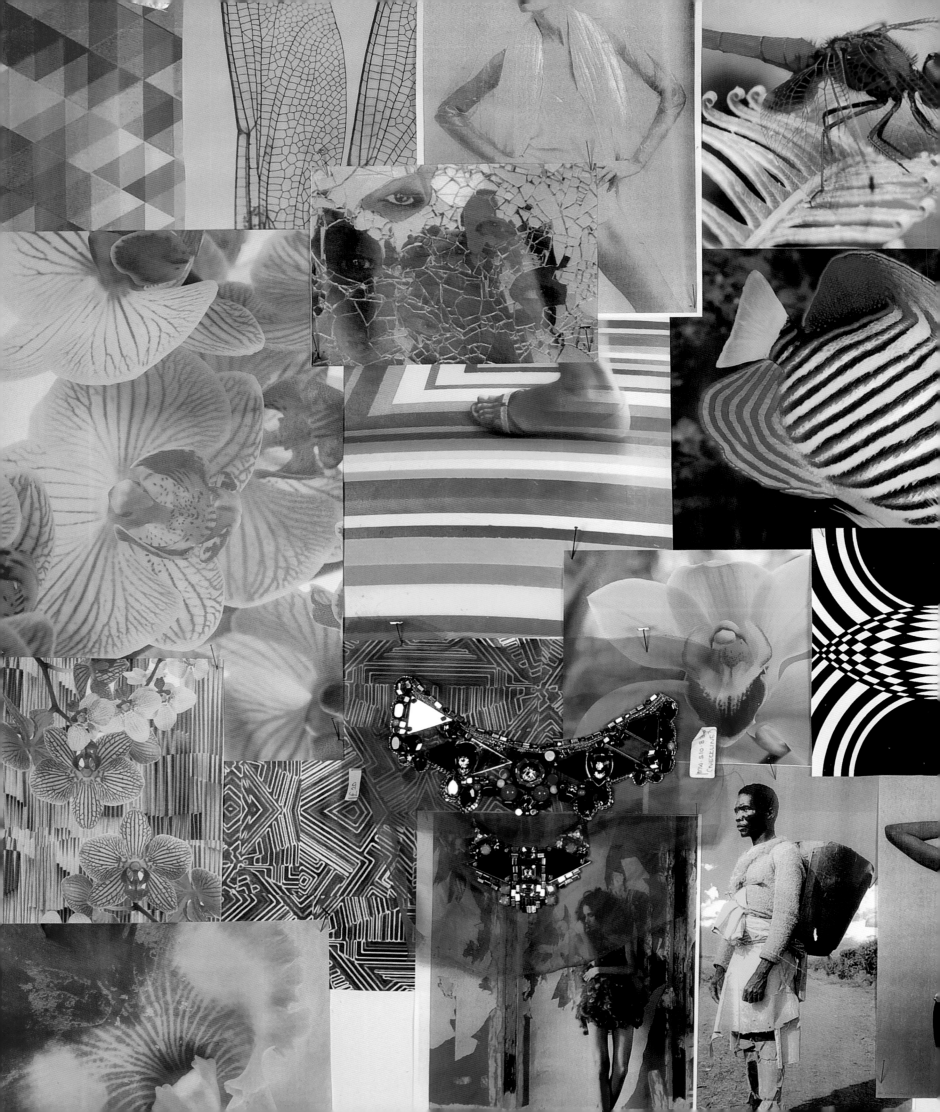

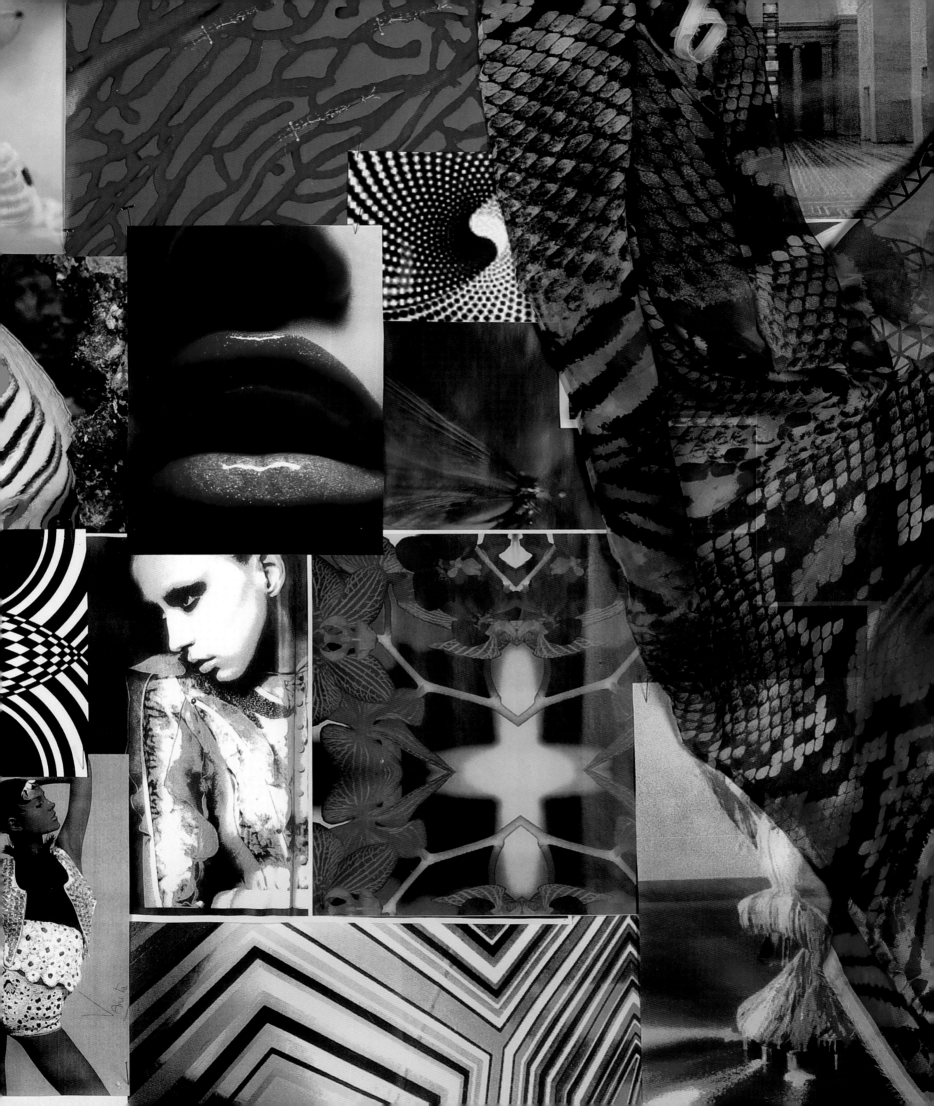

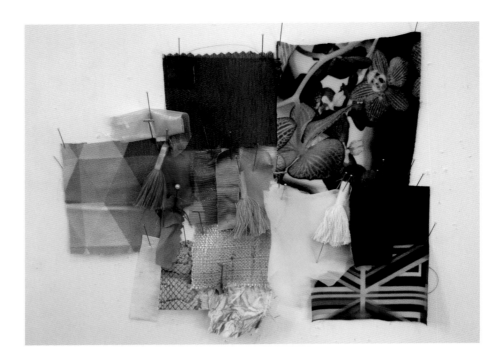

previous spread
|
Mood board image from
SS10 collection

this page
|
Fabric swatches showing
the two colour stories that
were developed for the
SS10 collection.

right
|
In-house images of fittings
which take place throughout
the months leading up to a
runway show. Model is seen
here wearing toiles from the
SS10 collection.

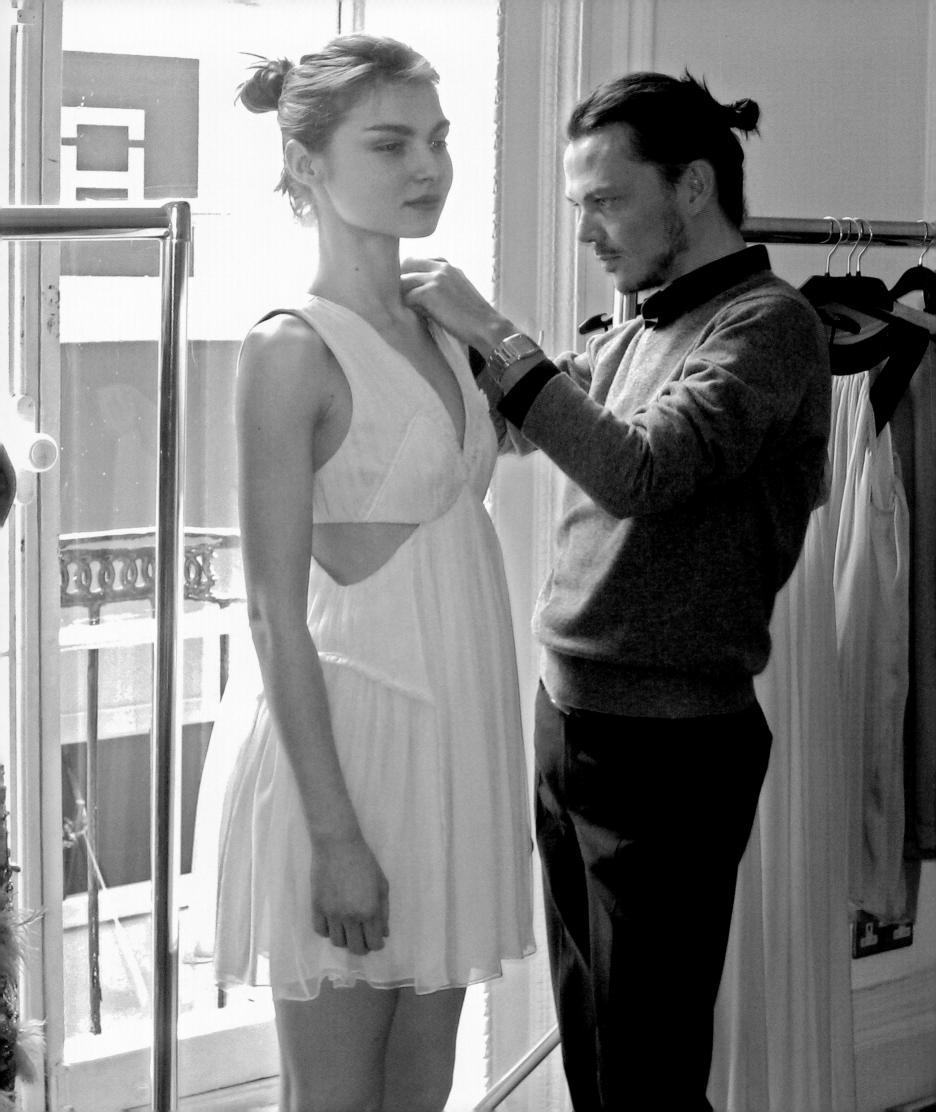

26

29

ENIKO

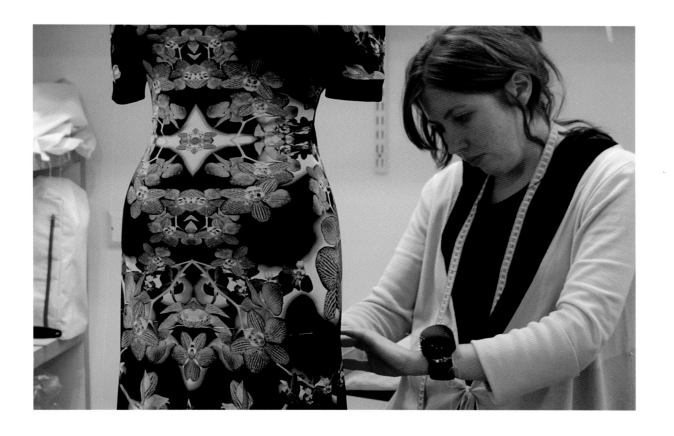

top
|
Polaroids showing runway
models in fittings of final
garments developed from
the toile shown opposite

right
|
Making final touches
to a runway dress in the
technical department
before SS10 show

opposite page
|
Matthew seen adjusting a
toile on Kate, the in-house
model. There can be up to
5 toiles before Matthew
gives approval for
construction in the final
fabric.

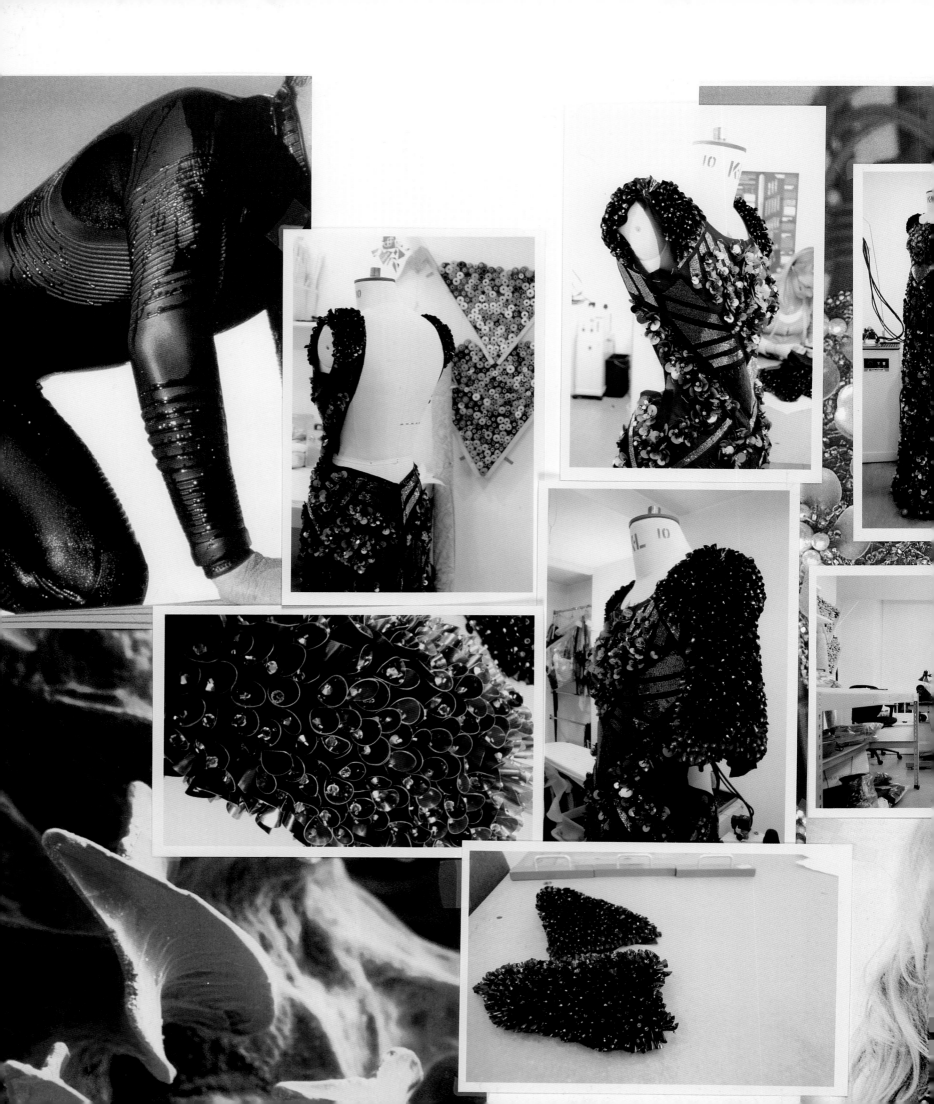

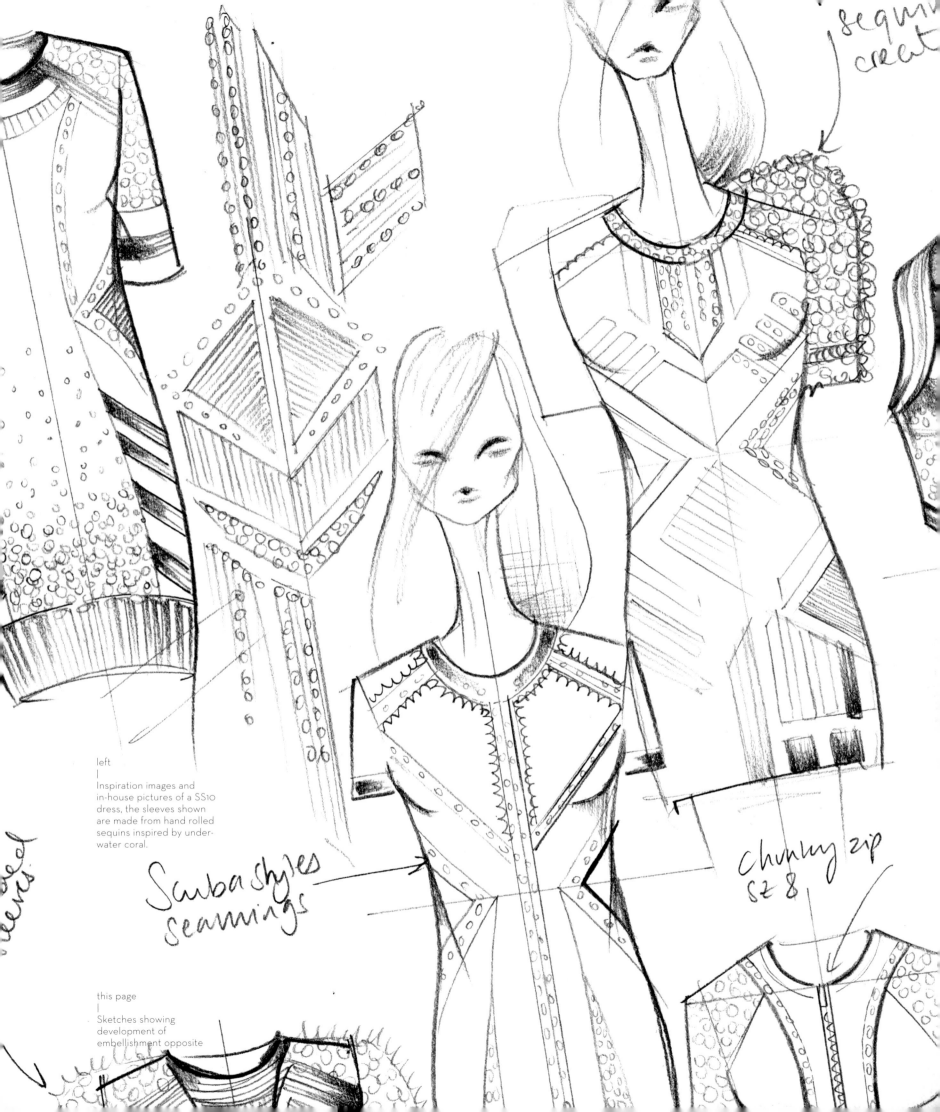

sequin
creat

Scuba styles
seamings

Chunky zip
sz 8

left
|
Inspiration images and
in-house pictures of a SS10
dress, the sleeves shown
are made from hand rolled
sequins inspired by under-
water coral.

this page
|
Sketches showing
development of
embellishment opposite

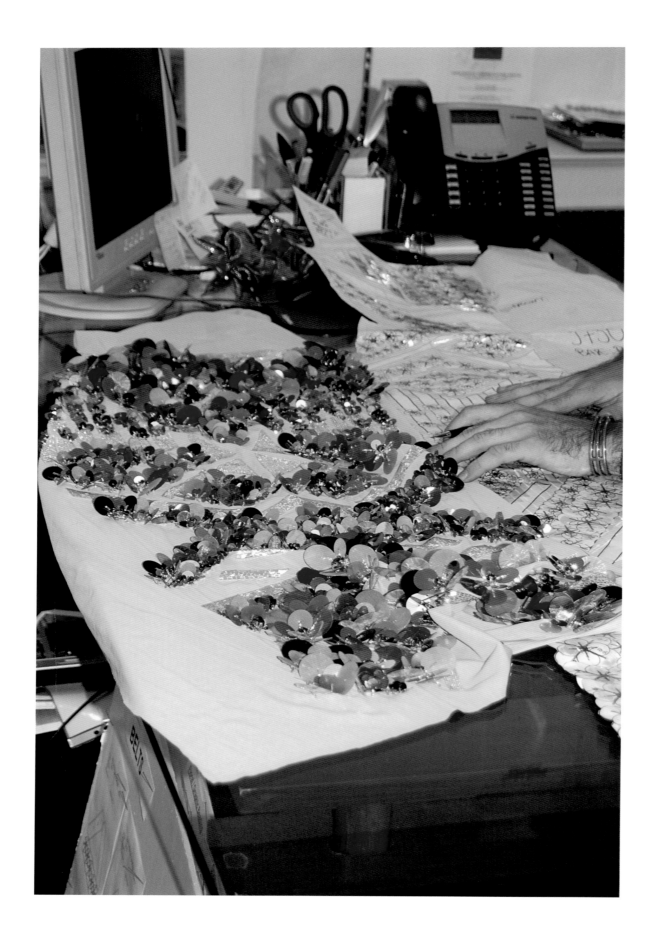

left to right
|
Checking
beaded fabric against
original artwork

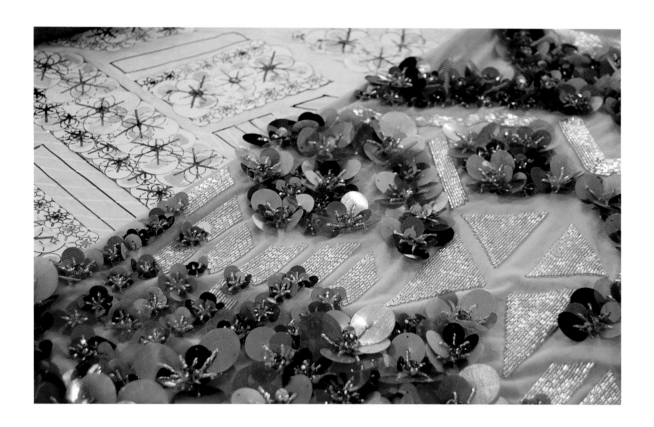

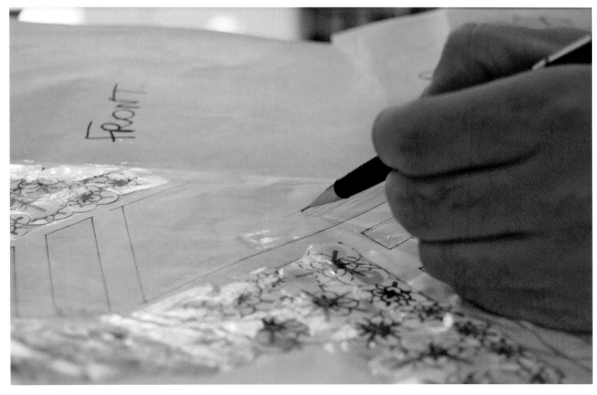

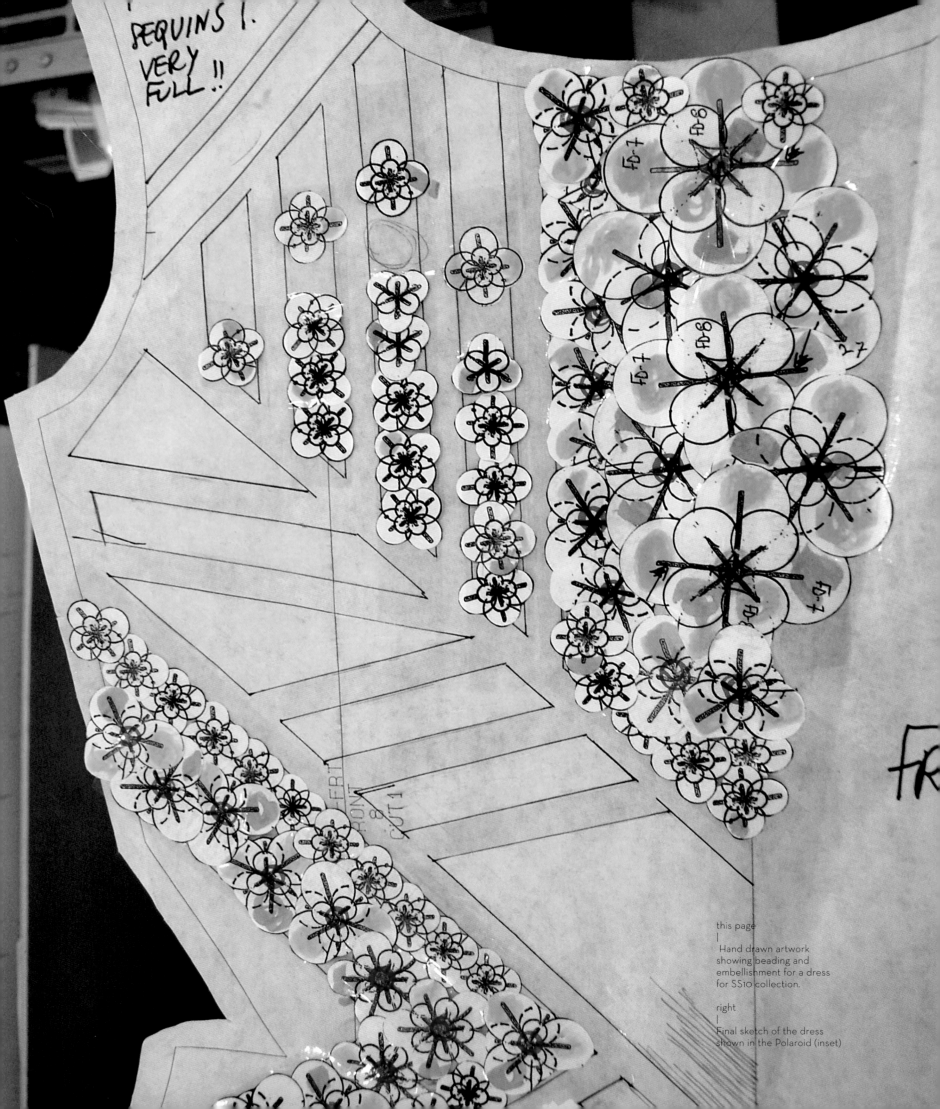

SEQUINS !.
VERY
FULL !!

FRONT 8
CUT 1

FR

this page

Hand drawn artwork
showing beading and
embellishment for a dress
for SS10 collection.

right

Final sketch of the dress
shown in the Polaroid (inset)

31

MELO

Orchid print
Summer 2010

MATTHEW WANTS HIS WOMAN
TO BE FABULOUS, JET SETTING,
AND FREE SPIRITED...

Vanessa Coyle,
Senior Fashion Editor,
Harper's Bazaar

Artwork from the invitation to the SS10 runway show

RUNWAY

"Long before I worked with Matthew, his brand represented uplifting colour, light and optimism. As a designer he hasn't subscribed to trends but has stayed true to his own spirit and that's why his brand speaks to people — it has an authenticity and that is reflected in everything Matthew does. He has also always understood the power of celebrity — even from the very early days.

Through working together as a stylist on his past couple of shows I have also seen an openness and ability to collaborate and evolve his brand, moving forward into more focussed collections without losing any of that amazing vitality and vibrance that his fans have always loved. He still wants his woman to be 'fabulous', jet setting, and free spirited . . . but he has expanded the brand to also appeal to a more urban, modern woman."

Vanessa Coyle
Senior Fashion Editor,
Harper's Bazaar

"You don't rehearse a fashion show", says Williamson, "it's one of the crazy things — you do a fitting, but you've got a model coming in who's got six fittings to go to that day, so it has to be done quickly. At that final moment, when the models are on the runway, my job is done. I think it's the circus that creates a lot of the magic in the fashion show system, from a designer's point of view, from a buyer's point of view, the media, press and journalists point of view: everyone's used to that system."

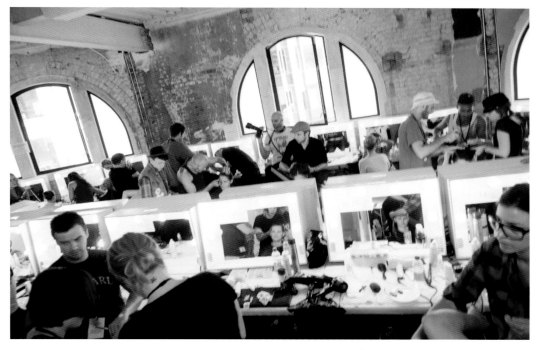

Backstage image of the hair and make-up area

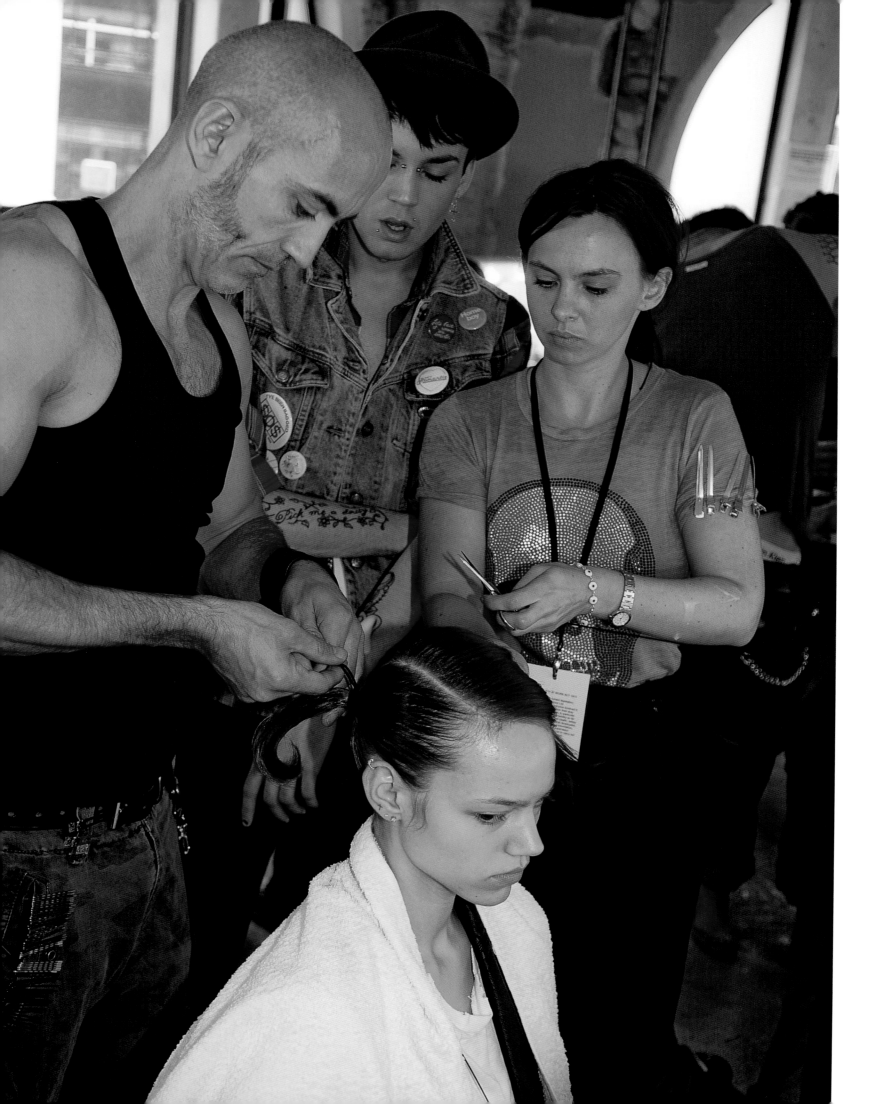

left
|
Malcolm Edwards'
hair team backstage
preparing a model prior
to a runway show.

right
|
Joseph talking with the
front of house team before
the SS10 show.

below
|
Matthew with his show
stylist, Vanessa Coyle,
discussing the first run
through of the show.

this page
|
Pictures of the runway walk
through and preparations
before the audience are
allowed into the show
space, SS10

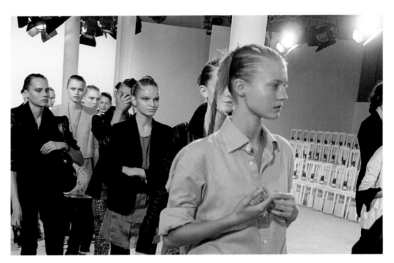

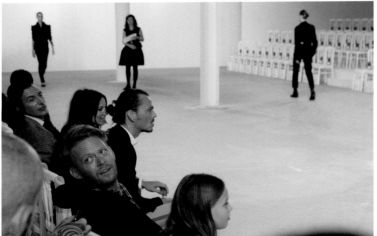

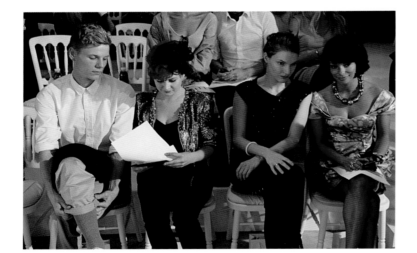

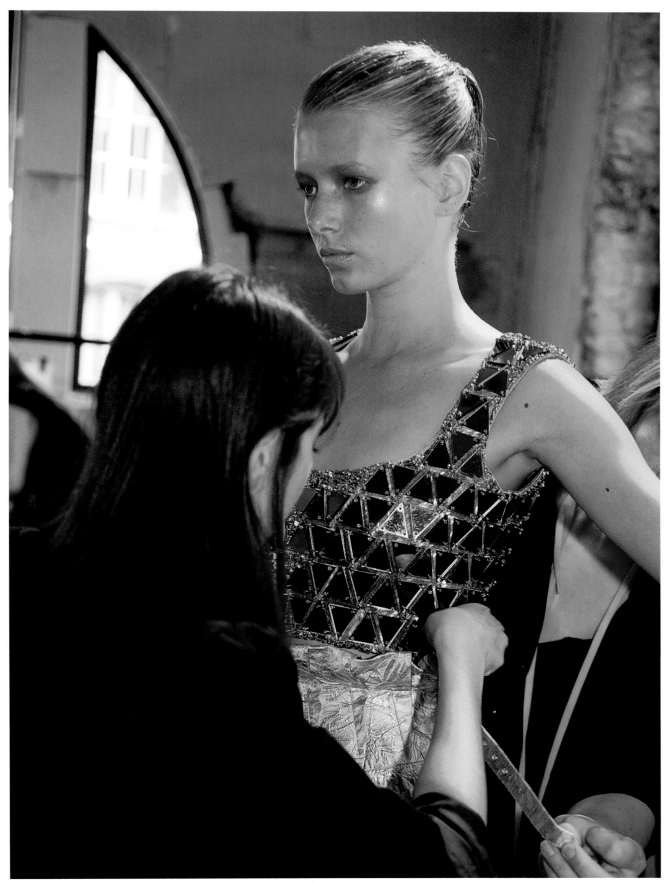

Model dressing backstage before the SS10 runway show

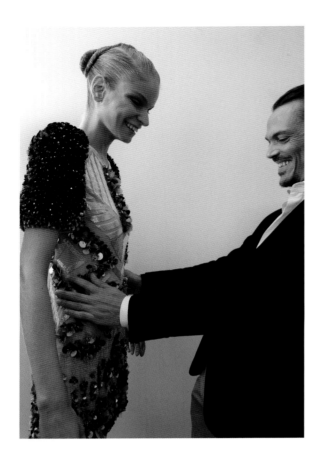

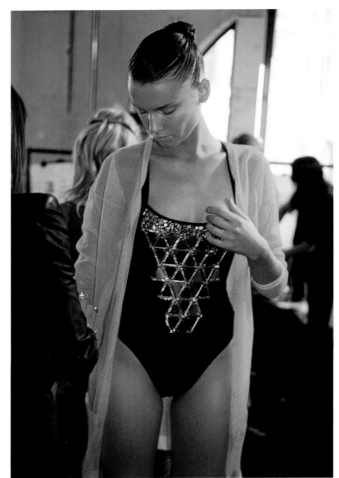

this page
|
Pictures taken backstage
of final dressing, every
detail is inspected

above right
|
Model wearing a black swim-
suit covered in hundreds of
bugle beads, Swarovski crys-
tals and perspex triangles

opposite
|
The models line up back-
stage for their first looks on
the runway.
(right) Abby Lee wears a
metallic linen shift dress,
hand embroidered neckline
and cropped leather jacket
with python inserts
(left) The model wears
bronze metallic shorts, hand
beaded jacket with hand
curled sequin embellished
sleeves, SS10

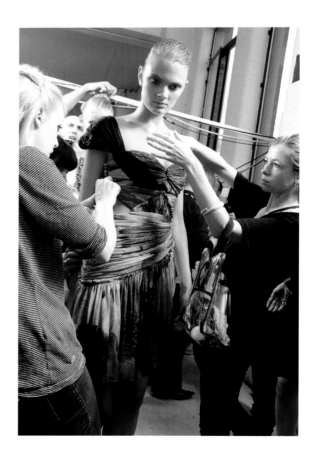

Backstage just before
the SS10 show

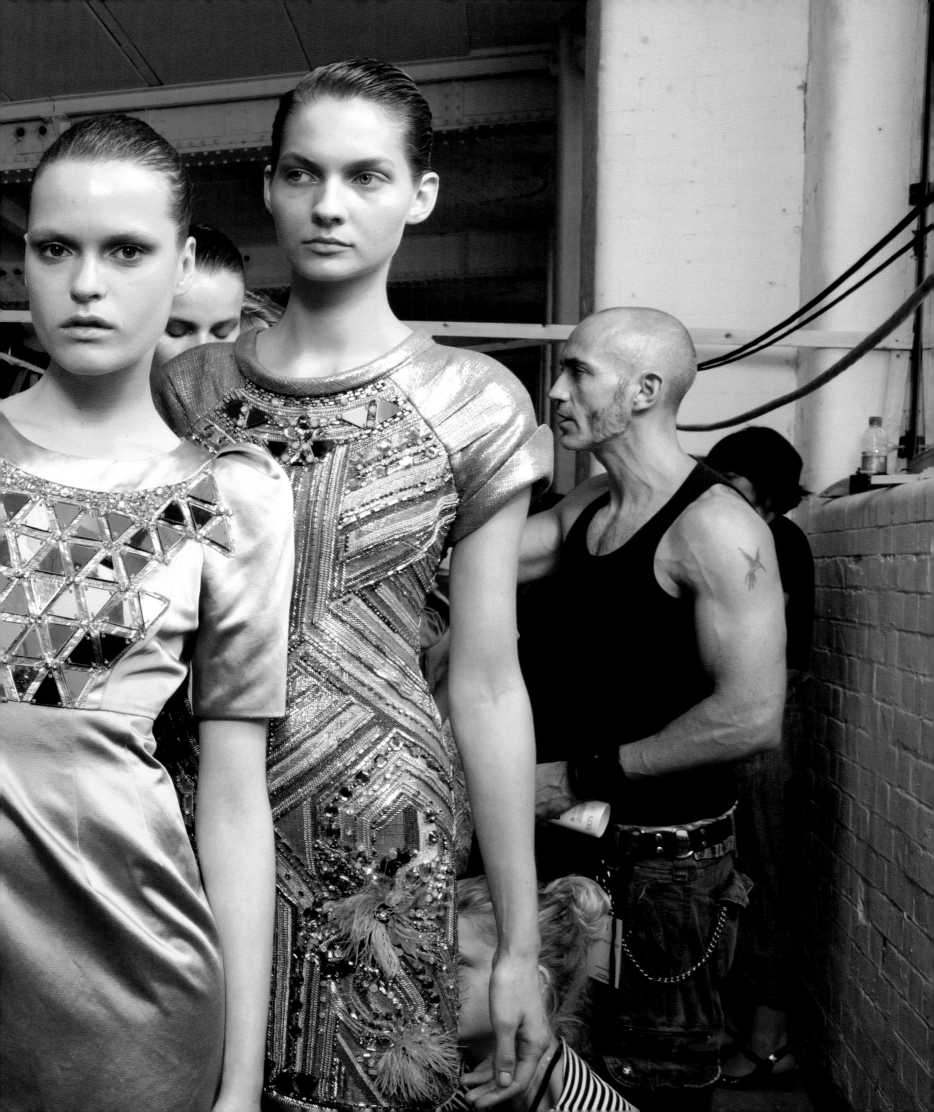

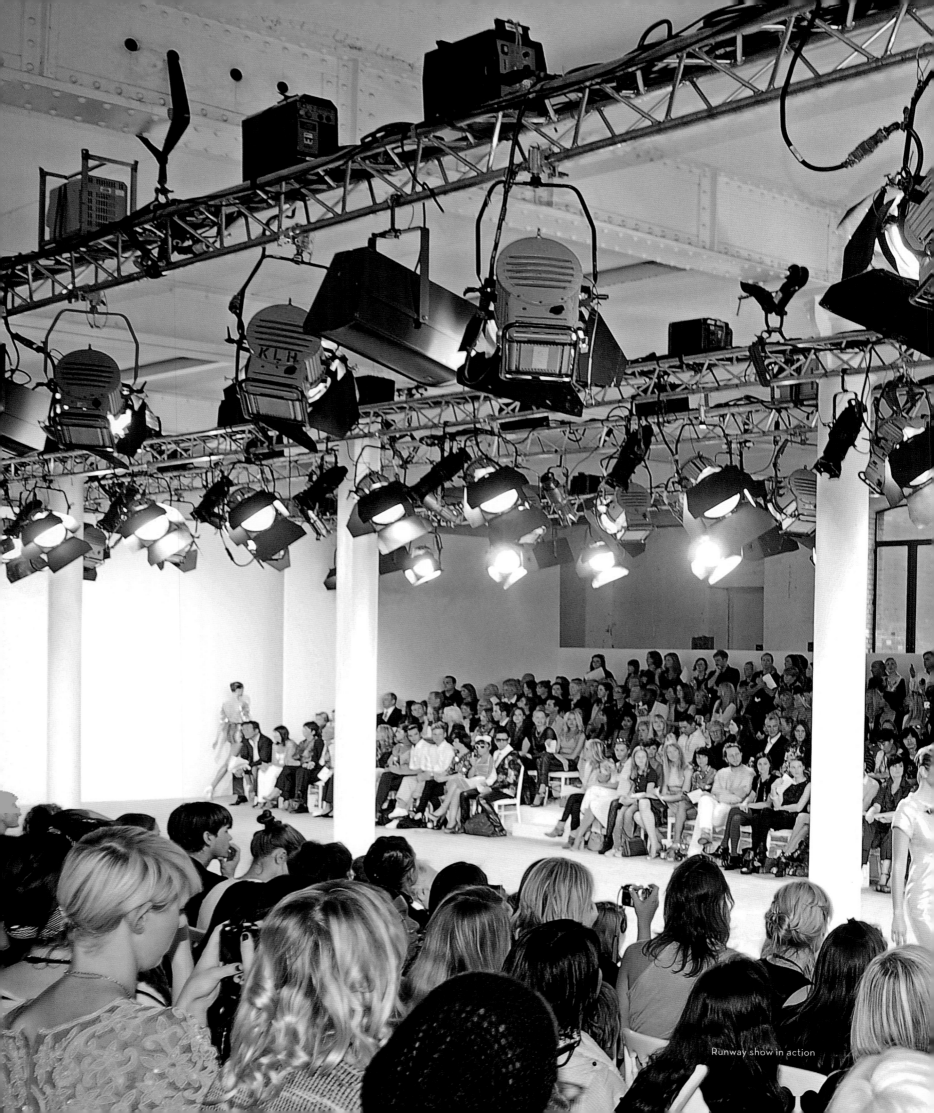

Runway show in action

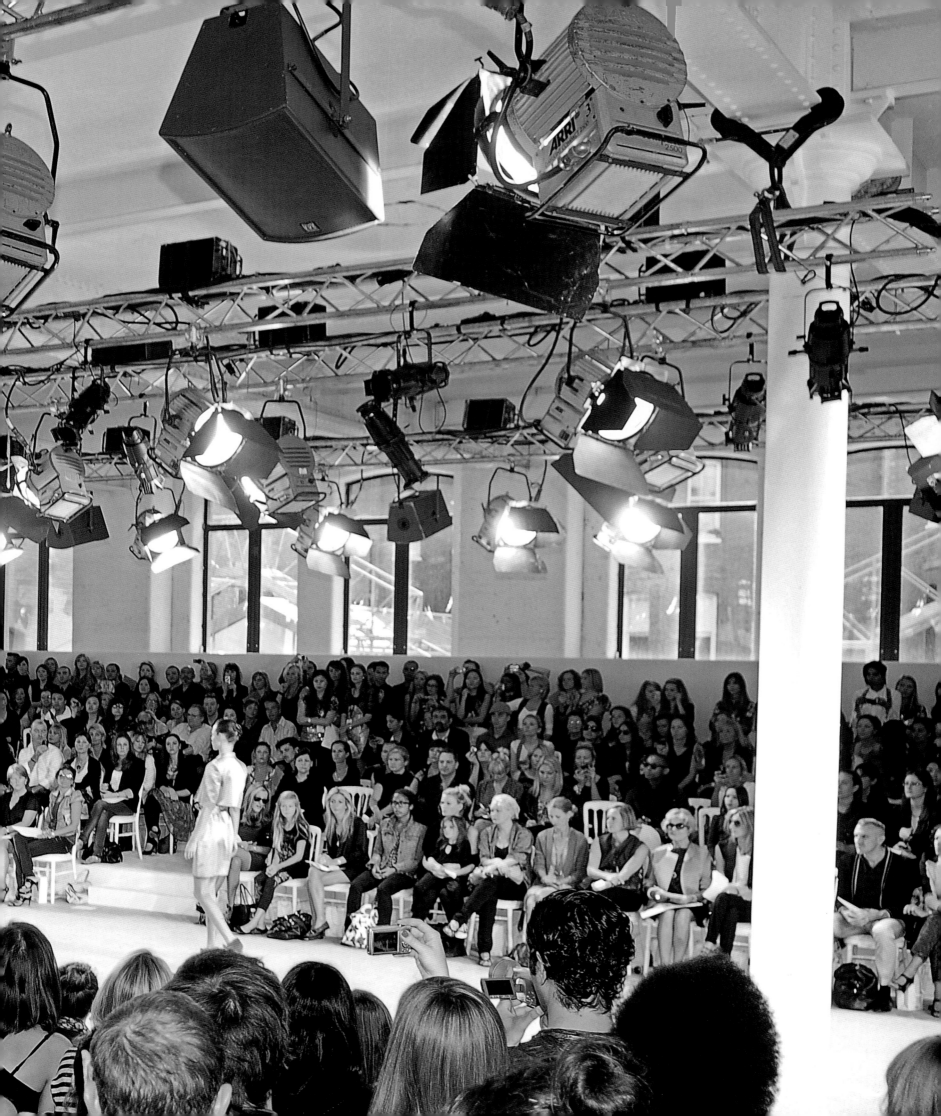

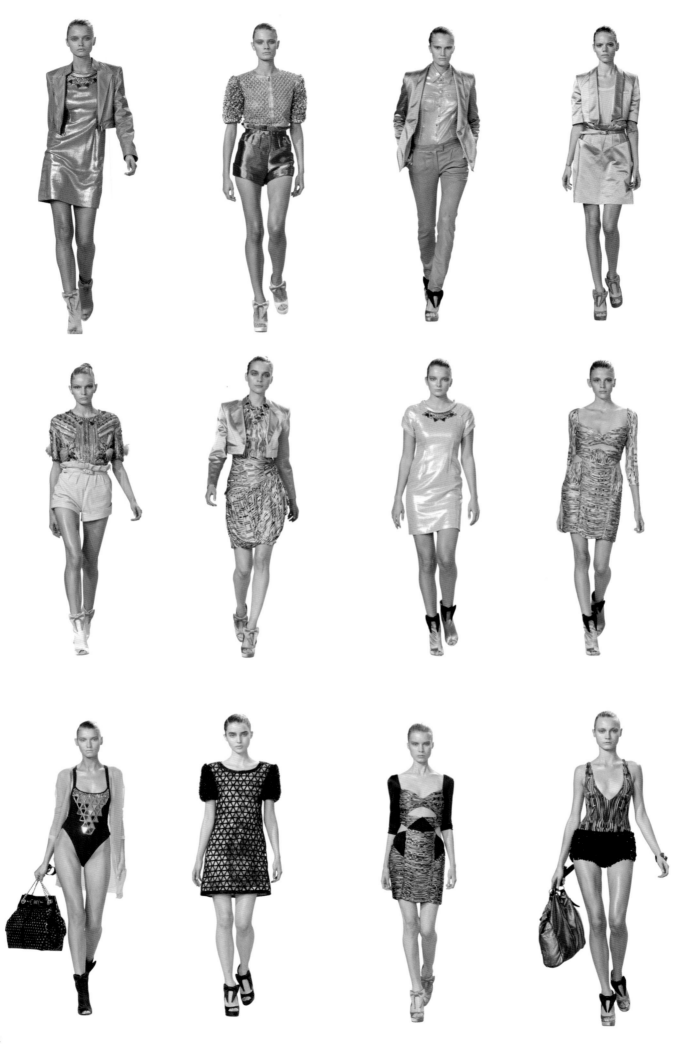

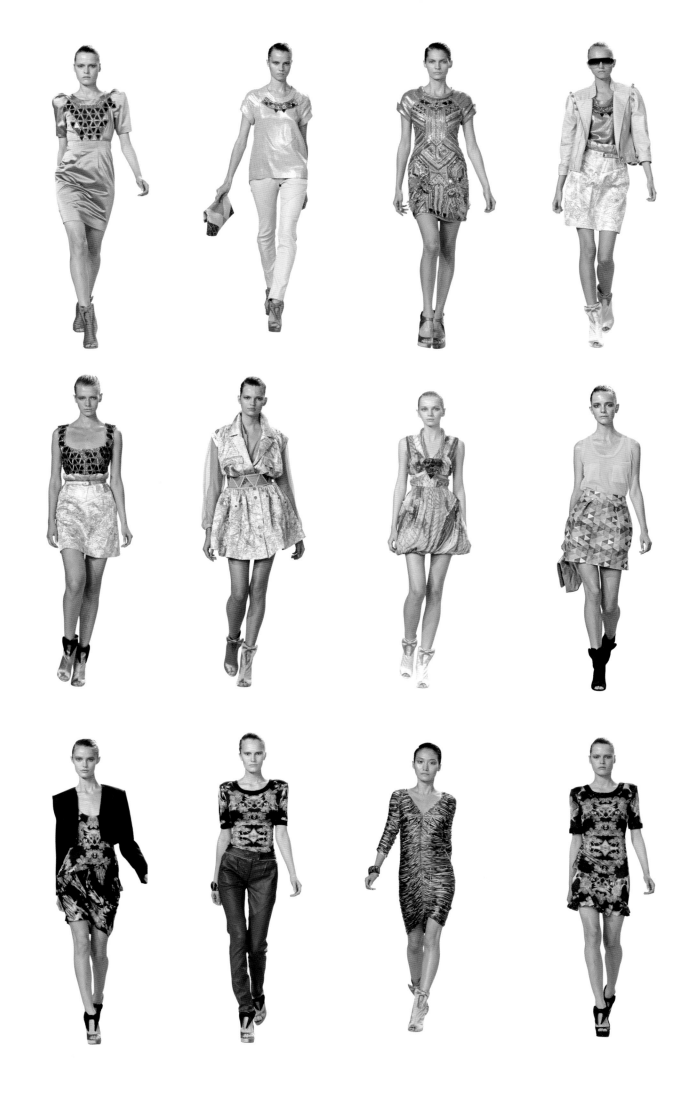

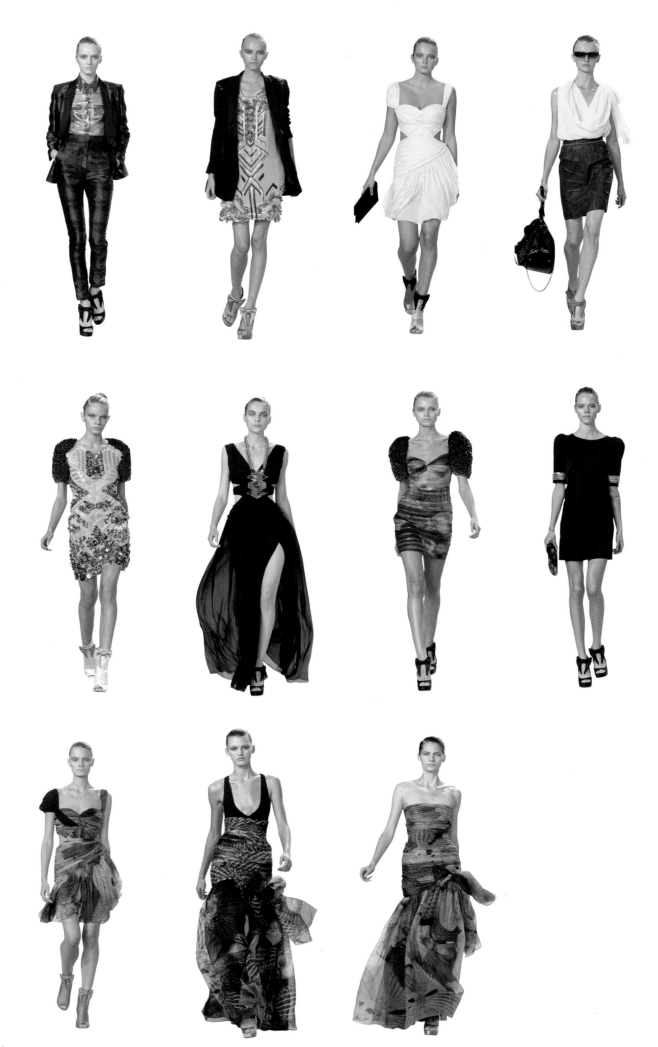

this page and
previous spread
|
Runway shots from
SS10 show

right
|
Matthew with models
backstage after the show

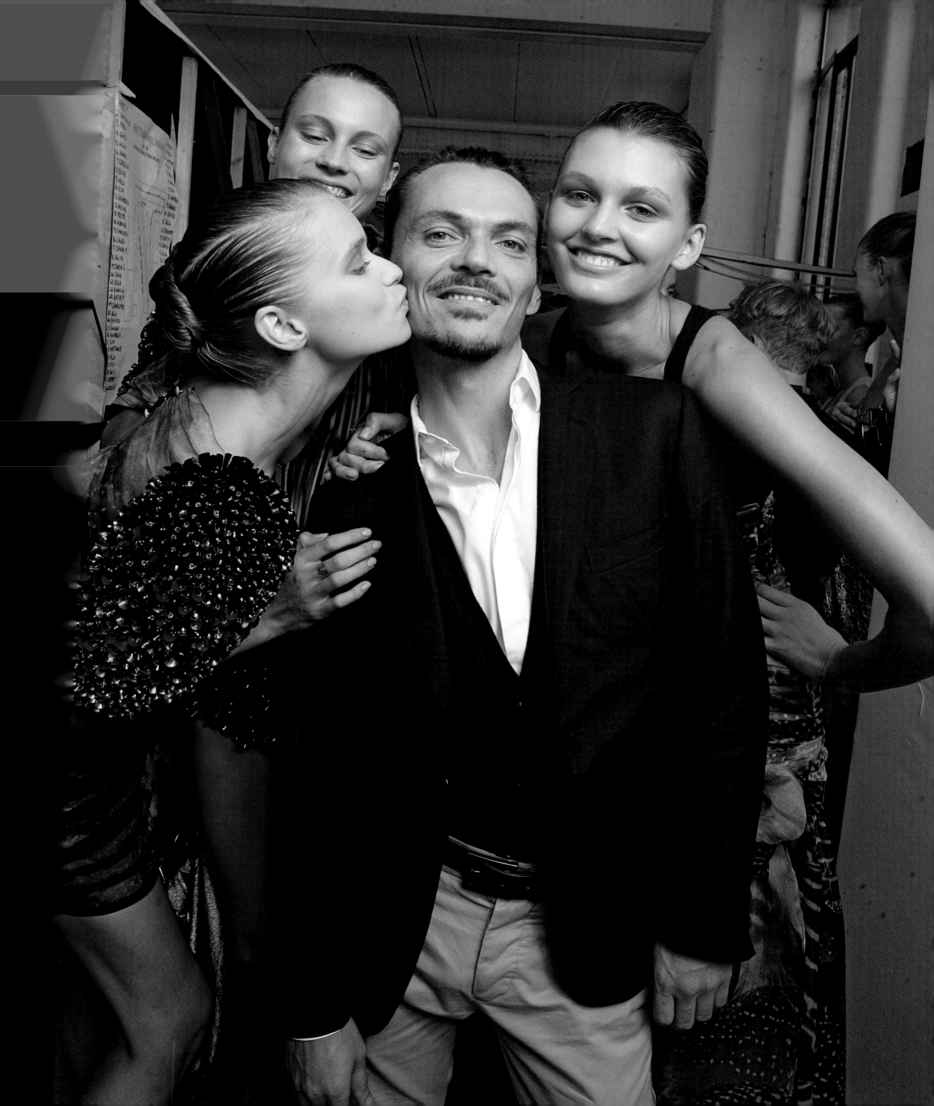

Dynamite print
Summer 2000

IT'S BEEN A REAL TREAT
TO WATCH HIS COLORFUL
CAREER UNFOLD

Anna Wintour
American Vogue

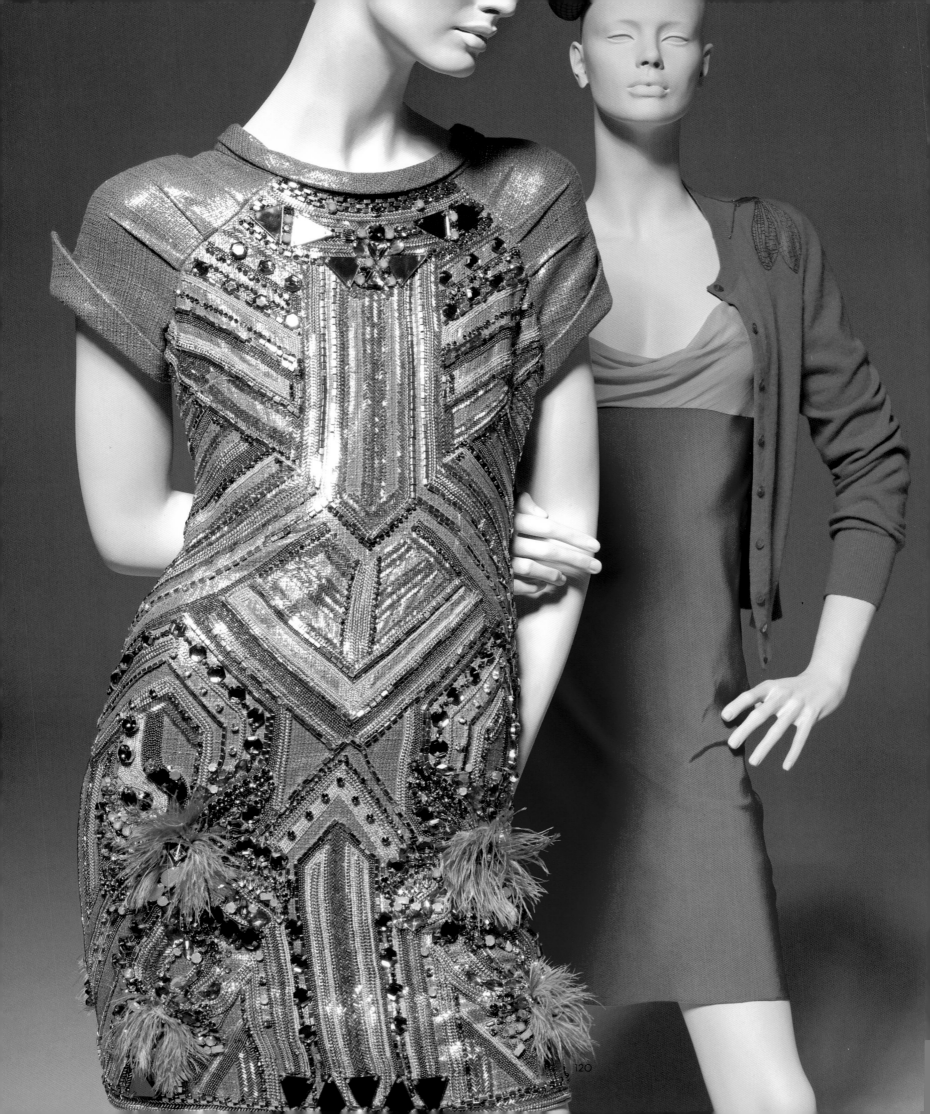

CREATIONS

"Matthew Williamson has brought such joyful energy to the London fashion scene with his wonderful dragonflies, bright bubbly prints, and unabashedly pretty clothes. He's always been so clear about who he is — a designer who understands lifestyle as well as style, a follower in the footsteps of Celia Birtwell and Zandra Rhodes — and who his young, beautiful customer yearns to be. It's been a real treat to watch his colorful career unfold."
Anna Wintour
American *Vogue*

"Since my first collection in 1997", Matthew recalls, "I have managed to keep every original garment that we have ever made. This archive has now become a great source of inspiration for me and my team when working on new collections. We often look through the archives to see how the collections have evolved over the years. On the following pages I have selected and styled my favourite pieces. These pieces are special to me as some hold memories of the people who have worn them and some of these garments have defined a particular theme of a collection. All these designs took months to create, made by hand with a real passion. I think they truly represent the work that we do. Each piece shows my love for colour, pattern and texture. Photographed in this way, attention is drawn to the many details within the garments that can often be overlooked on the runway, whether that be in intricate pattern cutting techniques and silhouette, colour combinations and prints, hand beadwork or embroidery."

For all captions
see page 254

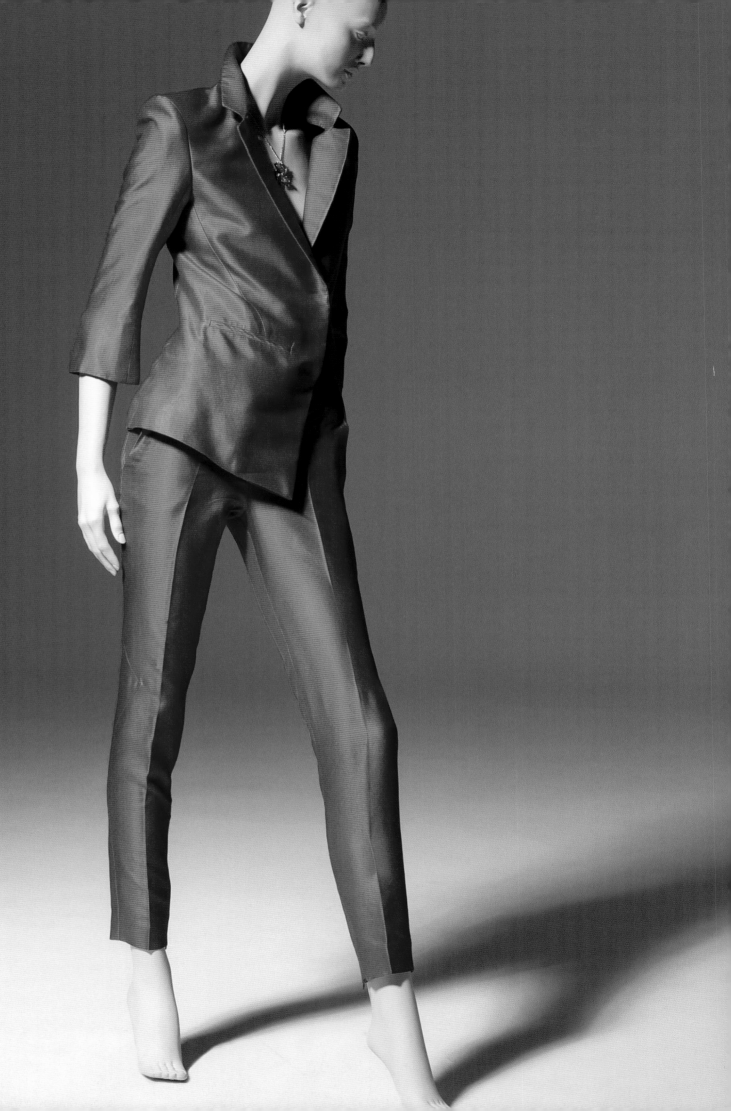

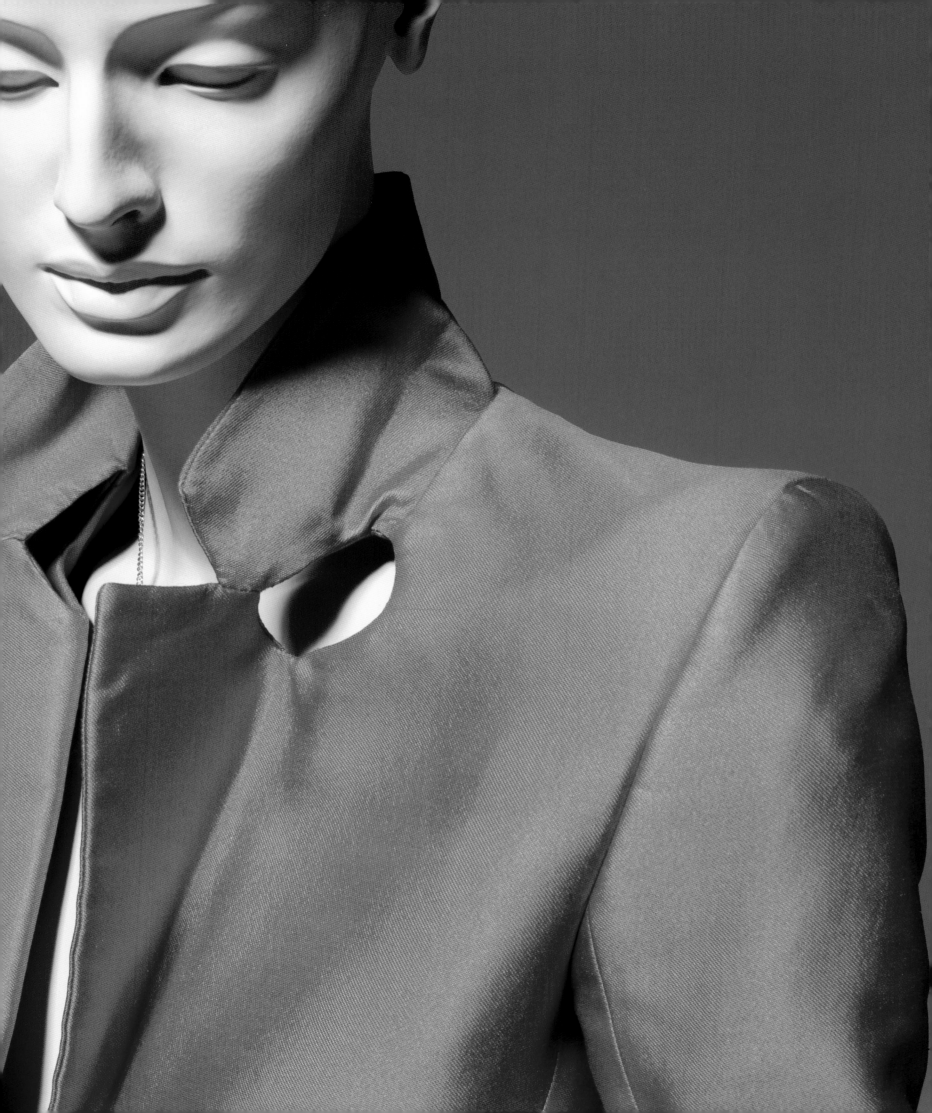

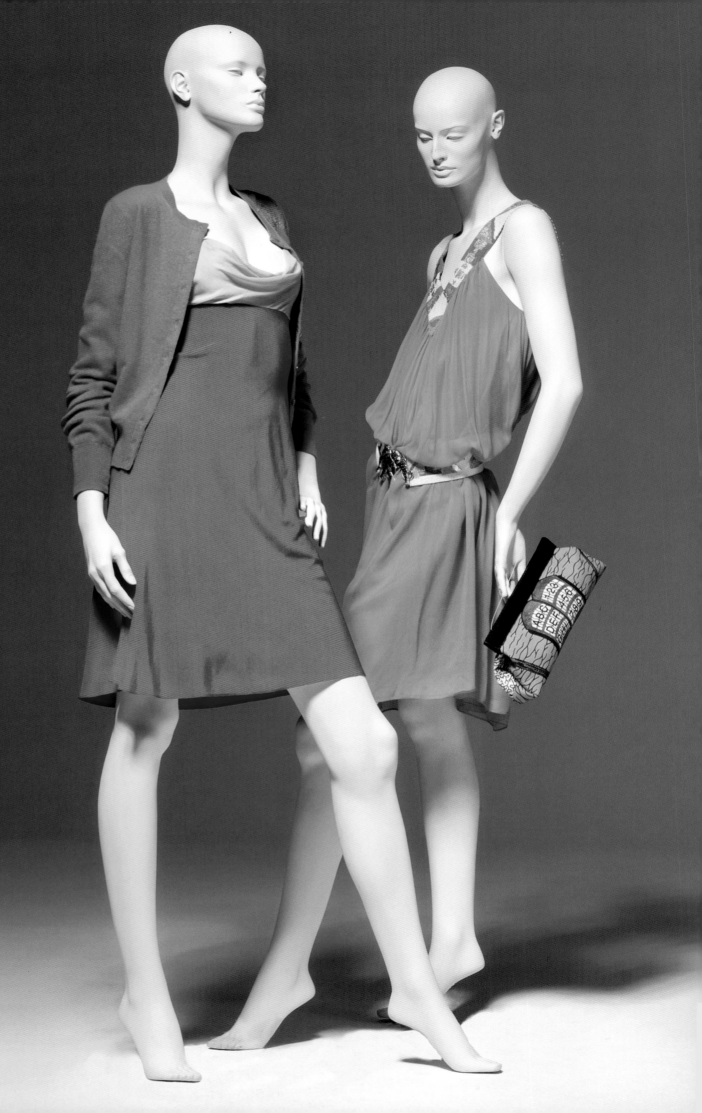

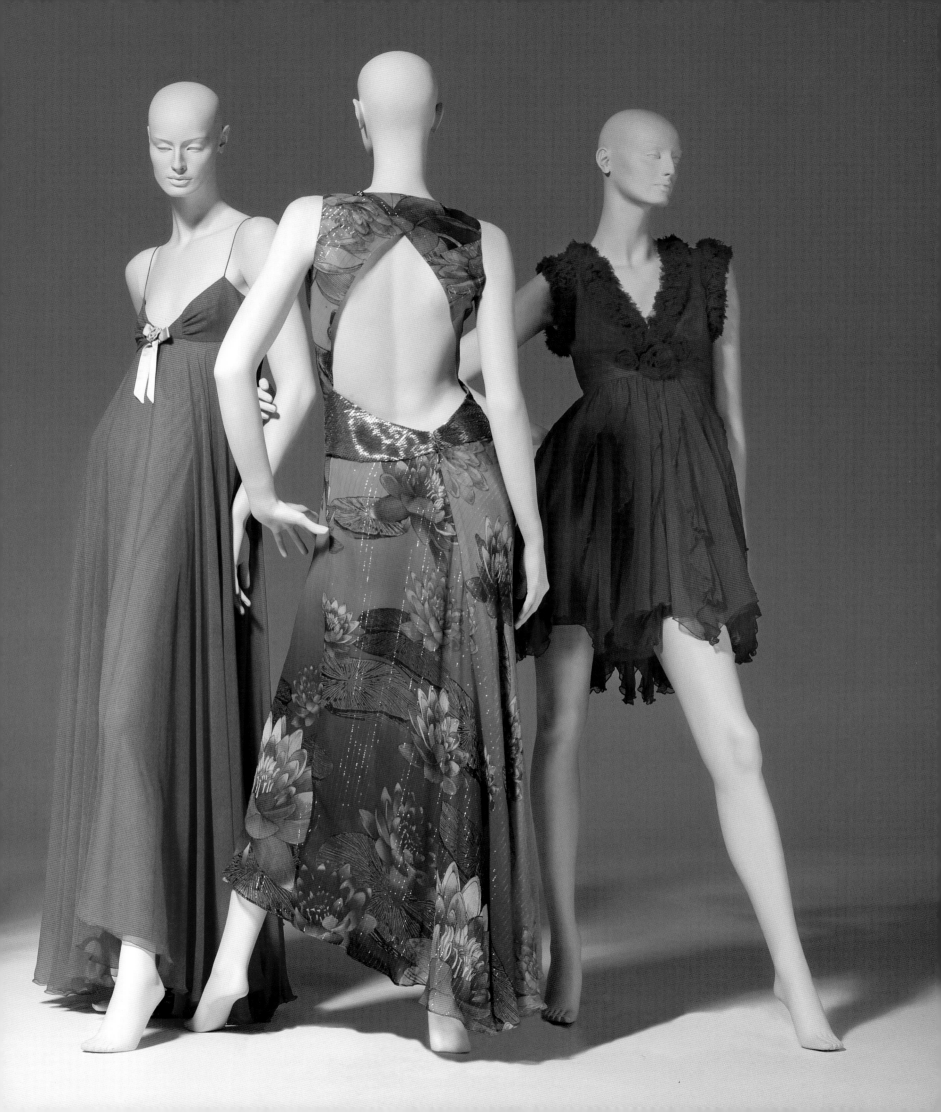

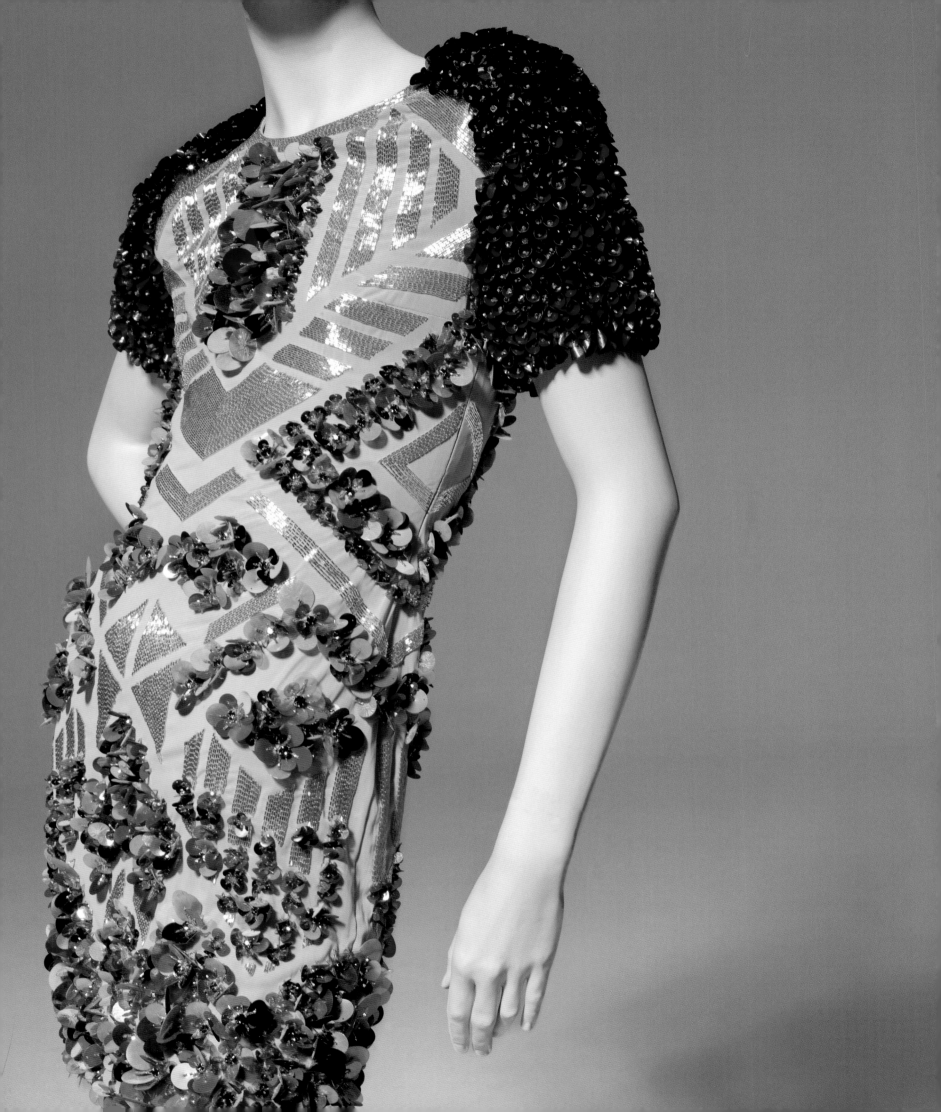

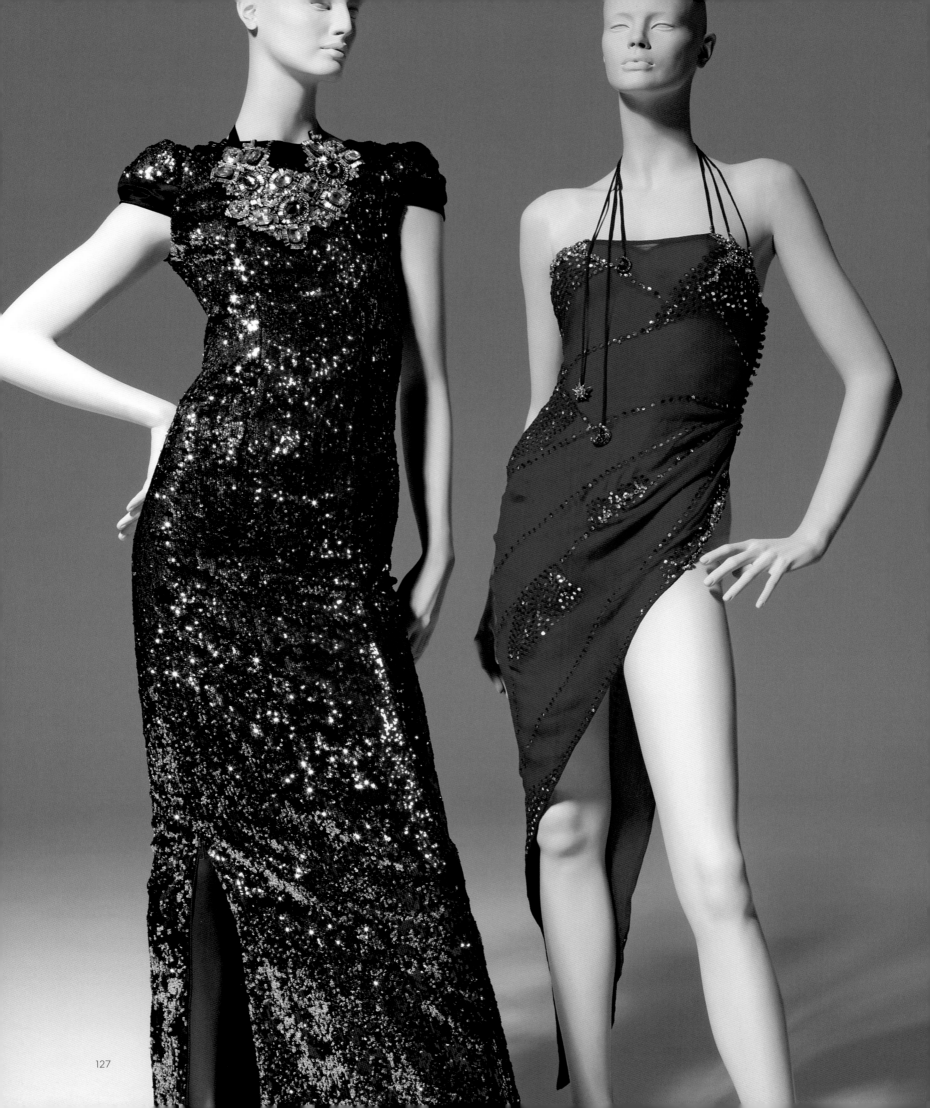

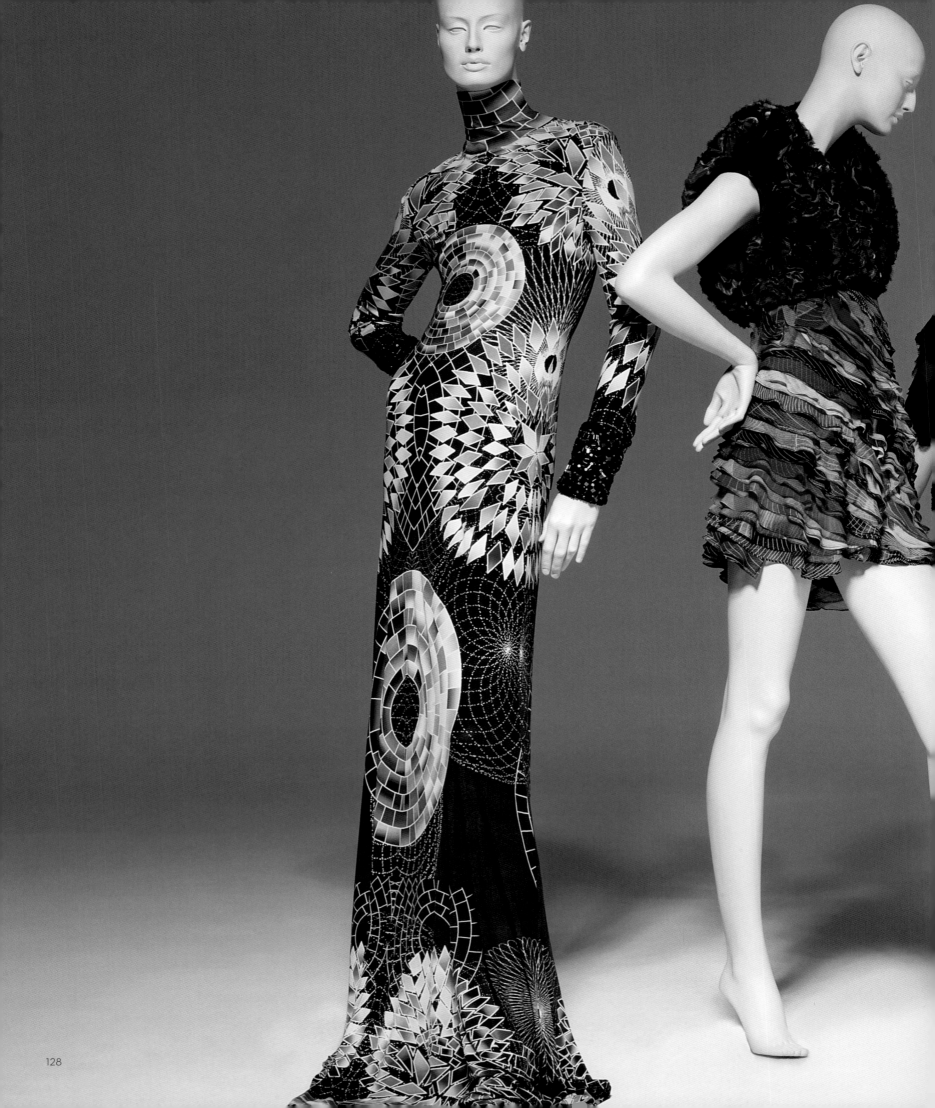

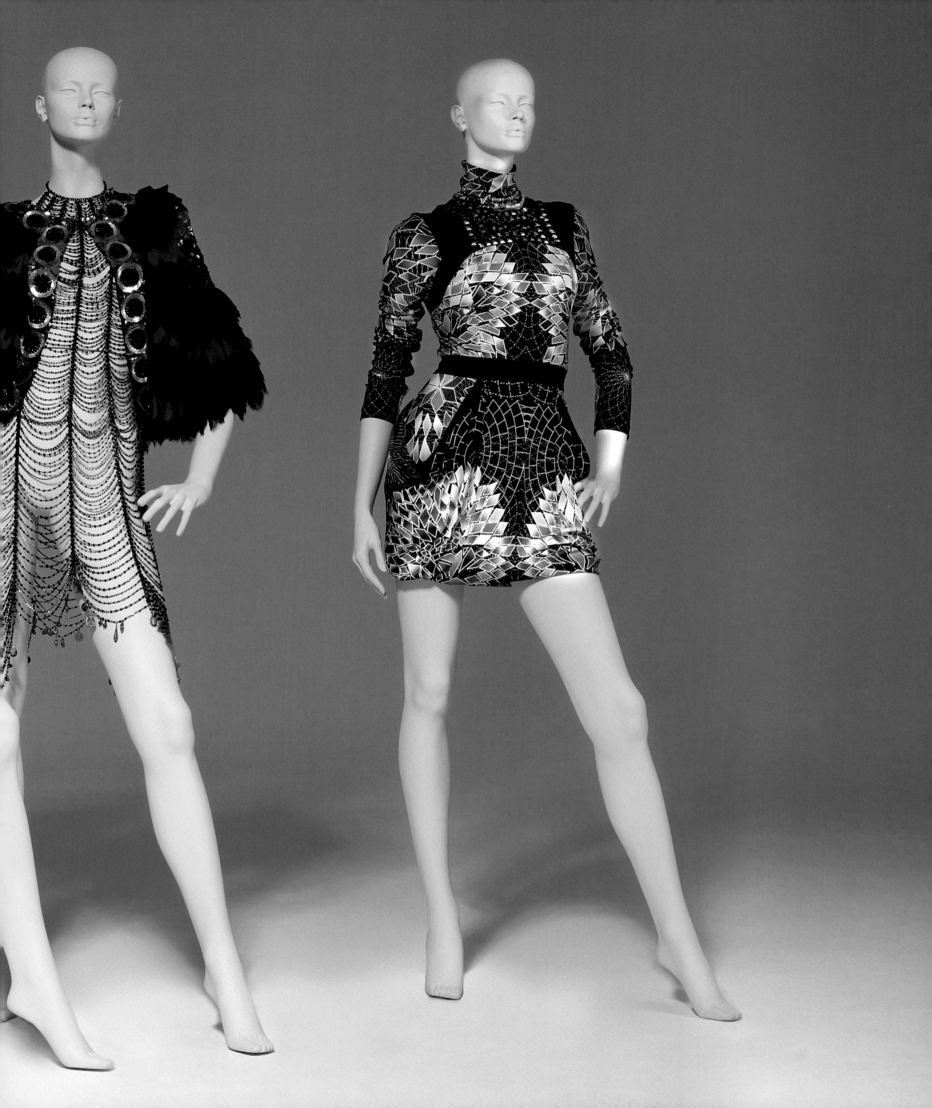

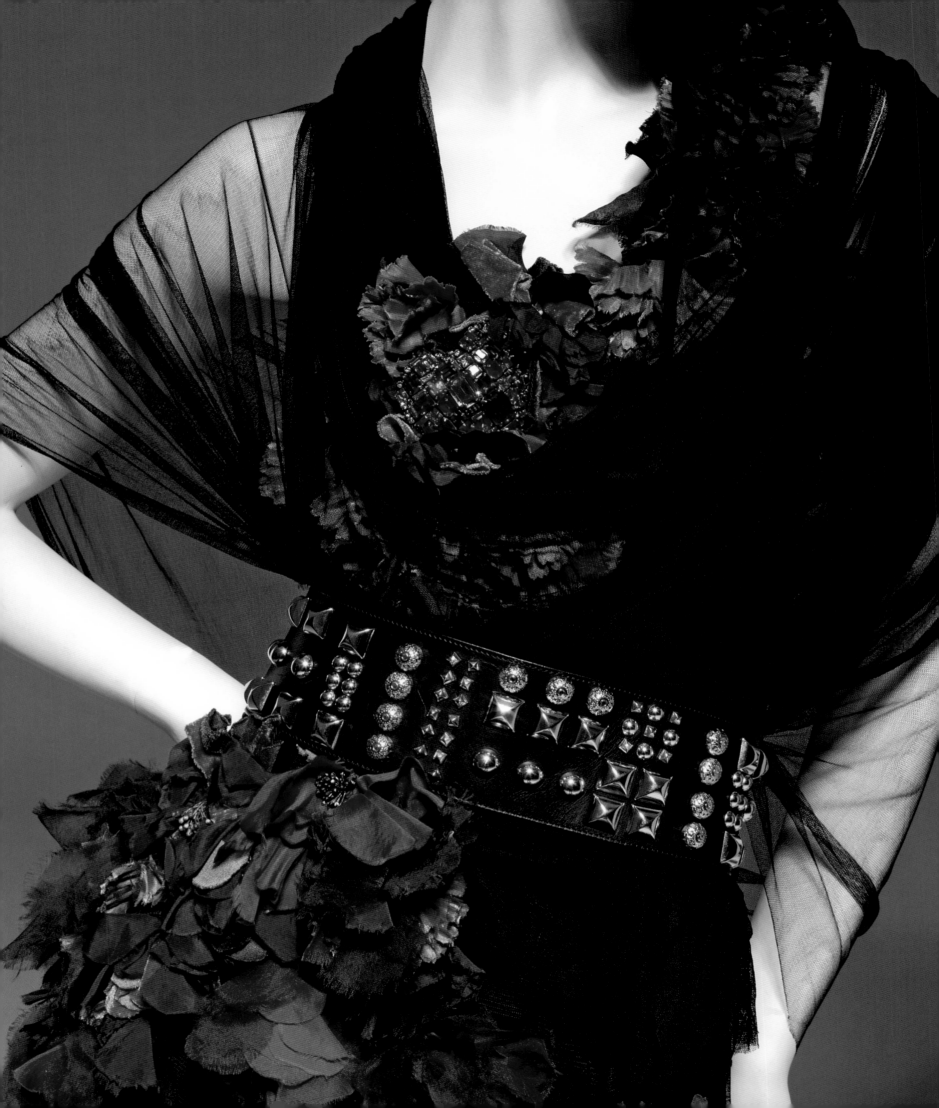

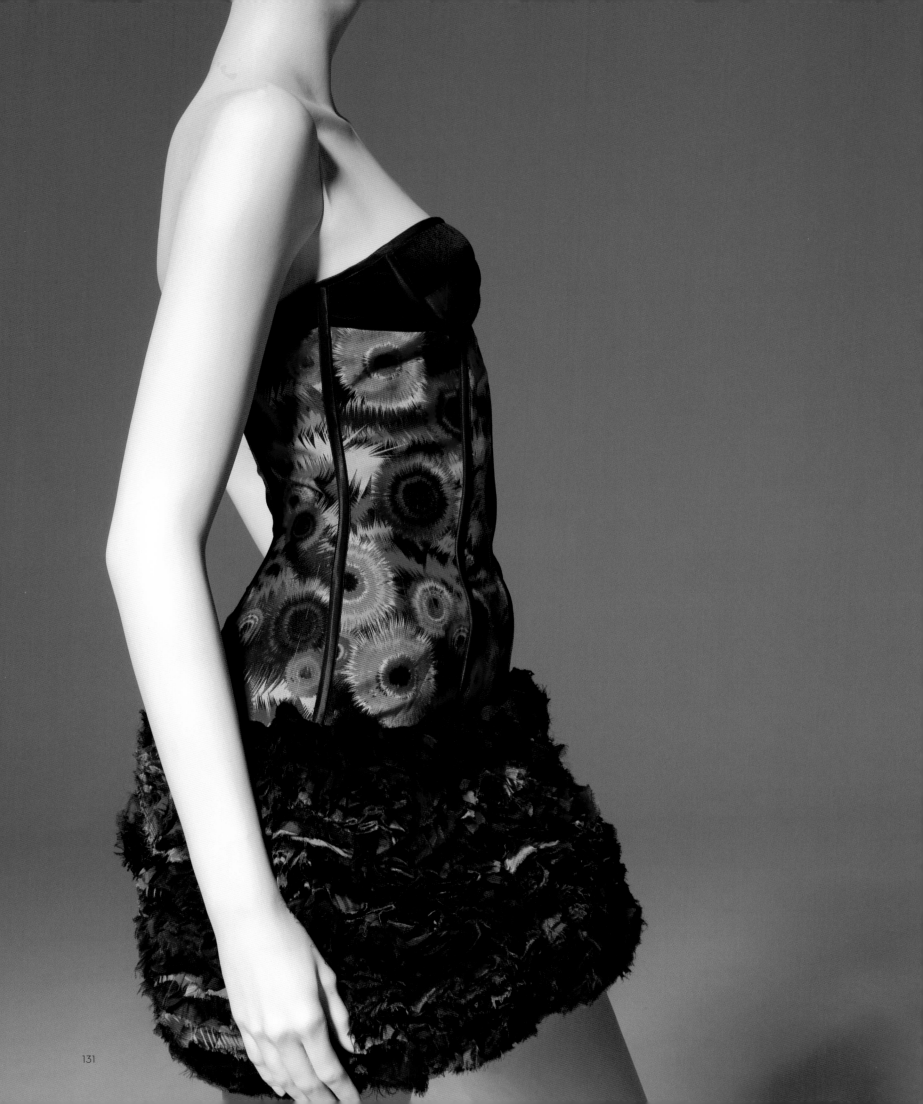

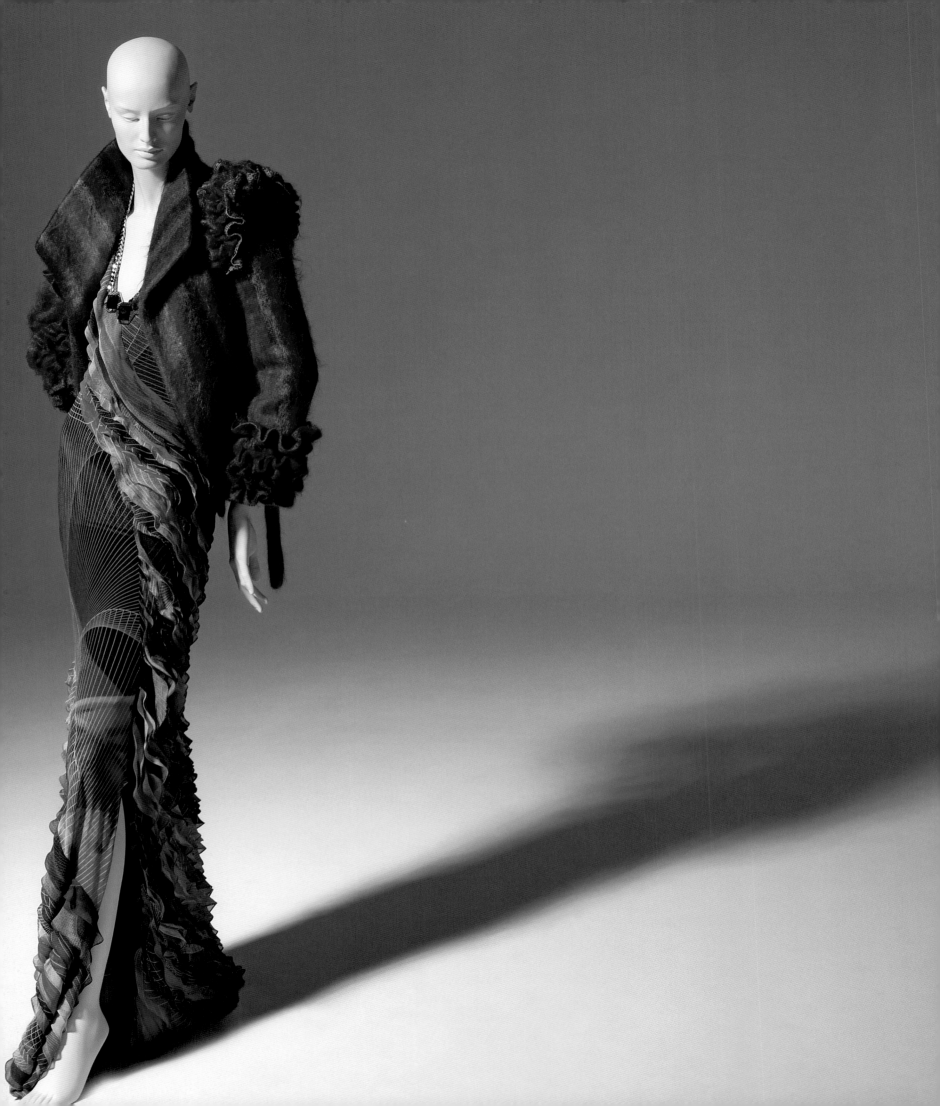

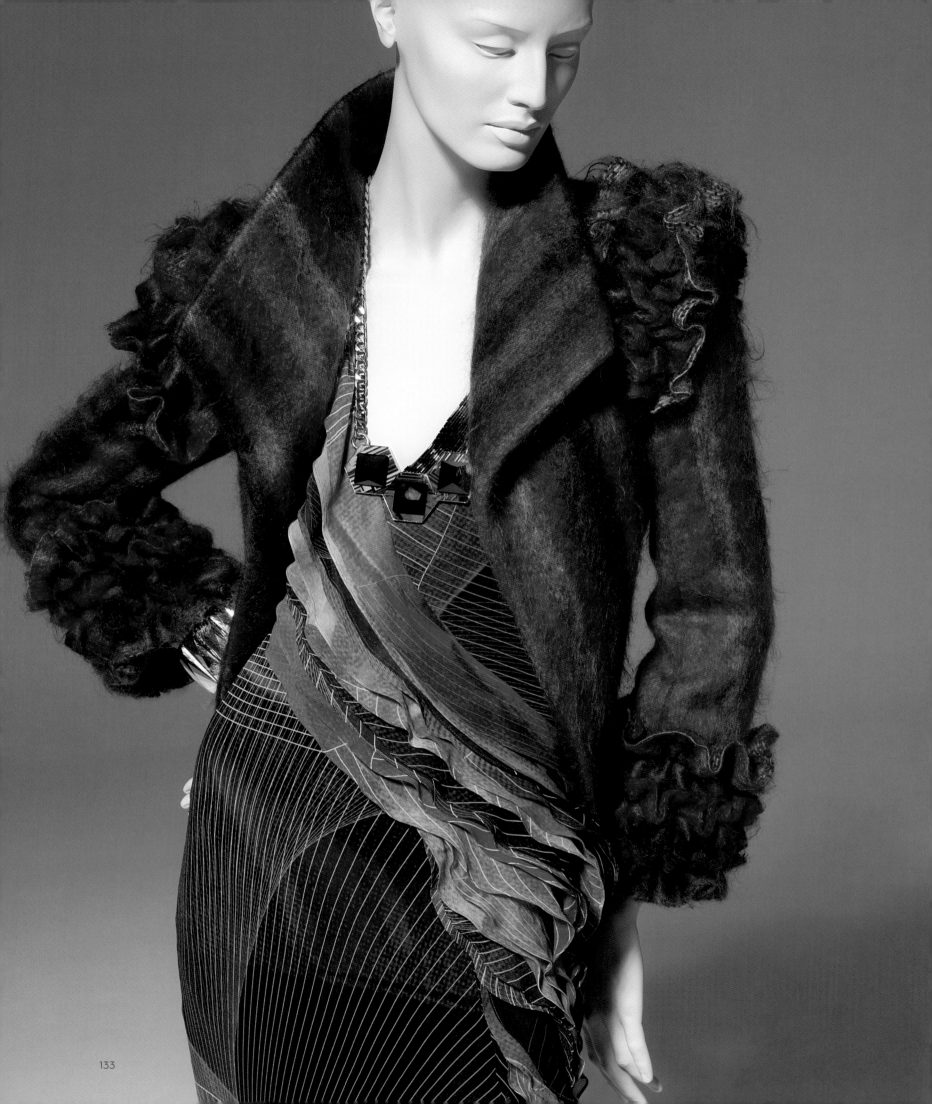

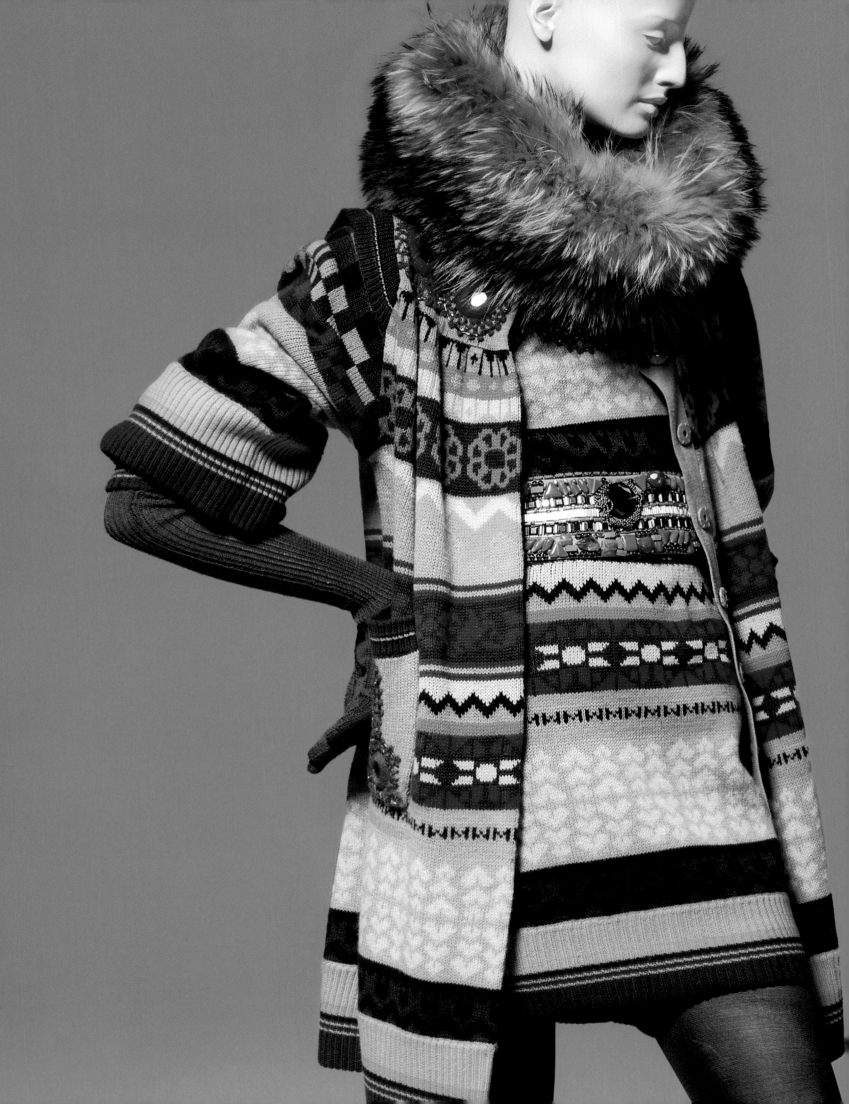

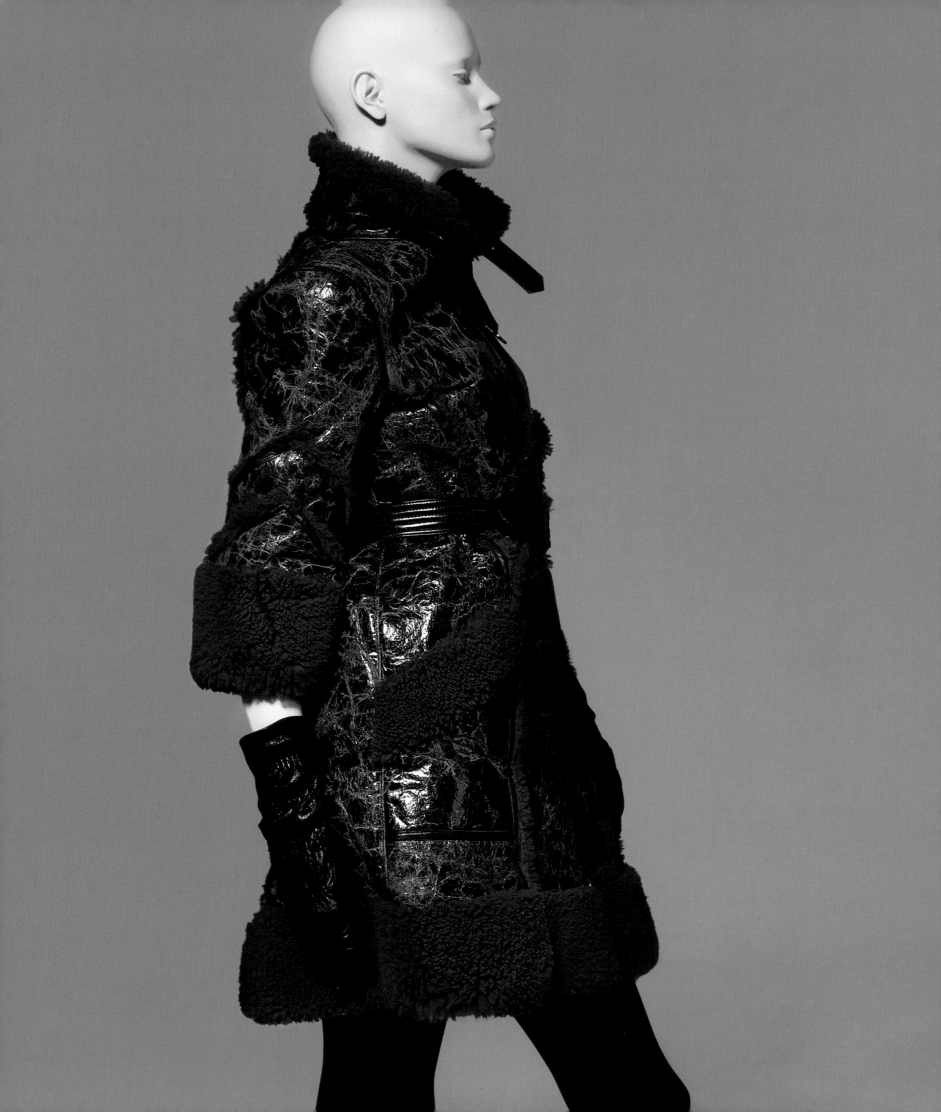

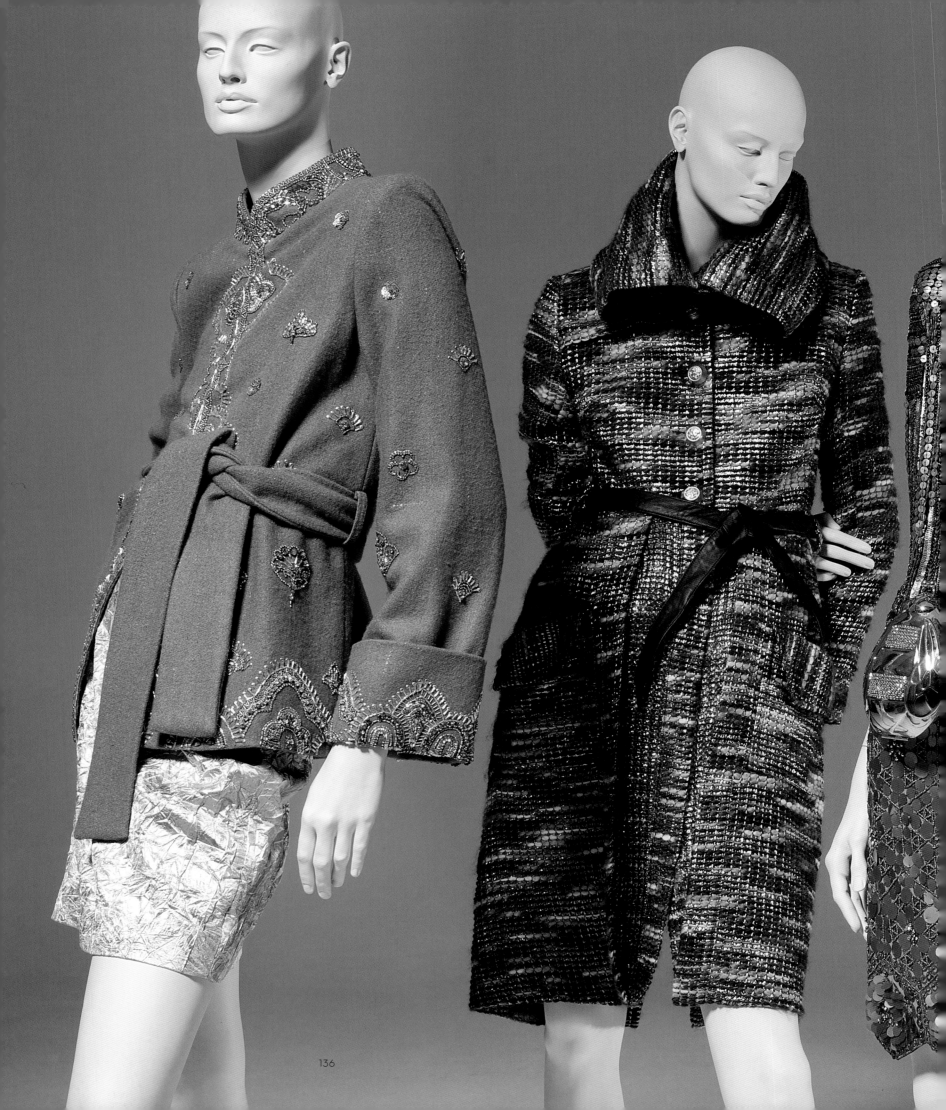

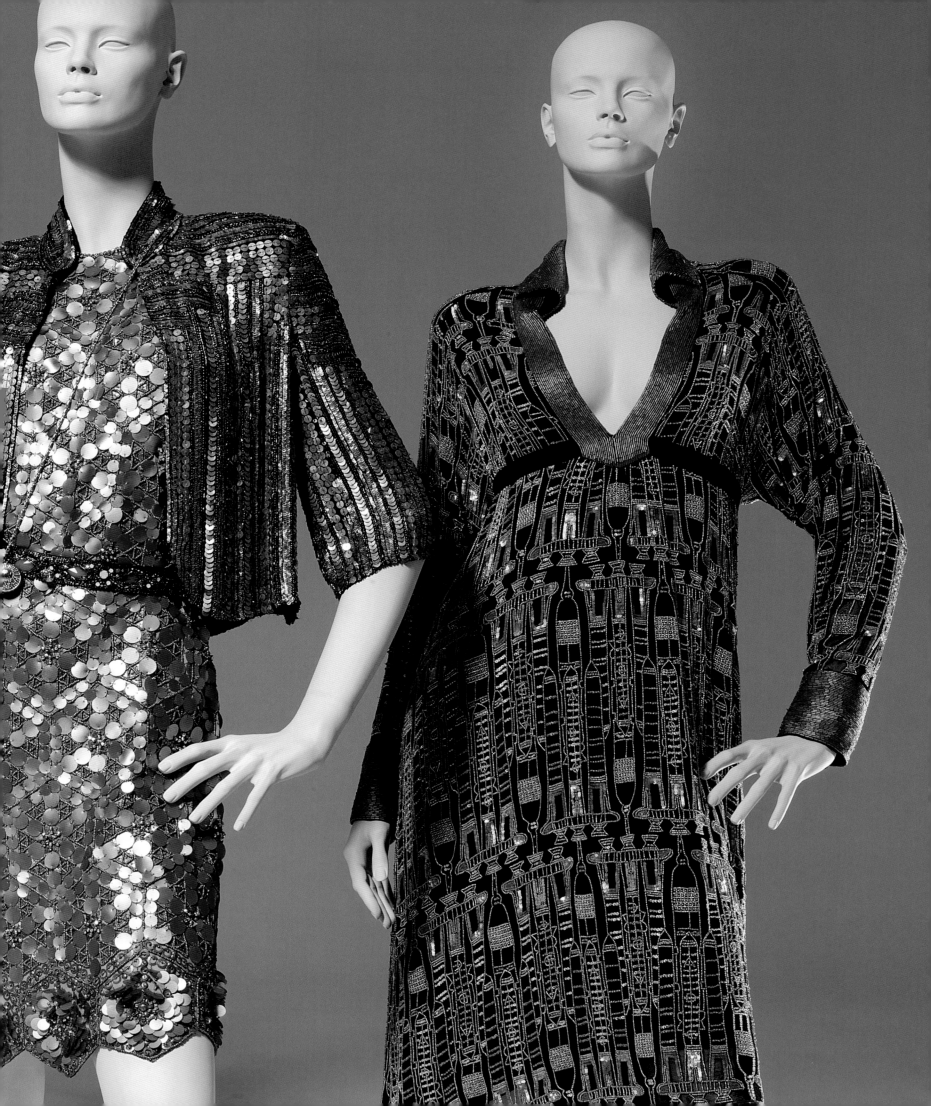

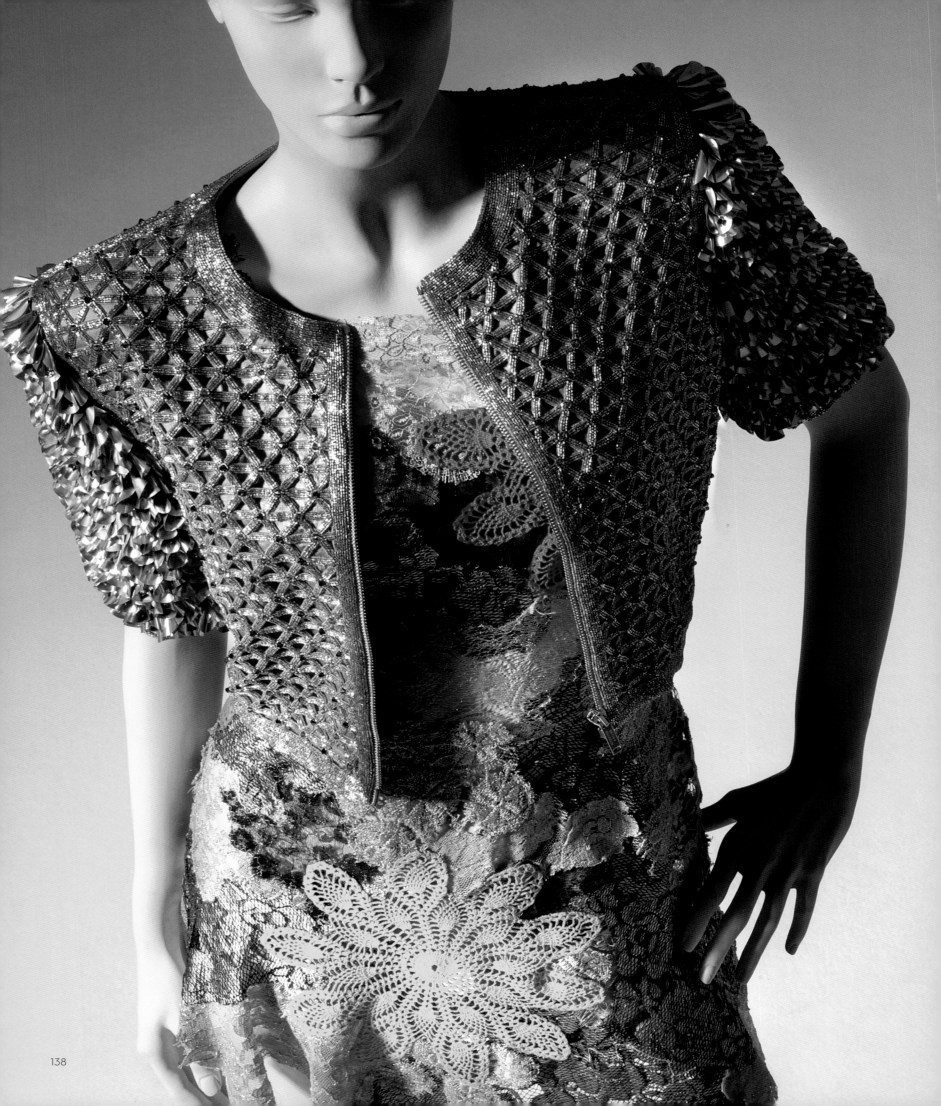

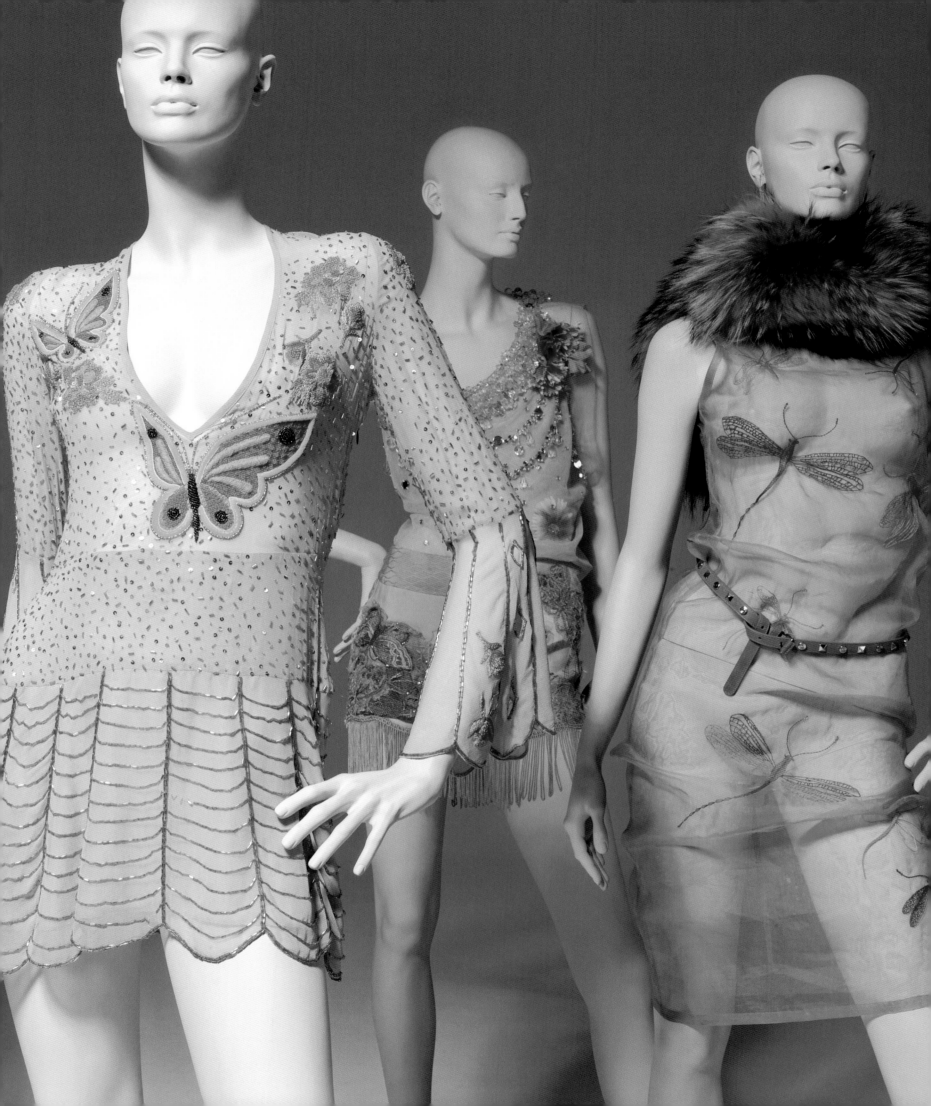

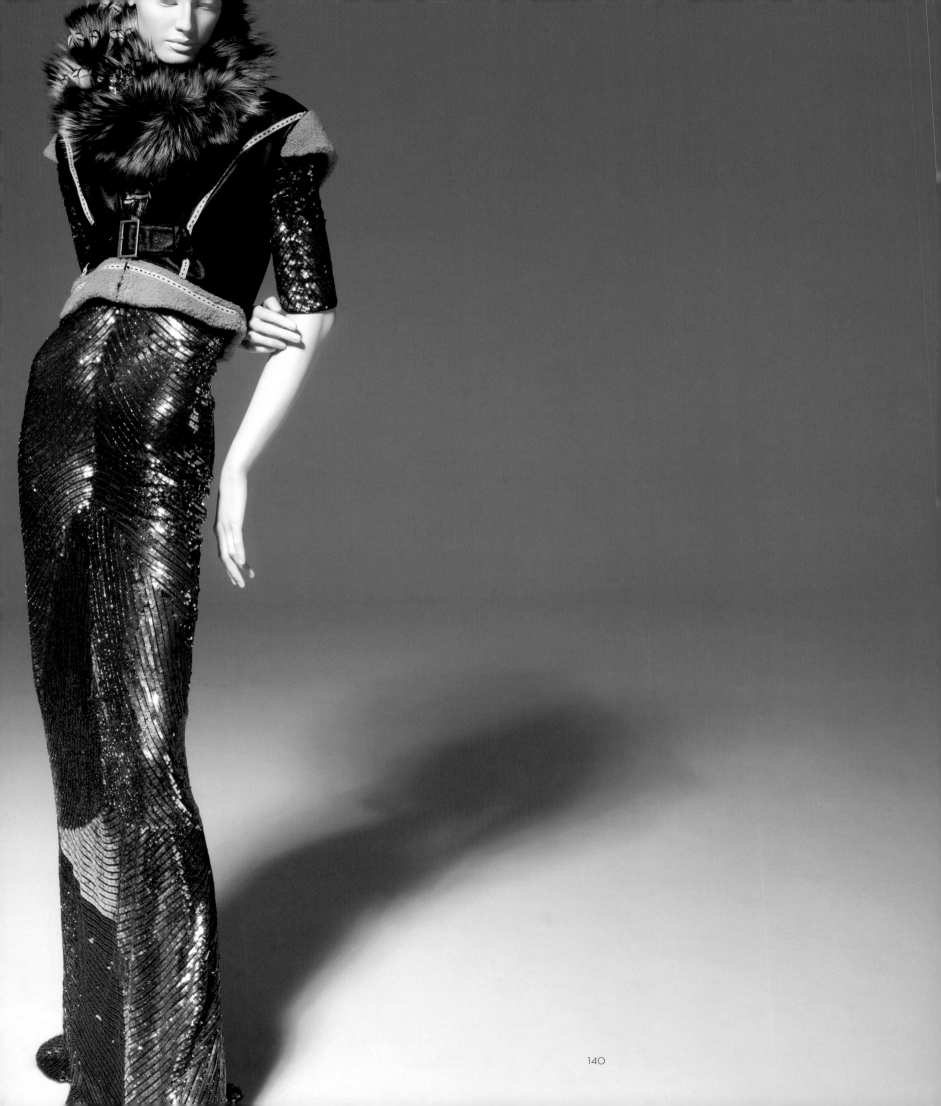

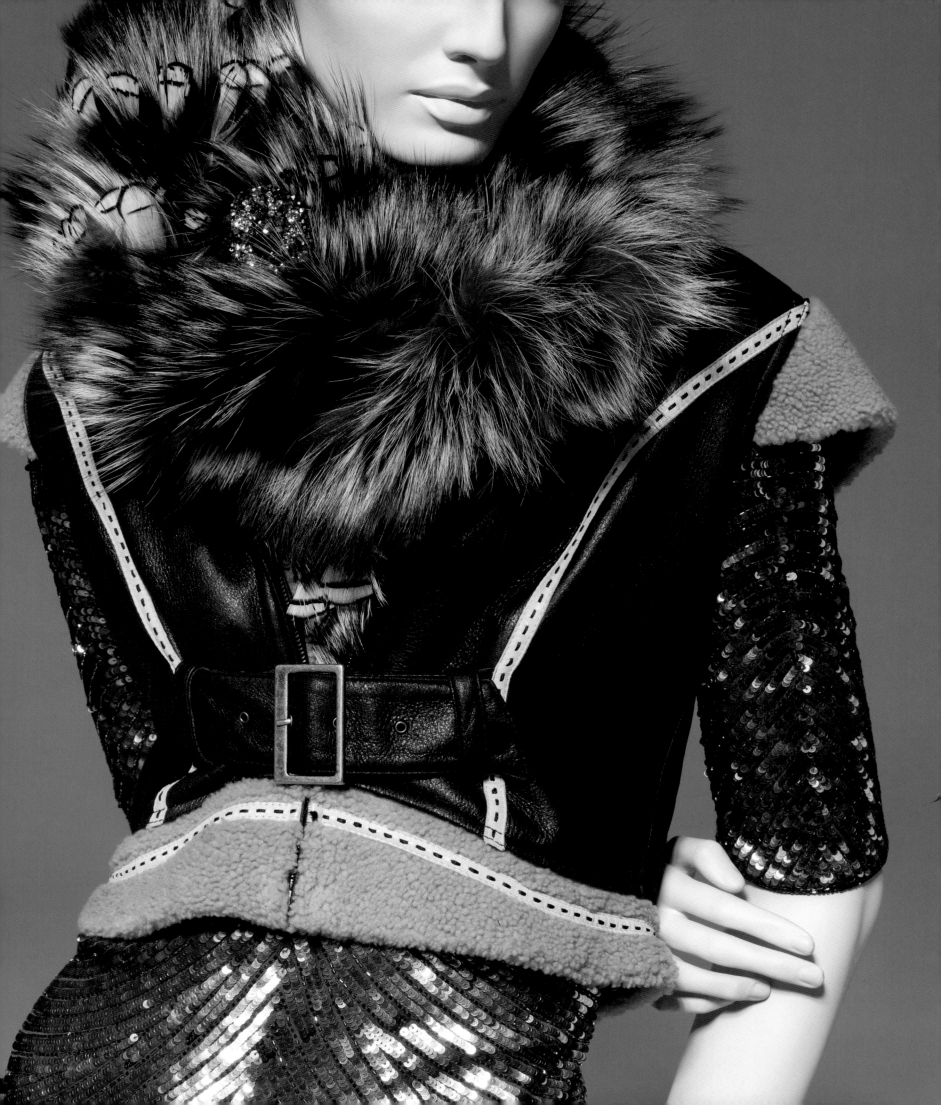

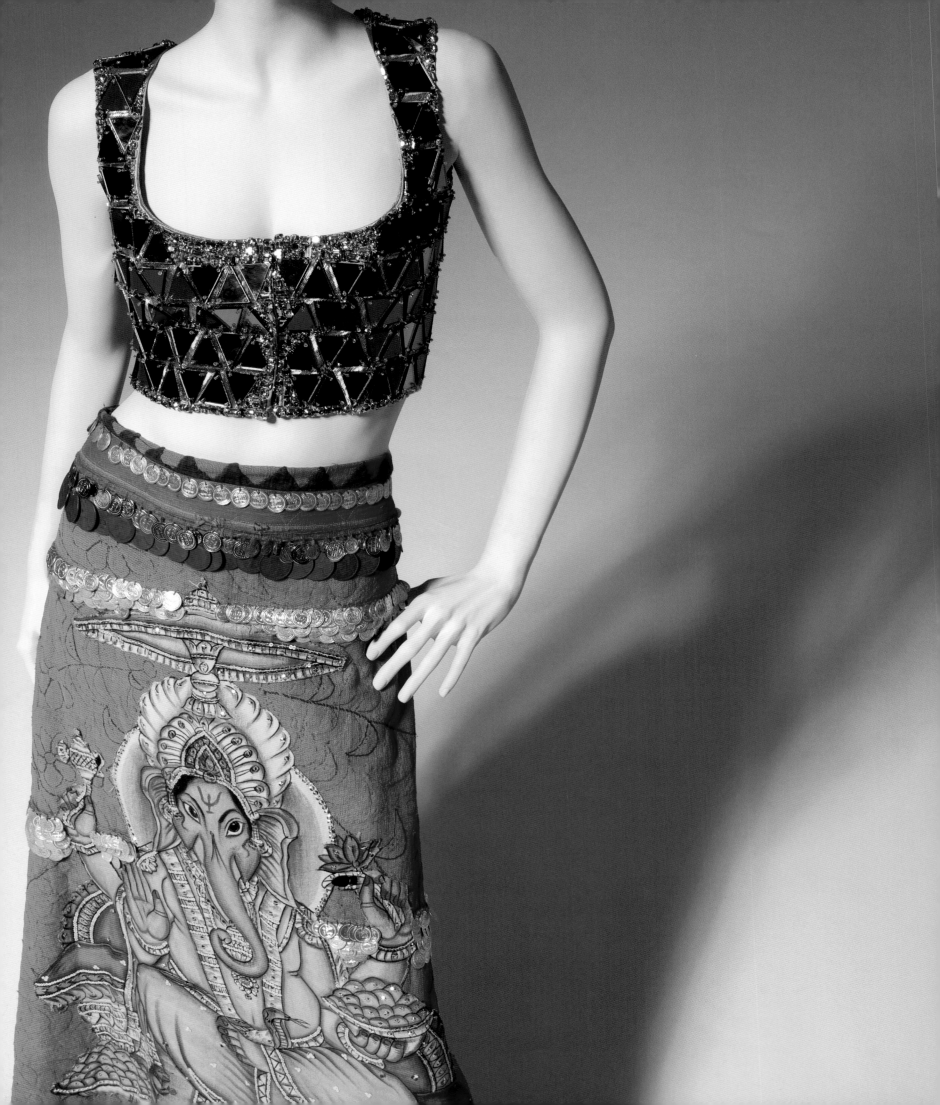

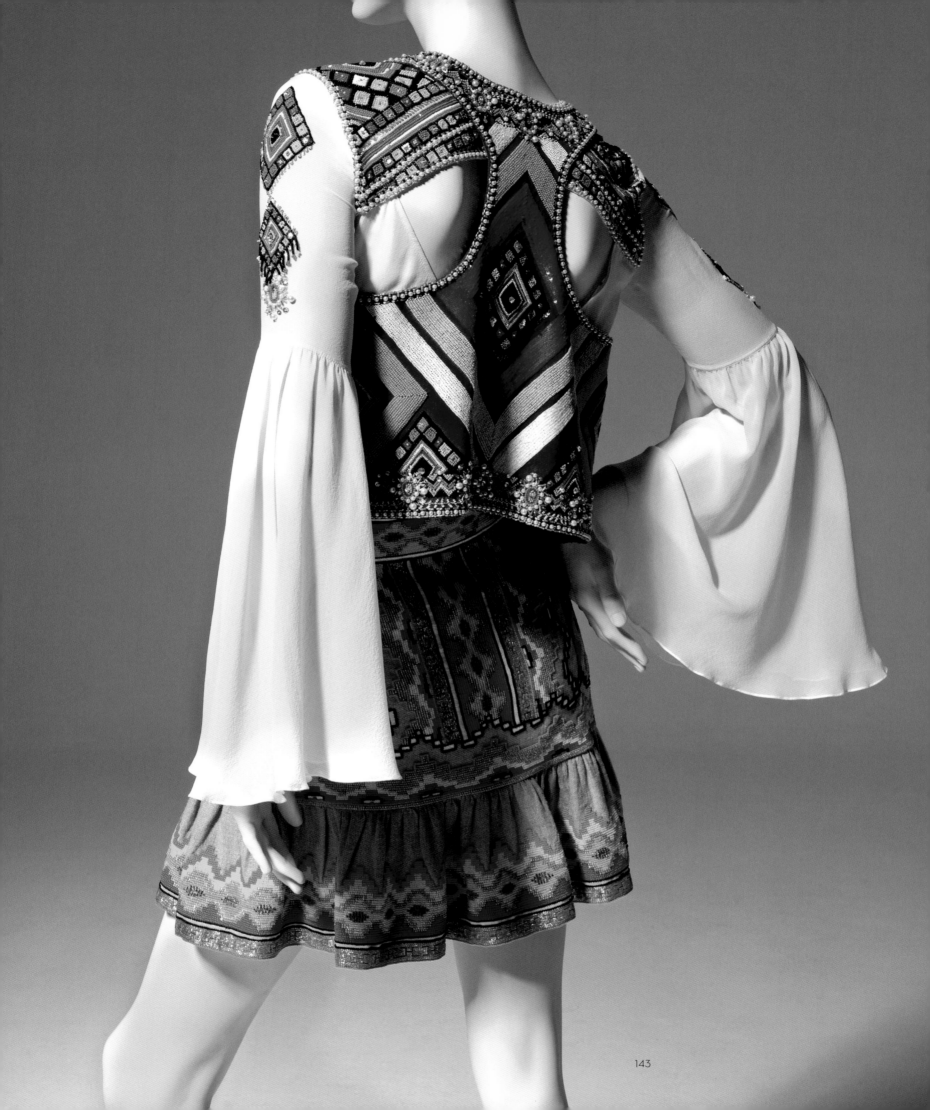

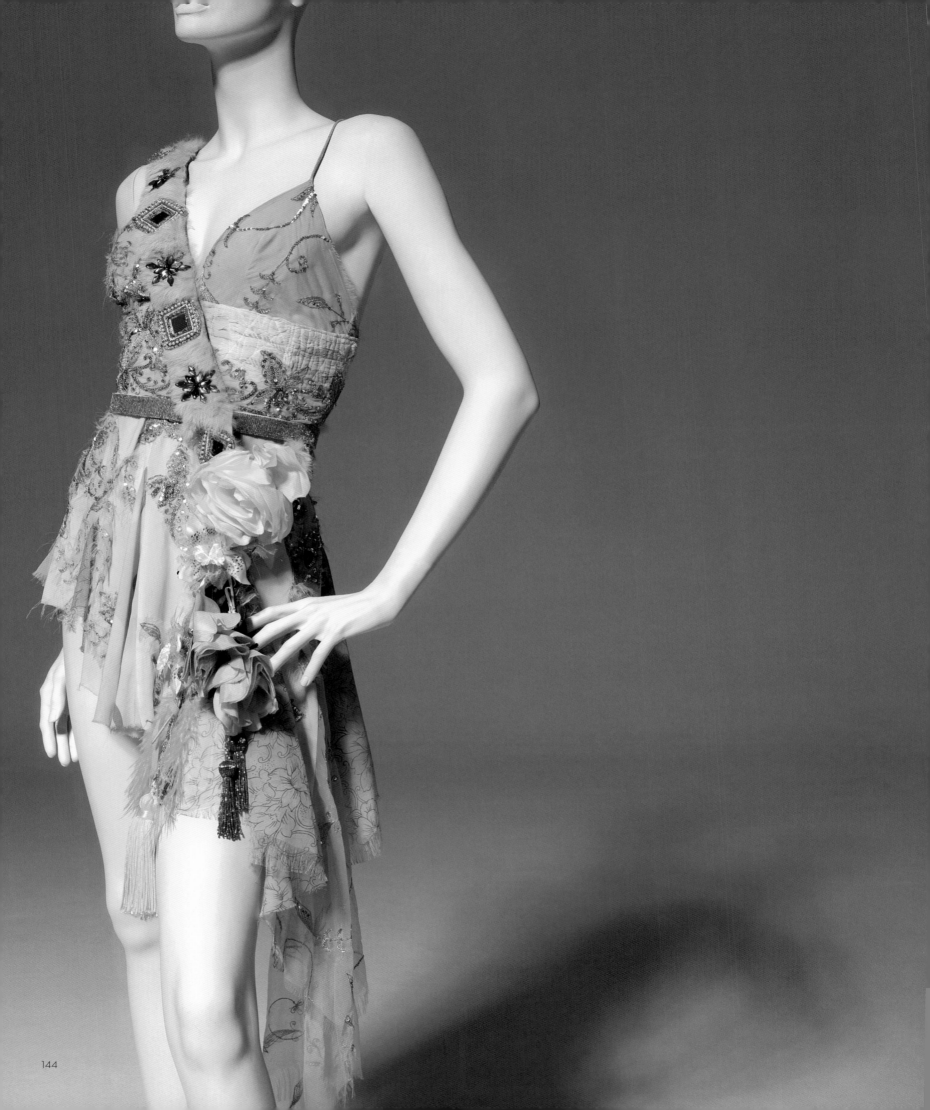

144

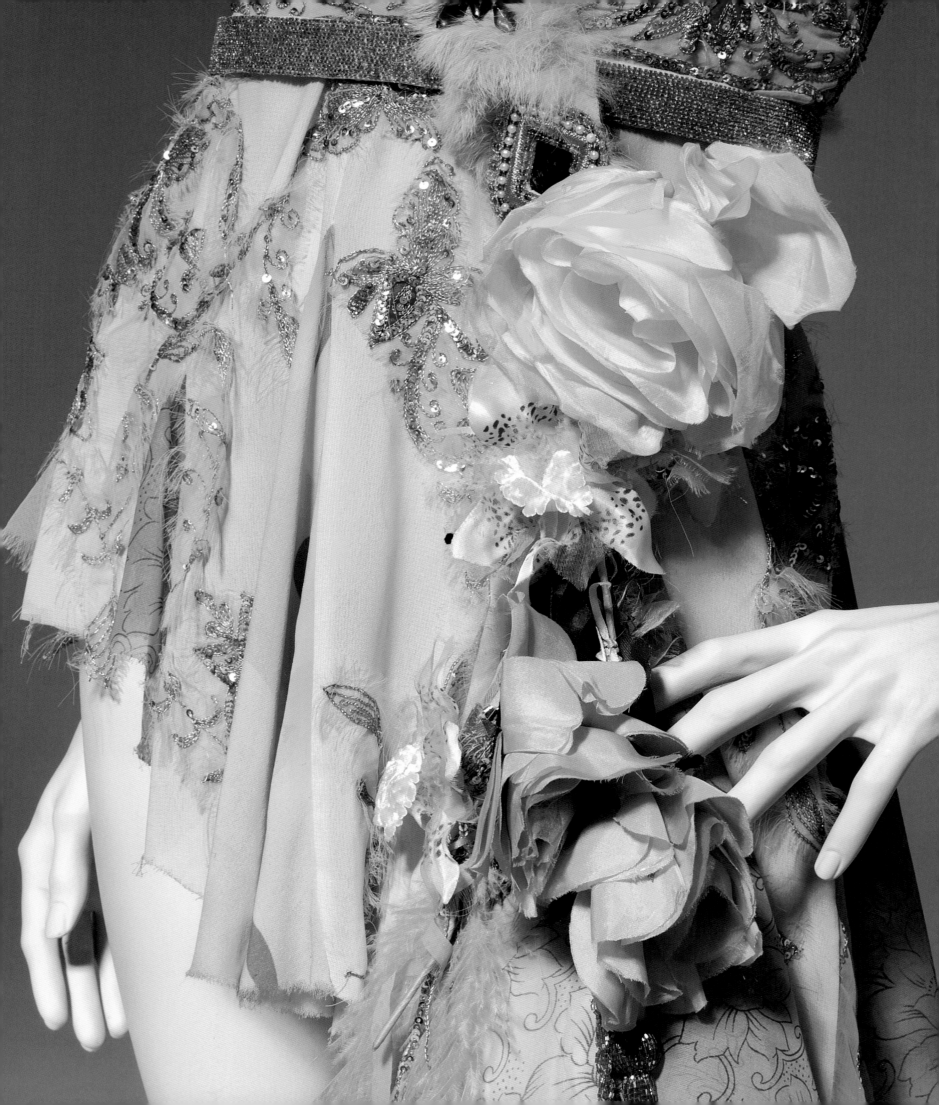

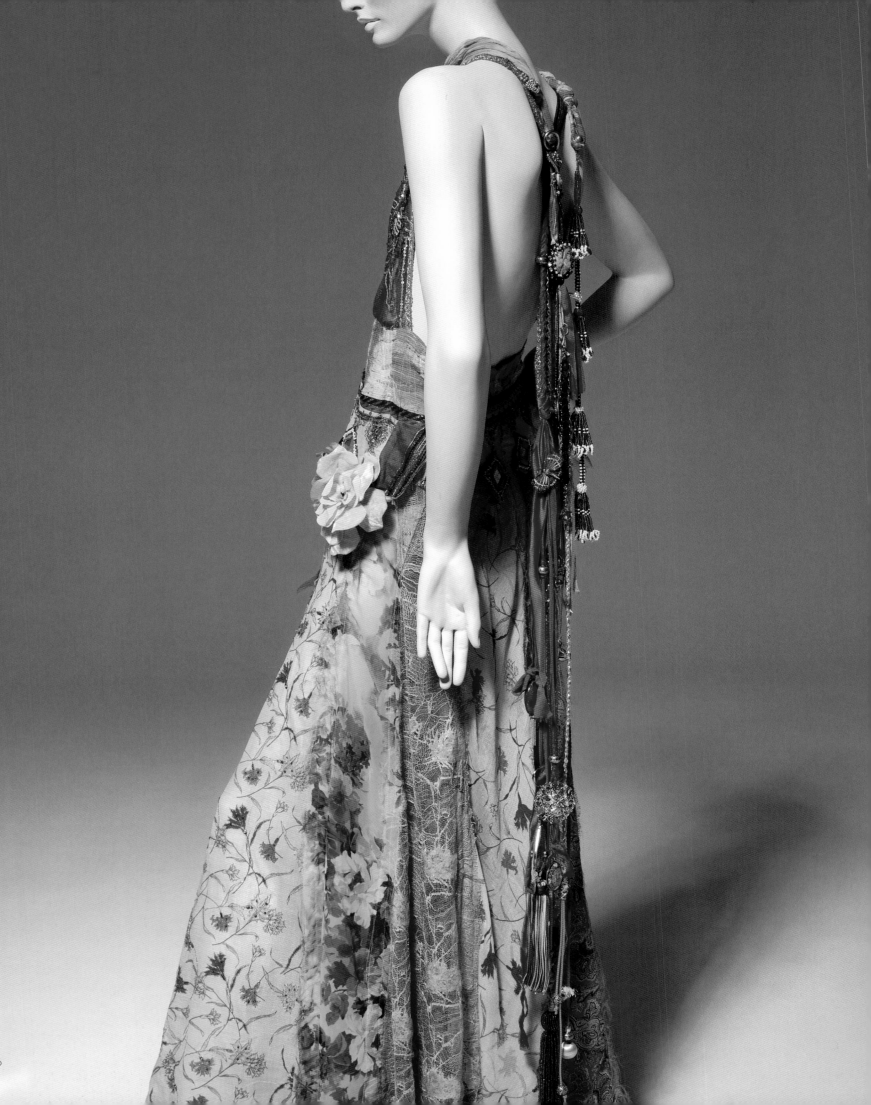

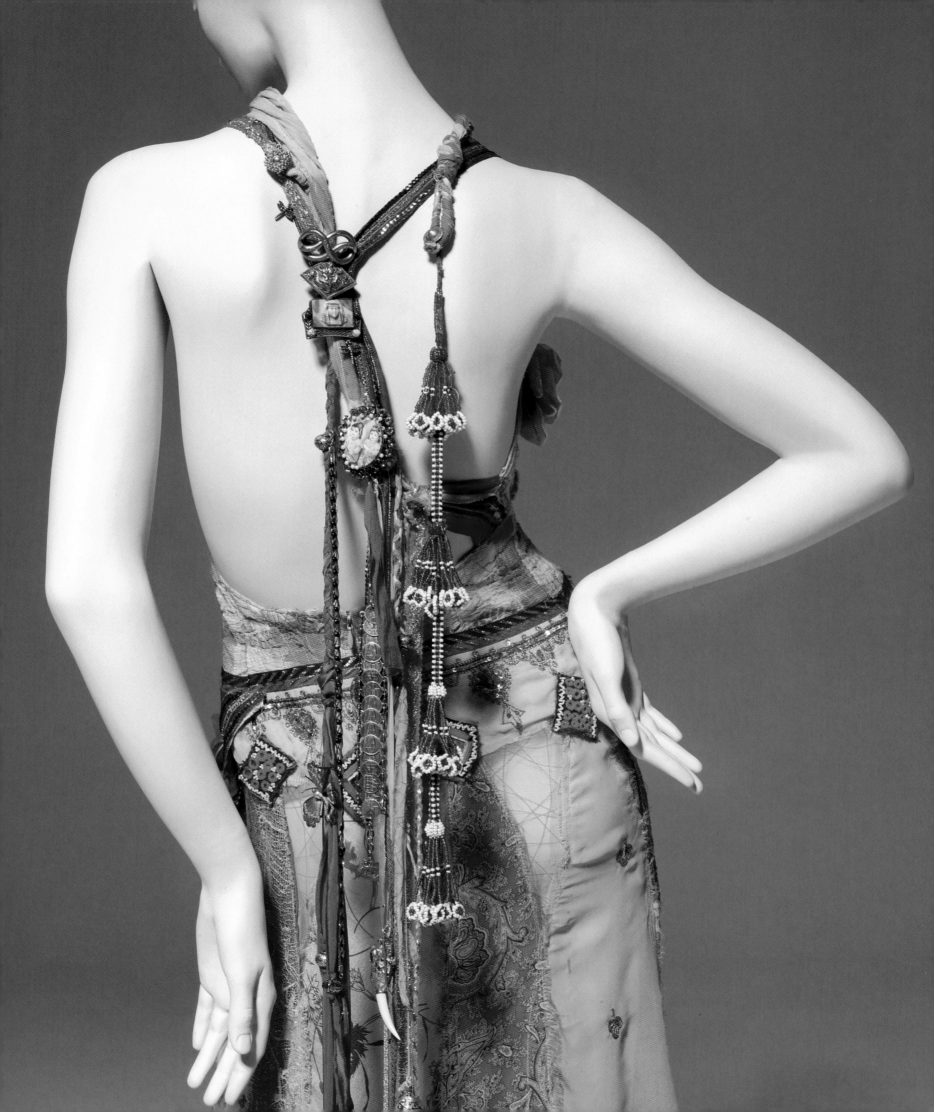

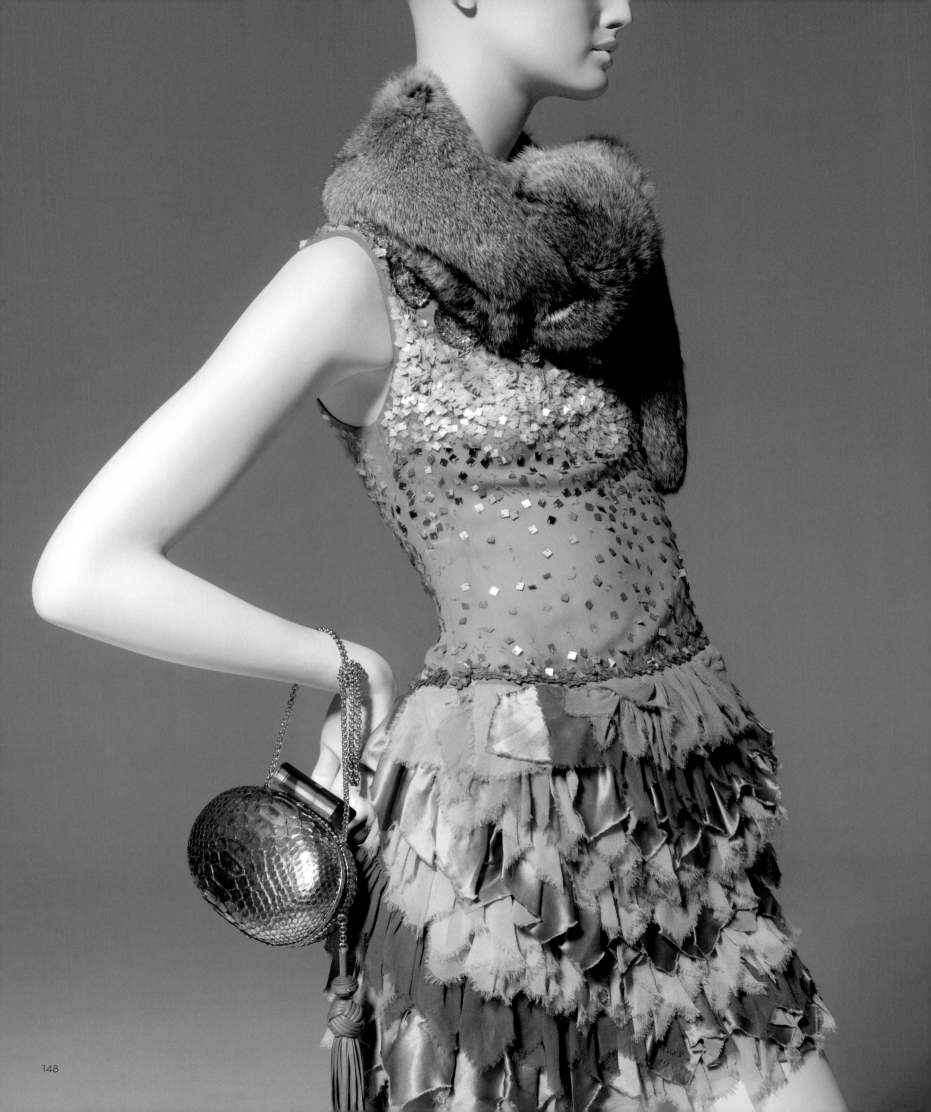

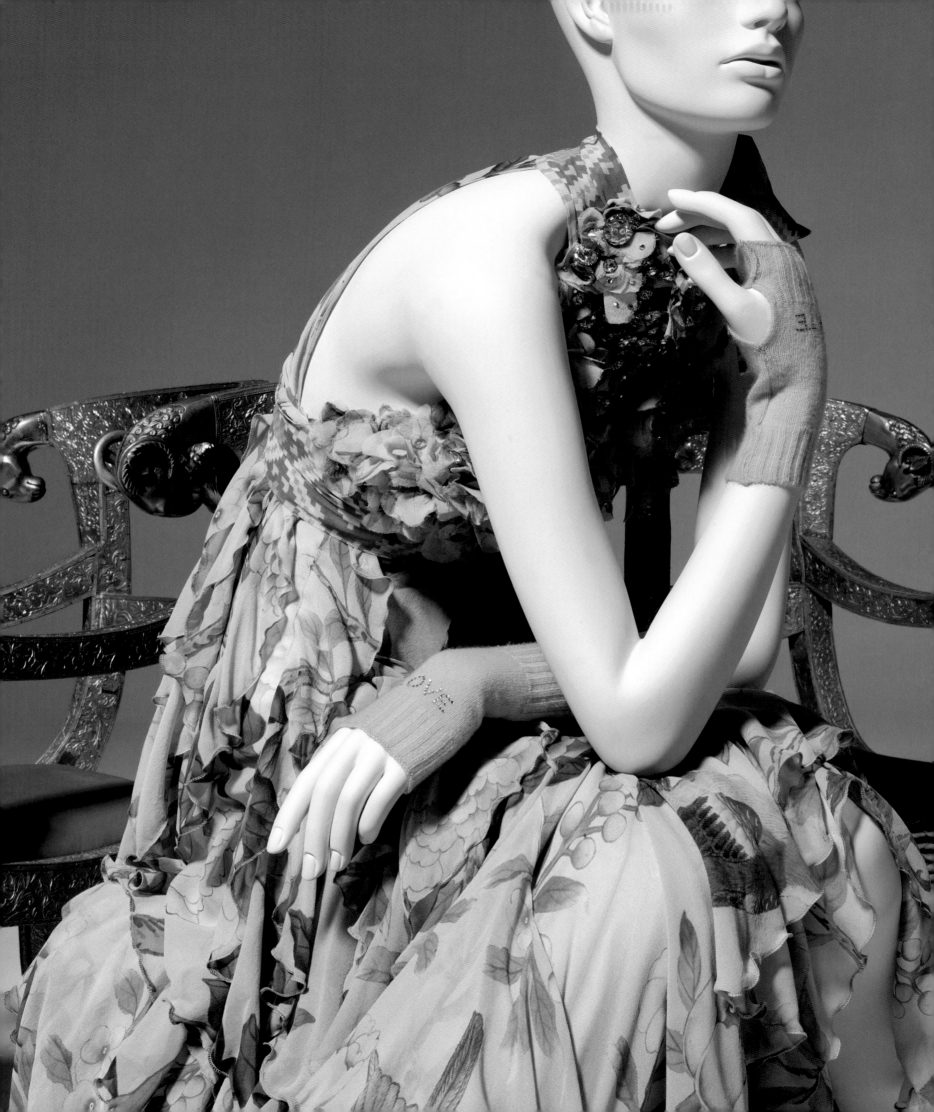

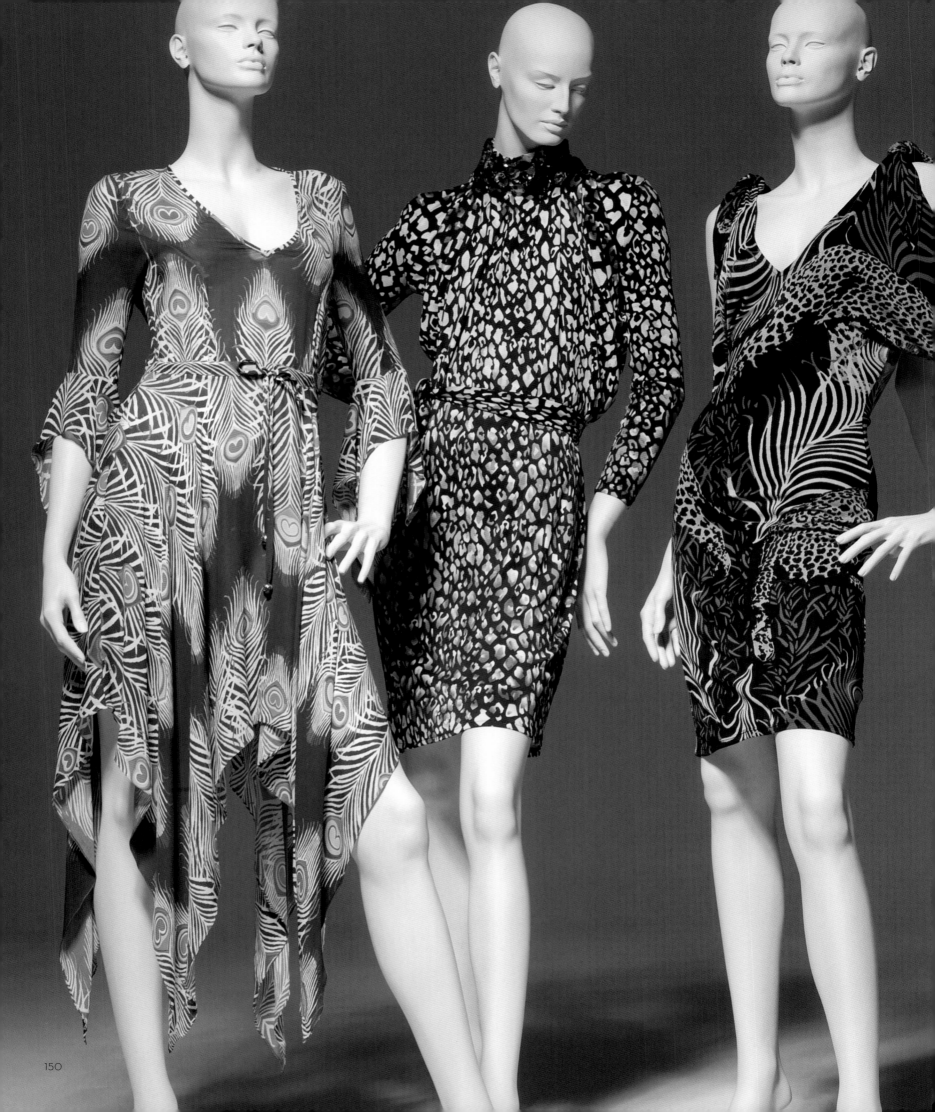

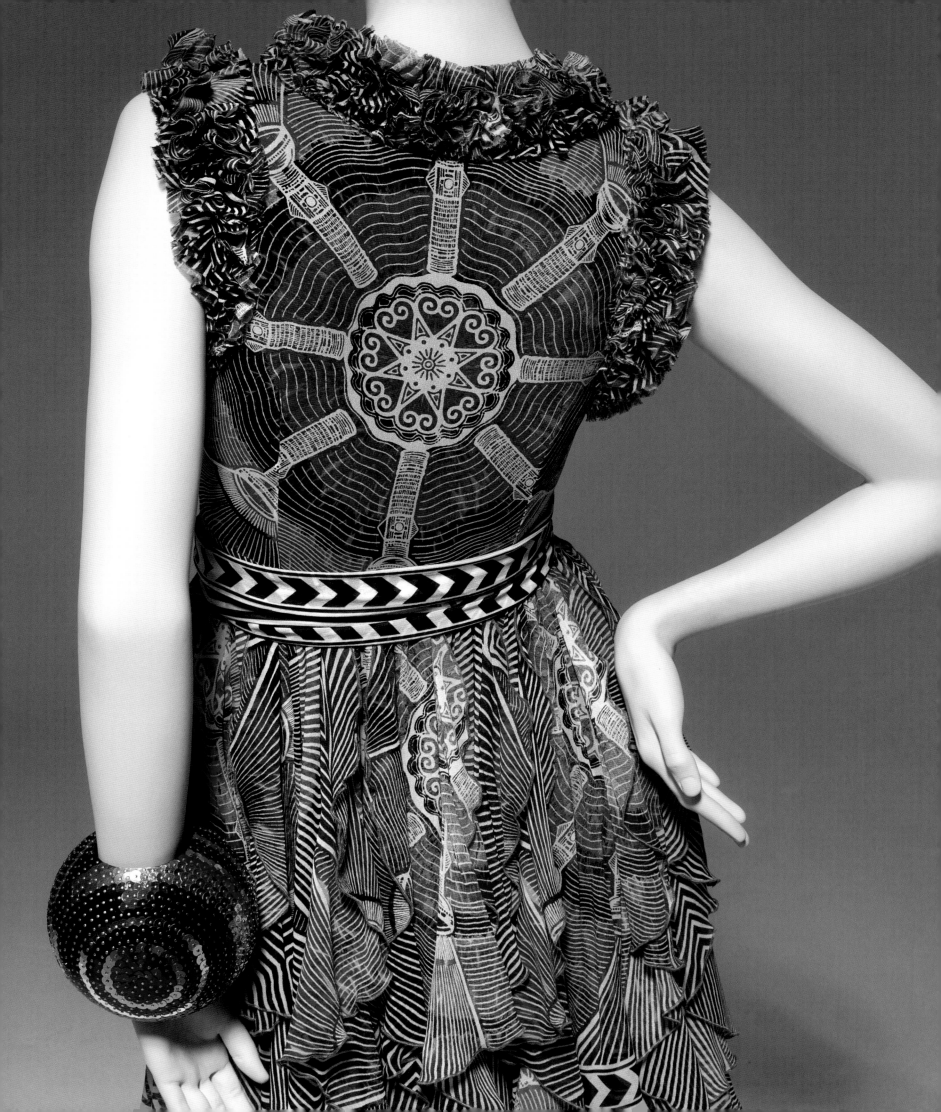

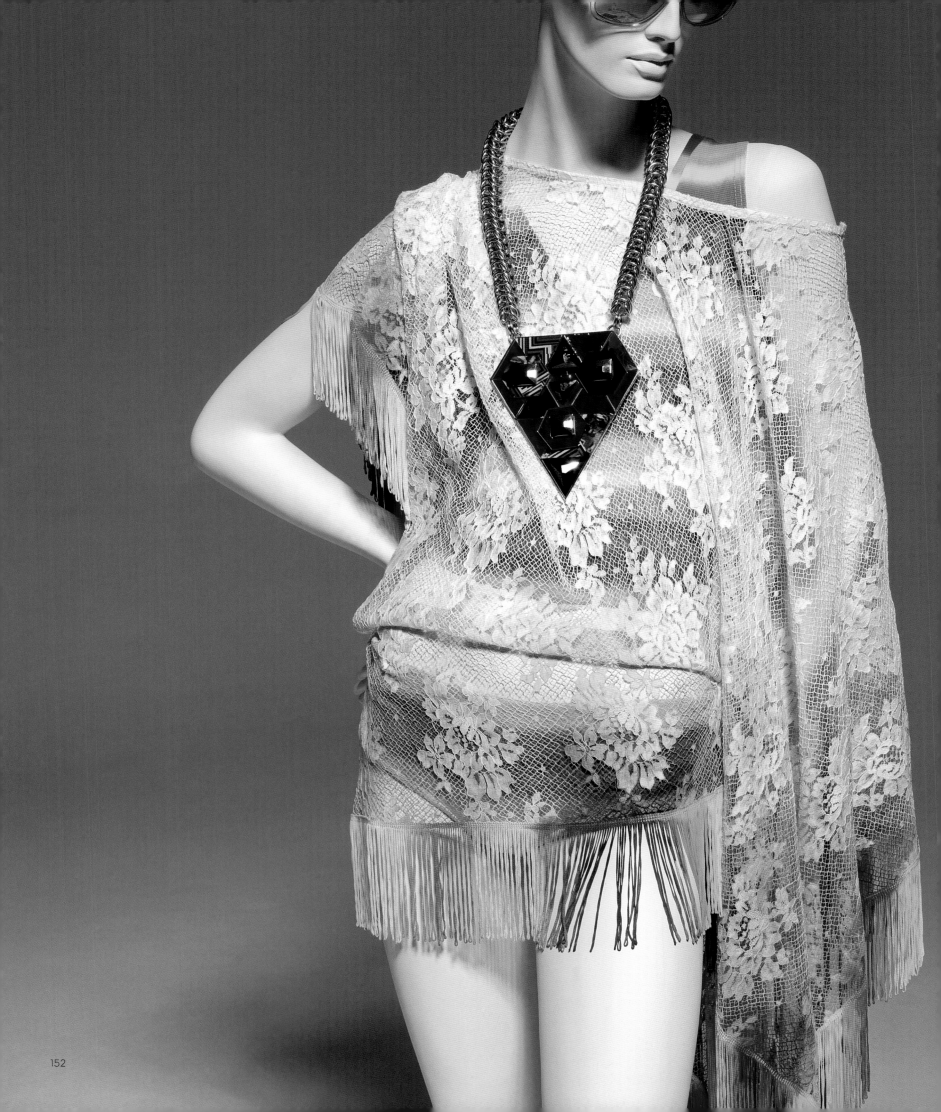

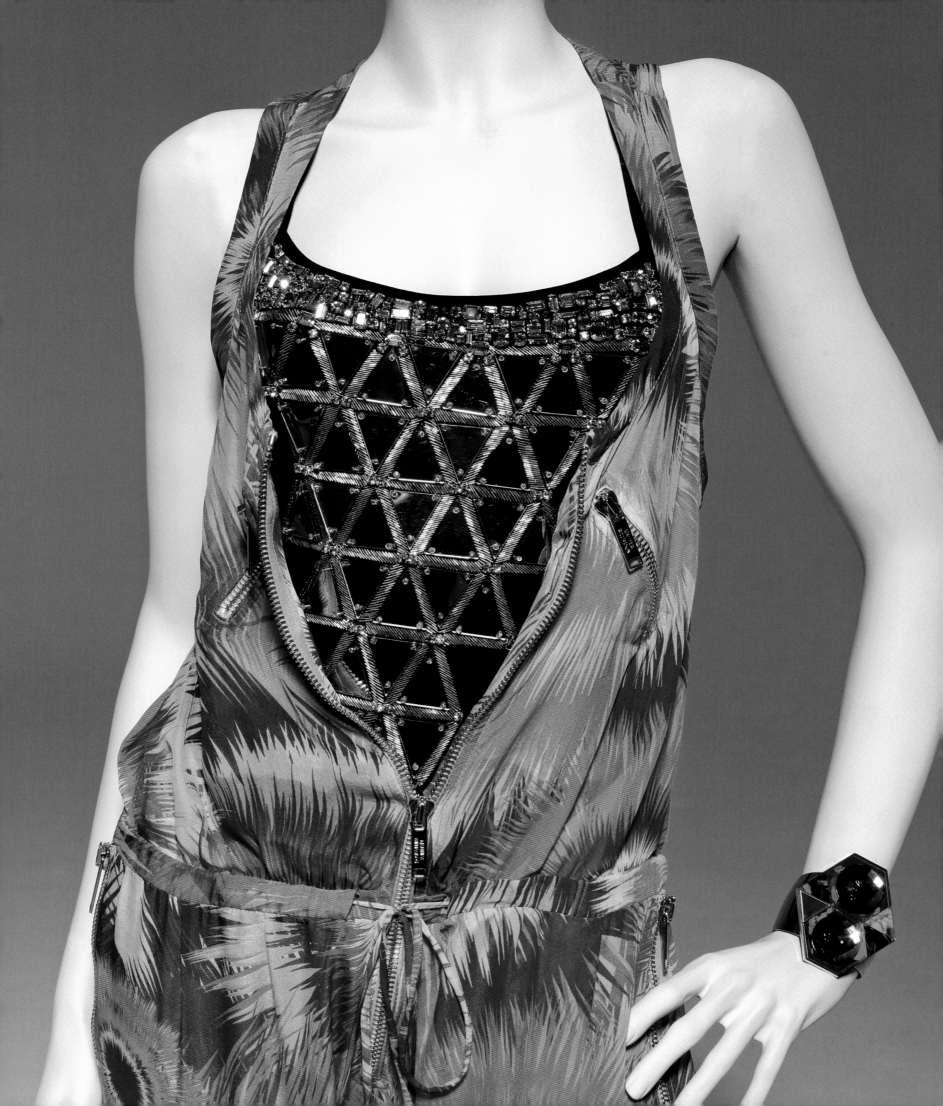

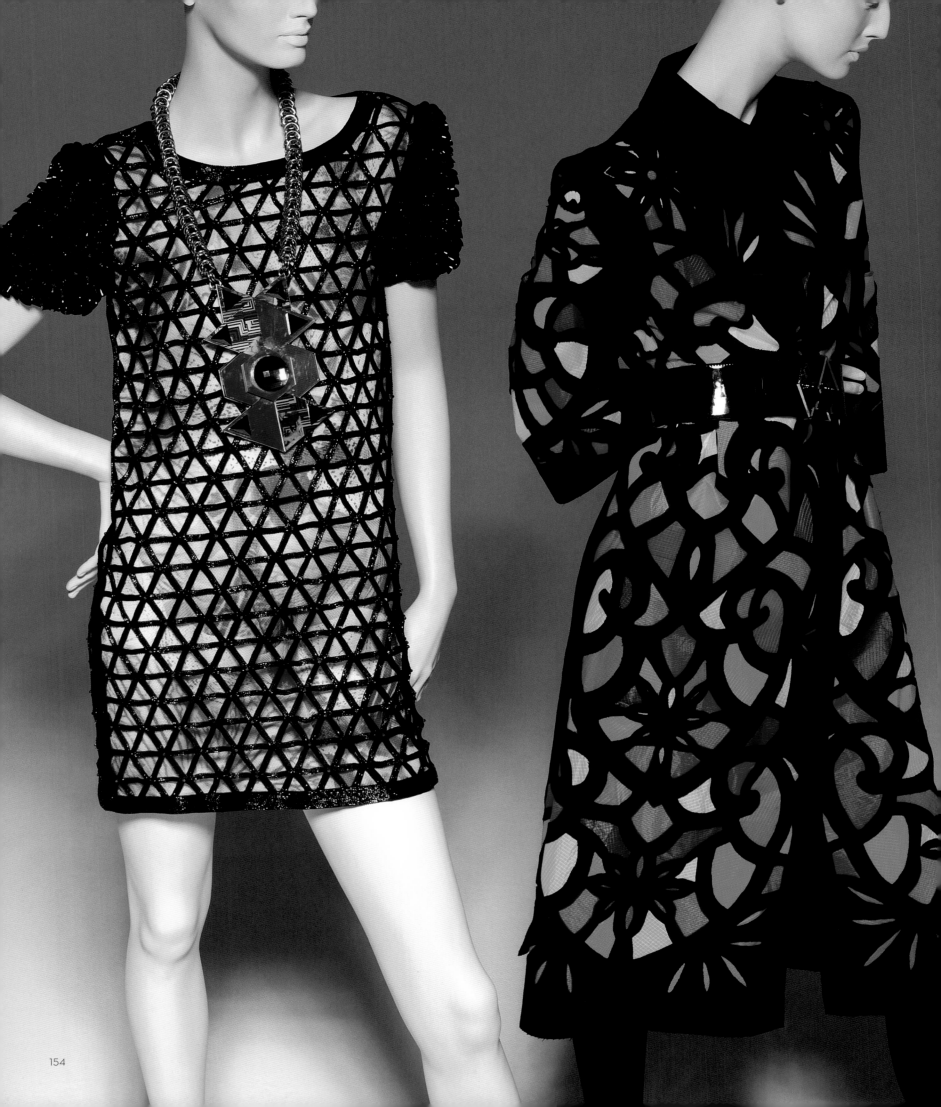

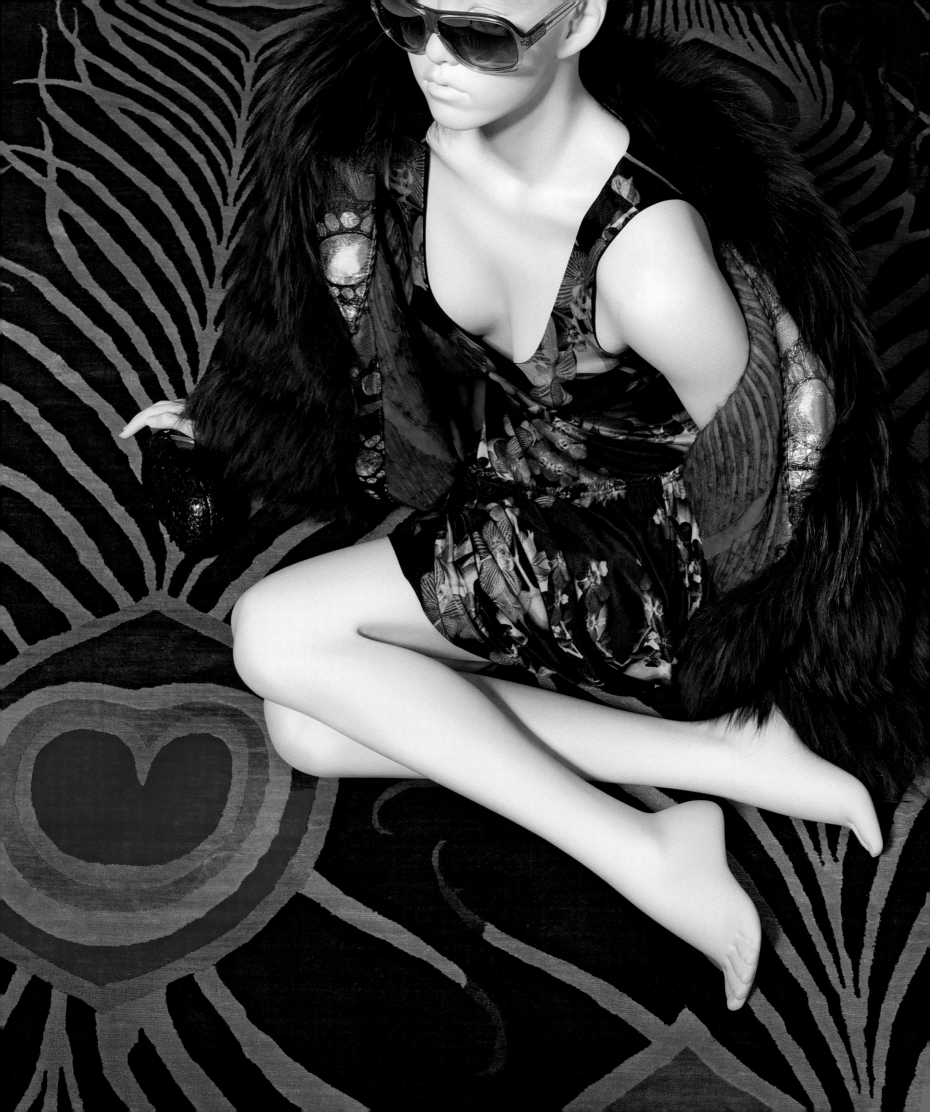

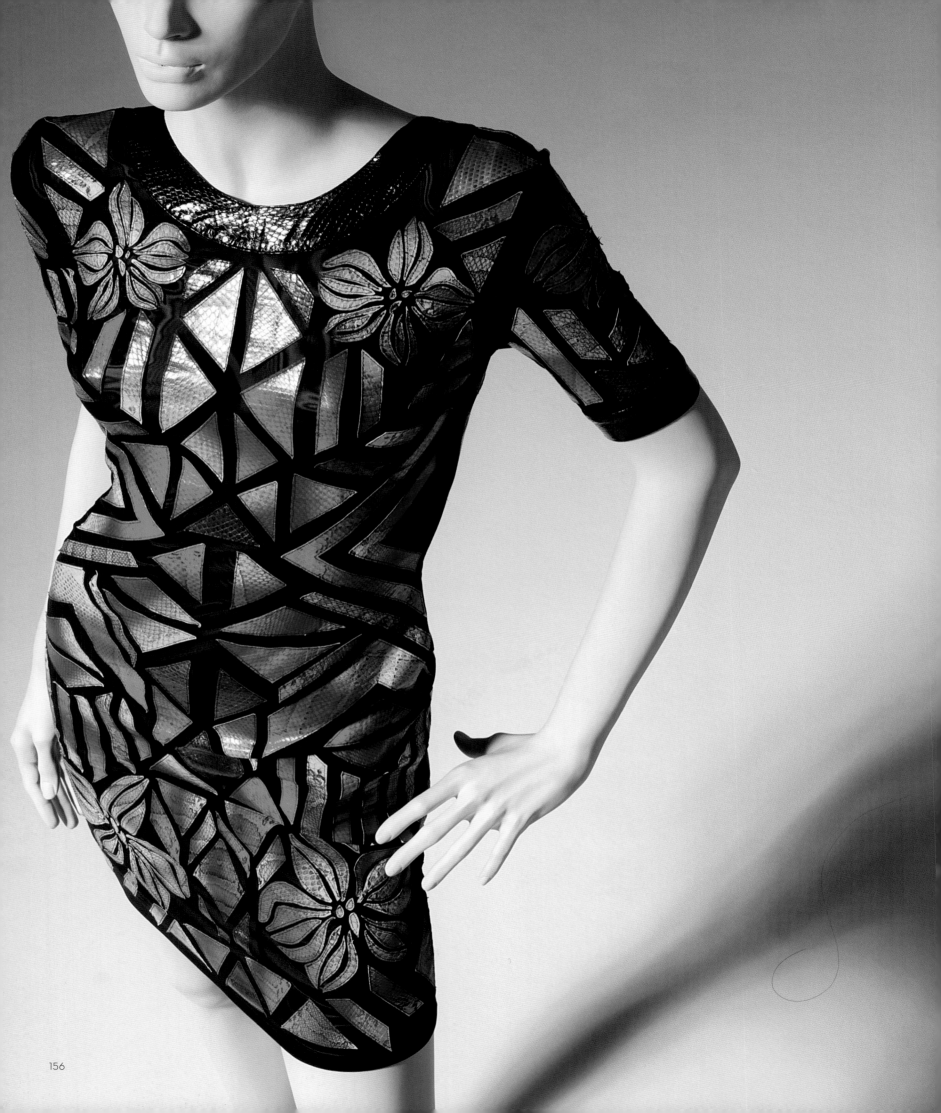

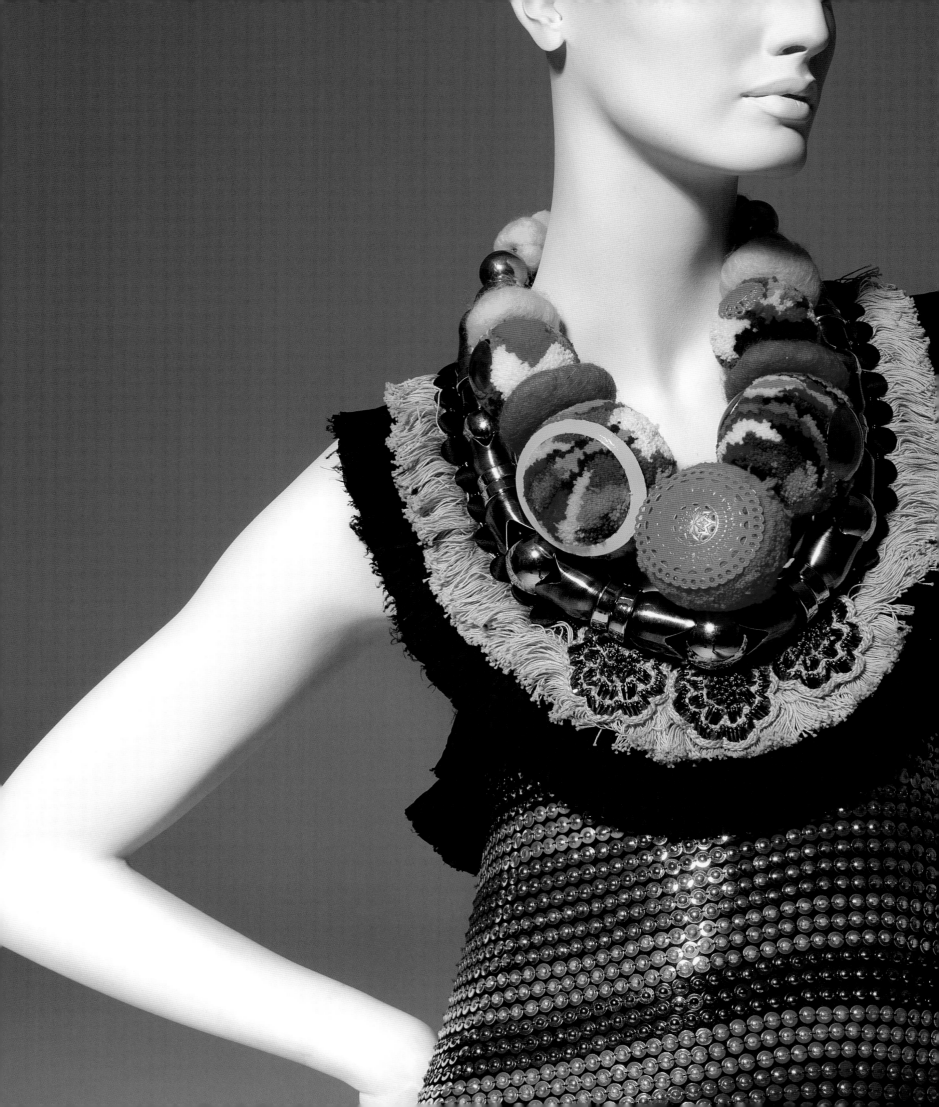

Harlequin print
Winter 2007

MATTHEW HAS REMAINED
TRUE TO ALL THOSE EARLY
CHARACTERISTICS OF THE
LABEL EVEN WHEN FASHION'S
DICTATES MIGHT HAVE URGED
HIM TO DO OTHERWISE

Alexandra Shulman
Editor, British Vogue

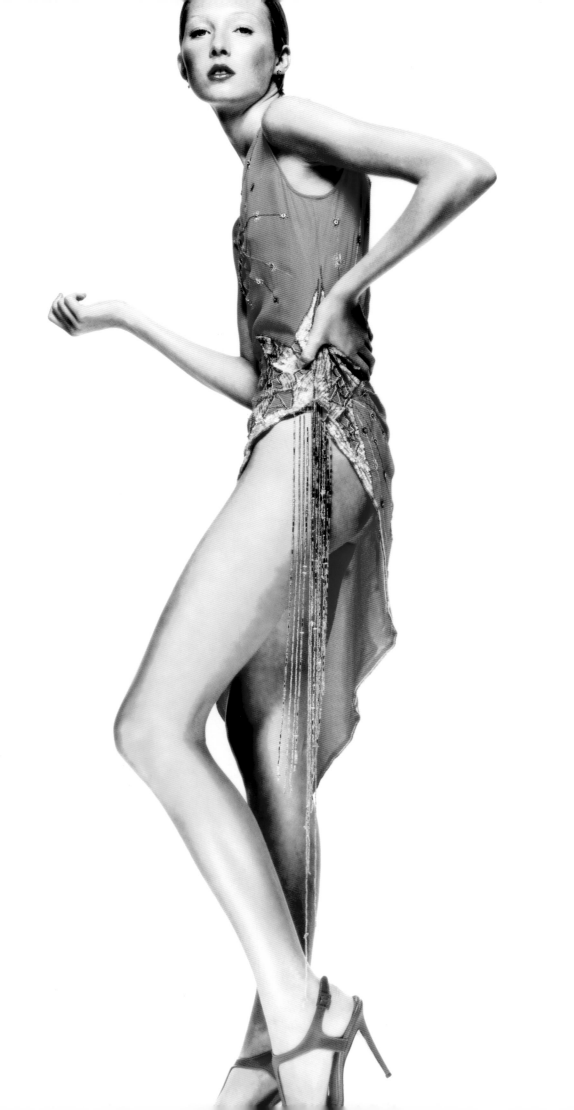

STYLE

"If you examine the ingredients of successful British brands it is always a trueness to themselves that is the strongest common thread. Matthew has remained true to all those early characteristics of the label even when fashion's dictates might have urged him to do otherwise. It takes conviction to embrace tangerine, cyclamen and turquoise as he so notably has, when all around are embracing black.

In the history of Matthew Williamson, I am pleased to note that *Vogue* played a pivotal role in those early days, when Matthew first appeared in the offices with a bag full of dresses. Attention was instantly paid to this pixie-like Mancunian talent and personal orders were speedily made. With his shimmering fabrics, feminine cuts, sexy silhouettes and party queen sass, those early clothes were original and yet accessible. Here was a designer who seemed to know how girls wanted to look—especially girls who wanted to have fun. Although the constituency has widened to become global and a generation has grown up along Matthew while a new generation covets him (as can be witnessed by the 24 hour sell-out of his collection for H&M), that essence of enjoyment is always a key factor when you buy Matthew Williamson.

Alexandra Shulman
Editor, British *Vogue*

"The following pages show a selection of my favourite editorials", says Matthew, "taken of our work over the years. I look forward every season to finishing a collection and handing it over to the stylists to see how they interpret the clothes for their magazines. Interestingly, when these images are grouped together in this way, for me they really do sum-up the brand and seem to represent what our label has become known for; femininity, exotiscism, jet-set and a rich kaleidoscope of colour, texture and pattern."

For all captions
see page 254

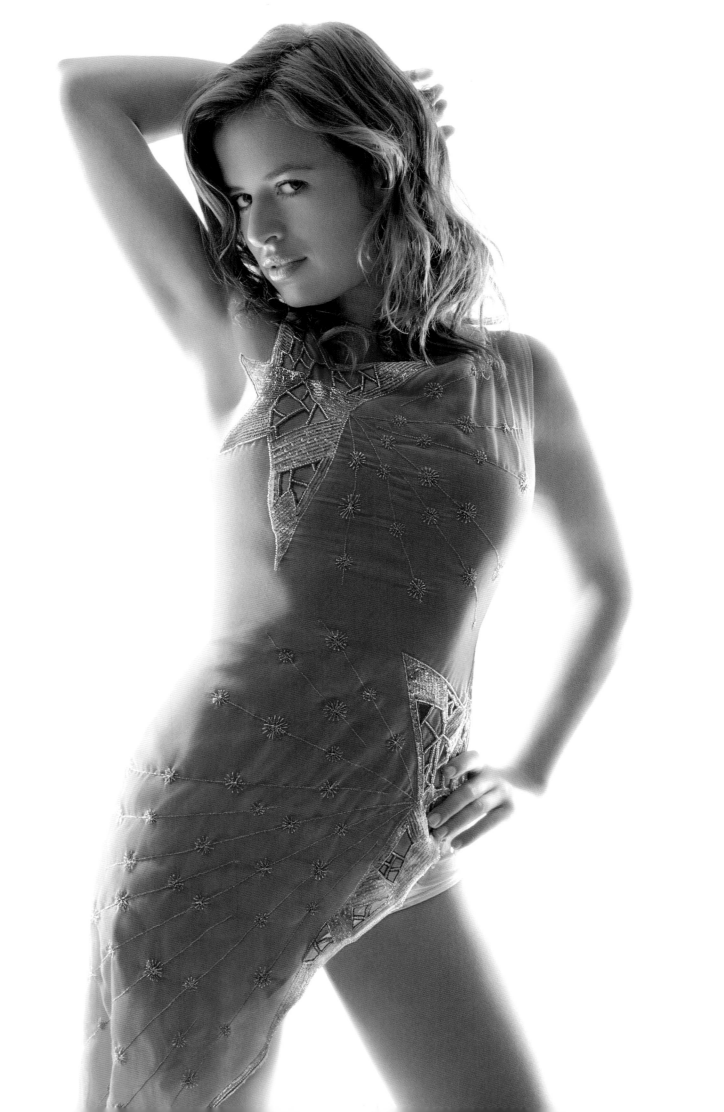

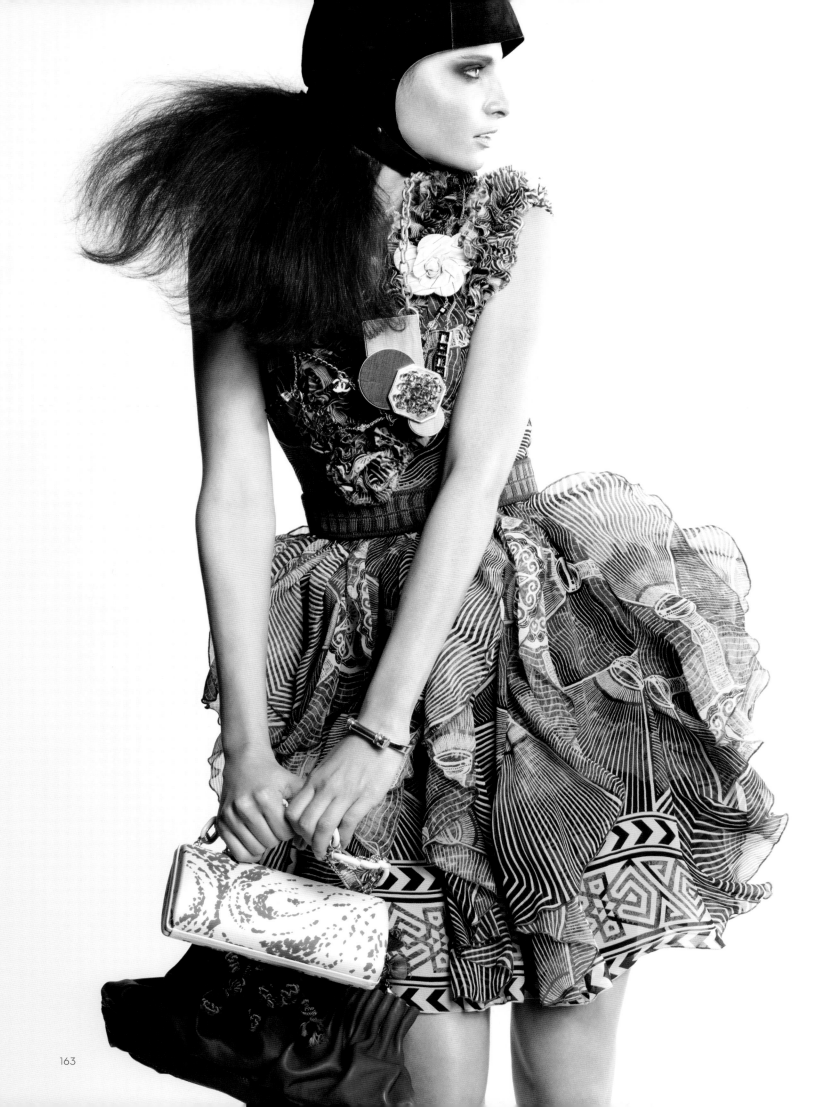

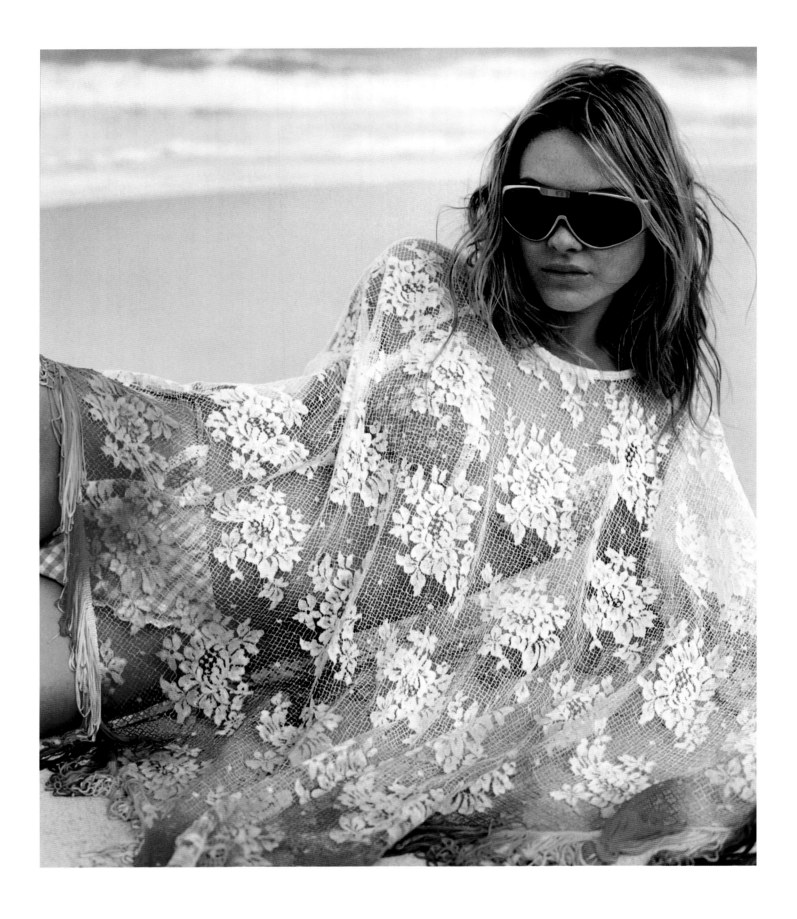

164

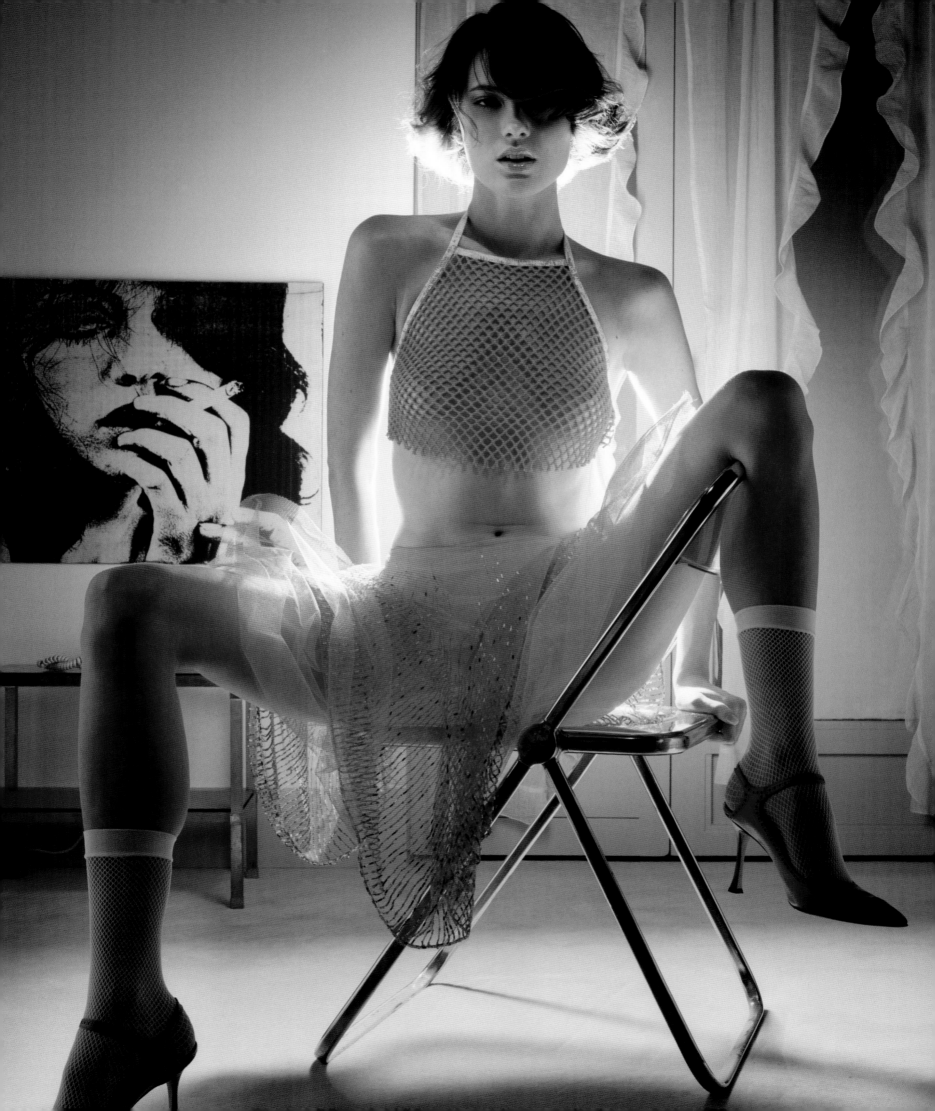

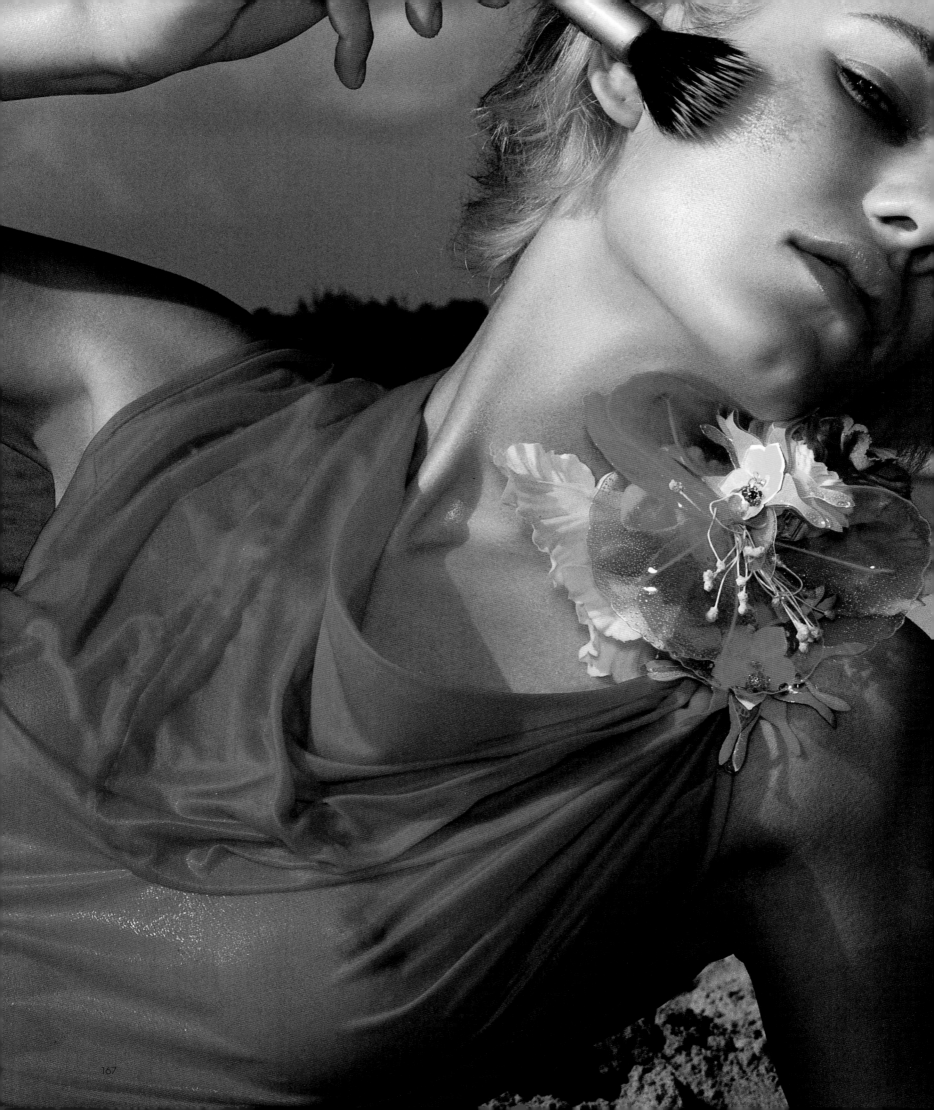

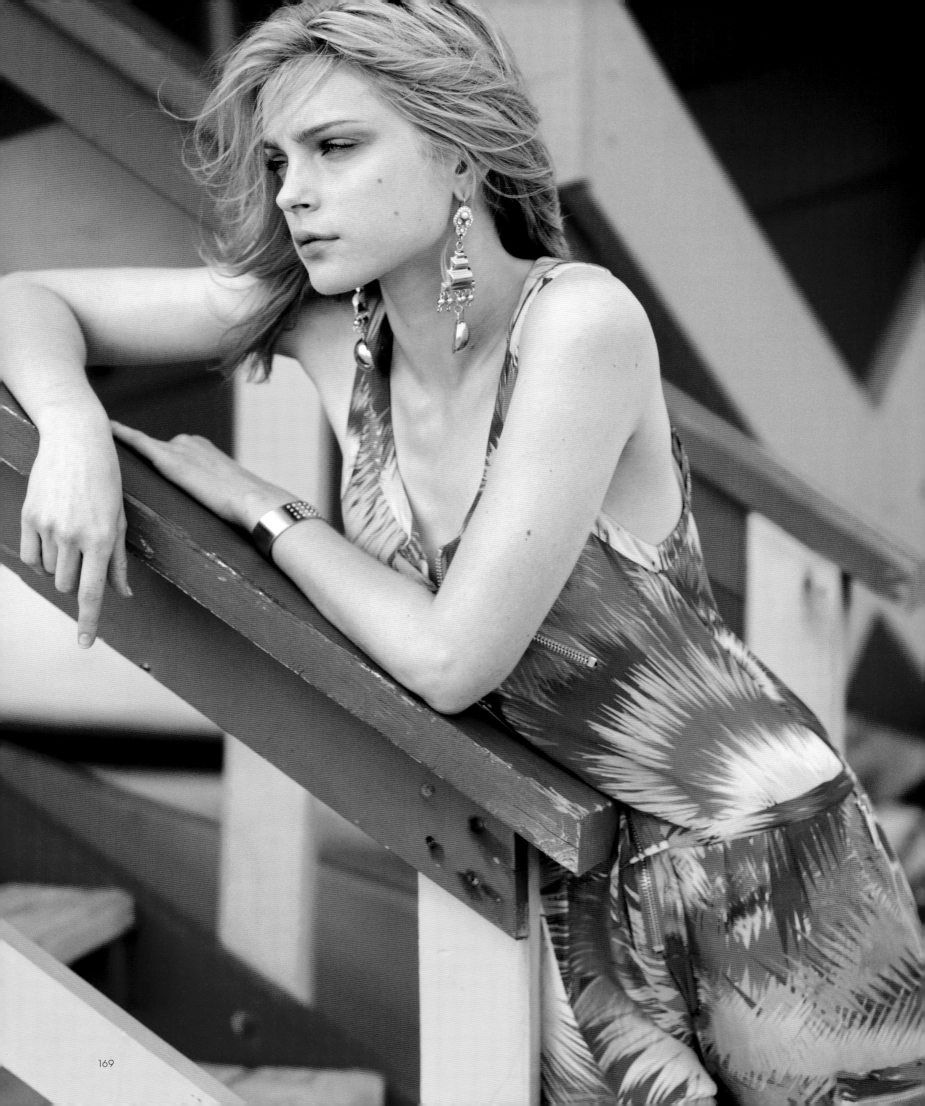

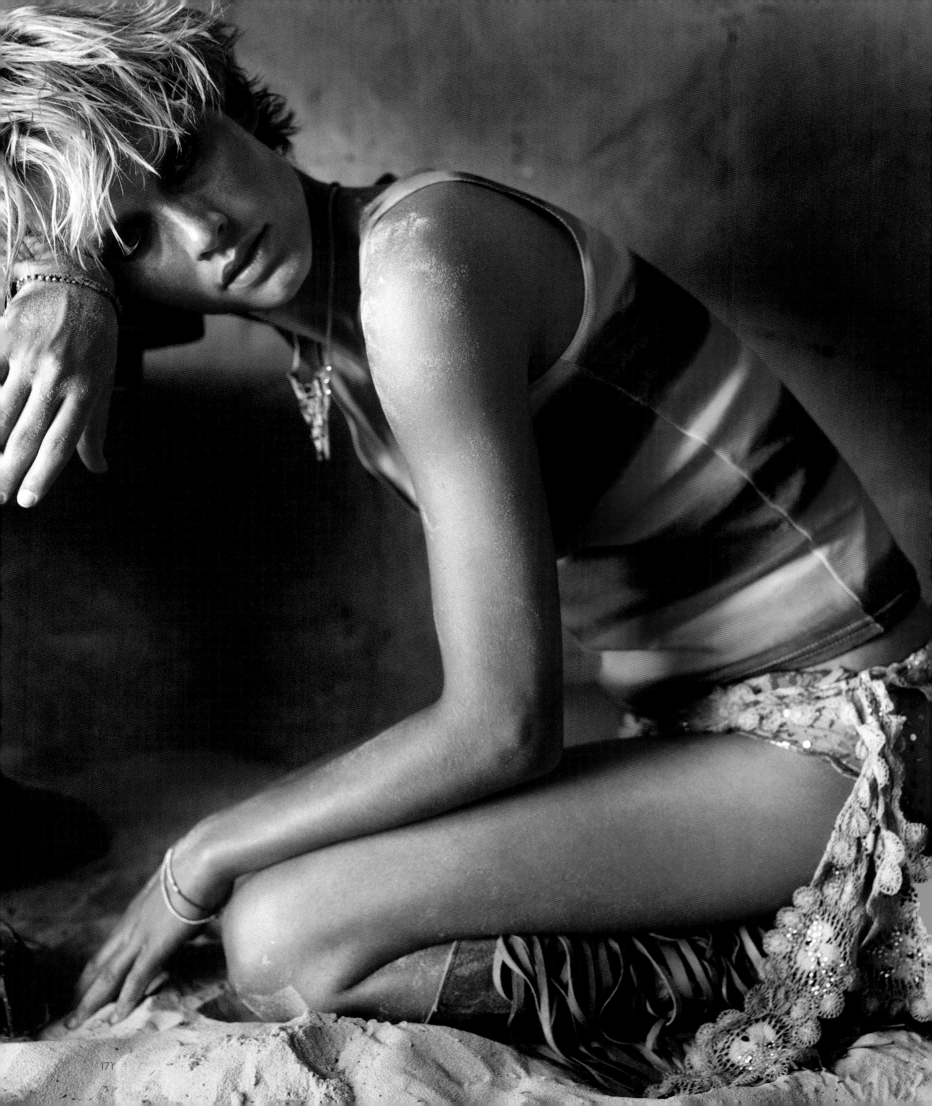

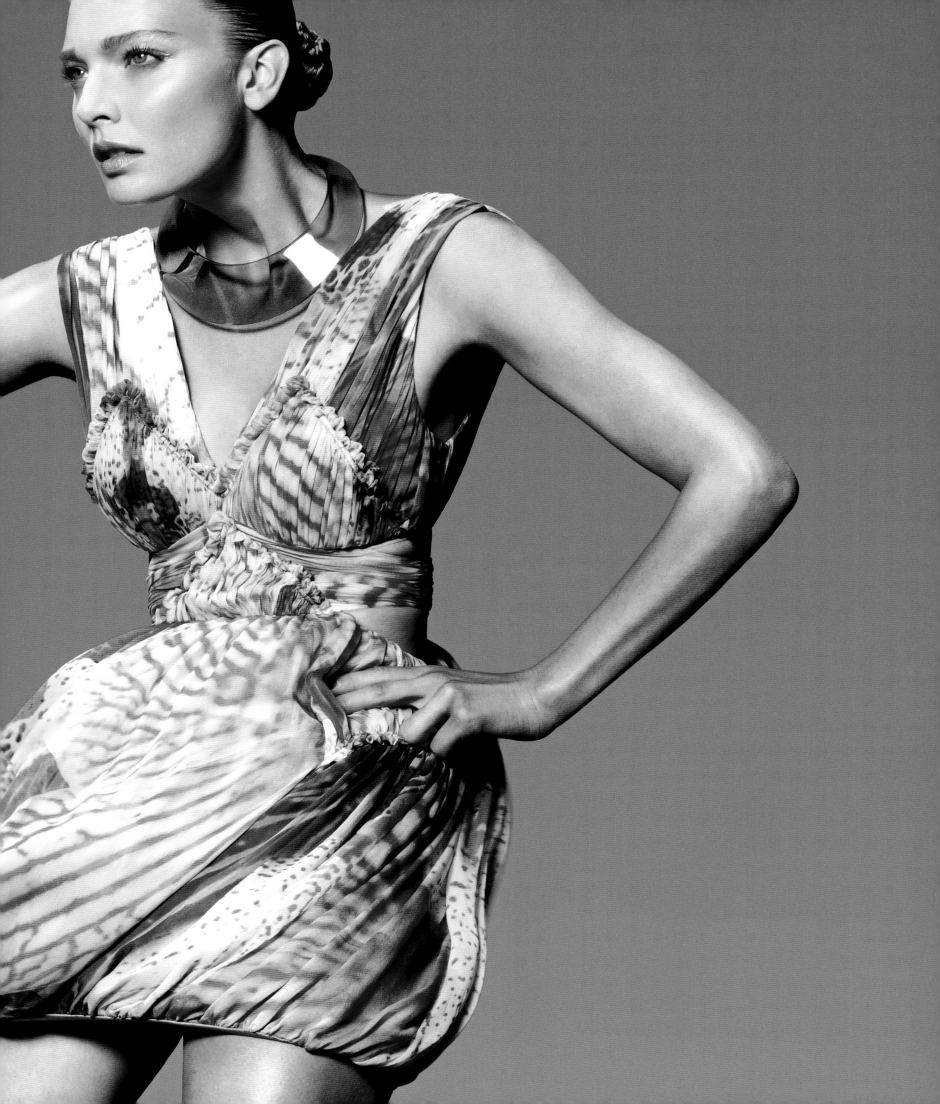

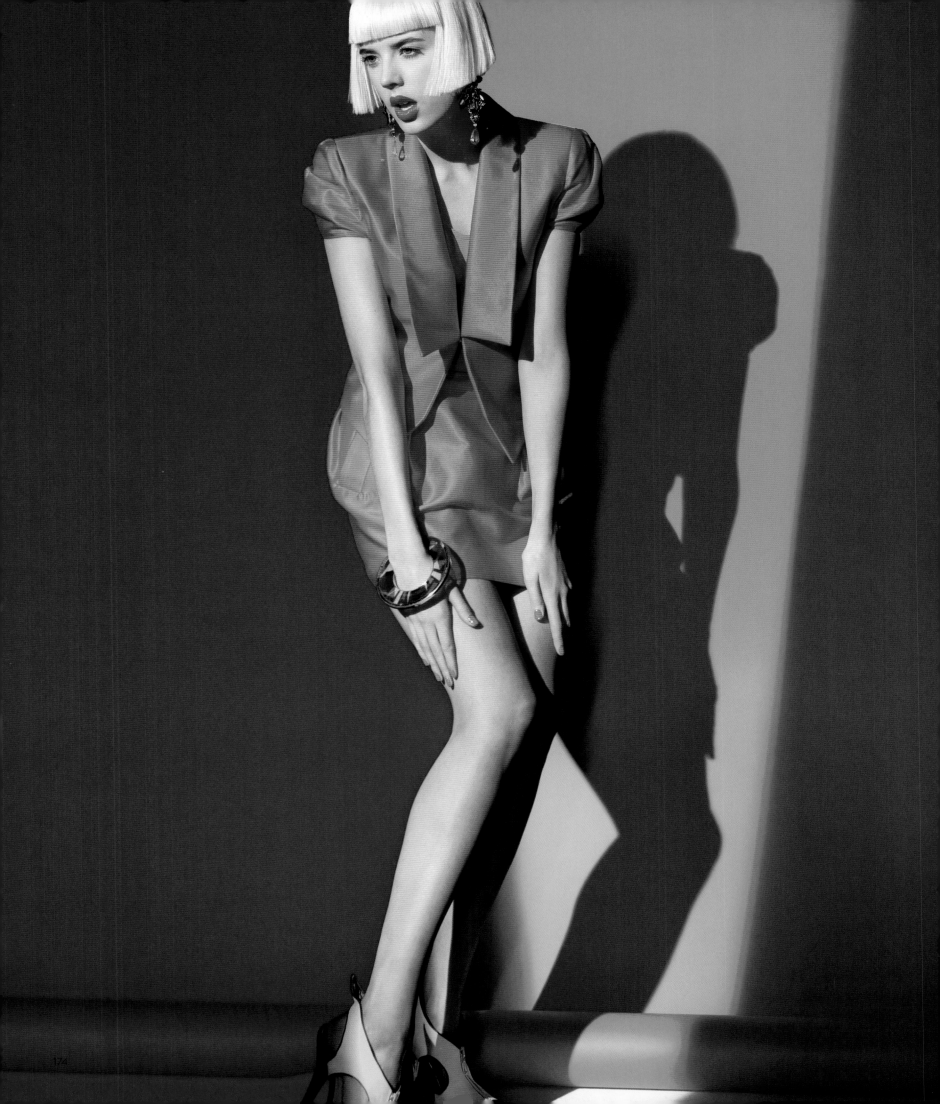

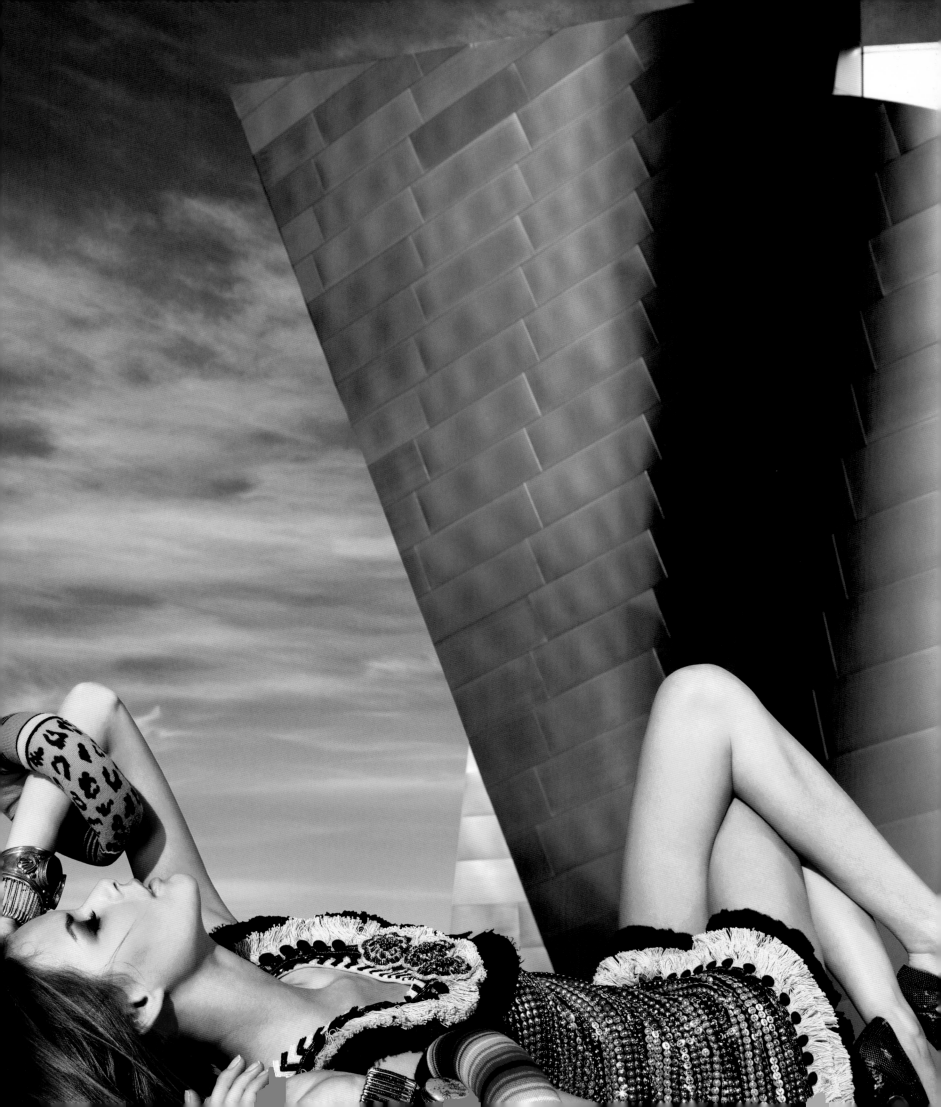

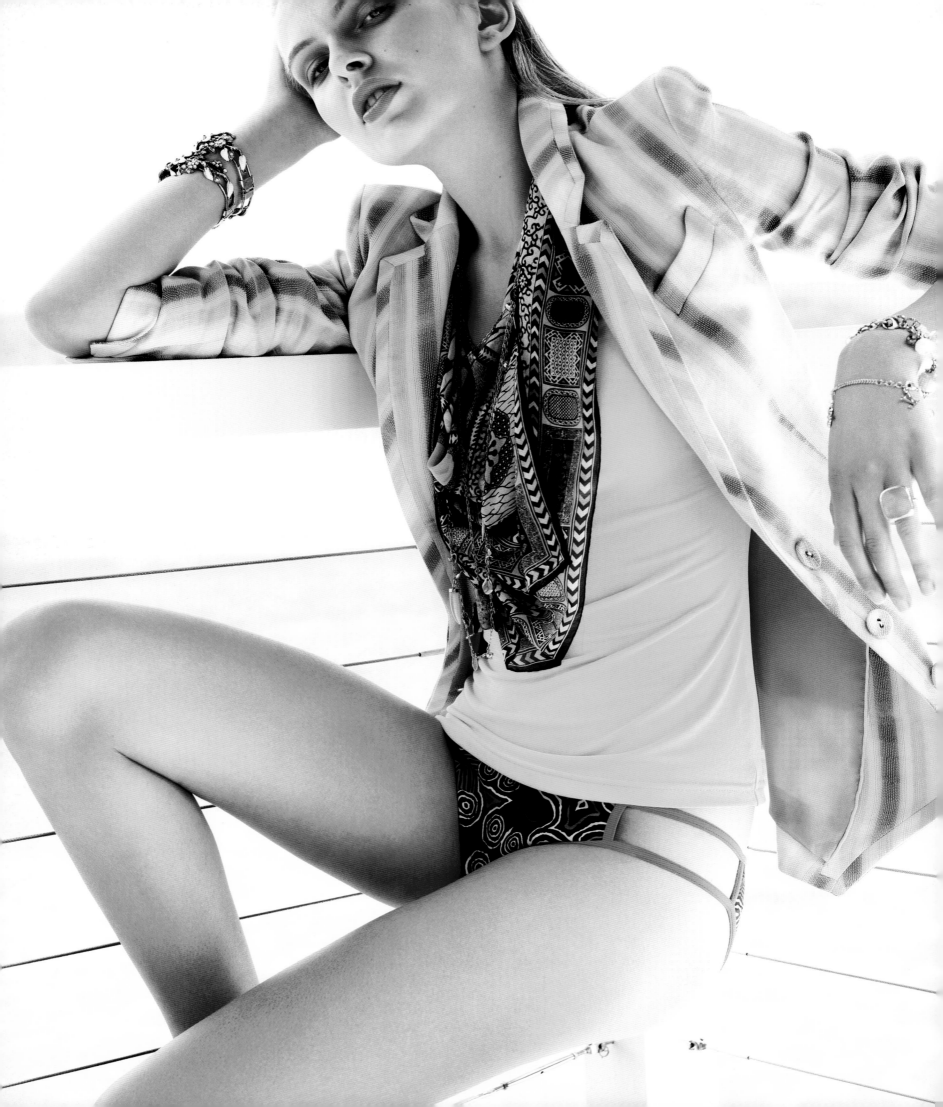

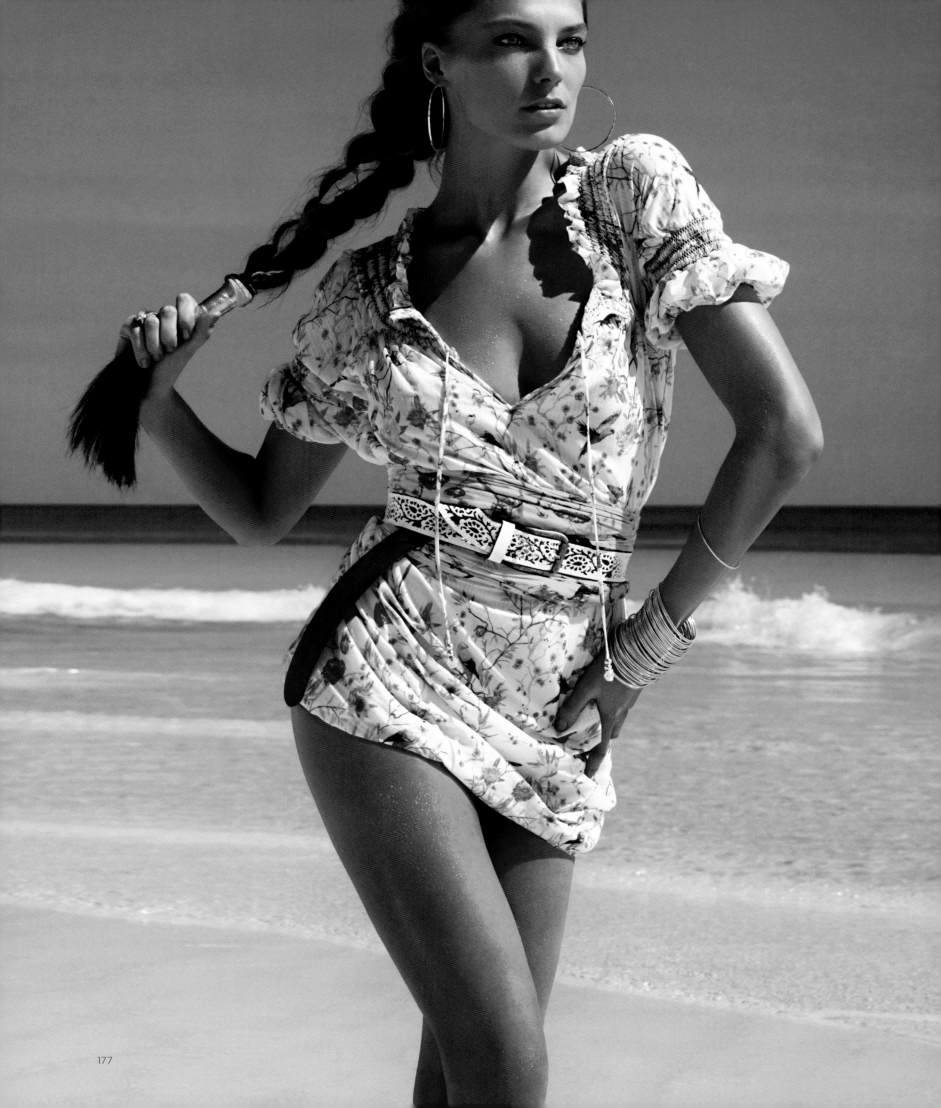

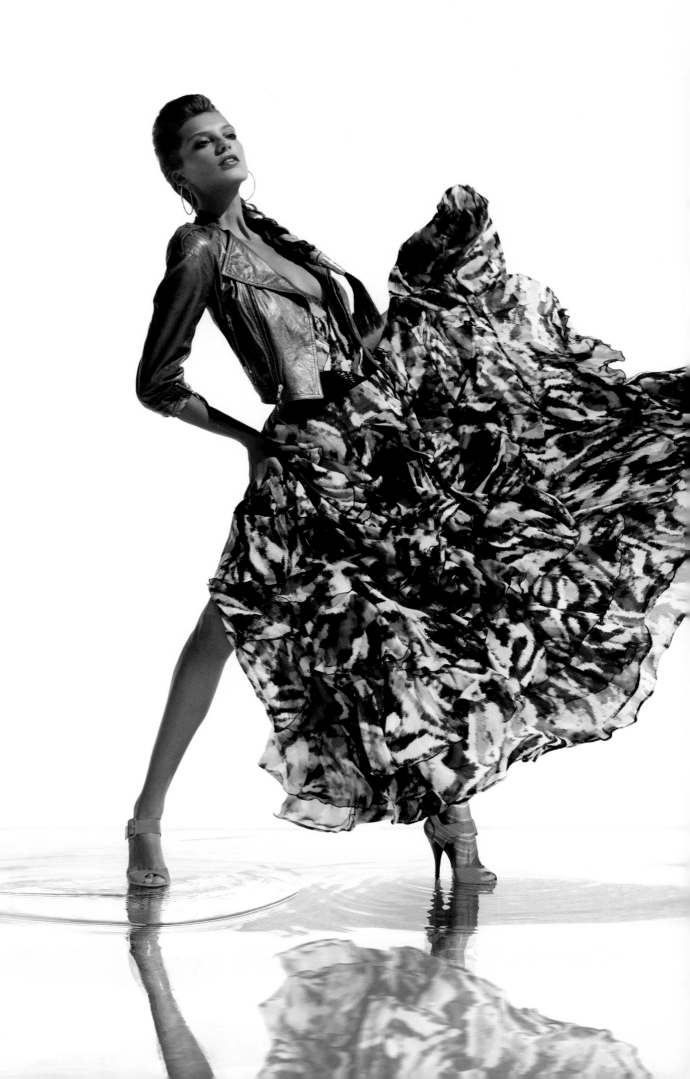

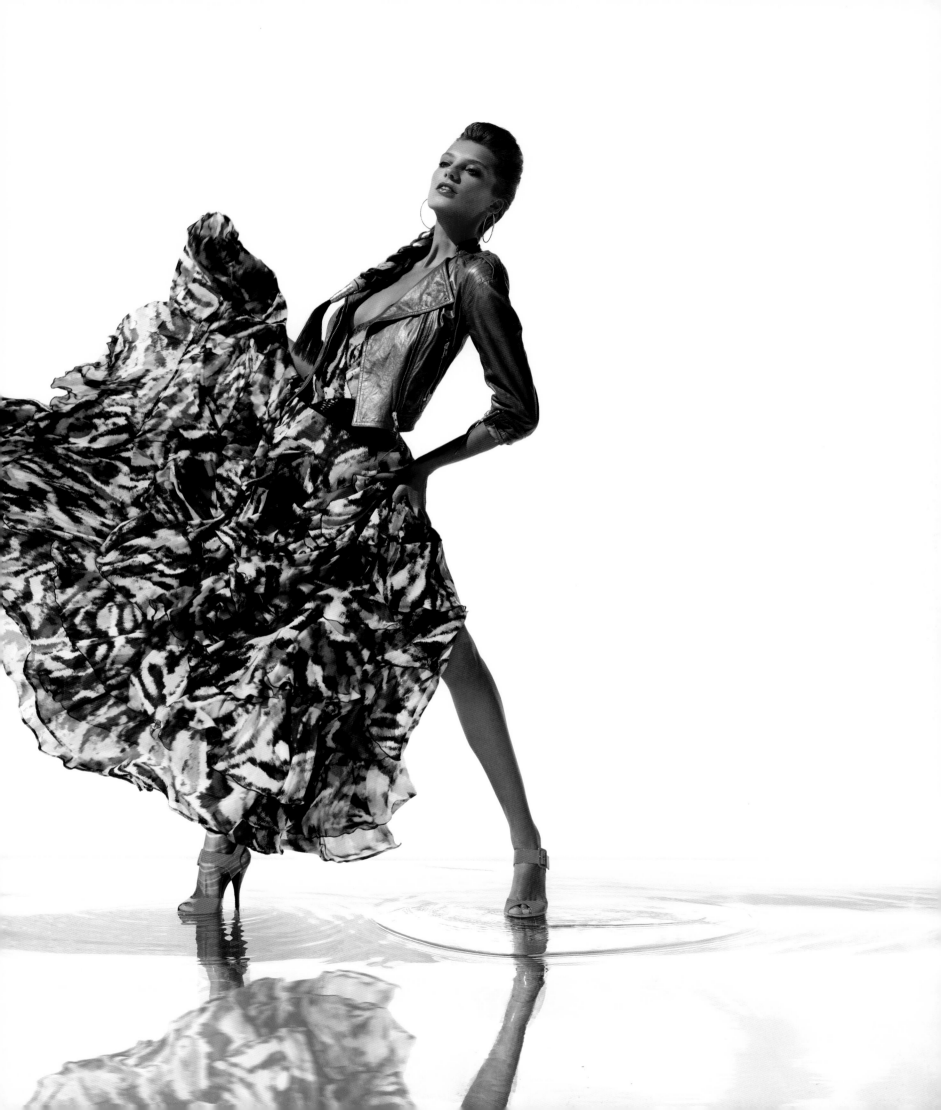

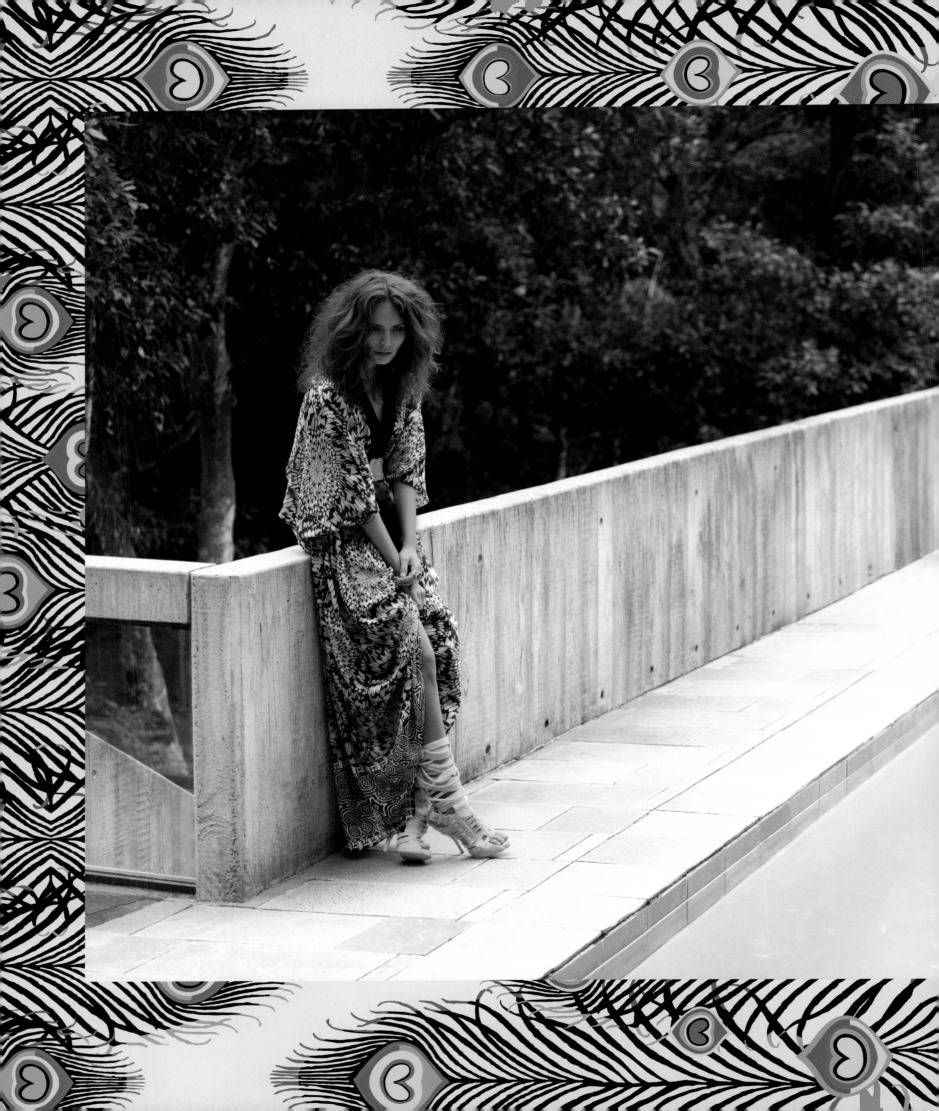

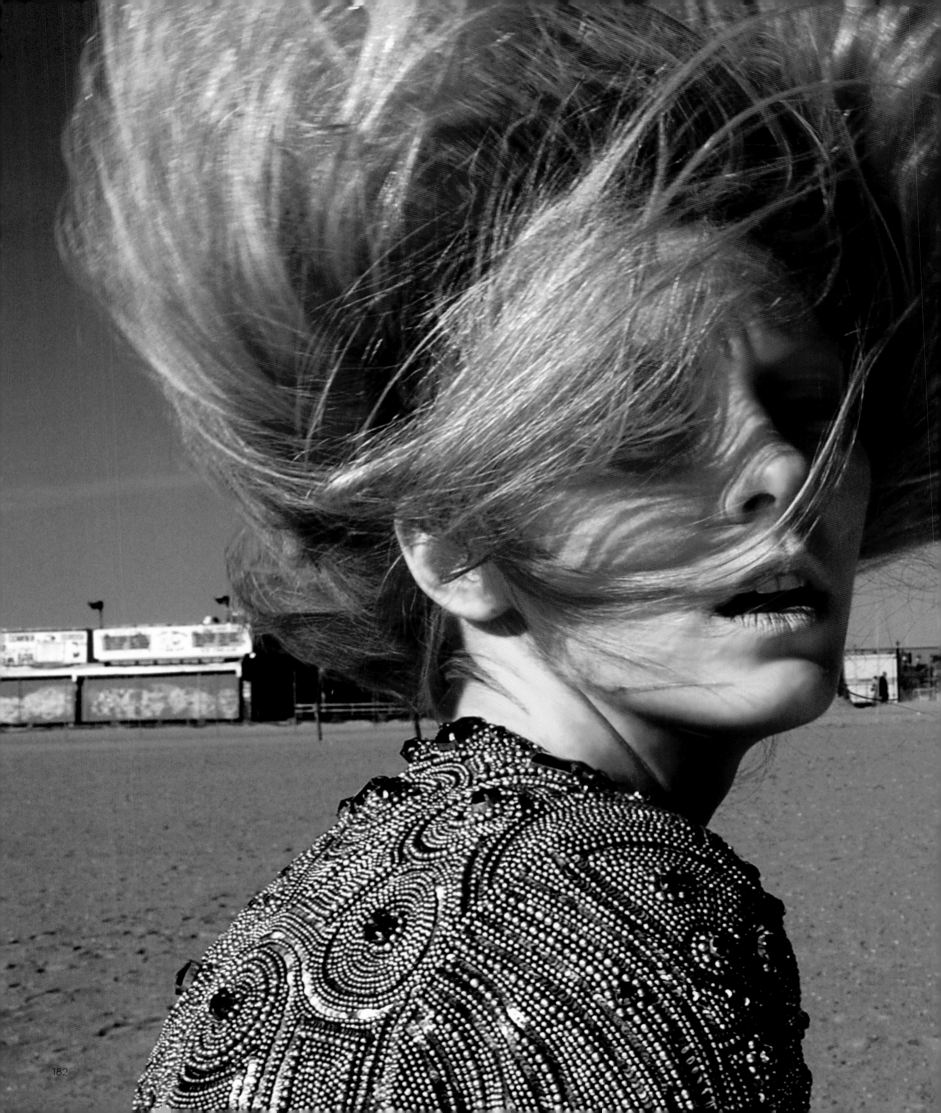

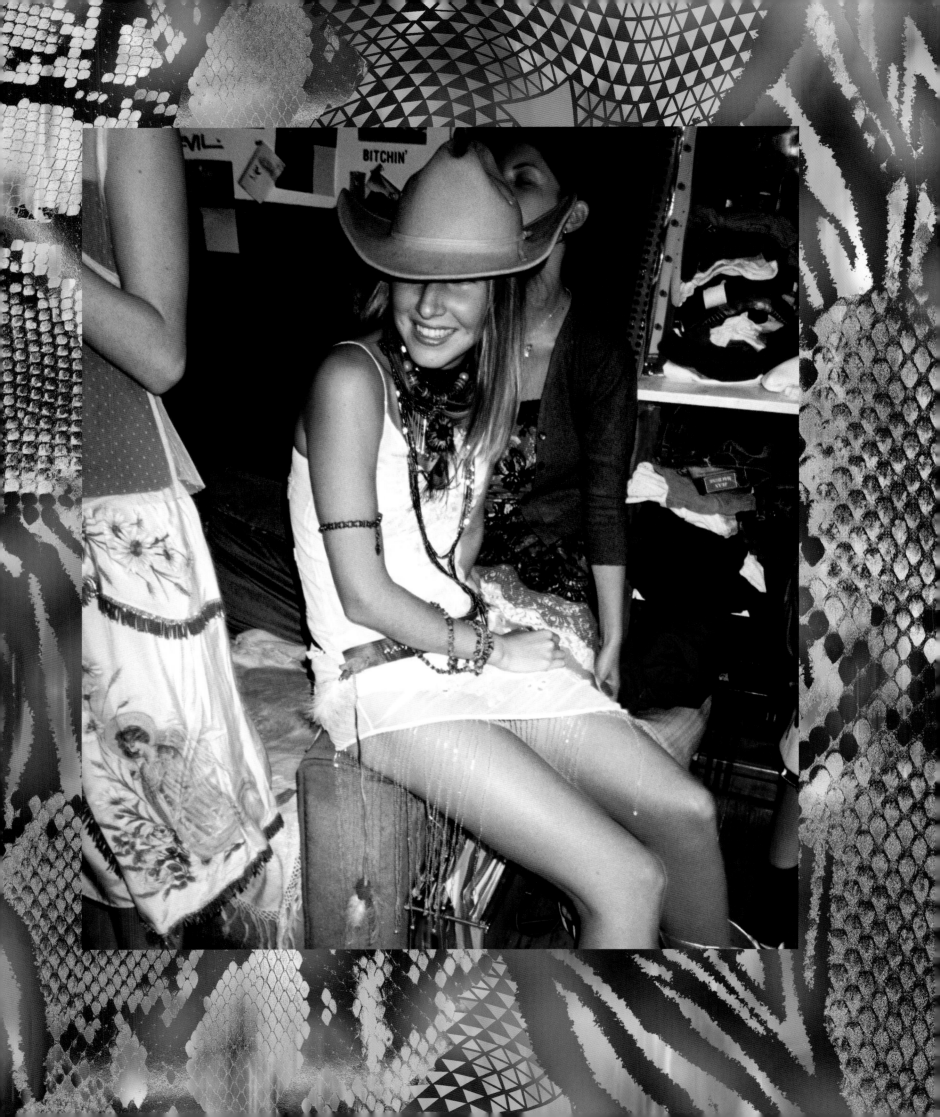

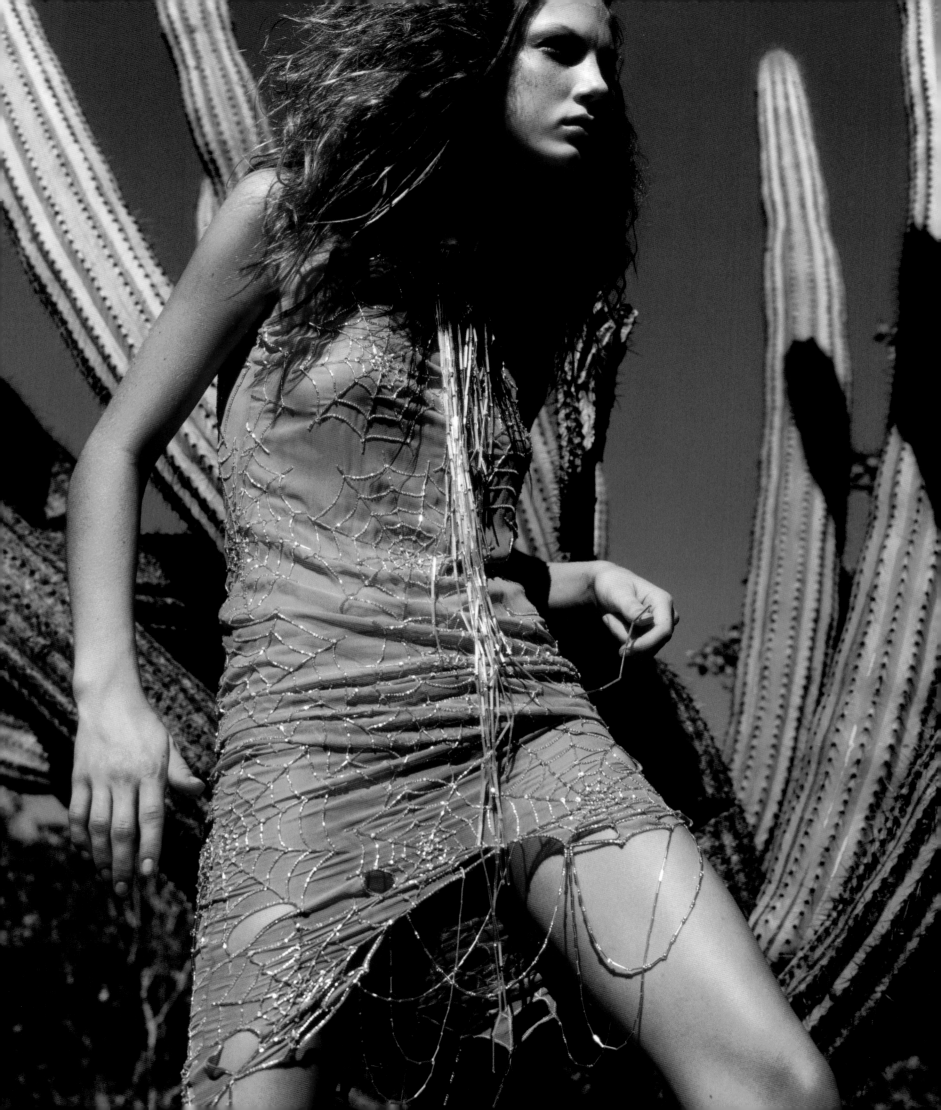

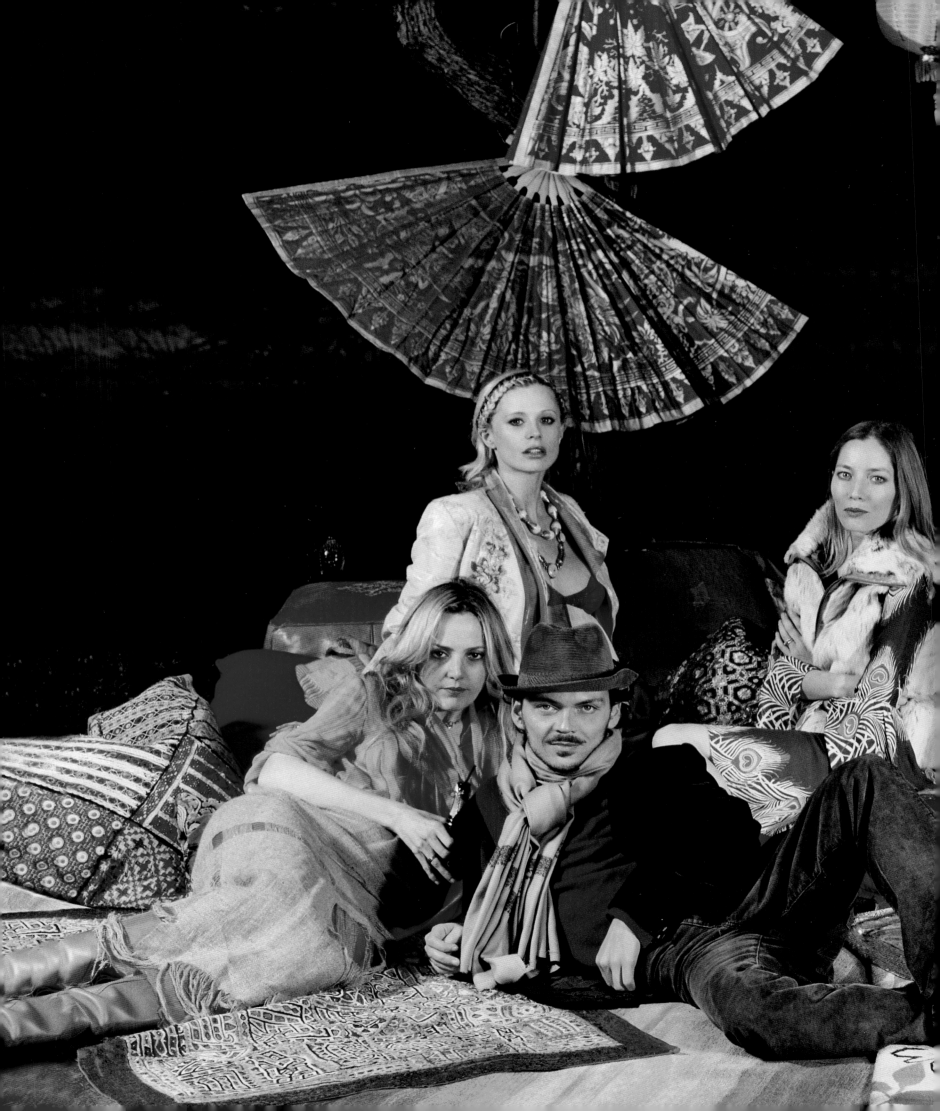

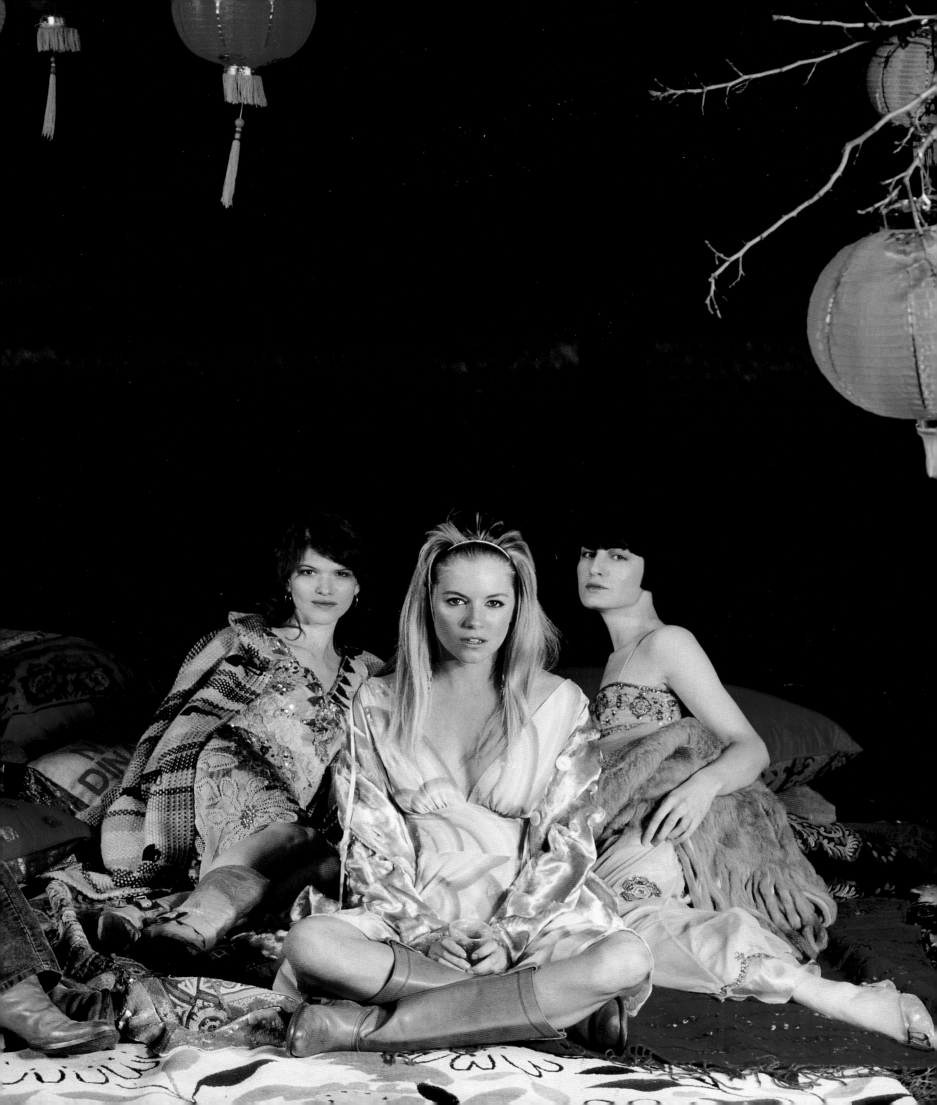

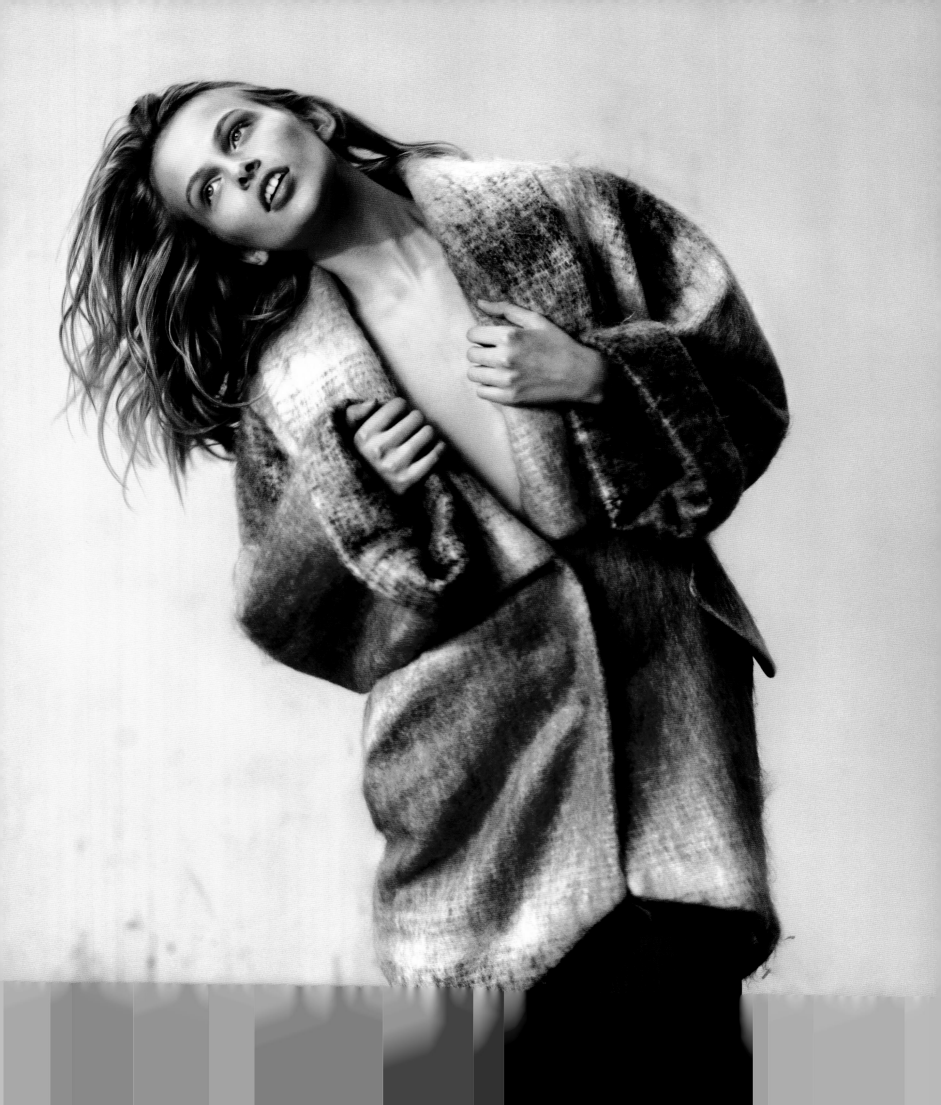

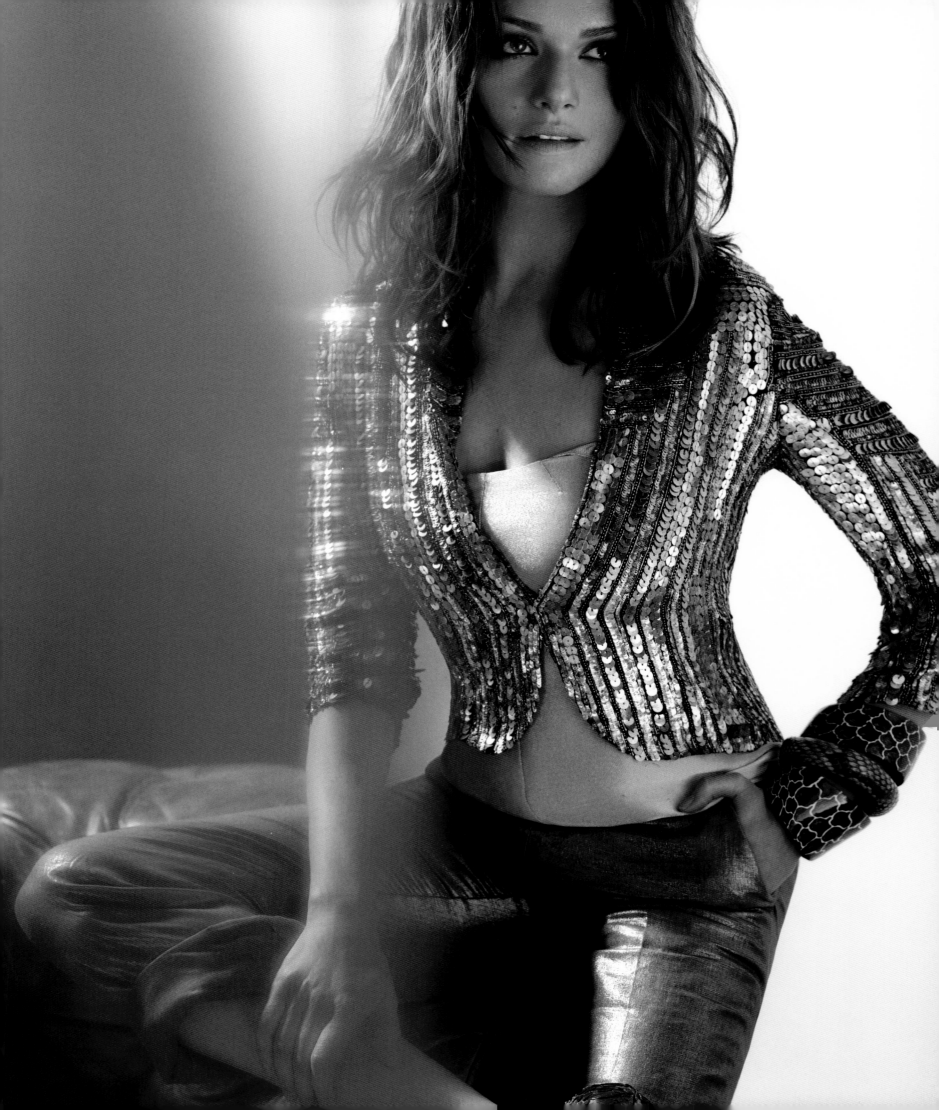

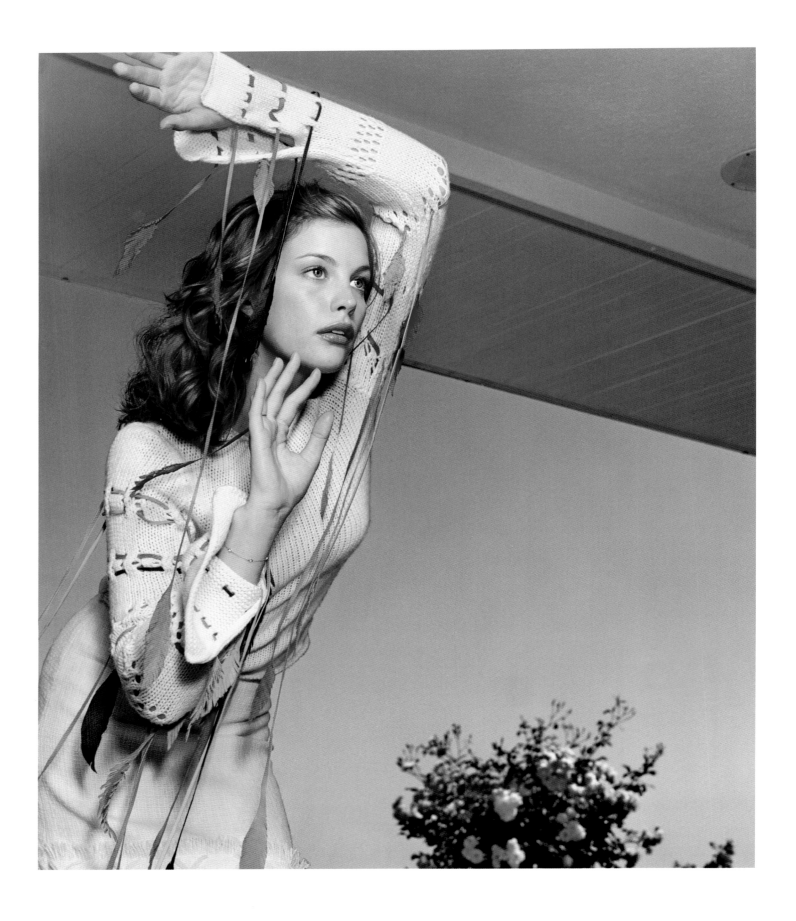

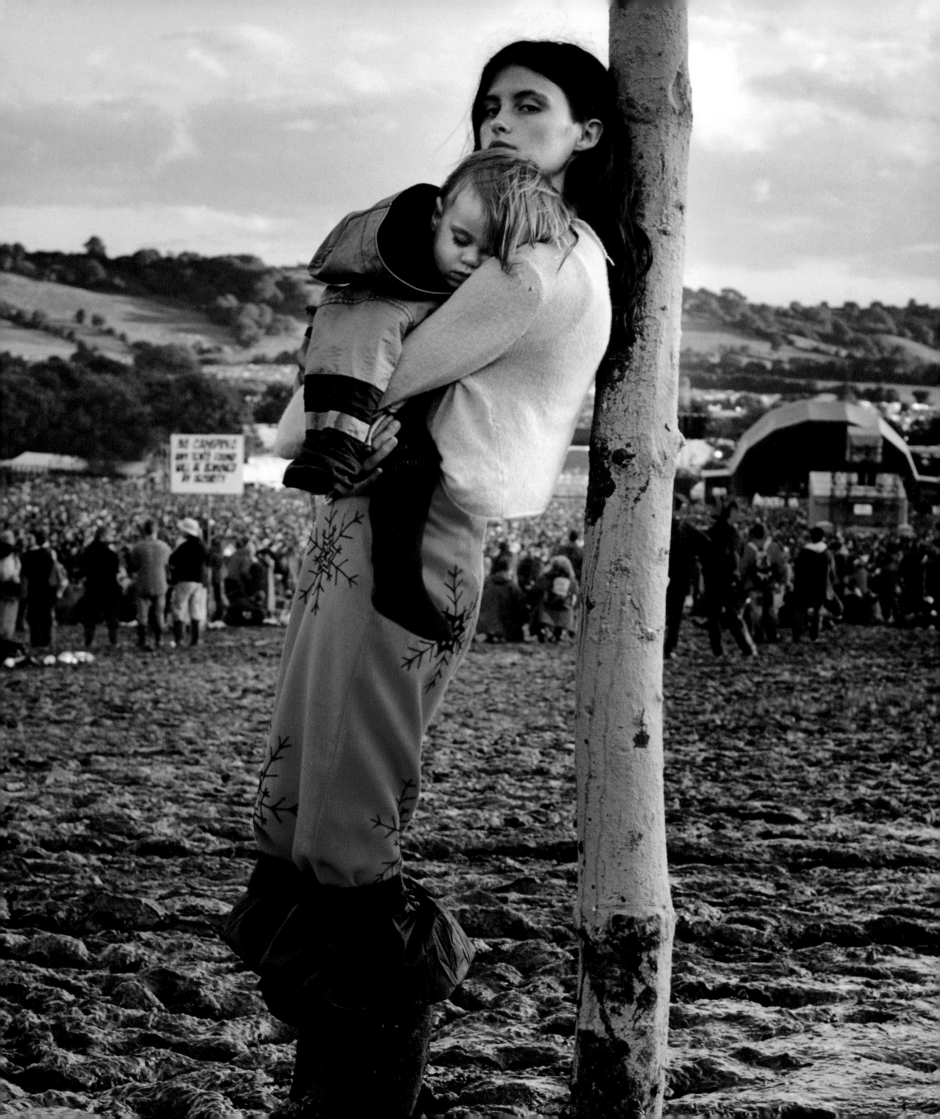

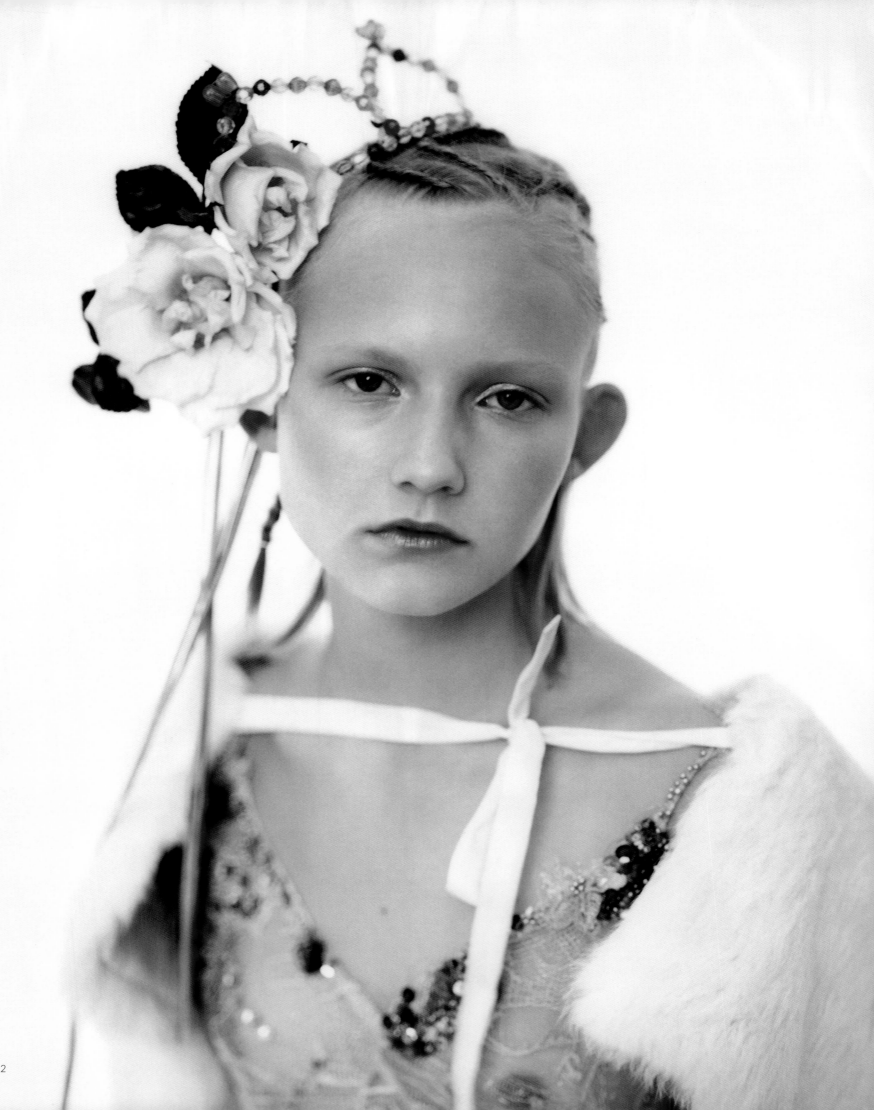

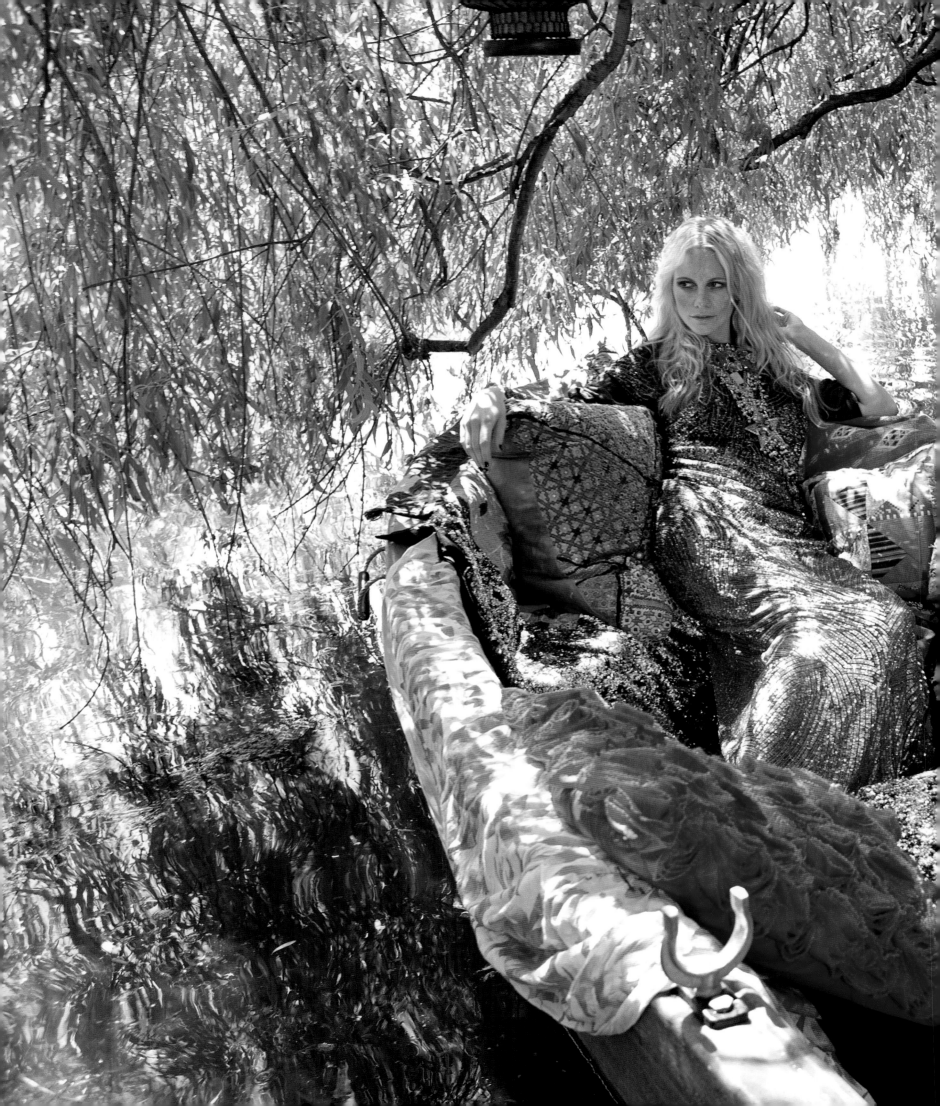

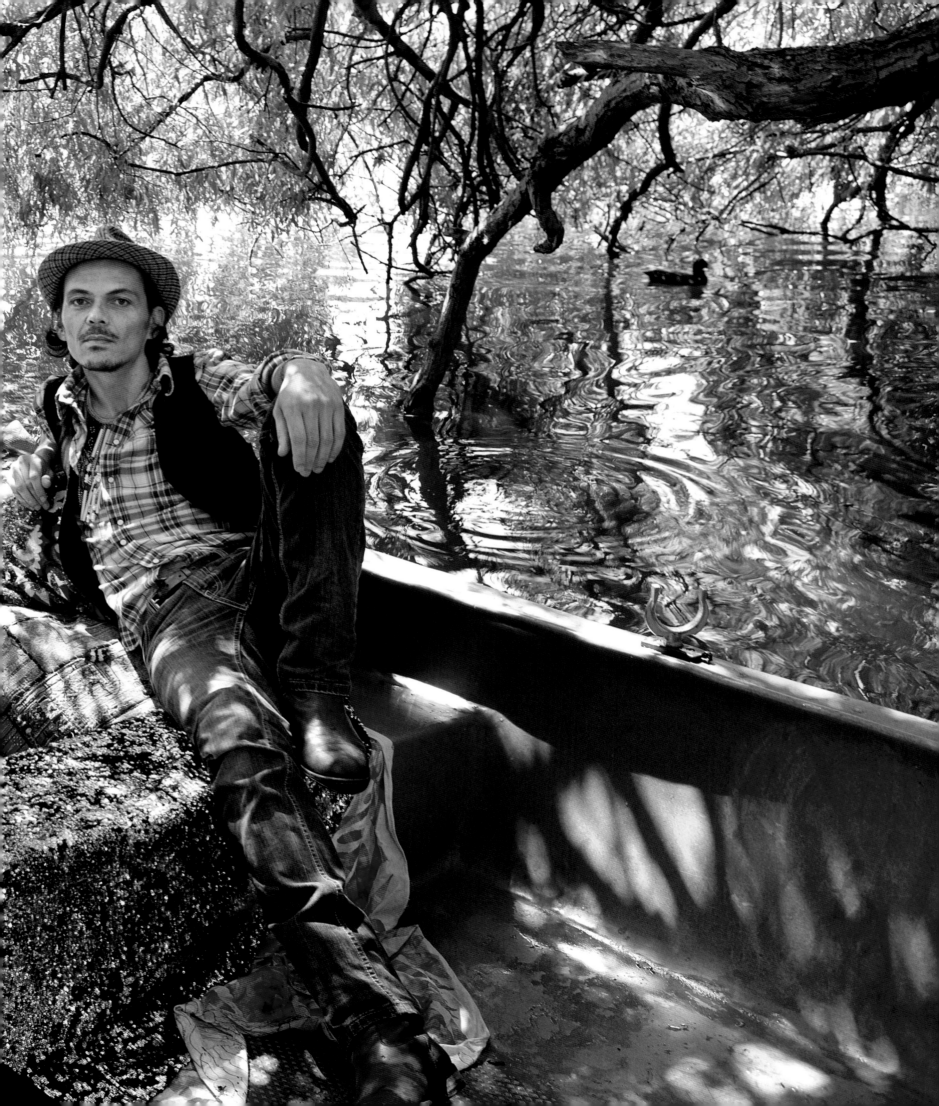

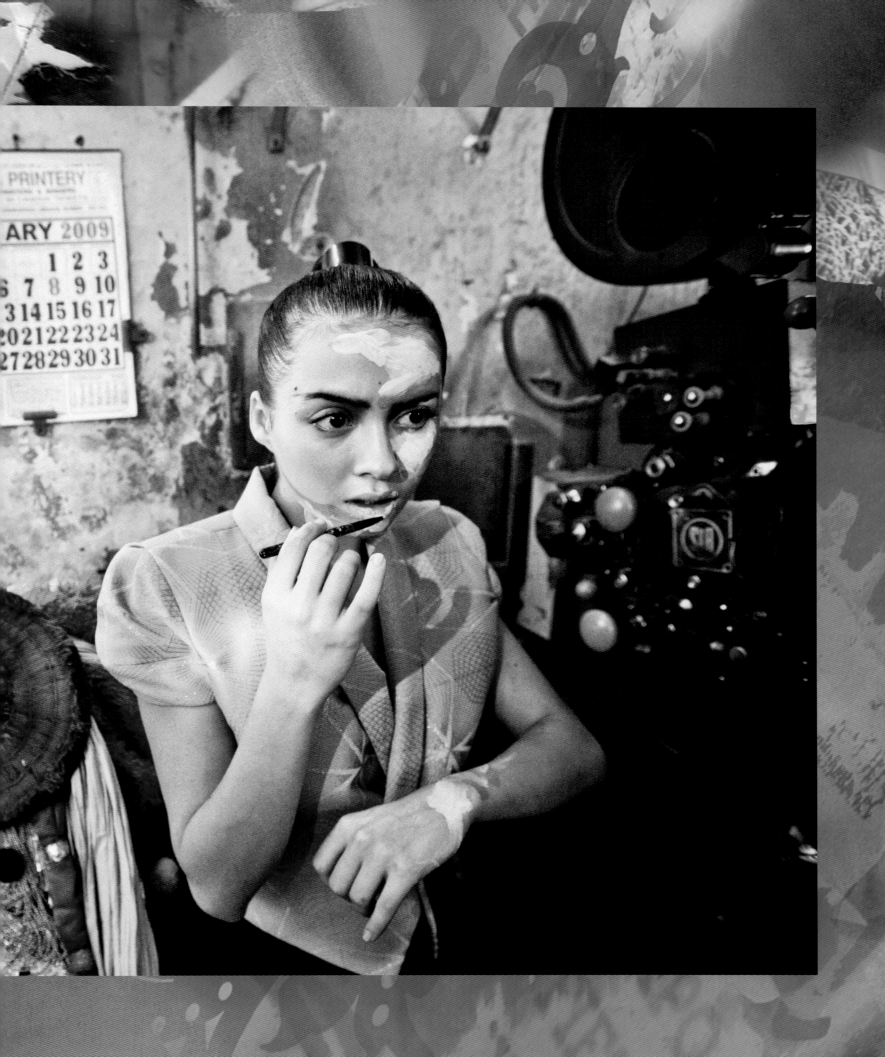

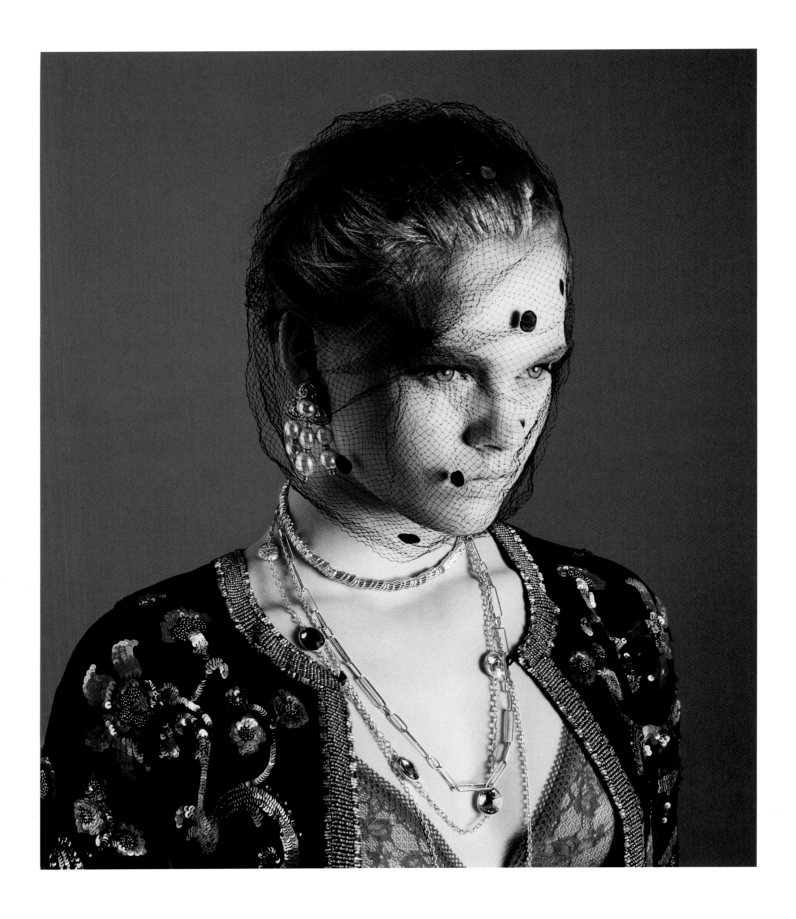

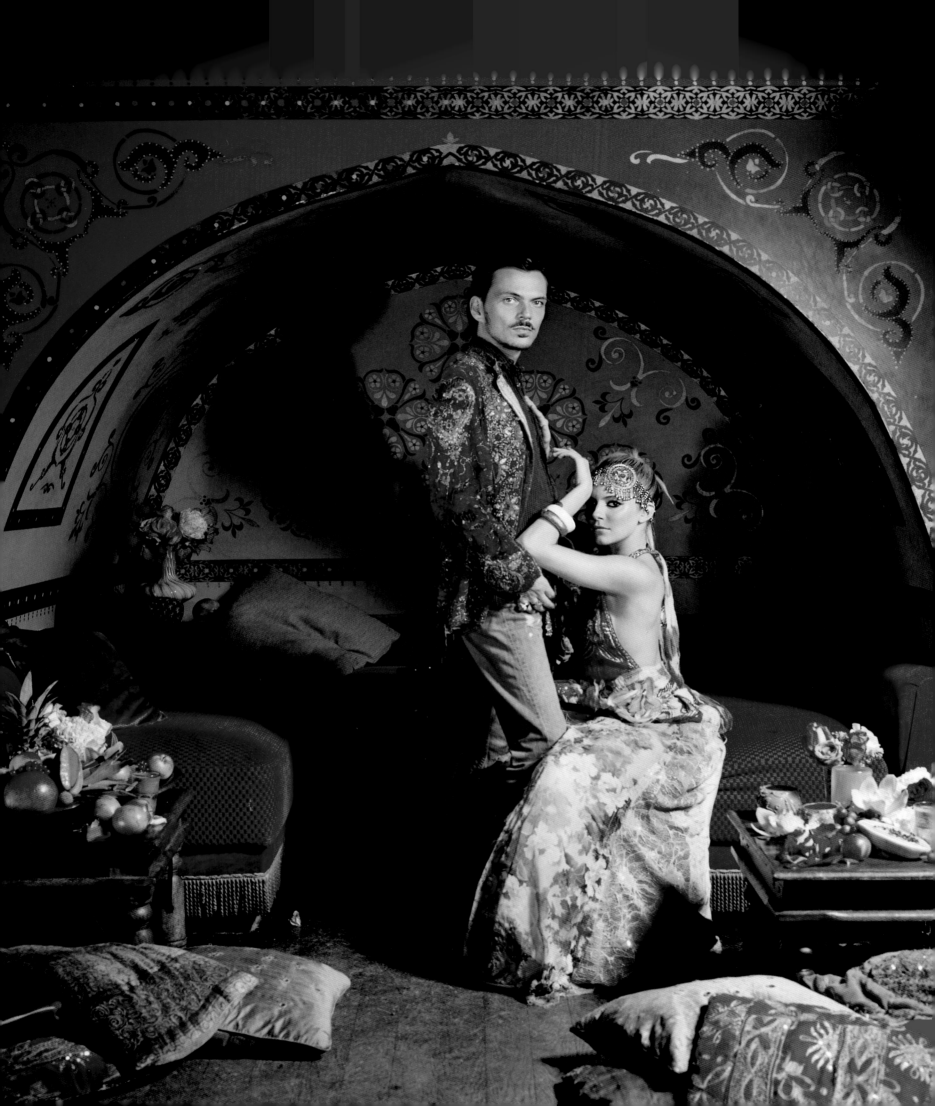

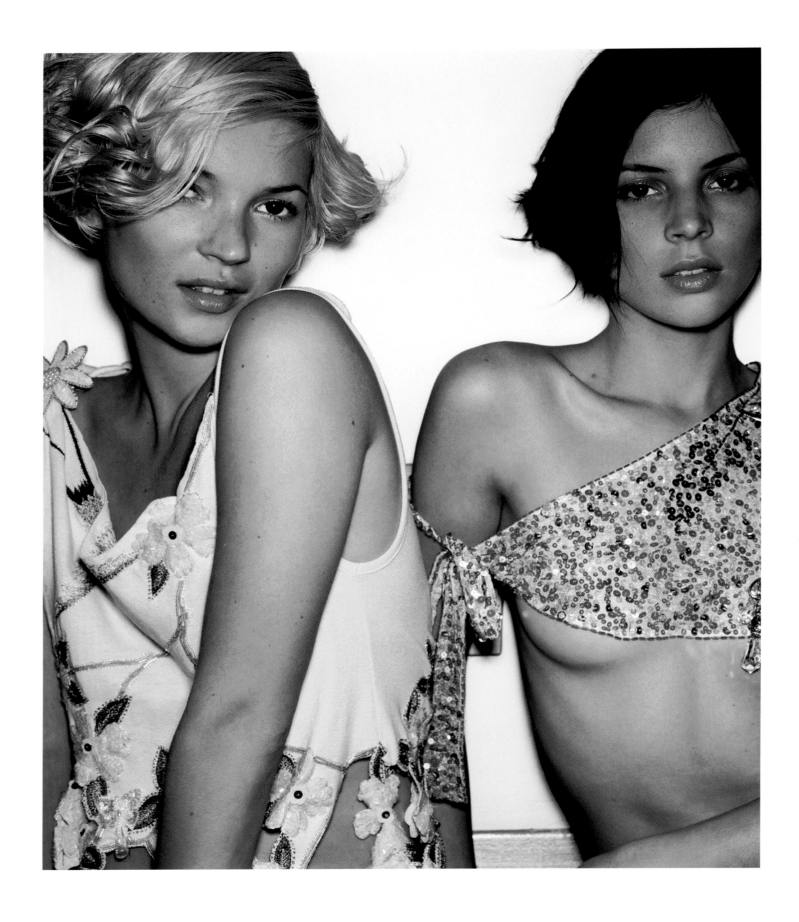

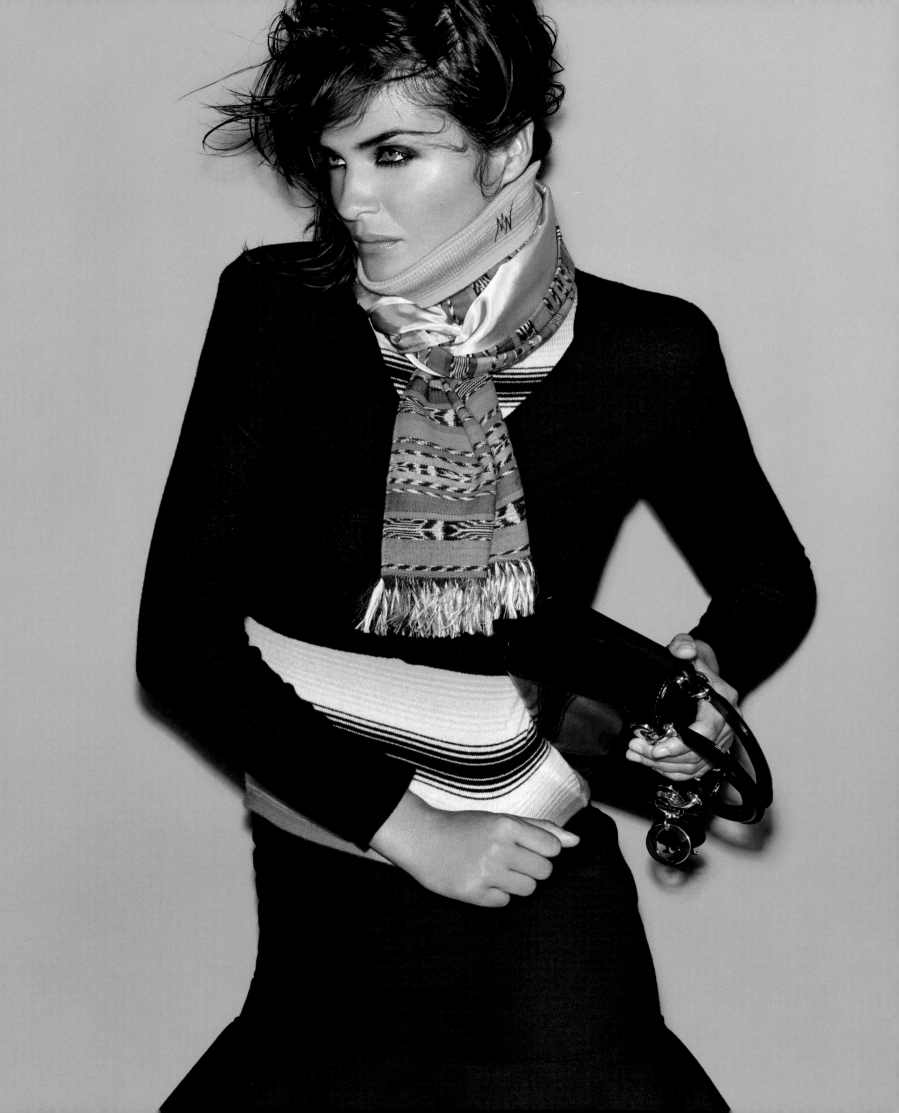

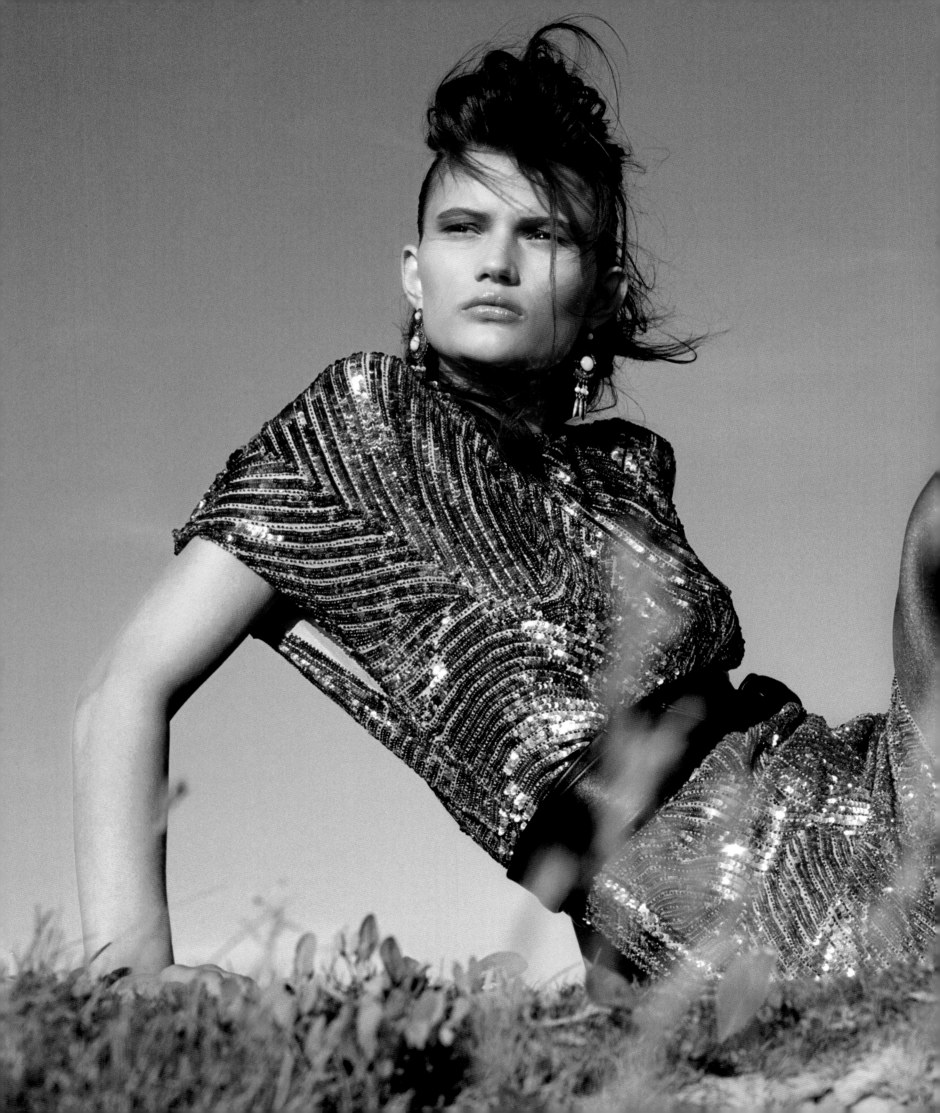

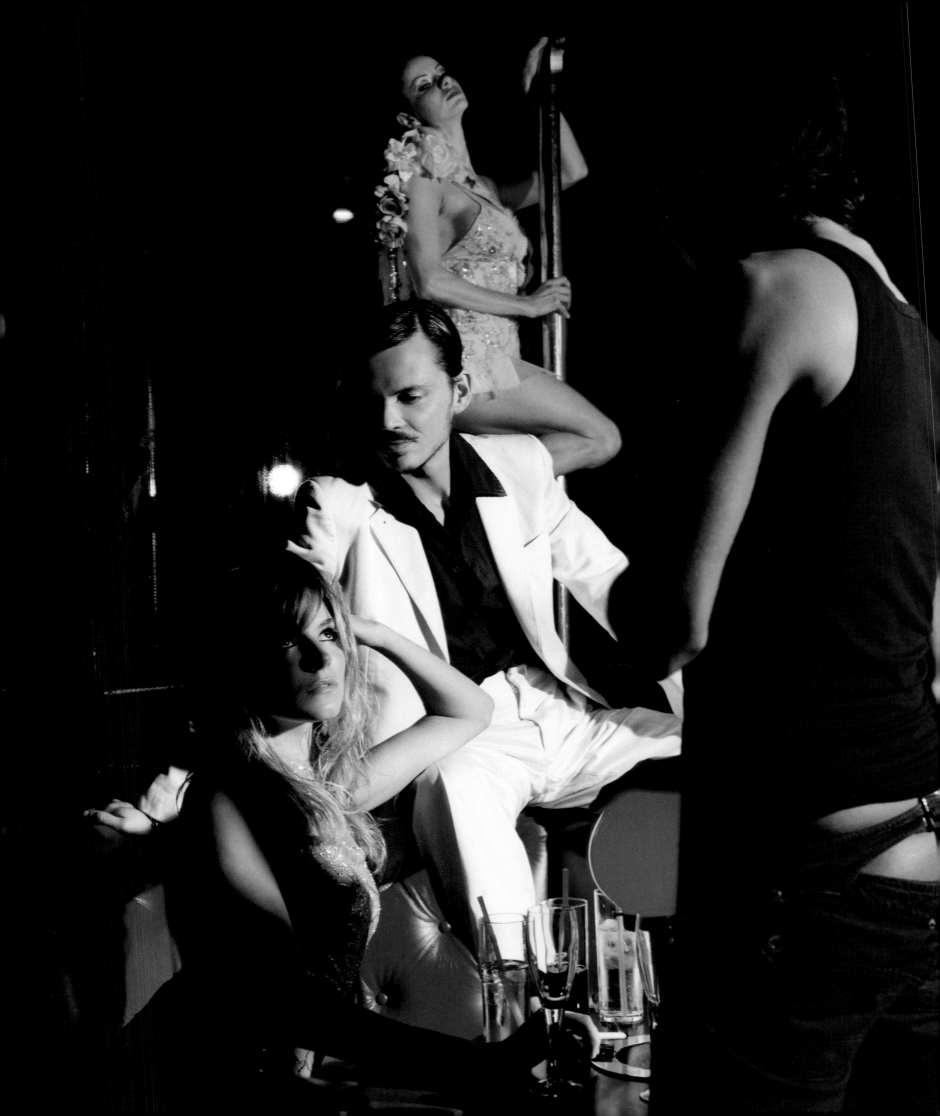

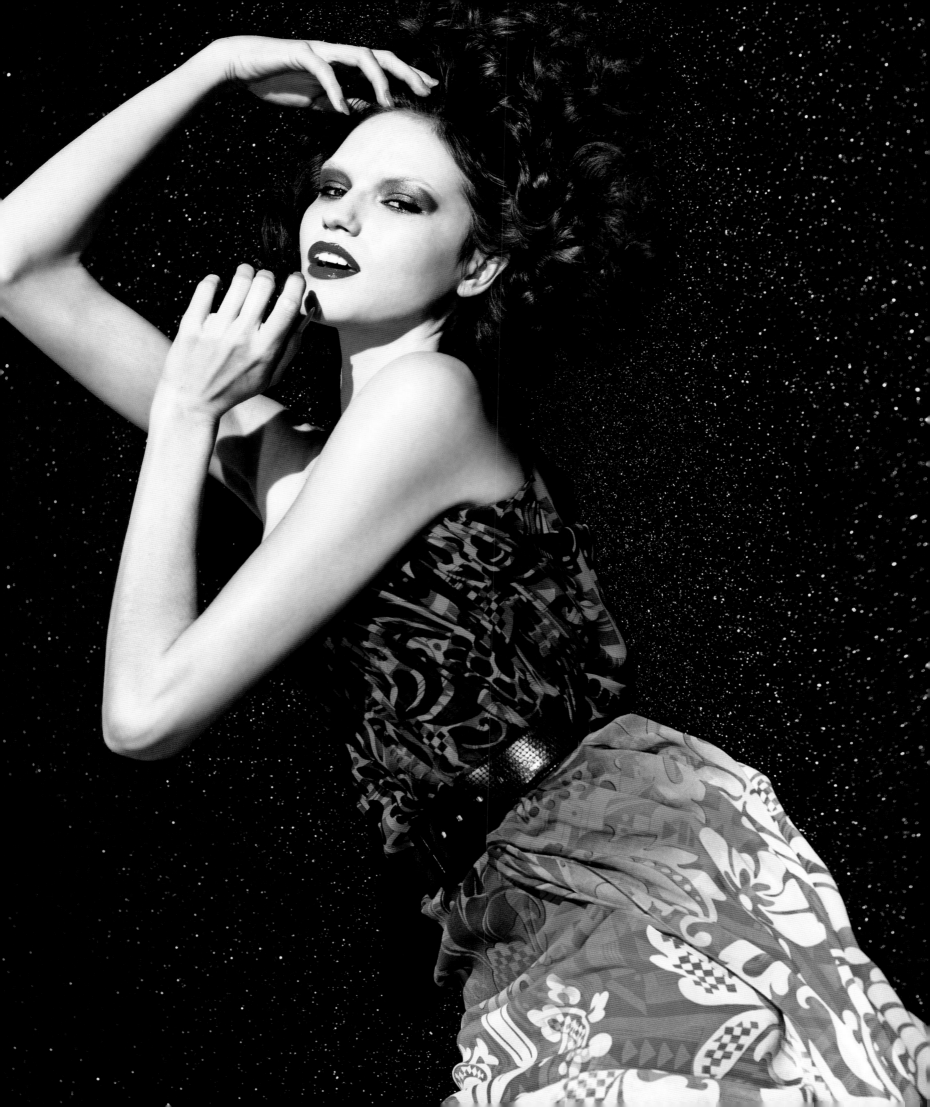

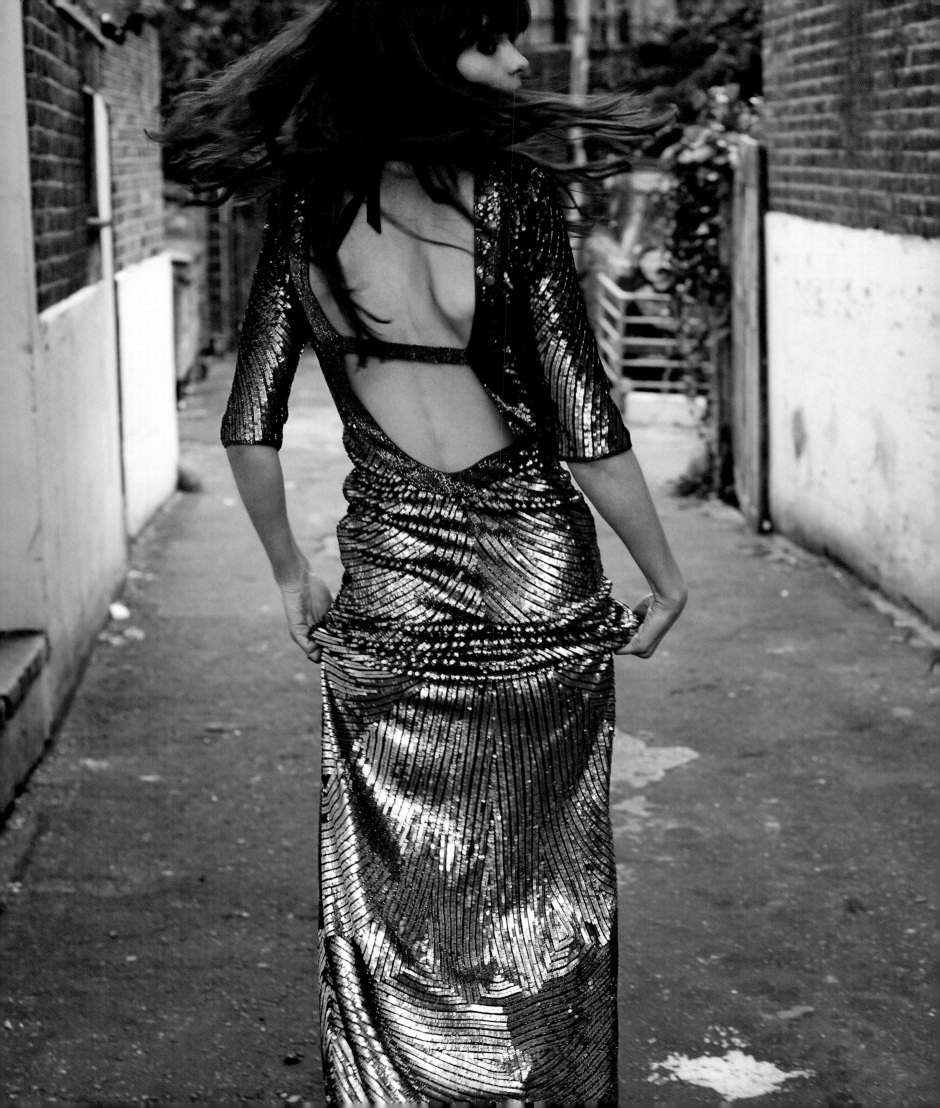

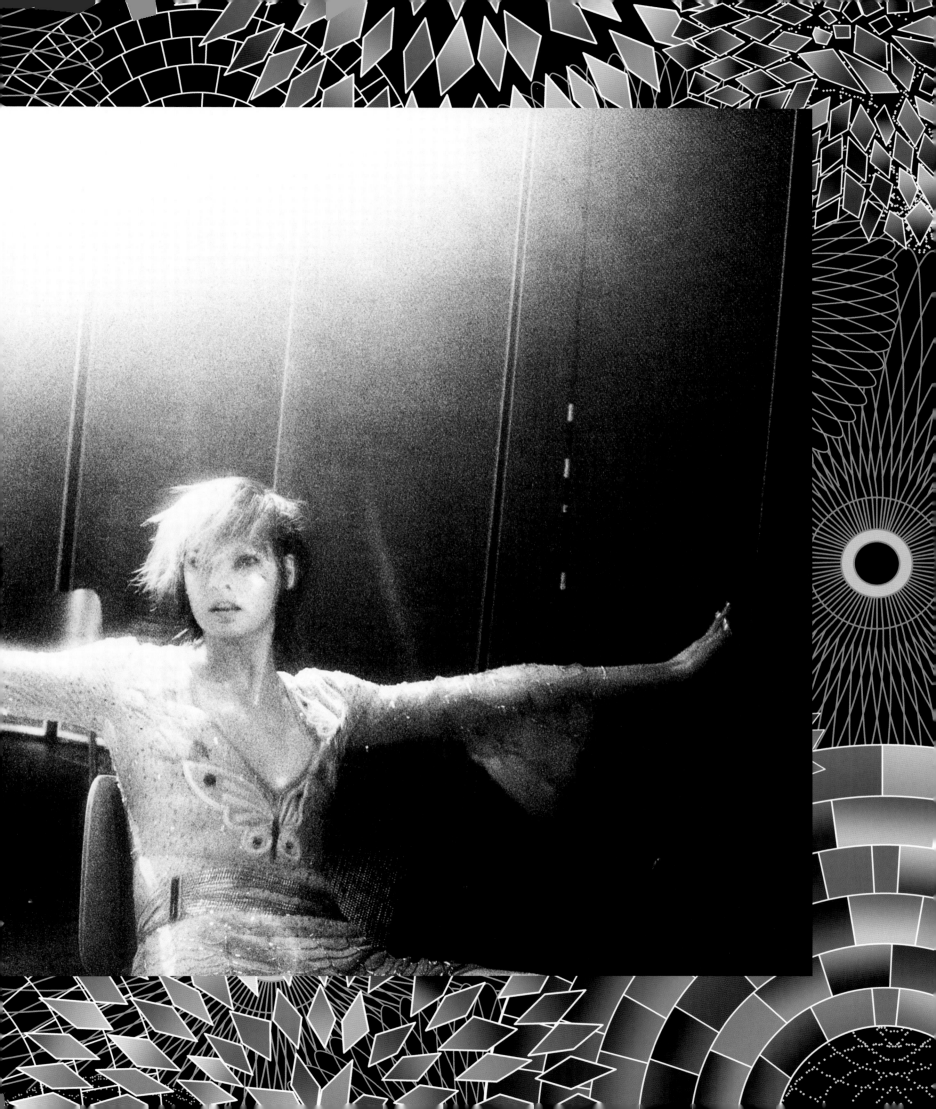

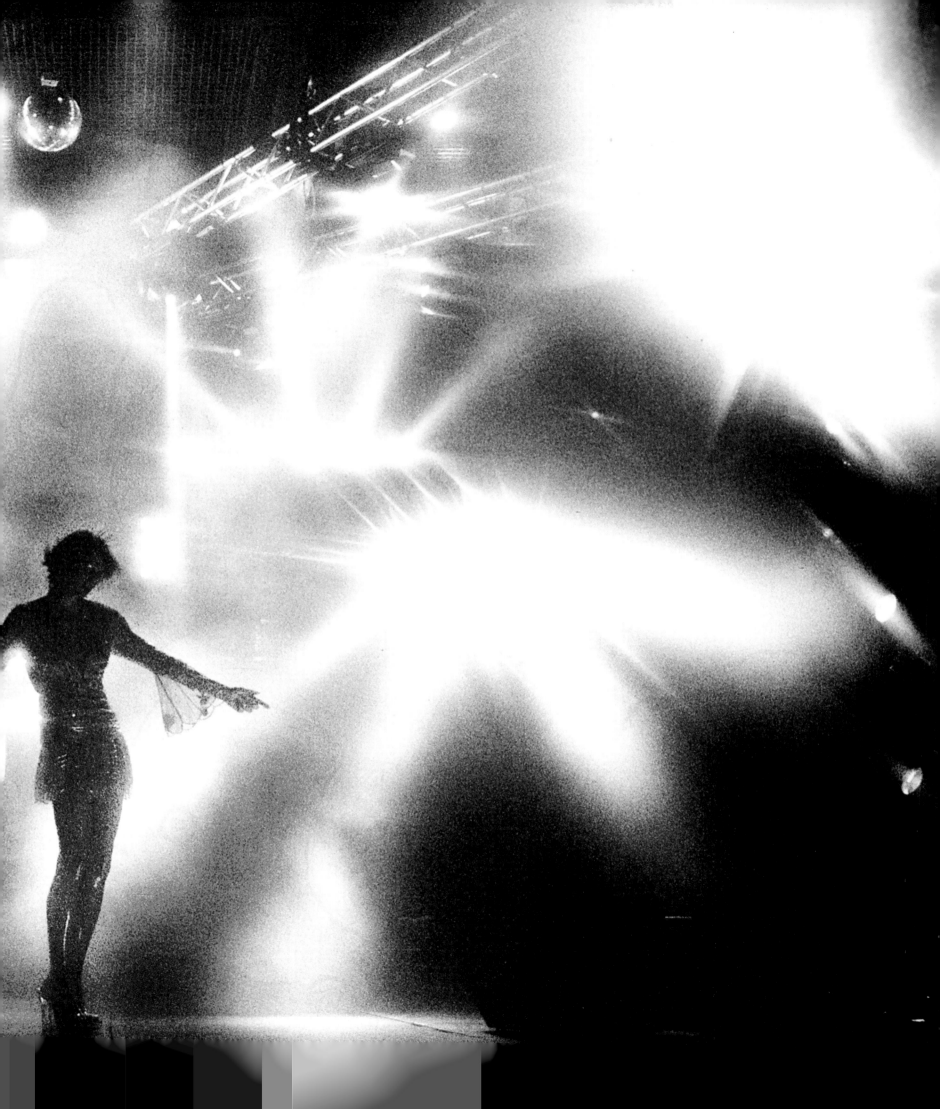

Serendipity print
Summer 2010

MATTHEW USES THE MOST
AMAZING COLORS AND
TEXTURES. HIS LOOKS ARE
NEW AND FRESH WITH
BEAUTIFUL EMBELLISHMENTS

Beyoncé

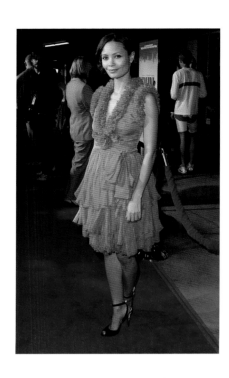

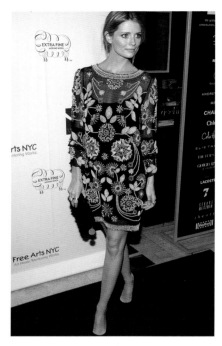

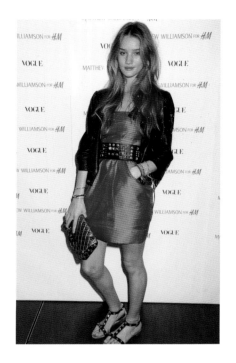

FAN CLUB

"When I think of Matthew and the women that wear his creations on the red carpet, I think of birds of paradise: colourful, shimmering, exotic creatures that light up the night. Who can forget the ethereal vision of Sienna Miller in that beautiful Grecian chiffon dress at the Oscars or Keira Knightly, sublime and smouldering [at the London premier of *Pride and Prejudice*] in his gold and purple silk goddess gown, undoubtedly one of her finest red carpet moments?

A few years ago I asked Thandie Newton, another admirer, if she'd like to be interviewed by Matthew for a *Bazaar* cover story, and she was thrilled. Since then I have watched her dazzle in countless Matthew Williamson creations, be it the cascade of fuchsia ruffles she wore to a film premiere in LA, [or] the multi-coloured silk belted mini dress that turned heads at the Serpentine summer party.

I believe the secret to Matthew's success lies in his love — and complete understanding — of the women he dresses. More often than not, they become his friends, drawn to his mischievous Northern sense of humour, colourful personality and bohemian sense of fun and adventure. It's no wonder, thus, that he can conjure up the dresses they dream of wearing — his unique sense of playfulness, charm and exotic glamour is apparent in every last stitch and swathe of fabric."

Lucy Yeomans
Fashion Features Editor
Harpers Bazaar

clockwise from lower right
|
Heidi Klum
Rachel Zoe
Thandie Newton
Mischa Barton
Rosie Huntington-Whiteley

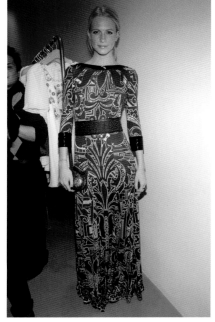

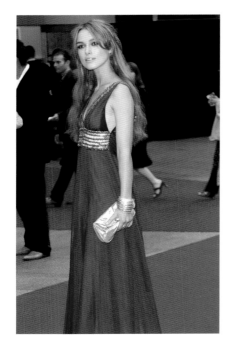

clockwise from lower left
|
Keira Knightley
Beyoncé Knowles
Katie Holmes
Poppy Delevigne

clockwise from right
|
Kelly Osbourne and
 Beth Ditto
Edita Vilkeviciute
Thandie Newton
Sienna Miller with Matthew
 Williamson

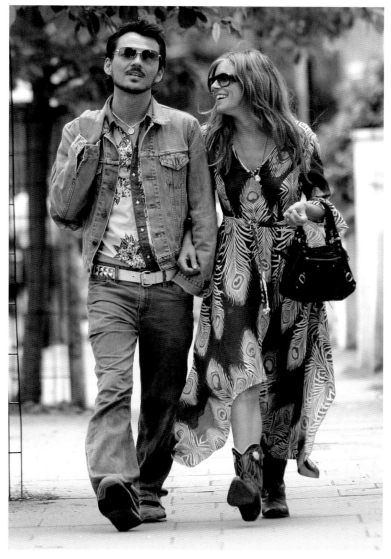

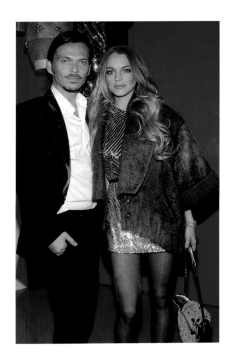

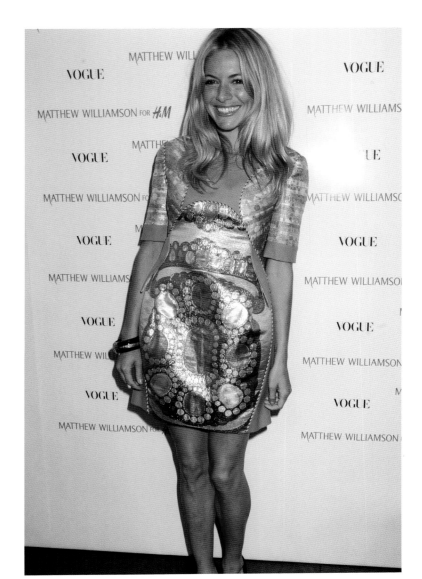

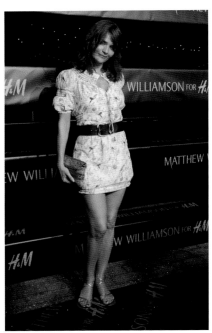

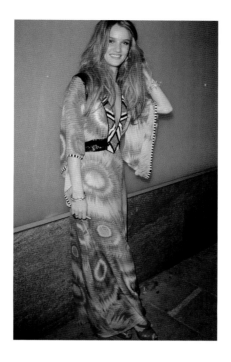

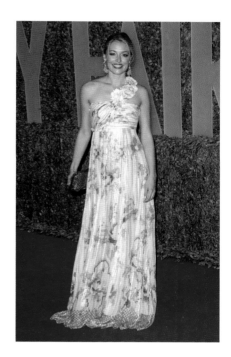

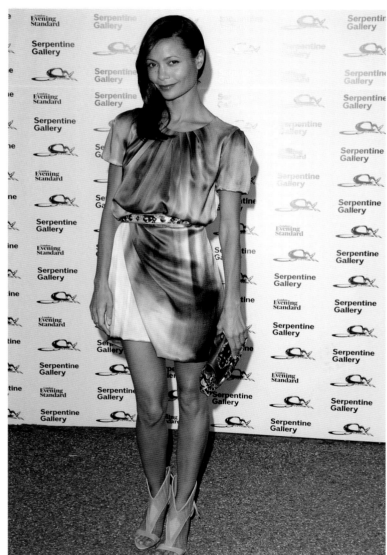

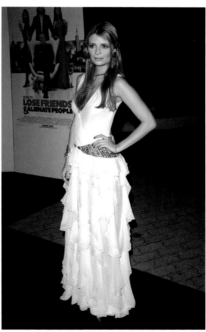

this page
clockwise from lower left
|
Mischa Barton
Cat Deeley
Rosie Huntington-Whiteley
Thandie Newton

opposite page
clockwise from lower right
|
Helena Christensen
Erin O'Connor
Matthew Williamson and
Lindsay Lohan
Sienna Miller

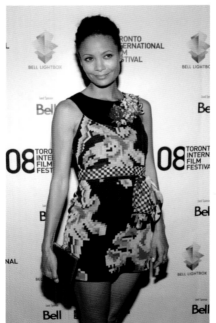

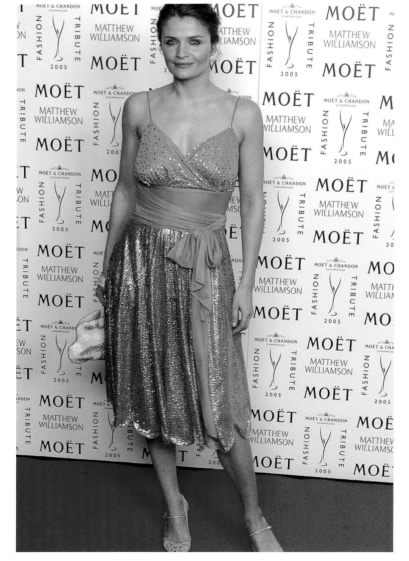

clockwise from lower right
|
Helena Christensen
Thandie Newton
Gwyneth Paltrow
Kim Cattrall and Miley Cyrus

opposite page
clockwise from top
|
Kate Moss
Emilie de Ravin
Scarlett Johansson
Sienna Miller

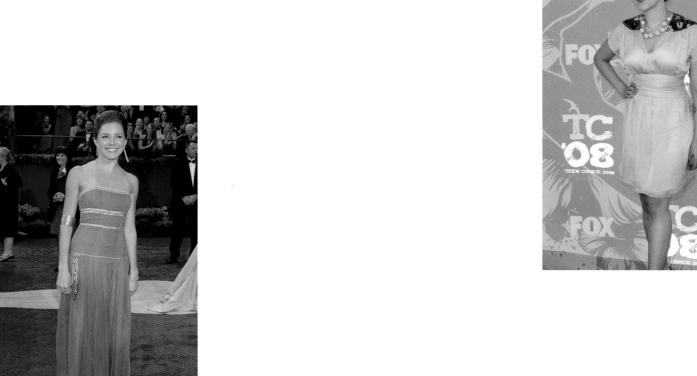

Valencia print
Winter 2009

HIS SHOPS REFLECT HIS
SENSE OF COLOUR, HIS LOVE
OF NATURE AND EXOTICISM
AND HIS COLLAGES SHOW HIS
FASCINATION WITH GLAMOUR.
THEY ARE AN OASIS OF BEAUTY!!

Diane von Furstenberg
Designer

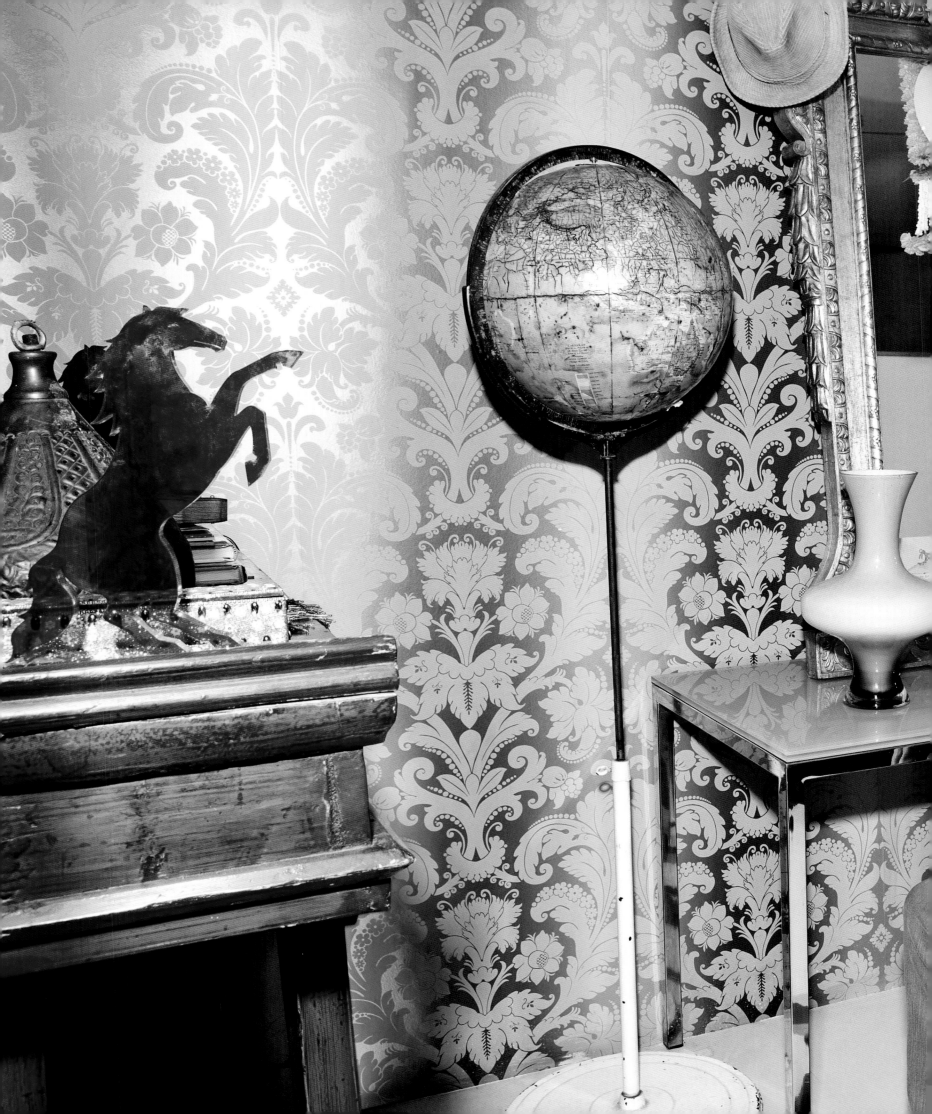

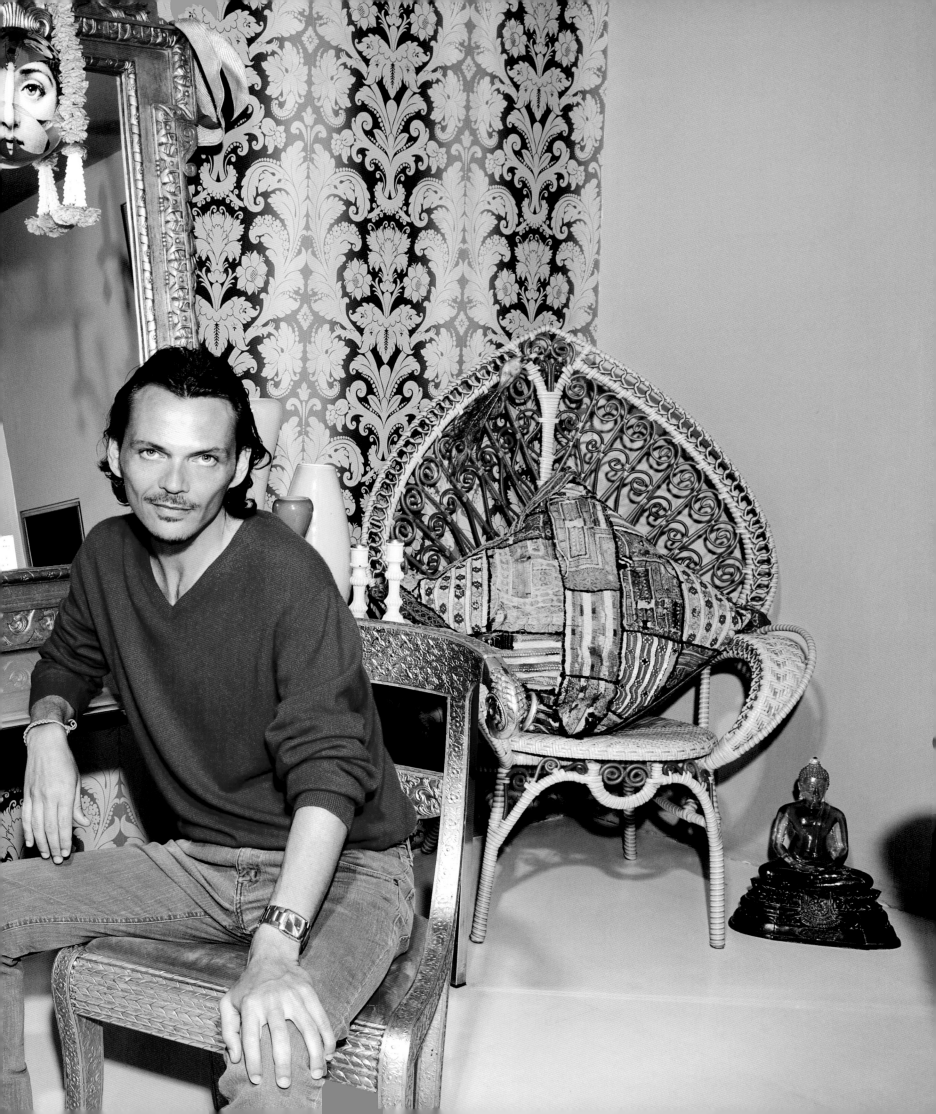

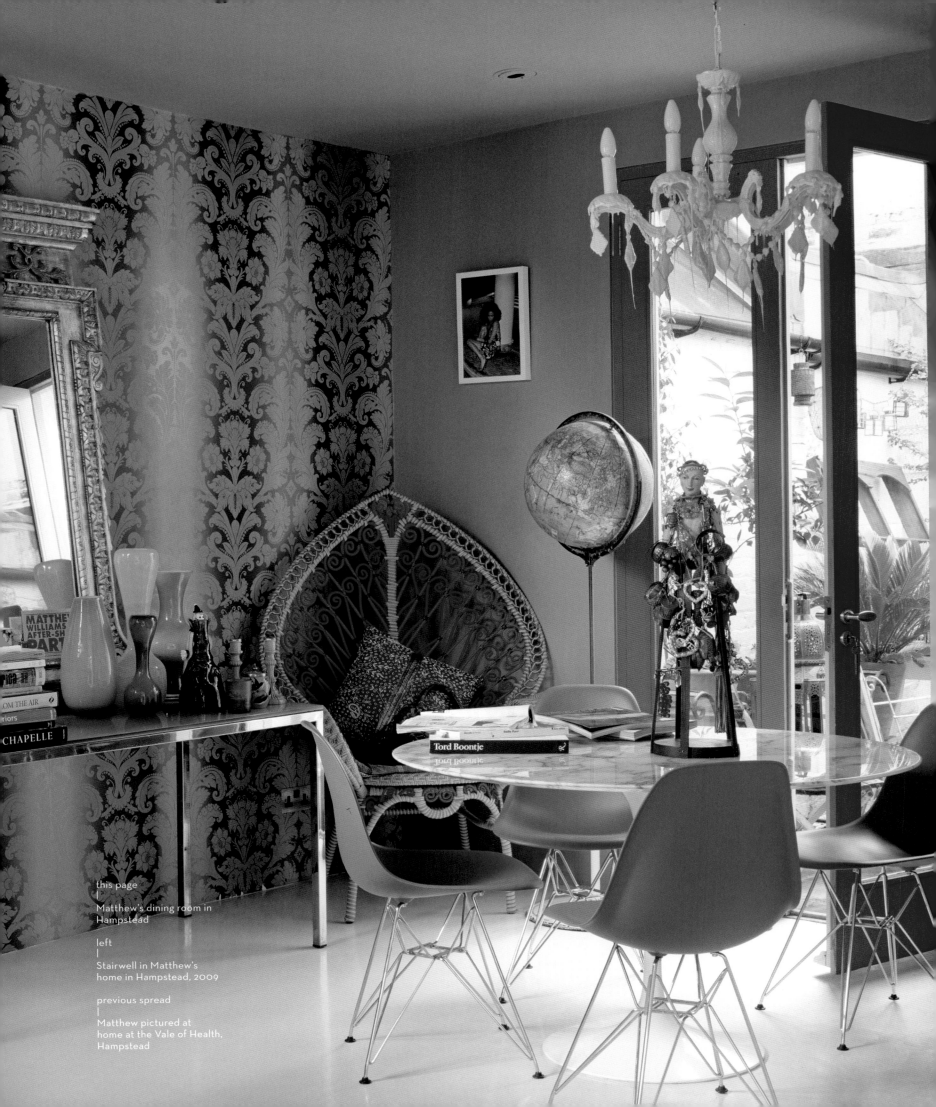

this page
|
Matthew's dining room in
Hampstead

left
|
Stairwell in Matthew's
home in Hampstead, 2009

previous spread
|
Matthew pictured at
home at the Vale of Health,
Hampstead

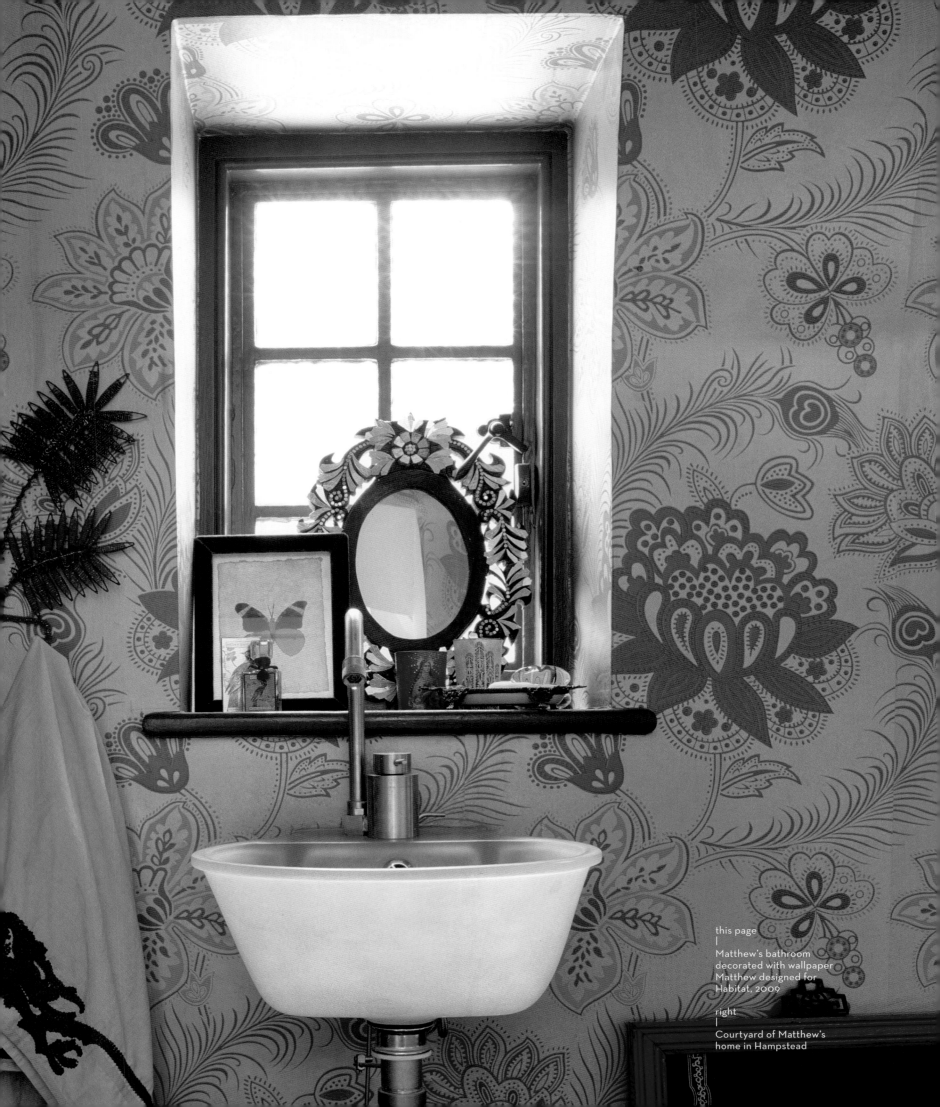

this page
|
Matthew's bathroom
decorated with wallpaper
Matthew designed for
Habitat, 2009

right
|
Courtyard of Matthew's
home in Hampstead

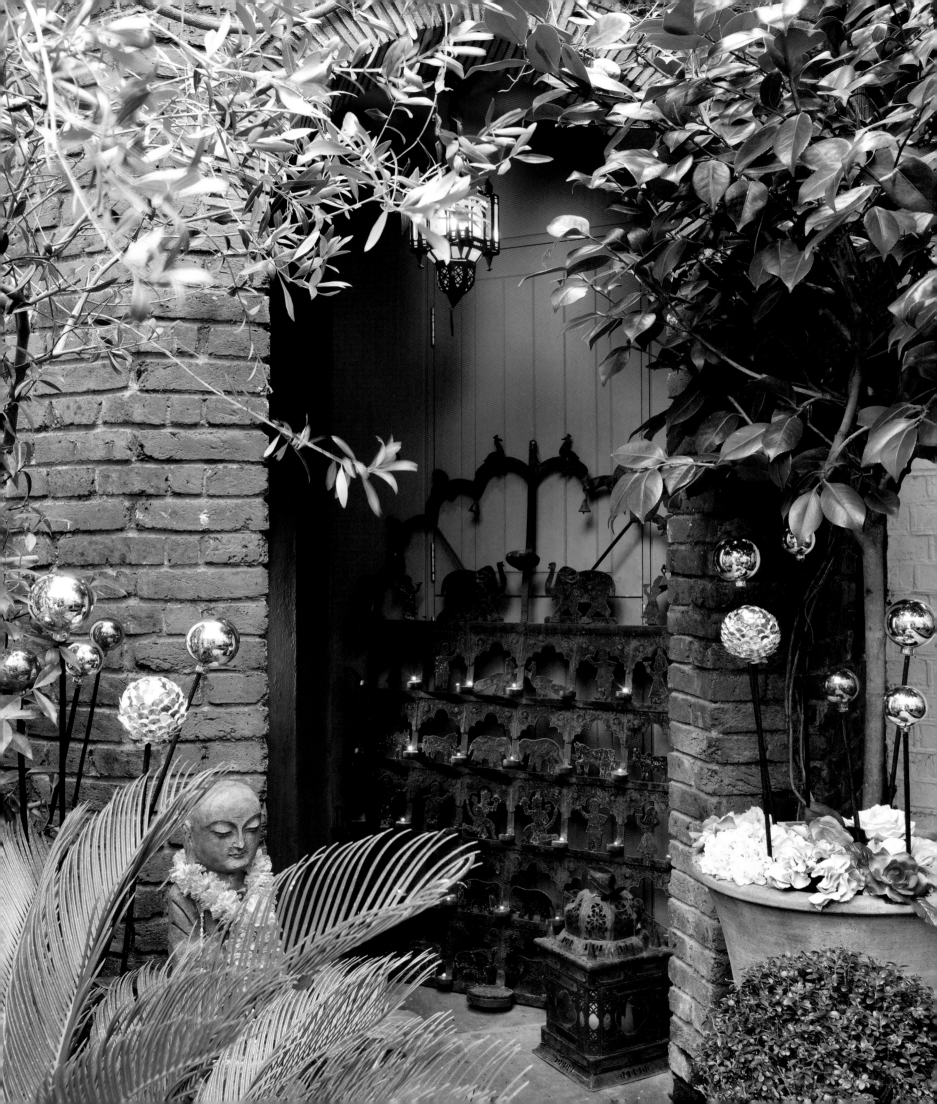

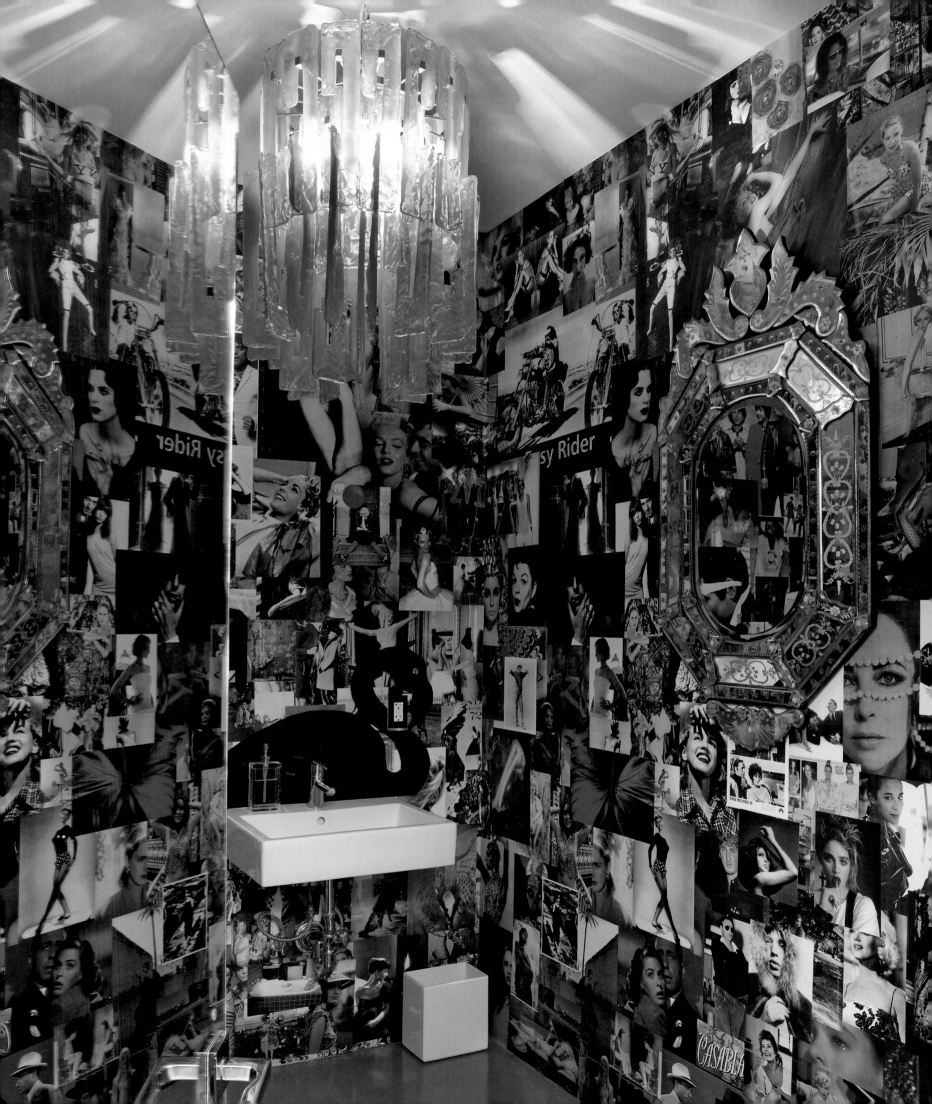

ENVIRONMENT

LIKE every fashion designer in the world, Matthew Williamson's aesthetic is not something that can be switched on or off. It is the basis of his personality. When he leaves the office, the world he returns to is not grey or drab but a colourful summation of everything he has learned from India and the many trips he and Joseph have taken over the last decade and a half. Joseph points out, "The first thing that strikes you in the way Matthew lives is the colour, of course. But more than that, it's a sensibility, a spirit he taps into for everything he does. Just as his woman is a free-spirited bohemian in outlook and spirit but still refined, so is his private space.

"Like his fashion, the way his house is decorated is exotic and very colourful. There are definite aesthetic similarities in his favourite countries, from Mexico to India and Bali to Brazil even. It's their unabashed love of colour, — so when we first went to Mexico" Joseph recounts, "I knew he was drawn to all those beautiful multi-textured carpets and rugs and textiles, the way they weave lines and lines of colours, and also he is drawn to the trinkets and the Day of the Dead paraphenalia, anything that had that almost naïve quality, but adorned with a beautiful kind of magpie aesthetic. Obviously, India really was the place where I saw he was in love with its sensibility. Our first drive cross-country was the first time I saw him spellbound by the array of bright saris crossing the deserts, the contrast between what were very cheap synthetic colours with huge landscapes and beating sun. It is all there, in the way he lives, in a beautiful cottage in Hampstead. It is a technicolour dream."

The Matthew Williamson signature is immediately apparent in the interiors of his shops in London, New York and Dubai. As Paul Smith remarks, "In the case of Matthew's London shop, it sits in quite a classical interior, but oozes glamour! As he is famous for his use of colour, this is represented in fluorescent coloured clothes rails, brightly coloured patterned rug with a lime green seat sitting on top of it, mint green chandeliers and a hot coloured counter housing the wrapping and cash area, and finally a glass boxed garden crammed full of exotic plants. All in all this shop fully represents the design and character of Matthew."

above
|
Matthew painting fluorescent highlights to the silk De Gournay wallpaper in the London flagship store, 2004

left
|
Bathroom in Matthew Williamson New York store. The wallpaper is a collage of tear sheets all individually placed, 2009

Original sketches of the Matthew Williamson retail space
designs for an in-store shop in Doha, Qatar

Original sketches of
the retail design of the
London store before
work commenced

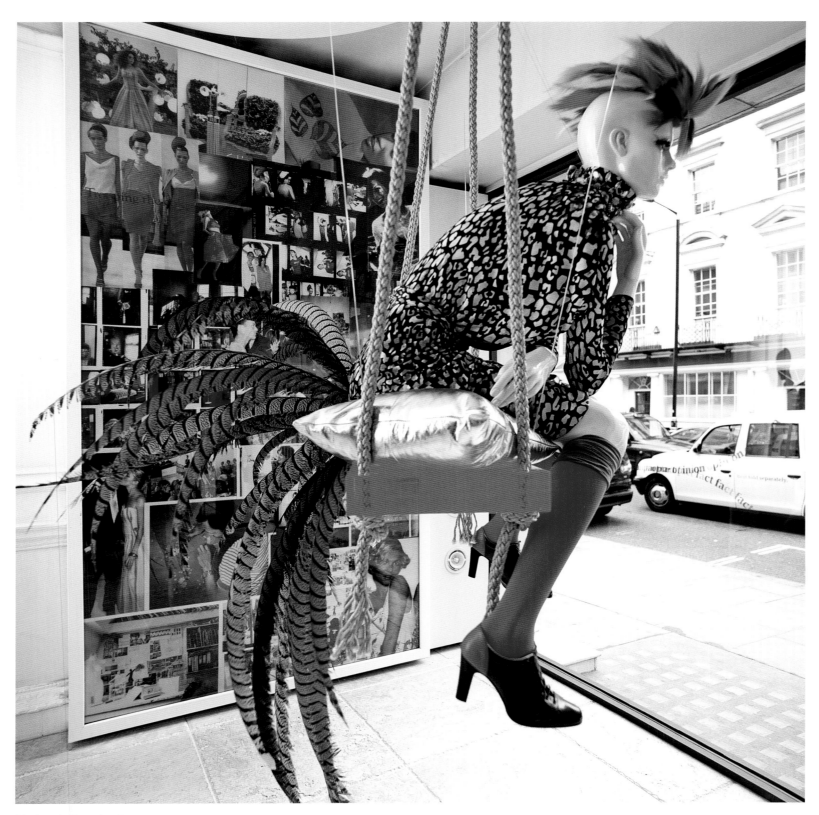

Window display in London store, 2008

right

Interior shot of the London
store, 2009

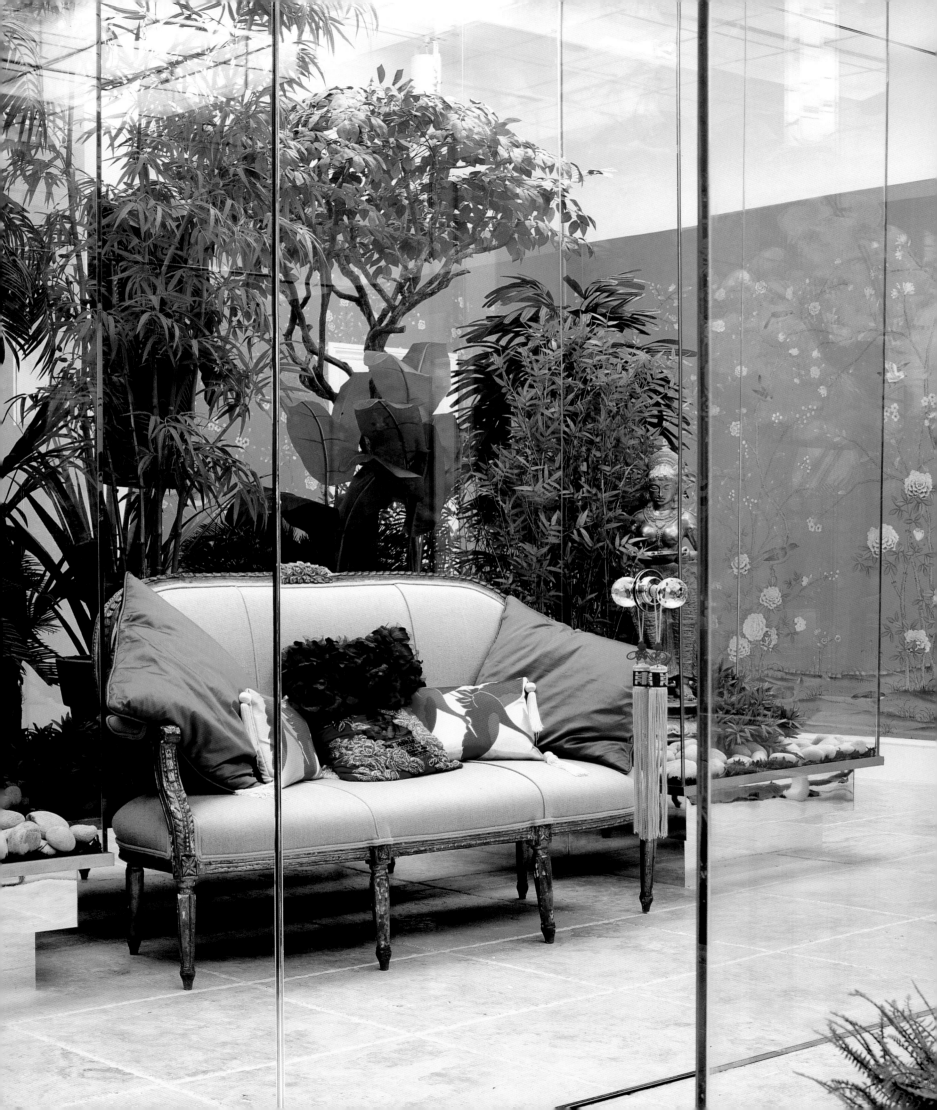

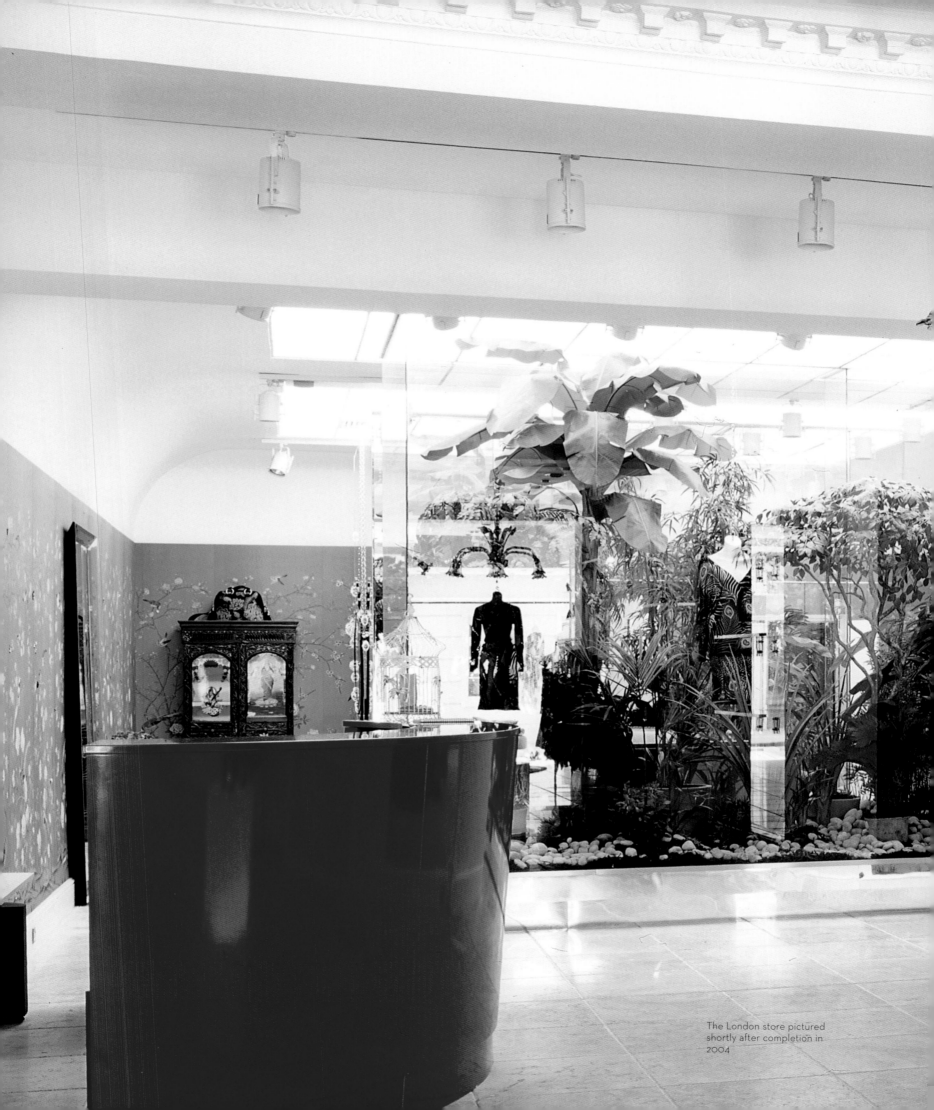

The London store pictured
shortly after completion in
2004

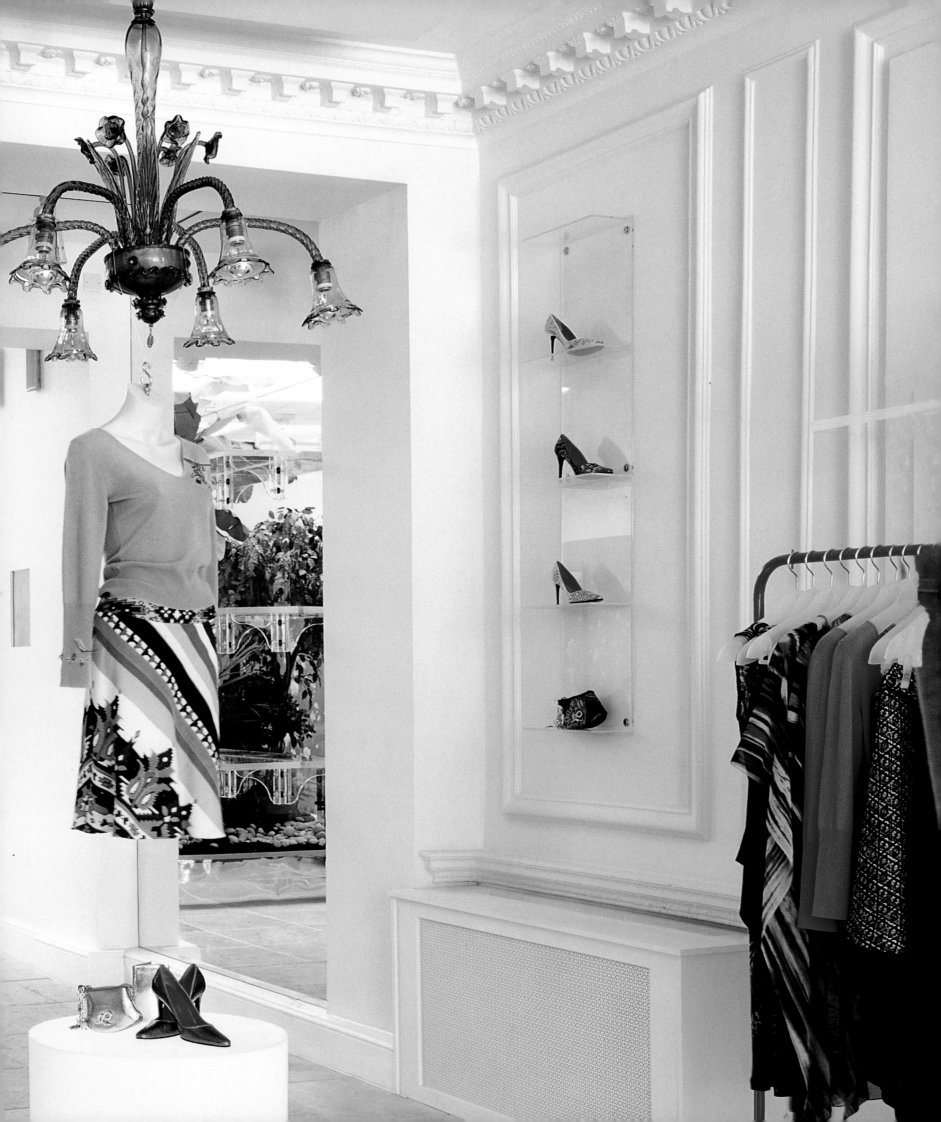

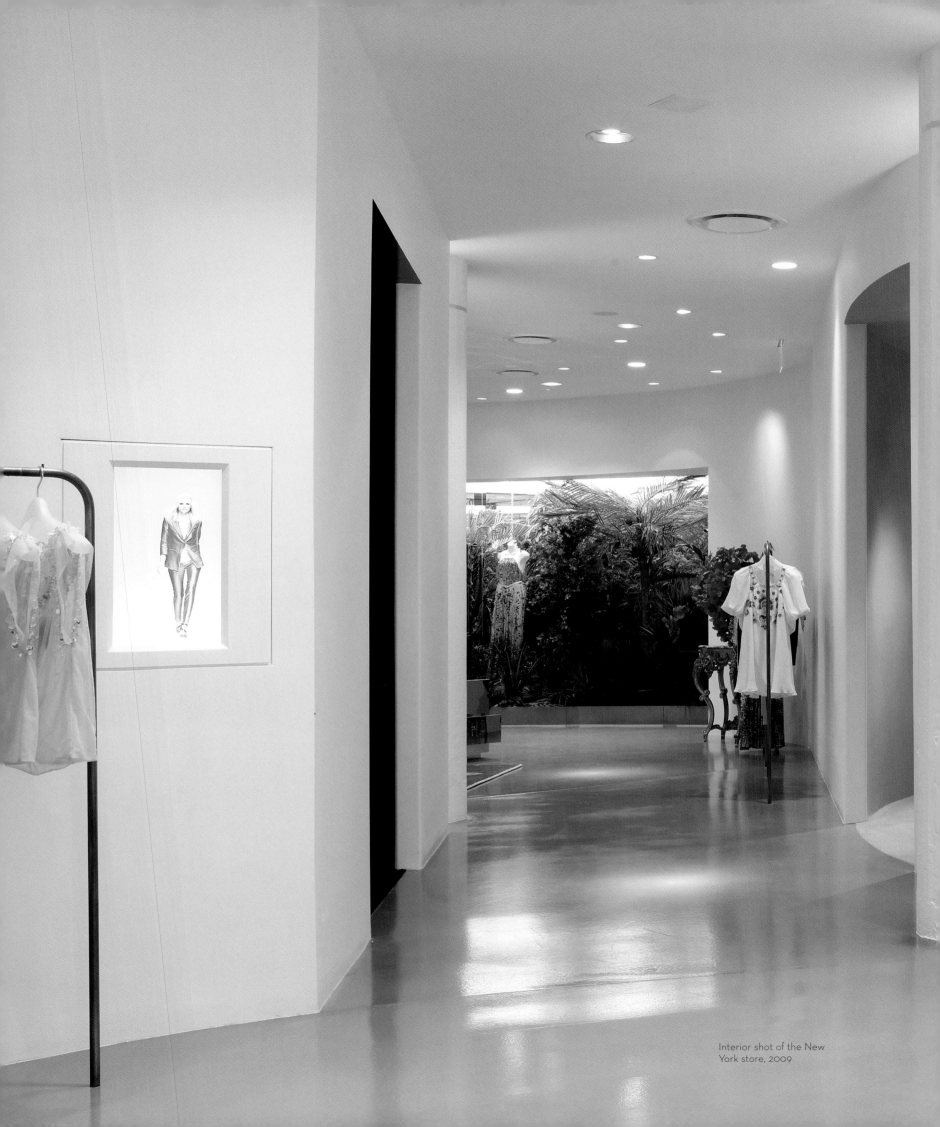

Interior shot of the New
York store, 2009

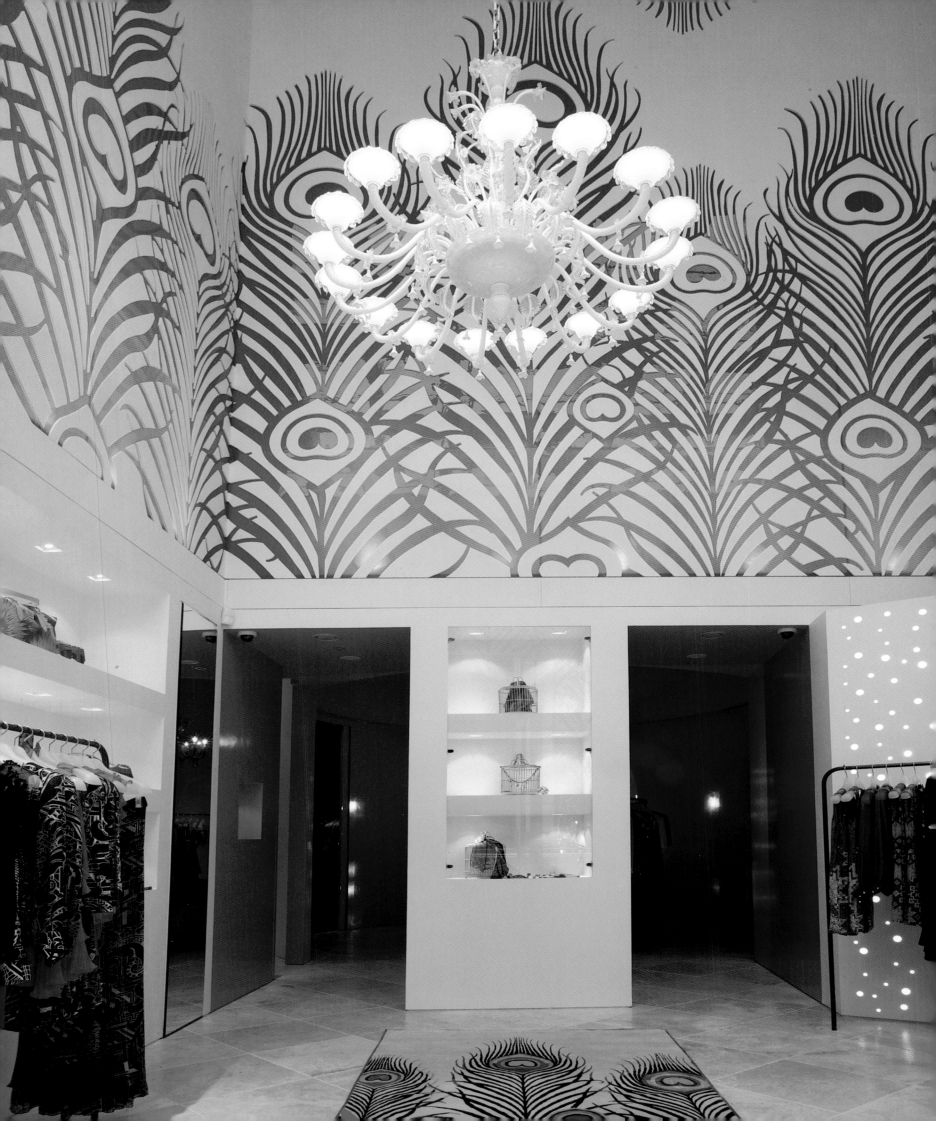

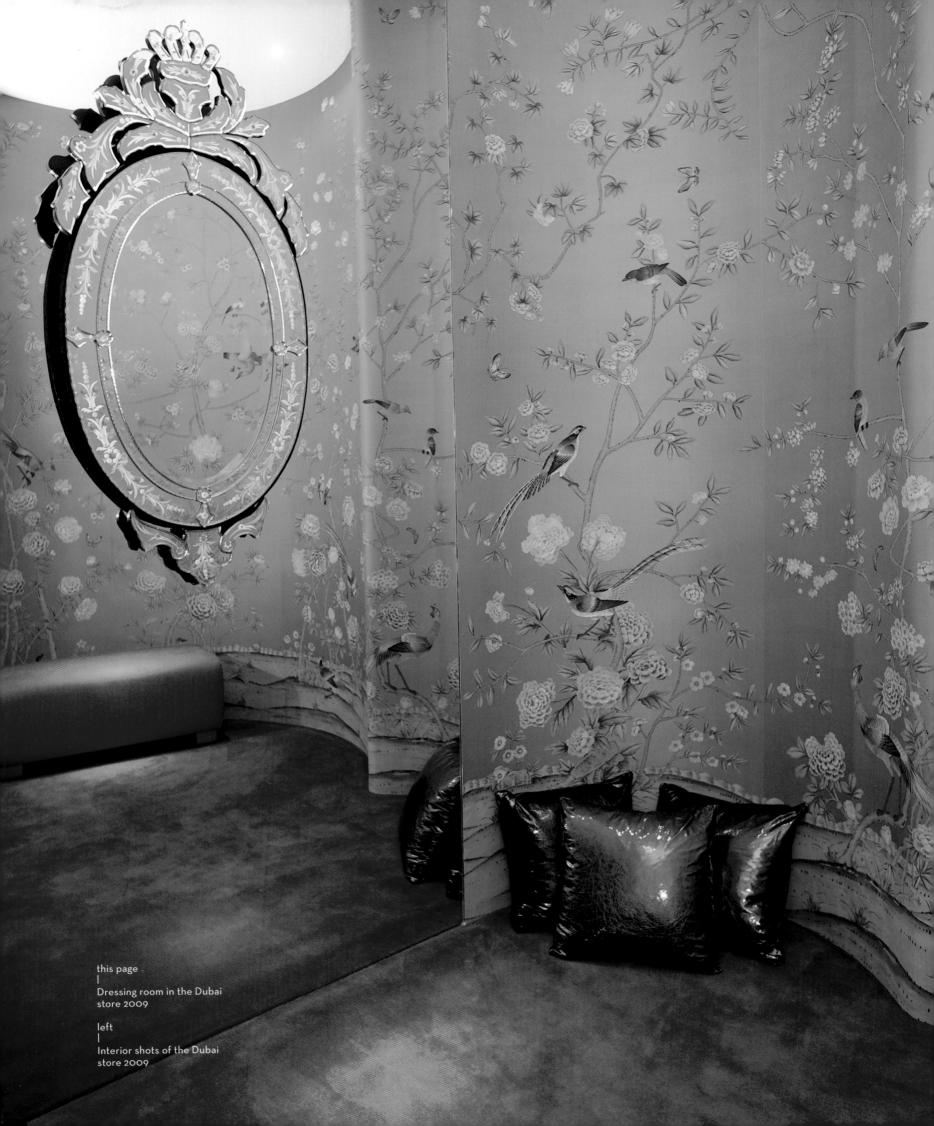

this page
|
Dressing room in the Dubai
store 2009

left
|
Interior shots of the Dubai
store 2009

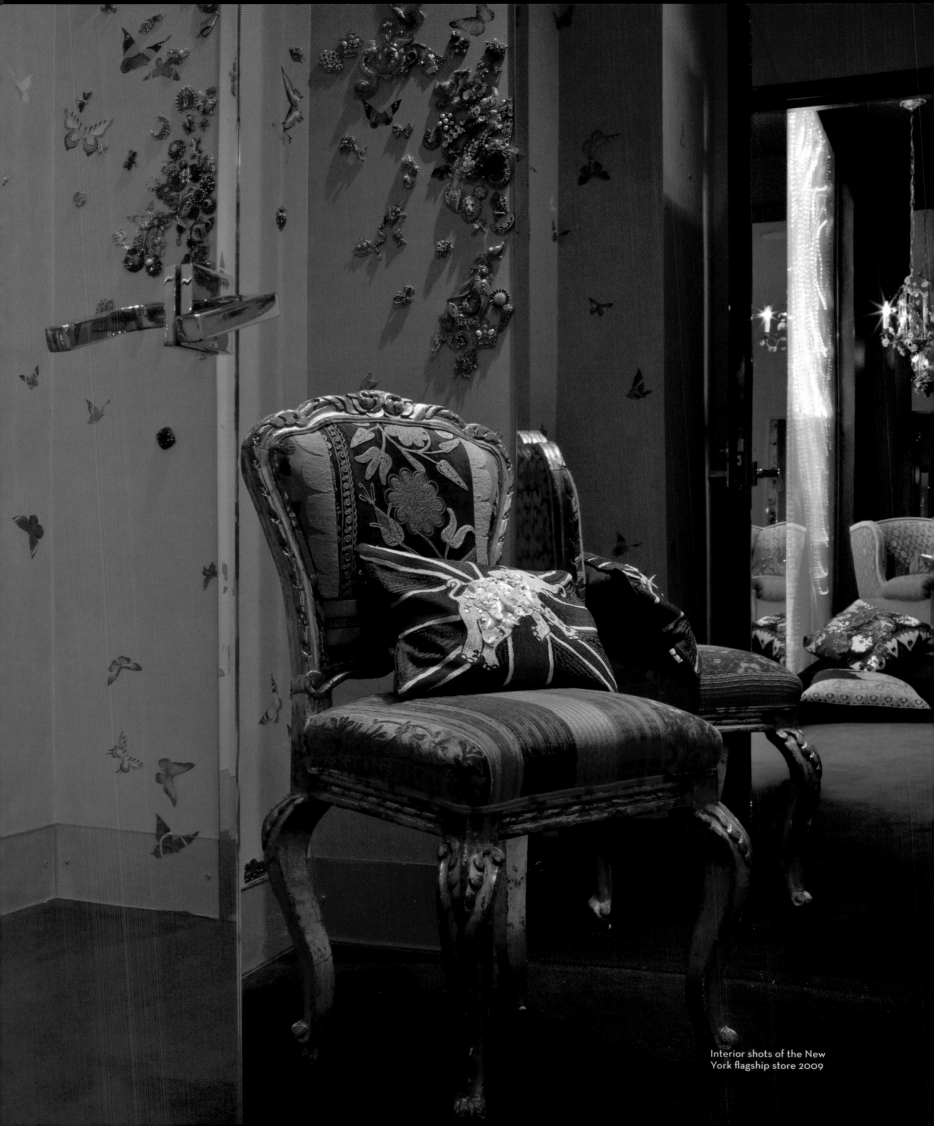

Interior shots of the New
York flagship store 2009

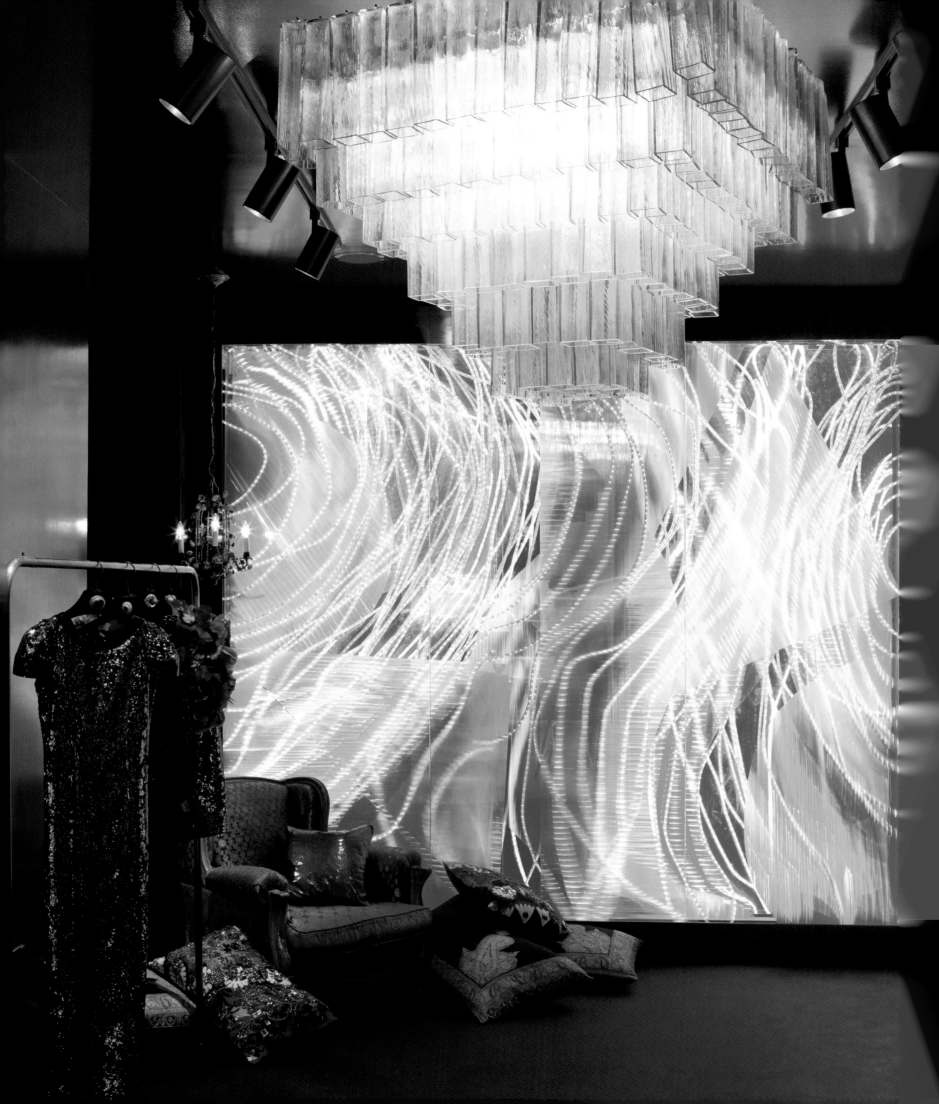

Water Lily Print
Summer 2007

1971–1992

— Born in Manchester in Oct 1971.
— Studied up to VI form in Loretto College in Chorlton, Manchester.
— Entered BA Fashion Degree at Central St Martins in Sept 1990.
— Placement at Zandra Rhodes from April to July 1992.

1993–1996

— Graduated from St Martins in June 1994 with a BA Hons 2:1 in Fashion and Print Design.
— Worked on various freelance projects including dance costumes for the Wayne McGregor company, Marni and Monsoon.
— Founded partnership company with Joseph Velosa in September 1996. The company was based out of a flat on the Gray's Inn Road, London WC1. By December 1996 the label was stocked in Browns London and Barneys New York and was given a 1 page "Spy" feature in UK *Vogue*'s Jan 1997 issue.

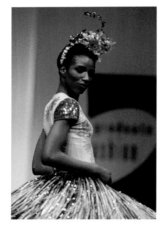

Matthew Williamson's graduate show, 1997

CHRONOLOGY

1997–2000

— The company has its first catwalk show in September 1997 held at Ladbroke Hall, London W9.
— The company moves into their first office in June 1998 on Ironmonger Row, London EC1.
— Matthew receives two successive nominations for Designer of the Year at the British Fashion Awards, 1999 and 2000.

2000–2002

— The company begins to work with Designers at Debenhams in 2001 and launches a womenswear diffusion line named "Butterfly by Matthew Williamson" with the store group.
— The company moves into a new studio building on Percy Street W1 in June 2001.
— The company celebrates its 5 year anniversary with a series of photographs taken by Rankin featuring celebrities such as Jade Jagger, Gwyneth Paltrow, and Kelis. These photographs were then exhibited in a converted gallery space in West London in September 2002.

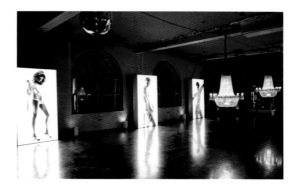

Interior shots for Matthew Williamson's 5th year anniversary celebration 2002

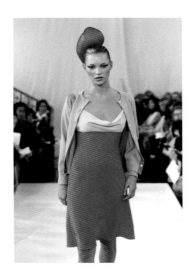 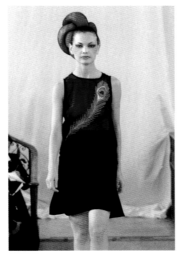

Electric Angels 1997

2002–2003

— The company moved to show its collections during New York Fashion Week beginning with the Autumn/Winter 2003 show.
— In June 2003 the company collaborated with the Rug Company on a range of 4 rugs using prints from the ready-to-wear collections.
— Starting in September 2003, the company began collaborating with Coca-Cola on applying Matthew Williamson prints onto the iconic glass bottles. The first "Parrot Print" bottle was so successfully received that the collaboration was extended to include three further prints which were launched in conjunction with the opening of the company's first flagship store.

28 Bruton Street store interior, 2004

2004–2005

— The company open its first flagship store at 28 Bruton Street London, W1 in April 2004.
— In Oct 2004 the company collaborated with Smythson, on a range of stationery using Matthew Williamson prints.
— In March 2005, Matthew was awarded the Moet and Chandon Fashion Tribute Award. The award ceremony was attended by, amongst others, Sienna Miller, Keira Knightley, Jade Jagger and Helena Christensen and featured a catwalk show of the company's archive collection.

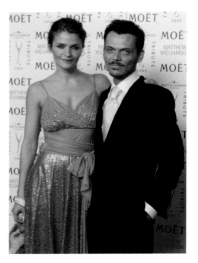

Matthew Williamson and Helena Christensen, 2005

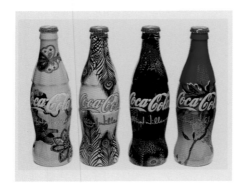

Coca-Cola, Matthew Williamson print collection, 2003

Rug Company, Matthew Williamson print collaboration, 2003

2005–2006

— In collaboration with Aspects Beauty UK, the company created its first fragrance which launched in Harvey Nichols London in June 2005.

— In October 2005 Matthew was appointed Creative Director of the Italian fashion house, Emilio Pucci. Matthew divided his time between the UK and Italy during this time, creating the womenswear collections for both the Matthew Williamson and Pucci companies. Matthew worked at Emilio Pucci for 3 years.

2007

— In March 2007, the company was invited by the London Design Museum to curate an exhibition, which opened in October 2007, featuring highlights of the designer's work over the past 10 years.

— In September 2007 the company celebrated its 10 year anniversary by returning to show in London Fashion Week. The show also featured a surprise performance by Prince who was in London on tour at the time.

Fragrance launch 2005

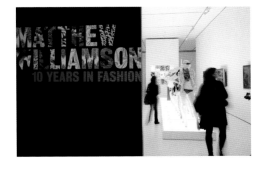

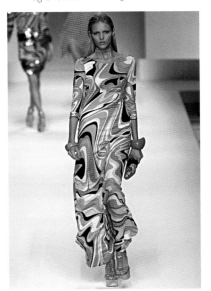

Matthew Williamson designs for Pucci, 2005

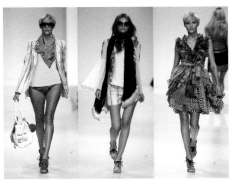

10th year anniversary show, 2007

2008–2009

— Matthew was awarded Red Carpet Designer of the Year Award at British Fashion Awards in November 2008.
— In February 2009 the company opened its first international flagship store at 415 West 14th Street, New York. This was followed by the opening of a third flagship store in June, located in the Mall of Dubai, UAE.
— In April 2009, the company collaborated with H&M on a Summer collection which comprised men's and women's ready-to-wear and accessories and was sold from H&M stores worldwide for a limited period. The collection was accompanied by an advertising campaign shot by Sølve Sundsbø with model Daria Werbowy.

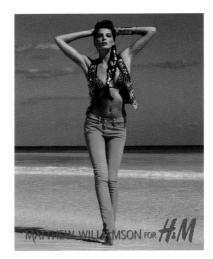

ad campaign

Peacock Print projection at Marble Arch to promote the Matthew Williamson/H&M collection 2009

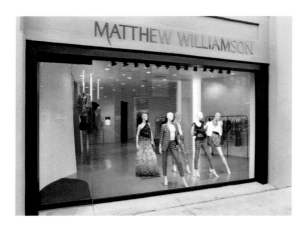

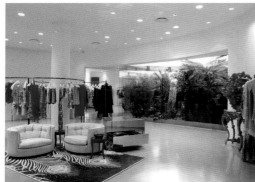

Interior shot of the New York store, 2009

2009–2010

— In September 2009, the company collaborated with Swarovski , the Austrian crystal company on a range of jewellery. The range consisted of 7 items which featured cut crystal embedded into prints taken from the SS10 collection.

— In February 2010 the company launched a capsule range of menswear in partnership with Harrods. This first collection comprised a range of cashmere knitwear, scarves and t-shirts.

— In Spring 2010 the company collaborated with Bulgari on a range of handbags for the SS11 season to be sold in Bulgari and Matthew Williamson stores worldwide.

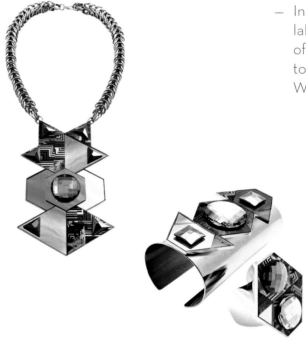

Matthew Williamson and Swarovski collaboration, 2009

Menswear, 2010

PAGE NO.S 000–117

PAGE NO.S 120–157

PAGE NO.S 160–211

PAGE NO.S 214–253

THANK YOU

Matthew would like to personally thank the following for their contribution to the book:

Colin McDowell
Sienna Miller
Hynam Kendall
Jade Jagger
Louise Wilson
Plum Sykes
Maureen, David and Andrea Williamson
Priya Tanna
Zandra Rhodes
Joan Burstein
Glenda Bailey
Mary Greenwell
Sam Mcknight
Catherine Kendall
Vanessa Coyle
Anna Wintour
Alexandra Shulman
Beyonce
Lucy Yeomans
Diane Von Furstenberg
Sir Paul Smith
Nick Knight
Mario Testino

Special thanks to our Publisher Charles Miers and Ellen Nidy, Allison Powers, Maria Pia Gramaglia of Rizzoli International Publications.

THE TEAM

Editor Minnie Weisz at Rizzoli
Copy Editor Mandy Delucia
Digital Operator Santiago Arribas Pena
Picture Co-ordinator Cat Staffell
Caption Co-ordinator Estella Thomas
Archive Photography James D Kelly
Art Director Clare Ceyprinski
Assistant Marianne Stroyeva
Designed by Sean Murphy and Hazel Dexter at Value and Service

We would also like to thank all the Matthew Williamson staff (past and present) for their hard work and commitment in helping to make this book possible.

First published in the United States of America in 2010 by Rizzoli International Publications, Inc.
300 Park Avenue South
New York, NY 10010
www.rizzoliusa.com
© 2010 Rizzoli International Publications
© Matthew Williamson
Essay © 2010 Colin McDowell

Distributed to the U.S. Trade by Random House, New York
ISBN-13: 978-0-8478-3394-8
Library of Congress Control Number: 2010929448
Printed and bound in China
2010 2011 2012 2013 2014 / 10 9 8 7 6 5 4 3 2 1

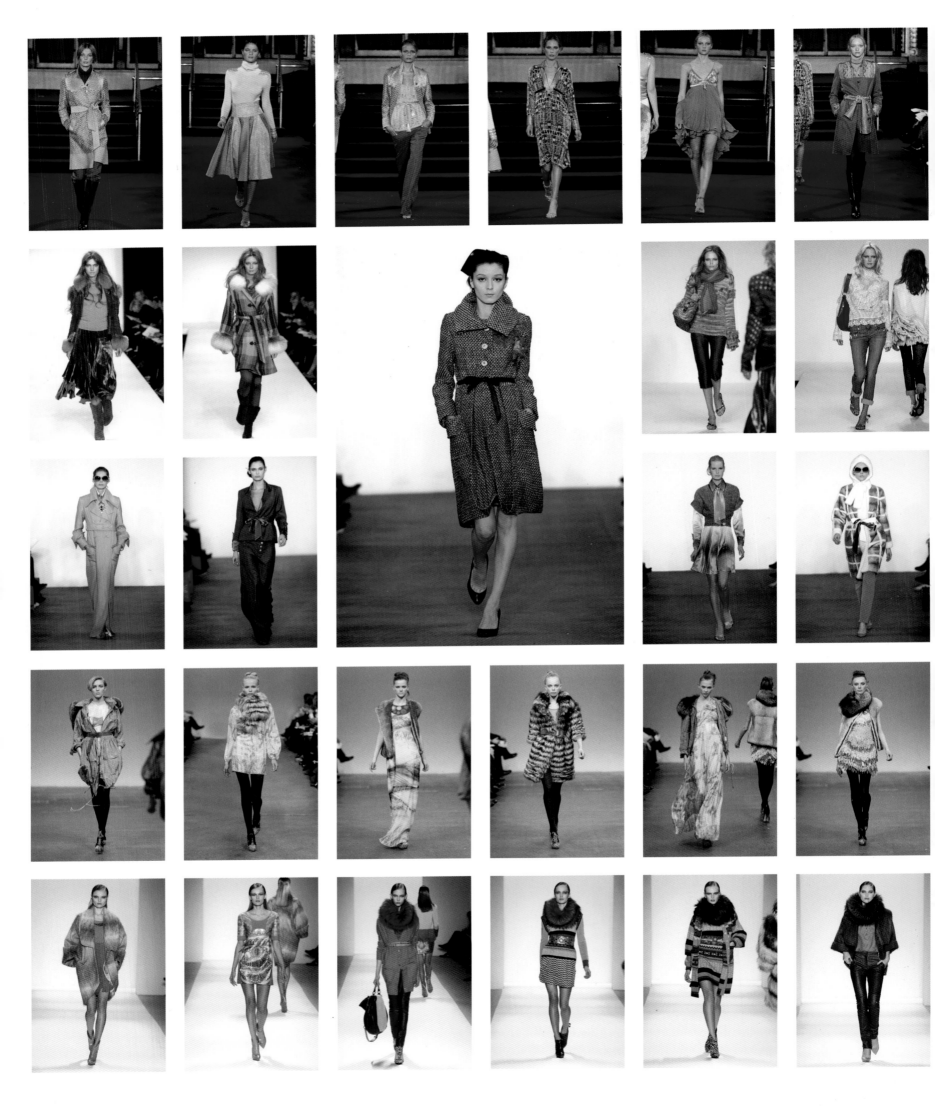

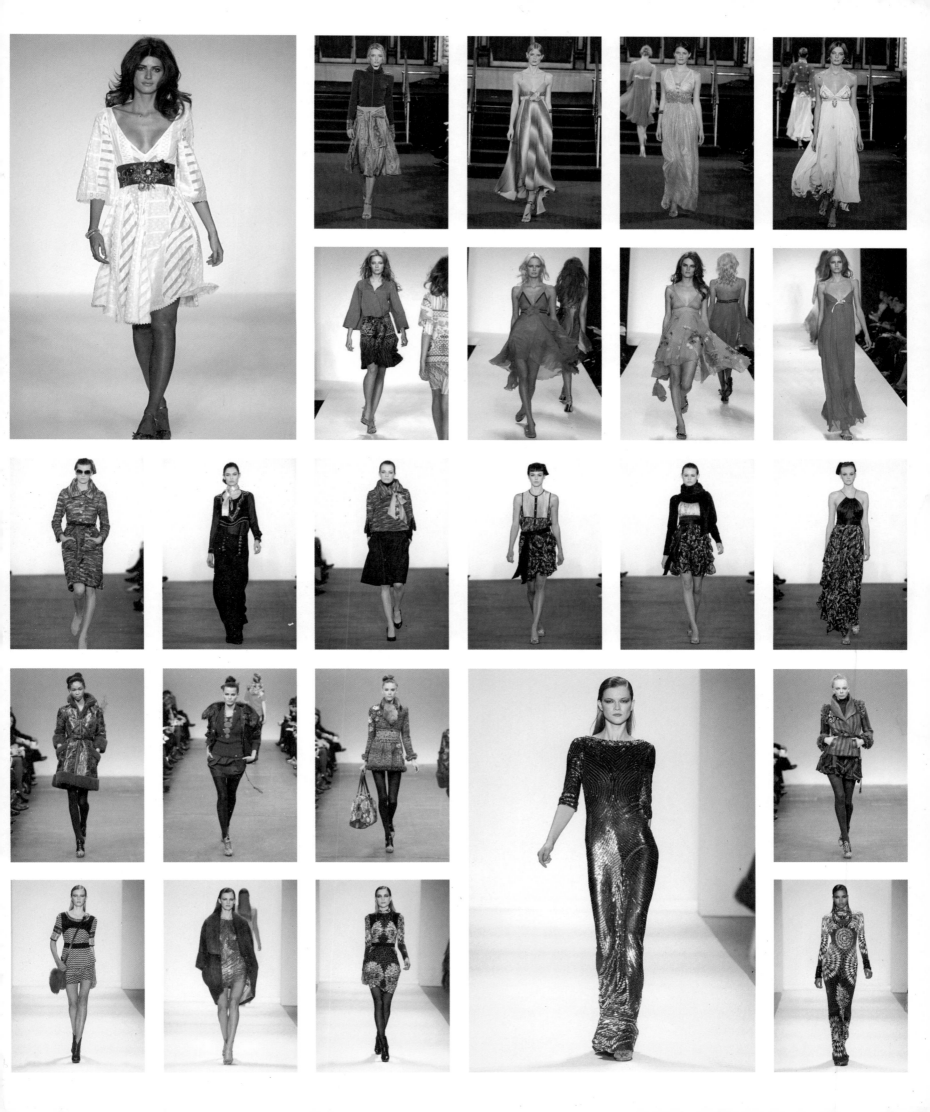